A CENTURY OF ARTISTS BOOKS

A CENTURY OF ARTISTS BOOKS

RIVA CASTLEMAN

THE MUSEUM OF MODERN ART, NEW YORK

Published on the occasion of the exhibition *A Century of Artists Books*, organized by Riva Castleman, Chief Curator, Department of Prints and Illustrated Books, The Museum of Modern Art, New York, October 23, 1994–January 24, 1995.

This exhibition is supported in part by a grant from the National Endowment for the Arts.

Produced by the Department of Publications
The Museum of Modern Art, New York
Osa Brown, Director of Publications
Edited by Harriet Schoenholz Bee
Designed by Antony Drobinski,
Emsworth Design, Inc., New York
Production by Marc Sapir
Composition by U. S. Lithograph, typographers, New York, and Emsworth Design, Inc.
Printed by Stamperia Valdonega, Verona, Italy
Bound by Legatoria Torriani, Milan, Italy

Library of Congress Catalogue Card
Number: 94-76019
ISBN 0-87070-151-7 (clothbound, MoMA, T&H)
ISBN 0-87070-152-5 (paperbound, MoMA)
ISBN 0-8109-6124-5 (clothbound, Abrams)

Published by The Museum of Modern Art
11 West 53 Street, New York, New York 10019

Clothbound edition distributed in the United States and Canada by Harry N. Abrams, Inc., New York, A Times Mirror Company

Clothbound edition distributed outside the United States and Canada by
Thames & Hudson, Ltd., London

Printed in Italy

Front cover: Detail from Sonia Delaunay-Terk. *La Prose du Transsibérien et de la petite Jehanne de France* by Blaise Cendrars (Frédéric-Louis Sauser). Paris: Editions des Hommes Nouveaux [Cendrars], 1913. Pochoir. 81⅛ x 14¼" (207.4 x 36.2 cm), irreg. The Museum of Modern Art, New York. Purchase (see plate 118)

Page 264: Detail of *Le Cygne*, from Henri de Toulouse-Lautrec. *Histoires naturelles* by Jules Renard. Paris: H. Floury Editeur, 1899. Transfer lithograph. 7⅞ x 7¹⁵⁄₁₆" (20 x 20.2 cm), irreg. The Museum of Modern Art, New York. Louis E. Stern Collection

Contents

FOREWORD

THIS VOLUME IS PUBLISHED on the occasion of the first extensive exhibition to focus on the Museum's extraordinary collection of books illustrated or wholly created by modern artists. Over the past thirty years the expansion of the collection has followed the parallel increase of publications in this form by artists. This, then, is a celebration of the history of the modern artist's book as exemplified by richly inventive and beautiful works included in the Museum's holdings with a few additional examples from other distinguished collections.

A project of this scope could not have been realized without the support of many individuals and organizations. An essential aspect was the thorough cataloguing of the Museum's book collection, which has been carried out during the past six years with deeply appreciated assistance from Mrs. Arthur Stanton, Mrs. Donald B. Straus, Philip A. Straus, The Cowles Charitable Trust, the National Endowment for the Arts, and the New York State Council on the Arts. We are also most grateful to Walter Bareiss, the Drue Heinz Foundation, and the National Endowment for the Arts for grants which have aided this presentation of *A Century of Artists Books*.

We owe a large and very special debt of gratitude to Riva Castleman, who conceived, planned, and directed the exhibition and this accompanying publication. She has graciously and appropriately dedicated both to Monroe Wheeler, whose early recognition of the illustrated book as a significant expression of modern art laid the foundation for the Museum's outstanding role as a collector and exhibitor in this field. The fact that most of this exhibition, representing a hundred years of artists' books through superb and often rare examples, could be drawn from the Museum's own holdings is impressive testimony to the dedication, care, and connoisseurship with which she has expanded and shaped our collection of artists' books during more than three decades at this institution—as a member of the Drawings and Prints Department beginning in 1963 and subsequently as Director of the Department of Prints and Illustrated Books since its inception in 1976. Her accomplishments in the world of prints and her contributions in other program areas are equally notable, and the present occasion is only the most recent manifestation of the professionalism, knowledge, and perceptive eye which characterize every exhibition she organizes. *A Century of Artists Books* is special, however, in offering the opportunity to appreciate in high degree how greatly Riva Castleman has enriched the inheritance she received from Wheeler and his colleagues and what a remarkable legacy of her own achievements she will pass on to the next generation of curators entrusted with this collection. On their behalf, as well as my own, I am happy for this occasion to express to her our admiration and very warm thanks.

Richard E. Oldenburg

ACKNOWLEDGMENTS

In organizing this exhibition and producing its accompanying publication, a multitude of colleagues, collectors, publishers, and dealers assisted, advised, and supported my research and helped to bring these endeavors to a successful conclusion. They all deserve my most enthusiastic appreciation and heartfelt thanks. At the outset, however, the following individuals must be accorded special recognition for their support and crucial contributions: Walter Bareiss, collector, connoisseur, and longtime donor to the Museum's collection; Robert Rainwater, Miriam and Ira D. Wallach Librarian of Art, Prints, and Photographs and Curator of the Spencer Collection of the New York Public Library, who graciously brought his considerable knowledge on the subject to reviewing my manuscript; and Gérald Cramer, John Fleming, Lucien Goldschmidt, and Warren Howell—four illustrious members of the commercial world of books, who inspired my own love of the book but died before I could demonstrate my profoundest gratitude in this form.

In addition, while the collections of many esteemed institutions were made available to me for research, the opportunity I was given as a Visiting Scholar at the Resource Collections of the Getty Center for the History of Art and the Humanities, Santa Monica, was an invaluable occasion to organize a wealth of material and my thoughts about artists' books.

Other friends and colleagues to whom sincere thanks are owed are: Daisy Aldan; Charles Altschul; Andrew Hoyem, Arion Press; John Ashbery; Brigitte Baer; Dr. Karl Dachs, Dr. Elmar Hertrich, and Dr. Béatrice Hernad, Der Bayerischen Staatsbibliothek, Munich; Pierre Berès; Loriano Bertini; Antoine Coron, Conservateur à la Réserve des Imprimés, Bibliothèque Nationale de France; Françoise Woimant, Conservateur en Chef du Département des Estampes, Bibliothèque Nationale de France; Timothy A. Eaton, Curator, Boca Raton Museum of Art; Elaine Lustig Cohen; Marilyn Symmes, Curator of Drawings and Prints, Cooper Hewitt Museum, Smithsonian Institution, National Museum of Design, New York; Patrick Cramer; François Chapon, Bibliothèque Littéraire Jacques Doucet, Paris; Harriett Watts, Associate Director, Lyonel Feininger Galerie, Quedlinburg; Rainer Michael Mason, Conservateur, Cabinet des Estampes du Musée d'Art et d'Histoire, Geneva; Donald Anderle, Assistant Director, J. M. Edelstein, Senior Bibliographer and Resource Coordinator, and Marcia Reed, Special Collections Curator of Rare Books, The Resource Collections of the Getty Center for the History of Art and the Humanities, Santa Monica; Sabine Solf, Leiterin des Forschungs und Kulturbereichs, Herzog August Bibliothek, Wolfenbüttel; Kimball E. Higgs, Cataloguer, The Grolier Club; Anne Anninger, Philip Hofer Curator of

Printing and Graphic Arts, and Eleanor Garvey, Philip Hofer Curator Emeritus of Printing and Graphic Arts, Houghton Library, Harvard University, Cambridge; Ralph Jentsch; Gunnar Kaldewey; E. W. Kornfeld and Christine E. Stauffer, Galerie Kornfeld und Cie, Bern; Emmanuel Benador, Jan Krugier Gallery, New York; Maurice Jardot, Galerie Leiris, Paris; Helmut Friedel, Director, and Annegret Hoberg, Curator, Städtische Galerie im Lenbachhaus, Munich; Sid Shiff, Limited Editions Club; Kenneth Lohf; Jean-François Meijanès, Conservateur, Cabinet des Dessins, Musée du Louvre, Paris; William S. Lieberman, Chairman, Department of Twentieth-Century Art, and Colta Ives, Curator, Departments of Drawings and Prints, Metropolitan Museum of Art, New York; Isabel Monod-Fontaine, Conservateur, Musée National d'Art Moderne, Paris; Anna Lou Ashby, Associate Curator of Printed Books and Bindings, The Pierpont Morgan Library, New York; Andrew Robison, Curator of Prints and Drawings, National Gallery of Art, Washington, D.C.; Francis O. Mattson, Curator of the Henry W. and Albert A. Berg Collection, Virginia Bartow, Rare Book Curator, Roberta Waddell, Curator of Prints, and Margaret Glover, Librarian, New York Public Library, Astor, Lenox, and Tilden Foundations; Ben Shiff, Osiris, New York; Michael Owen; Carlo Bella, Pace Prints, New York; Innis H. Shoemaker, Senior Curator, Prints, Drawings, and Photographs, Philadelphia Museum of Art; Elizabeth Phillips; Anatole Pohorilenko; John Russell; Dr. and Mrs. Marvin Sackner; Lawrence Saphire; Mary C. Schlosser; Ulrike Gauss, Leiterin, Graphische Sammlung Staatsgalerie Stuttgart; Carlton Lake, Executive Curator, Linda Ashton, Assistant Curator, and Debra R. Armstrong-Morgan, Registrar, Harry Ransom Humanities Research Center, The University of Texas at Austin; Christine Swenson, Curator of Graphic Arts, The Toledo Museum of Art; William Goldston, Universal Limited Art Editions; Gerrard White; May Castleberry, Editor, "Artists and Writers Series," Whitney Museum of American Art, New York; Mrs. William Wolgin; Richard Field, Curator, Department of Prints and Drawings, Yale University Art Gallery, New Haven; Tony Zwicker.

Over the many years since the Louis E. Stern Collection of illustrated books arrived at The Museum of Modern Art, there have been numerous members of the Museum's curatorial staff who have worked with the Museum's book collection. Among these, I particularly wish to acknowledge Deborah Wye, Curator in the Department of Prints and Illustrated Books, and Kynaston McShine, Senior Curator in the Department of Painting and Sculpture, both of whom have written catalogues including them and have brought a considerable number of works into the collection. I have benefited greatly from their experience and expertise, and also from that of Clive Phillpot, former Director of the Library, who made the Museum a major resource of the Artist's Book.

Both the exhibition and this publication are the result of the dedicated work and rigorous intelligence of the following individuals, mostly members of the Museum's staff, to whom the preponderance of my gratitude belongs. In the Department of Prints and Illustrated Books, Starr Figura, Curatorial Assistant, did most of my work and hers, perfectly; Carol Smith, Research Assistant, devoted such care in cataloguing the Museum's illustrated book collection that it was possible to under-

take this project; and Audrey Isselbacher, former Associate Curator, assured the accuracy of the cataloguing. For this intricate publication, I wish to thank Harriet Schoenholz Bee, Managing Editor in the Department of Publications, who brilliantly improved my phrases and pages while leaving their messages intact; Antony Drobinski, of Emsworth Design, Inc., this book's splendid designer, who mastered the narrow line between classic purity and modern accessibility; and Marc Sapir, Assistant Production Manager. I sincerely appreciate the thorough contribution of Daniel Starr, Associate Librarian and always the consummate bibliographer. For the exhibition, I am especially grateful to Jerome Neuner, Director of Exhibition Production and Design, who organized the display of the material with the skill and fine eye of a magician; Barbara London, Assistant Curator, Department of Film and Video, whose research led to video presentations of complete books; and Nestor Montilla, Assistant Registrar and caretaking manager of the many valuable loans.

Thanks are also owed these members of the Museum's staff: Sue B. Dorn, former Deputy Director for Development and Public Affairs; James S. Snyder, Deputy Director for Planning and Program Support; Charles Danziger, former Assistant General Counsel; Wendy Weitman, Associate Curator, Alyson Shotz, Senior Cataloguer, and Frances Nicosia, Executive Secretary, Department of Prints and Illustrated Books; Terence Riley, Chief Curator, Matilda McQuaid, Assistant Curator, and Christopher Mount, Curatorial Assistant, Department of Architecture and Design; Magdalena Dabrowski, Senior Curator, Department of Drawings; Peter Galassi, Chief Curator, and Virginia Dodier, Study Center Supervisor, Department of Photography; Rona Roob, Museum Archivist; Janis Ekdahl, Assistant Director, and Eumie Imm, Associate Librarian, the Library; Richard L. Palmer, Coordinator, and Eleni Cocordas, Associate Coordinator, Exhibition Program; Antoinette King, Director, Karl Buchberg, Conservator, Patricia Houlihan, Associate Conservator, and Erika Mosier, Mellon Intern, Department of Conservation; Diane Farynyk, Registrar, and Meryl Cohen, Associate Registrar; John L. Wielk, Manager, Exhibition and Project Funding, and Rebecca Stokes, Grants Assistant, Department of Development; Jessica Schwartz, Director, and Rynn Williams, Press Representative, Department of Public Information; Osa Brown, Director, and Kim Tyner, Executive Secretary, Department of Publications; Mikki Carpenter, Director, Photographic Services and Permissions; Kate Keller, Chief Fine Arts Photographer, and Mali Olatunji, Fine Arts Photographer; and Michael Hentges, Director of Graphics.

My final words of thanks are to the Committee on Prints and Illustrated Books, its Chairman, Joanne M. Stern, and Vice Chairman, Jeanne C. Thayer, for their loyal and generous support, and to Richard E. Oldenburg, the Museum's Director for the past two decades, for his leadership and enthusiastic encouragement of this and the many other projects I have undertaken during his notable tenure.

Riva Castleman

DEDICATED TO
MONROE WHEELER
1899–1988

A CENTURY OF ARTISTS BOOKS

FOR THE PAST THREE DECADES exhibitions at The Museum of Modern Art have included small selections from the Louis E. Stern Collection of illustrated books, which was presented to the Museum by the executors of Stern's estate in 1964. For the most part, the contents of the present survey are taken from that collection, which was itself formed under the influence of other surveys, particularly a singularly historic exhibition organized by Monroe Wheeler. The Museum of Modern Art and all who admire and cherish modern artists' books are, therefore, greatly in his debt for revealing their beauty and importance more than fifty years ago.

Monroe Wheeler, to whom this book and the exhibition it accompanies are dedicated, was director of publications and exhibitions at the Museum. Since his youth in Evanston, Illinois, he had published poetry. During the late 1920s and early 1930s, under his own imprint, Harrison of Paris (occasionally called by the names of additional backers, but never by his), he was able to design and publish several beautiful books, including Alexander Calder's *Fables* of Aesop (plate 52). His tremendous accomplishment in putting together over two hundred books in the 1936 exhibition *Modern Painters and Sculptors as Illustrators* opened up to the art audience a previously nearly invisible field of creation. In 1933 Iris Barry, the acting librarian of the Museum, had written on behalf of the director, Alfred H. Barr, Jr., to the incomparable collector Philip Hofer, asking him if he would have anything to lend to a projected exhibition of *livres de peintre*. Pursuing the idea two years later, in April 1935, Hofer suggested that such an exhibition be held to open the Museum's library. He noted that an exhibition of illustrated books in the modern style had never been held in America and recommended Wheeler, who had organized part of the international exhibition in the Petit Palais in Paris and was to make a small exhibition of the bookbindings of Ignatz Weimeler at the Museum in September and October, 1935, as the unpaid director of such an exhibition. Hofer wrote, "It would be my idea wherever possible to have *original drawings, proof impressions of lithographs*, etchings and woodcuts, etc. for *wall* display and to accentuate the *art* side of the exhibition. As you know, almost *all* the important modern English, French and German artists have done work for books."[1] Wheeler of course knew the publishers and artists in Paris and America.

In his exhibition Wheeler included a facsimile of Paul Gauguin's *Noa Noa* manuscript (plate 4) to make the point that when artists first illustrated books with their sketches (that is, reproductions of their drawings and watercolors) it "stimulated them to mastery of first-hand techniques. For only if they themselves drew on stone or plate, or cut in the wood, could they be sure that the qualities they prized

most highly in their work would not be lost."[2] With this in mind, Wheeler dedicated his exhibition to Ambroise Vollard, a generous lender as well as the father of the modern illustrated book, and followed the footsteps of the great French publishers of the first third of the twentieth century, devaluating if not entirely disdaining the reproduction and the literal illustration. He wrote that having concentrated on painters and sculptors, "I honestly believe that the elimination of those whose specialty and chief source of income have been book-illustration—while conveniently reducing the number of books I had to choose from—has automatically raised the level of excellence and the percentage of sincerity." Because of this, the "exhibition may be studied as a miniature survey of modern art in general."[3] After decrying the lack of American painters who had turned their hand to books, he pointed out to the American viewer that "no effort be made to like what seems repugnant, or to rationalize what may indeed be irrational. . . . I believe this to be a necessary step in the evolution of any people in any period, toward the enthusiasm and the critical temper favorable to creation."[4]

Among the books included in the present exhibition are three that were published by the Museum while Wheeler was director of publications (he officially joined the staff in 1938). Shortly after World War II Wheeler's attempt to associate the Museum's publishing program of exhibition catalogues with the type of artist's book he so admired began in 1946 with a reprint of a booklet by Calder, first issued by the art dealer Curt Valentin. Antonio Frasconi and Leonard Baskin, perhaps the two most prominent and prolific creators of traditional artists' books in America since that time, were commissioned by Wheeler to create books with original woodcuts and wood engravings for the Museum. Bruno Munari, whose books were featured in an exhibition at the Museum devoted to his inventive graphic designs in the 1950s, also made a special book for the Museum in 1967, a year before Wheeler retired and twenty years before he died.

Since Wheeler's retirement and over the thirty years since Stern's collection was added to the few valuable books that had been purchased for the Museum's library, artists in Europe and the Americas have created an incalculable number of books. Many of these reflect the lavish manner developed by French publishers during the first forty years of the twentieth century. However, a far greater number have been of a less luxurious character and share with the early publications of the Russian avant-garde, rediscovered during this period, a need to produce images and ideas by the most available and/or cheapest means. This type of recent publication is called an Artist's Book, and, in fact, all the books in this survey emphasize the artist's contribution.

A strictly chronological recitation of the history of modern artists' books made in Europe and the United States would present the outlines of how the book form was varied and reformulated by visual artists throughout a period of one hundred years. However, such summaries have rarely clarified how the participation of individuals other than artists has precipitated these changes in creating books in terms of both inspiration and collaboration. Because the relationships artists have had with publishers, authors, and printers have not only given books their form

but, even more important, have stimulated the artists' imaginations, several sections of this survey have been devoted to these collaborations as well as to artists. In the text of this volume, this has resulted in an examination of several books more than once, analyzing factors that were outside the artist's control as well as within it. Because producing books is a complex activity, the artist's many approaches to keeping the book his or her own creation are also studied. To make this multifaceted examination of artists' books as comprehensive as possible, without assembling a group so large that the trees would overwhelm the viewers of the forest, the following criteria have been employed to guide the selection of works. Books published in editions are included, but unique printed or handmade books and all types of periodicals are excluded; whenever possible, early examples of an artist's work, particularly when they present stylistic or other theoretical breakthroughs, have been selected, while some well-known ones that are less pertinent to the explanation of the art of the book have been left out.

Several ground-breaking examples of the directions in which artists wished to take books at the end of the nineteenth century are studied before a description of the collaborative aspects of making books is given. Producing books in more than one copy is always a matter of organization and having money to pay for the costs. Entrepreneurs who felt inspired by art and books and who cultivated artists' interests in illustrating or embellishing them became the encouraging and often inventive publishers whose work is reviewed here. Then the various relationships between artists and authors are explored. The perceived primacy of art or text in books often defines the conditions under which the two are brought together. Artists with authors, artists as authors, and artists for authors are three aspects of this subject. Another is how artists dispense with text altogether without departing from the essential components of the book: integrity of idea and sequential presentation. Yet the text is a perennial and expected component, so that certain themes that have been traditional vehicles for the meeting of word and art over the centuries are also examined. Ways of dealing with the physical parts of books—their covers, paper, typography, and shape—evolve from the interactions of artist' ideas. Finally, the integration of the book form into the mainstream of art making is indicated by noting the kinship artists' books have with other kinds of works they create.

There is a distinct and incontrovertible difference between the group of works selected by Wheeler for his exhibition in 1936 and that selected in 1994. While twenty-five of his selections are included in the present survey, assumptions about the book and the artist's relation to it have changed dramatically in the past thirty years or so. Added to painters and sculptors who create books there are now photographers, designers, and Conceptual, Performance, video, and even book artists. The book has emerged as a central formal element in art. It is no longer solely a text printed on pages that have also been decorated by an artist in one of the traditional print techniques, but an object totally created by an artist, which may not have text, paper pages, covers, or any other properties usually associated with books. The following overture to a description of these changes reviews the development of the book form itself and how it became the site of artistic creativity.

FORMS OF OBJECTS EVOLVE from needs, then become refined, elaborated, and often needlessly embellished until they become radically transformed by ensuing needs. The book as an object took its familiar form many centuries ago. At first it was a gathering together of handwritten sheets of vellum (made from the skin of calves, lambs, or goats), the earliest appearing around A.D. 100. Although word of mouth predominated, from the beginning of the use of symbols to convey information there was a written tradition. On clay tablets and scrolls of papyrus or vellum, the edicts from gods and governments provided the irrevocable texts upon which professionals based their duties. It was only after the codex, or bound book, form evolved, however, that important texts could be easily read and available in many places to many types of readers. Manuscript books were duplicated by scribes who made errors, comments, and emendations as they carried out their devoted but monotonous work.

The advent of printing in the Orient and Europe, as with other mechanized inventions that made duplication possible, did not immediately transform the book. Although impressions in clay from carved stones and woodblocks predated Christ, it was in the Far East where such objects were first printed directly onto cloth and paper. In the West the earliest printed images were probably decorative designs on fabrics. The Chinese invented paper nearly two thousand years ago and made both accordion-folded and codex-style books of it only two centuries later. The knowledge of papermaking made its way from China through the Islamic centers, arriving on the European continent at the end of the eleventh century. Between the mid-twelfth and late-thirteenth centuries small religious images were printed from woodblocks on this material (the earliest recorded printing occurred in what is now Germany at the end of the fourteenth century). The importance of this step in the spread of images and ideas can be illustrated by the use, less than a century later, of printing to provide a fixed system for calculating astronomical calendars. Until the fifteenth century, astrolabes (sets of discs on which were engraved signs of astronomical features that, when revolved, plotted their movements and, thereby, the annual calendar) were hand-engraved and, like the scribe-written texts, often incorporated slight errors that produced incorrect calculations. The first printed astrolabes were, therefore, the first absolutely identical instruments producing identical information. They appeared in books as early as 1476, for example, in Johannes Regiomontanus's *Calendarium*, published in Venice (figure 1) only two decades after Johannes Gutenberg began to use letters that, instead of being engraved, one at a time, into metal or woodblocks, were separate pieces of type that could be put together into words and paragraphs, and printed, one full and absolutely repeatable page at a time.

At the end of the twentieth century we are still the legatees of this object—the book—made of sheets of paper, bound together, and printed with words made of separate letters. The manner of printing and binding has changed, and there are other forms of mass-printed pages that we handle and read in ways that differ con-

FIGURE 1: Johannes Regiomontanus. *Calendarium*. Venice: Maler, Ratdolt & Löslein, 1476. Woodcut with string. The Pierpont Morgan Library, New York

siderably from the way privileged prelates read their Gutenberg bibles. But the basic book published in the late twentieth century does not substantially differ from that of the late fifteenth century. Its essential quality, that of an object containing information that can be taken into one's own hands, read and contemplated in privacy, and projected by the reader into the most personal of realms, the imagination, has yet to be broached—though there is every sign that a radical transformation is in process.

But before contemplating the future of the book versus other reading forms, we will address the role of pictures and decorations in the book form and how it became possible to refer to some books as artists' books. The earliest forms of visual communication were pictures, or more exactly, signs representing things. Pictographs in caves related how and where to hunt; in the Orient very simple line drawings of things were combined to form ideograms; more complex and formalized, hieroglyphs on Egyptian burial chamber walls praised the dead and associated divinities and provided information for their journey through the netherworld. Hebrew letters evolved from signs of things, so that the Hebrew alphabet is a listing of names of those things, whereas the Roman alphabet, the familiar one you are now reading, is a listing of abstractions that, when recited, consists of one or two connected sounds imitating what the letters sound like when combined into words. No wonder such an alphabet encouraged pictorial embellishment!

Until the Renaissance, when manuscripts were decorated with ornament or images, texts and pictures were so closely associated that the total work was clearly understood to have come from an initiating higher spirit, not from those who made it a physical entity. Although we look at the Book of Kells (circa eighth–ninth century) or the early illustrated psalters as works of art, those who made the pictures did not create them: they followed the directions of the Creator. The earliest treatises on mathematics and science, including their illustrations, were the works of monks who understood that they were merely conduits, passing divine knowledge on to their species. Yet the invention of printing came at a time when mankind was beginning to observe its own history and place in the universe. Once this had occurred, the idea of the genesis of pictorial invention, too, was transformed. While the religious book and its associated illustrations remained the transmitted invention of a divine other, the understanding of human intervention underwent a critical change.

Many types of books were made possible by printing, or, rather, the possibility of distributing many copies of the same book contributed to the kinds of books demanded by those now able to obtain them. Books with pictures were the nucleus of this commerce, as they could be acquired and understood by those whose reading skills were slight. Sets of moral tales, proverbs, and emblems (images accompanied by words in motto form that indicated laudable human qualities) were predominantly in the realm of the inspirational, but rudimentarily in that of the educational as well. The sixteenth century saw the first printed examples of the do-it-yourself book. Studies of the body and other elements of nature, whether scientific or artistic, as well as plans for mechanical and architectural projects, included illustrations that indicated size, proportion, and that new feature,

perspective. Pictures in books that had once been visionary began to be explicit. Stories were truly illustrated, that is, specific moments were provided with images uniquely designed to depict them. In the Romantic era of the seventeenth century both texts and images began to emphasize expression, thereby encouraging readers and viewers to imagine nuances of meaning.

After the flamboyant, elaborately illustrated special editions cultivated by the pretentious society of the eighteenth century and the heavy demands of high-speed printing presses that made hacks of the best illustrators in the nineteenth century there was a reaction. First, Francisco de Goya's *Los caprichos* of 1799 (figure 2), a book of satirical aquatints accentuated with scathing captions, and then, the inventive lithographs with which Eugène Delacroix paid homage to the great Johann Wolfgang von Goethe's masterpiece, *Faust* (figure 3), announced a definitive change in the attitude of artists toward working in the book form. Between the time that Delacroix's book appeared, in 1828, and the last decade of the century there were only a few times that fine artists (as opposed to illustrators—a designation that began to have meaning once painters no longer were commissioned to produce specific images) joined their images to literature. Most notable were Edouard Manet's lithographs to Stéphane Mallarmé's translation of Edgar Allan Poe's *The Raven*, published in 1875 (figure 4). However, his evocative prints were issued in a portfolio of loose sheets assembled together with the folded sheets of the text. The intention that these items were created as a "book"—to be bound together—was asserted by a small extra print of the raven itself, titled *Ex libris*.

Several illustrated-book formats had developed over the preceding years. The earliest block books of the mid-fifteenth century consisted of full-page woodcuts, each containing both picture and text, printed on one side of a sheet, leaving the other, or verso, blank. At about the same time, Gutenberg's invention of movable

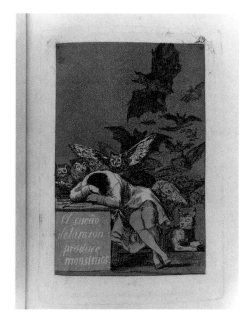

FIGURE 2: Francisco de Goya. *The Sleep of Reason Produces Monsters*, plate 43 from *Los caprichos* by Francisco de Goya. Madrid, 1799. Aquatint and etching. The Museum of Modern Art, New York. Louis E. Stern Collection

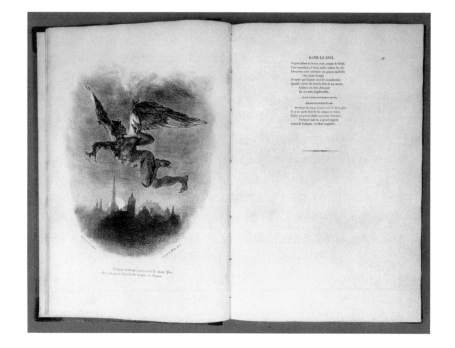

FIGURE 3: Eugène Delacroix. *Mephistopheles in Air* from *Faust* by Johann Wolfgang von Goethe. Paris: Ch. Motte Editeur, 1828. Lithograph. The Museum of Modern Art, New York. Louis E. Stern Collection

type allowed for more flexibility in placement so that illustrations could be designed to fit into a page of printed words, at the top, middle, bottom, or side of blocks of text. Other volumes with full-page or folded plates opposite pages of text gave the illustrator much more space for detailed representations. Series of prints, such as those of *The Great Passion*, made by Albrecht Dürer at the end of the fifteenth century (circa 1497–1500), perpetuated the format of the picture book in which the entire narration was clear from the images. Sets of prints in books, such as Goya's *Los caprichos*, accompanied by individual captions, carried on this tradition. On the other hand, because of the technical disparities between printing type (from shaped surfaces) and printing lithographic stones (from flat surfaces), Delacroix's single-page lithographs had to be separately printed and inserted between appropriate pages of the text. The result was totally new: the richness of the lithographs, both in their bold emphasis on the range of darks made possible by the medium and in their dramatic imagery, presented the artist's contribution as equal, if not somewhat superior, to that of the author of the text.

The propensity of many artists during the past hundred years has been to fill entire pages rather than share them, creating completed compositions rather than incidental vignettes. In this they have been encouraged by those who have believed that books were excellent vehicles for artists' ideas as well as a means of expanding an audience for them. During the first decades of the hundred years of this survey, many of the publishers of these often luxurious, limited editions were the artists' dealers. As the pictures themselves were explicitly associated with the artists' total oeuvres, they could be less dependent upon the text for inspiration. They were no longer expected to define the text exactly and thus became the pictorial equivalents of musical obbligatos or cadenzas—related to the theme, but tangentially.

There were two important components that had to be attained before fine artists, that is, painters, would find enough creative satisfaction in their work to feel complete freedom in embellishing the book form. Color was an easy element when manuscripts were themselves painted, rare when it came to printing. The first book to include more than one color in an image was published in 1482; it was a version of the thirteenth-century English mathematician Johannes de Sacrobosco's *Tractatus de sphaera mundi*. However, this and subsequent experiments, most of which required the printing of each added color separately on a hand-operated press, were time consuming, particularly in the production of books. Hand labor being cheap, hand-applied color, either to the matrix or to black-and-white printed images, freehand or brushed through stencils, solved the problem for centuries.

The second component was control over the print mediums, and this occurred in the context of the relationship of artworks and books to each other, specifically in the reproduction of the former in the latter. Until the advent of photography and color printing, all extant works of art were reproduced by artists and artisans, who painstakingly engraved, etched, or cut their images into copper or wood. From the early years of printing, images were reproduced—that is, recut into woodblocks or re-engraved into metal. The printing process alone often ruined the matrices, but more often printers who had not initiated an illustrated text

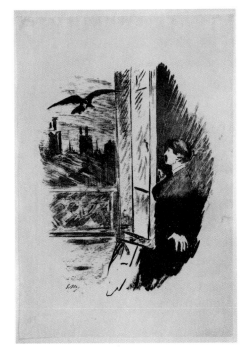

FIGURE 4: Edouard Manet. *At the Window* from *Le Corbeau* by Edgar Allan Poe. Paris: Richard Lesclide Editeur, 1875. Transfer lithograph. The Museum of Modern Art, New York. Louis E. Stern Collection

wanted to publish it in their town or country, their language, and their type. So from the beginning there were frequently several versions of the same printed illustration. Once it was necessary to reproduce specific paintings and sculptures in printed books, the task was to interpret, for there was no way that linear print-making techniques could copy totally nonlinear paintings without distortion. With the tonal possibilities of lithography, a clearer sense of these nonlinear art-works emerged.

Photographs pasted onto book pages in the mid-nineteenth century conveyed a better idea of three-dimensional sculpture, but photographs themselves could not be printed on a press until a method was devised, only two decades before the end of the nineteenth century, of putting their images on a matrix capable of retaining tonal nuances (the *cliché*, or halftone). Only after a method of combining red, yellow, and blue with black was invented in the early eighteenth century and applied to lithography (chromolithography) in the mid-nineteenth century was it possible for prints to convey some of the colorful aspects of paintings. Neverthe-less, the success of chromolithographic reproduction was subject to the skill and sensitivity of artisans (*chromistes*), who still had to draw their compositions after artworks. By the end of the century photomechanical color separations could be made, but the prints from the plates etched from them consisted of flat colors. Not until after World War I was it possible to convey the varying tones of photographs. Plates consisting of minute dots were produced by overlaying the photograph with a screen, which, at long last, offered the semblance of continuous textures in print. Among the many kinds of books that took the Great War as their theme, several reproduced in color both photographs and paintings done by war artists in this way in 1919. A surge of interest in the publication of art books occurred, and in the mid-1920s brilliant color reproductions of watercolors were interspersed among black-and-white drawings in George Grosz's *Ecce Homo* (plates 107–108), and the embellished manuscript of Paul Gauguin's *Noa Noa* was published in full color by R. Piper & Co. Verlag, Munich (plate 4).

The economic atmosphere of the Depression did not aid and abet costly printing projects. However, public awareness of the vast treasure of art in the world was finally captured after World War II when reproductions were published in what must have been among the first coffee-table books, the ambitious books published in Switzerland by Albert Skira under the series title *Painting, Color, History*; in lavish magazines such as *France illustration* and *L'Oeil*; and in well-illustrated exhibition catalogues. After examples of artists' works became widely known through books, it followed that the book itself was an excellent medium for creating new work. In the 1930s Skira had published an important art magazine called *Minotaure* with a Greek named Efstratios Tériade. He also commissioned several outstanding books with black-and-white etchings by Salvador Dali, Henri Matisse, and Pablo Picasso and with texts by renowned but dead authors. In 1937 Tériade began *Verve*, his own deluxe art magazine, depending upon photogravure for the color, but after World War II he issued two extraordinary volumes by Fernand Léger and Matisse, who had created and designed their own books, combining their

own texts in their own handwriting with their own lively color prints. Color reproductions of these artists' paintings had appeared in magazines, but the prints in these books, *Cirque* and *Jazz*, were not reproductions of something one could see in an art museum; they were conceived, designed, and printed in colors that the artists chose to place in books (plates 20–23). The proliferation of reproductions actually liberated artists to recognize the potential of book pages as a field to be cultivated.

MODERN ARTISTS' BOOKS BEGIN

In the exuberance of the 1890s, color was everywhere. Color posters and various experiments to produce color on the pages of books and periodicals drew the public's attention. The publishers of chromolithographs issued views and reproductions that were gaudily exaggerated, like overly rouged old ladies, in misguided attempts to glamorize their products. When Pierre Bonnard and Henri de Toulouse-Lautrec made color posters, they created their images as lithographs, knowing the ways in which the medium might be altered to convey the shapes and color effects they sought. For example, Toulouse-Lautrec devised a spatter technique that produced subtle tones that were otherwise unobtainable. Unlike the designers of chromolithographs, artists who turned to lithography were not trying to imitate either painting or photography. This difference in concept of how a print medium might be exploited, which still exists today, also reflects a difference in attitude about illustration. Besides reproduction of existing images, chromolithography was also a system used by artists who did not choose to work directly on lithographic stones. Like the Japanese printmakers whose work was admired at the time, many artists were pleased to produce watercolors and other artworks for reproduction. For those who commissioned such prints, public attraction was a major factor, so that those prints had to appeal to popular sentiment. Some publishers were less interested in that aspect of commerce and, like André Marty, published works by younger, more experimental artists who, like Toulouse-Lautrec, might choose to picture the world but by a unique method and with a unique attitude—one that reflected the ideas of some of the literary creators of the time.

In 1894 Marty agreed to publish a limited-edition album with illustrations about the popular Parisian performer Yvette Guilbert by two of her admirers, Toulouse-Lautrec and a semiradical journalist named Gustave Geffroy (plates 5–7), at that time the editor of the journal *La Justice*, published by the clever politician, statesman, and writer Georges Clemenceau. Geffroy had written an article in *Figaro illustré* the previous year that included two portraits of Guilbert by Toulouse-Lautrec. The artist was already well known for his witty renderings of the denizens of the cabarets and *cafés concerts* where she declaimed her songs. Interested more in the social betterment of the working class than in the arts of popular singers, Geffroy wrote an essay that began and ended with admiring descriptions of Guilbert's performances, but dwelled for the most part on the severity of the workman's lot and the deleterious effects of the airless, smoke-filled cafés in which he relaxed. Geffroy's text ended by extolling the life-enhancing,

life-saving features of the natural countryside. Guilbert was used in the essay as a focus for this environmentalist discourse, since it was she, the author stated, who had the good sense to quit Paris after her performances and retreat to her home in the country.

On each of the sixteen pages of the unusual square book Toulouse-Lautrec filled the margins with images of Guilbert singing, preparing her makeup, meeting admirers, and so on. Every page was printed in olive-green ink—text as well as images—all melded into one clearly conceived object. The square cover depicted long gloves, the singer's trademark, lying casually on a stairway. Ribbon held the booklet together. All in all, the impression was of a feminine, perhaps boudoir, object, which was attractive to those who appreciated its oriental sensibility. Great pains were taken to promote the book at the time of its publication, at the end of the Parisian vacation period, with articles placed in appropriate journals. The combination of an homage to a popular star and a political message about the betterment of living conditions evidently reflected the opinions of one segment of so-called cultured society at the fin de siècle. It is impossible to know if the use of green ink in a book about the virtues of nature had the symbolic meaning it has today, but it is worth commenting on the fact that we still use famous performers to focus interest on environmental concerns.

Toulouse-Lautrec's approach to illuminating Geffroy's text heralded the era of freedom from the constraints of illustration that accompanied the entrance of painters onto the pages of books. His images not only did not show incidents in the narrative, but they also encroached upon the type, spreading their haze of green below the formal lines of the letters. Type had been set in various patterns since the fifteenth century (earlier manuscripts had visually emphasized letters within words so that messages besides those contained within the normal lines were visible); after the middle of the nineteenth century it was common for illustrations to divide areas of text, even diagonally, and marginal illustrations were particularly popular. However, in order to fit the page properly, these illustrations had to be made in techniques that could be printed at the same time as the text type. Since lithography was still incompatible with letterpress, the typography had to be printed on the lithographically printed sheets. Printed in the same color ink for both mediums with images bled into the text, the pages of *Yvette Guilbert* presented a fresh contiguity and spaciousness that was recognized in its day as "a new form of book production."[5]

Concurrent with such innovation was the reversion to past techniques. Woodcut is the oldest method of printing; the most symbolic, as it was the first to carry religious images; the most primitive when it takes the form of native relief sculpture from far off, uncivilized places; and the most evocative of an era of fine handicraft. By the end of the nineteenth century the Industrial Revolution had produced its biggest successes and its worst results. Political and social scientists had written their denunciations, some had suggested solutions, others had recognized problems that seemed to have no solutions. New directions were sought by those who could find no other means of avoiding the burdens of the age. Among artists, there were three men who took different routes toward reestablishing meaning in

their lives in the face of the industrial age: in Paris Alfred Jarry, a wild youth, looked to turn everything upside down and inside out, armed with his sharp poetic wit and lack of reverence; Paul Gauguin, a disappointed Parisian stockbroker and disillusioned painter, went to Tahiti; and William Morris, an English book collector, writer, and designer, sought the perfection of form and craft of the early Renaissance. In the work of all three the woodcut played a central role, and the subsequent repercussions of their work were widespread.

At age twenty-one, Jarry was already a published author. While he was still in school his untameable spirit had given birth to a scatological character, Ubu Roi, or, as first translated into English, King Turd. Writing at the height of the Symbolist movement, he based his ideas on "the identity of opposites." In his first book, *Les Minutes de sable mémorial* (1894), the obscurity of his vivid language made it impossible to pin down one idea without it being simultaneously understood in another sense (plates 80–81). This small book, containing poems, two multipart texts in play form, and portions of *César Anti-Christ*, was illustrated by the author. Among his several woodcuts is a nearly abstract figure of an owl in front of a window. The emphasis on planes of light reflected Jarry's use of geometric terms in some of the descriptions in the text of the second play in the book, *Haldernablou*, and has led some to believe that an elemental cubism was implied.

The book begins with a series of prose pieces that are substantially about death, so the first print, which evokes the country Calvary, filled with the instruments of Christ's torture as well as other symbols of his Passion, may easily be viewed as pertinent. However, the tone of the text, which is confusingly irrational, undermines the serious meaning of Jarry's illustrations and reinforces his penchant for confrontation, in this case, with the then-current fanatical interest in religious mysticism. At the time Jarry published this book he was co-editor with Rémy de Gourmont of the periodical *L'Ymagier*, profusely illustrated with religious images from Epinal (a French center for popular prints), renderings of Calvary, and brief texts that described specific religious symbols in the context of some of their examples. Jarry wrote a short article in the first number on the Passion of Christ. Another woodcut depicts medieval-style figures called *palotins*, who perform in the first "play" while their master, M. Ubu, creates havoc. Their representation (with an Ubu-like figure, who might also be a bumblebee, flying above) is surely an obtuse reference to the romantic notions of knights and their noble exploits. Jarry's fascination with medieval lore appears in the language of his poems, to the point that the colors of objects (that is, the misleading *sable* of the title—"sand" in French, "black" in heraldry) are heraldic designations, and the final woodcut of a bleeding heart over a skull, the drops equated with gules on an escutcheon, is given the form of a *sablier* (a sand-clock or hourglass), as in the title of the final poem.

Jarry's *Les Minutes de sable mémorial* was notable for more than its dynamic disharmonies. The typography of the title page (figure 5), designed by Jarry, preceded the better-known adventures in arrangements of letters and words of the Italian Futurists, Russian Constructivists, and, more directly, the *calligrammes* of Guillaume Apollinaire. Jarry was one of a group of writers who were known as the

circle of the periodical *Mercure de France*. It, therefore, might not have been peculiar if, when *Mercure de France* published his books, he had artistic control over them. He used several sizes of sans-serif letters, bunched tightly together, both for the title of his book and for the name of the publisher, balancing the two blocks of type on an otherwise unembellished page. The covers of *Les Minutes de sable mémorial* and *César Anti-Christ* were black paper, carrying only a heraldic symbol printed in gold on the front. From the outside alone it was possible to intuit the iconoclastic character of both books and presume that they might be breviaries for a black mass.

Jarry, impoverished and usually on drugs, was befriended by Apollinaire well after the publication of his renowned tales *Ubu Roi*, *Ubu cocu*, and *Ubu enchaîné*. Jarry's writings, imagery, and life (he was known to brandish a pistol at the slightest taunt to his sensibilities) were models for the circle around Picasso and Apollinaire during the first decades of the twentieth century. Apollinaire identified the unique contributions of the art of his time, participated in their adventures, and translated them into veiled fiction. Thus his association with, and understanding of, Jarry's tightrope walk through reality was extremely important. Little wonder that the first book Apollinaire wrote that contained illustrations, *L'Enchanteur pourrissant*, was tacitly about Merlin, the magician of King Arthur's medieval court (plates 12–13).

Jarry's religious background was the mystical Catholicism of Brittany. The attraction of this still unsophisticated area to certain painters of the late nineteenth century helped to form their imagery. Foremost among them was Paul Gauguin, whose paintings of biblical incidents in the midst of Breton landscapes are the most estimable examples of Symbolism. Never comfortable with his situation for long, Gauguin was a prime candidate for seeker of the romance of unsullied nature. From this search, which took place in Tahiti, Gauguin created *Noa Noa*, a book that never was published as he planned it (figure 6; plates 1–4).

Immediately upon his arrival in Tahiti, Gauguin realized that the French colony had lost its native simplicity. No longer guileless, the beautiful women (in this he was not disappointed) were tainted by European diseases and habits. In the summer of 1893 Gauguin returned to Paris, hoping to sell some of the canvases he had painted of Tahitian gods and daily life. He also had it in mind to create a book, and in October he began to write a text, picked up from older chronicles of Tahiti as well as some of his own adventures, which he hoped would "facilitate the understanding" of his Tahitian works (he did not permit translation of their Maori titles). Charles Morice, a poet and disciple of Mallarmé, who wrote a preface in the catalogue for the exhibition of Gauguin's Tahitian paintings in November 1893, was enlisted by the artist to help him put his text into a more literary form. Later Morice insisted that it was he who had suggested to Gauguin that they collaborate on a book combining the painter's themes with his own. Reorganizing and rewriting Gauguin's text took longer than expected, and the poems inspired by his paintings and native tales found in earlier commentaries took even longer. In February and March, 1894, Gauguin made woodcuts to illustrate the text, later noting in a letter to Morice, "Je viens de terminer mon travail (gravure) sur Noa Noa je crois que

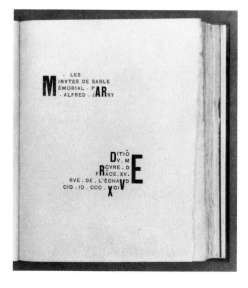

FIGURE 5: Alfred Jarry. Title page from *Les Minutes de sable mémorial* by Alfred Jarry. Paris: Mercure de France, 1894. The Museum of Modern Art, New York

celà contribuera beaucoup au succès du livre. Il *faut donc* que le livre soit fait et au plus tôt."[6]

The first ten illustrations for *Noa Noa* were cut on end-grain wood, the material used throughout the nineteenth century for the extremely detailed wood engravings that filled numerous volumes and provided some of the first images of exotic places. Such engravings had first exposed Gauguin to the Tahitian culture that he sought too late. But Gauguin did not cut his blocks in the reproductive manner of these prints; he treated them somewhat like relief sculpture. The images, derived from his paintings, were to be printed in color. Gauguin took a few proofs with a printmaker neighbor and then turned the blocks over to the printer Louis Roy, whose heavy unsubtle inking contrasted with Gauguin's less professional but far more sensitive printings. About thirty copies of each block were printed and awaited the completion of Morice's manuscript when, discouraged by the lack of interest in his paintings and financially able to return to Tahiti, Gauguin left France in June 1895. He carried with him what he considered to be the almost complete manuscript, copied in his own hand with blank pages awaiting Morice's poems, and a few additional woodblocks of various sizes. The first ten blocks and most of the prints remained with a friend in Paris. Morice retained in his possession an early draft of the manuscript in Gauguin's hand, and continued not only to add poems but also to rewrite some of Gauguin's narrative. In 1897 excerpts from *Noa Noa* "by Paul Gauguin and Charles Morice" were published in the journal *La Revue blanche*; and Morice's completed work was issued at his own expense as a book by Editions La Plume in 1901. There were no illustrations (the size of the book was smaller than the woodcuts), and it seems that Gauguin never received even one copy. He used the manuscript that he had taken to Tahiti and later to the Marquesas as a sketchbook, covering some of the writing with photographs, scraps of his own prints, and watercolors. Totally discouraged with his pilgrimage to a better world, without even the book left behind to show a wider audience the wonderful images he had invented from the land that had seduced him, he died in 1903.

Noa Noa was never published as Gauguin had conceived it, but its elements influenced subsequent art and artists' books for many years. The manner of making the prints, more carving than cutting, producing bold forms, encouraged twentieth-century artists to approach the woodcut in a direct, less technically inhibited, manner. Gauguin's blocks were similar in scale to Japanese woodcuts, and some incorporated decoratively framed panels filled with lettering (the titles of the prints) in a style borrowed from Japanese prints. It is likely that in choosing to imitate these idiosyncrasies of oriental woodcuts, Gauguin also planned to emulate other aspects (such as contrasts of flat colors and patterns). Most definitely, his manner of cutting the lines was not that of the methodical Japanese craftsmen who cut around tracings of each and every line the artist had drawn. Finally, Gauguin's artistic contributions were, according to the preface of *Noa Noa*, derived from the "memory of a painter," and illuminated pages of a text that derived from the "imagination of a poet."[7] They neither described nor explained. In 1926, when the decorated manuscript of *Noa Noa* was published in full color (a remarkable event in

FIGURE 6: Paul Gauguin. *Noa Noa*. 1894. Autograph manuscript. The Resource Collections of the Getty Center for the History of Art and the Humanities

book publishing), a misconception of how Gauguin's book was meant to look resulted. Since that time, even Gauguin's original manuscript has been reproduced with the same later embellishments as illustrations. *Noa Noa* has been, from the beginning, a piece of fiction, both in its conception and in its history. Had it been published as Gauguin wanted it to be, its aesthetic contribution would have been a major influence on subsequent artists' books.

While William Morris's publications in England had marginal impact on the ensuing history of artists' books, that is, the books primarily known for artists' contributions, they were decisive in the field of typographical design and printing. His ambition, to bring art and craft together in the harmony he believed existed in the early years of Italian printing, culminated in several projects. It was the period in England of the Pre-Raphaelite artists, who romanticized the past by painting canvases and designing stained-glass windows, using great themes such as the Creation and the quest for the Holy Grail. Edward Burne-Jones, Morris's college friend and associate in his design company, Morris, Marshall, Faulkener and Co., illustrated most of the books for Morris's Kelmscott Press, founded in London in 1890. In 1893 he embarked on a new edition of Geoffrey Chaucer's *The Canterbury Tales*, the earliest and worthiest British contribution to travel lore: *The Works of Geoffrey Chaucer, Now Newly Imprinted* of 1896 (plate 33). In the linear manner found in illustrated volumes of the great fifteenth-century Venetian printer Aldus Manutius (printer of Aldine books) and those of printers he influenced, Burne-Jones made drawings that were then redrawn by Robert Catterson Smith, revised, and then photographed onto eighty-seven blocks that were hand-engraved. These were set into pages filled with ornamental letters and margins designed by Morris, the printed equivalents of the whorls of ferns and vines that embellished the fourteenth- and fifteenth-century manuscripts that had provided the models for early printing. The type, which emulated those letters that filled the pages of the earliest printed books from Mainz by Gutenberg and Peter Schoeffer, was one of several fonts designed by Morris. The pages were of a thick handmade paper, specifically milled to resemble the weight and feel of those sheets that, in the past, were considerably less uniform than the slick, pulp-based, sized, and mechanically perfect paper of Morris's time. The result was a formidable volume—equal in every way to the monumentality of the famous text— the most ambitious book of the Kelmscott Press.

Morris and his associates had designed wallpaper, fabrics, tapestries, and other materials for interior decoration: these were "objects—including books— whose value lay not in rarity, lavishness, or intricacy but in thoughtful design and a conscious appeal to medieval traditions of committed craftsmanship."[8] After Morris's death in 1896, the Kelmscott Press continued for two more years to produce volumes and pamphlets that were notable for the balance of type, design, and meticulous production admired by those for whom the book was the most noble object. The finely honed conjunction of those elements became an aspiration for many initiates in the art of the press book in primarily English-speaking countries. Only a few of these books incorporated additions by artists, who, for the most part, were more involved with the design of the page than with their illustrations. All

these books were hand set from type, and all the decorations were cut from wood or metal. Thus the lowly woodcut had become a highly refined element in what had originally been the pursuit of high art in simple craft.

While the three volumes discussed above were the seedlings of the modern concept of books in which artists play a major role, there were others in which the artist took a different route. One example, Aubrey Beardsley's version of Oscar Wilde's scandalous play *Salome, a Tragedy in One Act*, will have to stand for a number of marvelously excessive tall tales (plate 32). Whether designed for children or adults, the curls, wisps of foam, diaphanous wings, and all manner of adaptations from the exotica of nature were means of conveying an aberrant world, nice or naughty. Beardsley had taken a massive step away from acceptable illustration by using his pen (all his book decorations were line blocks, photographically made from ink drawings) to confer a dangerous or perverted twist on the subjects of, in this case, Wilde's play. Filled with the decorative tendrils and serpentines of Art Nouveau, the ten full-page plates of *Salome, a Tragedy in One Act* parade the skewed story of Salomé's infamous dance and perquisite in calculated combinations of sinuous line and heavy blacks. The pictures exude sensuosity and delectable revulsion.

The sense of titillating disgust created by Beardsley's illustrations mirrors the fin-de-siècle disdain for the ordinary. Decorative volutes, in varying degrees of ornateness, covered buildings all over Europe. Without reverting to illustration, the decoration of a book could convey a similar sense of the extraordinary. The book designs of the Belgian architect Henry van de Velde, like his furniture and architecture, captured this love of shape and material. In stimulating contrast to their texts, he decorated two books by Friedrich Nietzsche, *Ecce Homo* and *Also sprach Zarathustra, ein Buch für Alle und Keinen* (plate 34). In the latter, the massive maroon-and-gold titles and geometrical motifs that punctuate lines of type transform the philosopher's text into a sumptuous magical tale, evoking the mystery of the narrative while, perhaps, subverting the tough truths it teaches.

PUBLISHERS

HENRY VAN DE VELDE designed type and pages for Count Harry Kessler, a German nobleman who loved books and began to commission artists to make them in the early twentieth century. More like William Morris than André Marty, Kessler was enamored of the craft of bookmaking. He was involved in type design, paper manufacture, choice of texts, and selection of artists, who were not only to embellish the texts but be active participants in the production of their books.

More common was the type of publisher of artists' books who succeeded Marty in Paris. Marty was the publisher of, among several enterprises, *L'Estampe originale*, a series of albums of artists' lithographs that appeared periodically and were purchased by subscription. *La Revue blanche*, the literary and art journal, also issued sets of original prints by artists, advertised in the journal. After seeing the early editions of these sets, the art dealer Ambroise Vollard began to publish his own series: first *L'Album des peintres-graveurs* and then *L'Album d'estampes originales de la*

Galerie Vollard. Among the artists he included in his albums were Odilon Redon and Auguste Rodin. Furthermore, he decided that he would publish albums of prints by individual artists, and had begun with a reissue of Gauguin's zincographs of Brittany in 1894, a series of lithographs by the twenty-eight-year-old painter Pierre Bonnard in 1895, and a group of haunting lithographs by Redon inspired by Gustave Flaubert's *La Tentation de Saint Antoine* in 1896. Redon had prepared ink drawings for a book as well, incorporating the lithographs and Flaubert's text, but, unfortunately, the author's heirs refused to give Vollard permission to publish it. Because nothing more was done with the book until around 1910, Vollard never considered this his first book project, probably because he was able to publish many others before it was issued. As time went on, other difficulties arose, so that the book's appearance had to wait until, for example, the discovery of misplaced prints (two were never included in the book). More than forty years passed before the book was published in 1938, twenty-two years after Redon's death (figure 7; plate 11). The large volume, printed on a thick Arches paper that took beautiful impressions of the woodcuts made from Redon's ink drawings, was produced in a style that Vollard would return to in the several books he issued by another, equally arcane, artist: Georges Rouault.

While Redon's experience as an artist whose book was languishing in the hands of Vollard was largely the result of outside constraints, Rouault suffered from another cause. Vollard was foremost an art dealer, eccentric and moody. He came to France from the French island of Mauritius to do what the sons of many colonists did—pursue his education. He was to be a lawyer, but became sidetracked by the wonder of art. He was clever (many thought, crafty) and successively took up artists who were not represented in galleries (first Paul Cézanne and Gauguin, then Bonnard and Picasso, among others). Rouault began a long association with Vollard in 1913 when he signed a contract turning over all his paintings in his studio to the dealer. He was fascinated by circus performers and other unusual characters, like other artists of his time, but unlike them he was profoundly devout and used his images metaphorically in his paintings and prints. He worked in an expressive manner that was restrained formally by his tendency to outline his figures in black, like the stained-glass panels in church windows. It was a style that could be transferred successfully to the print mediums, and it was Vollard's idea to begin most of Rouault's illustrations by photographing his drawings onto copper plates. Vollard planned several books with Rouault, some with texts by André Suarès. Rouault would prepare numerous ink drawings and sometimes paintings, and then the artist would scrape and etch the heliogravure (photogravure) plates made from them, adding aquatint to reinforce and emphasize the strong black outlines. In many cases, with the assistance of Roger Lacourière, one of the finest intaglio technicians of the century, color passages were added.

Only three of the albums and books planned by Rouault were published during Vollard's lifetime. The first, *Réincarnations de Père Ubu* (1932), a compendium of several tales Vollard wrote about Jarry's character, Ubu, seems to have been part of a bargain he made with the artist in 1922 to assure that work on

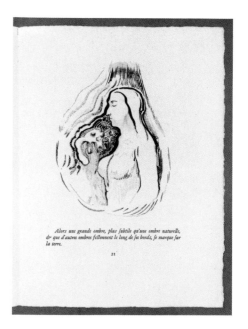

FIGURE 7: Georges Aubert, after Odilon Redon. *La Tentation de Saint Antoine* by Gustave Flaubert. Paris: Editions Ambroise Vollard, 1938. Wood engraving. The Museum of Modern Art, New York. Louis E. Stern Collection

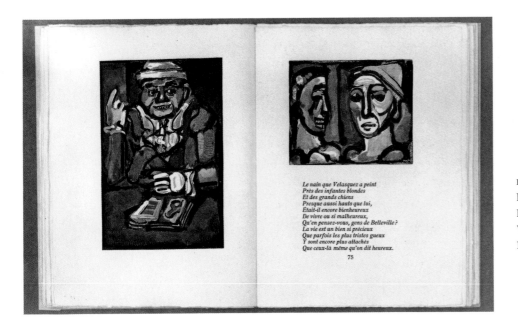

Le nain que Velasquez a peint
Près des infantes blondes
Et des grands chiens
Presque aussi hauts que lui,
Etait-il encore bienheureux
De vivre ou si malheureux,
Qu'en pensez-vous, gens de Belleville ?
La vie est un bien si précieux
Que parfois les plus tristes gueux
Y sont encore plus attachés
Que ceux-là même qu'on dit heureux.
75

FIGURE 8: Georges Aubert, after Georges Rouault. *Cirque de l'étoile filante* by Georges Rouault. Paris: Ambroise Vollard Editeur, 1938. Wood engravings. The Museum of Modern Art, New York. Louis E. Stern Collection

Rouault's favorite project, *Miserere*, would be completed. Another book, started in 1926, *Cirque de l'étoile filante* (1938), contained color aquatints as well as woodcuts made by Georges Aubert after Rouault's gouaches (figure 8; plate 10). Suarès had written the text, but Vollard found that some of his critical remarks would be offensive to his customers, and Rouault was compelled to write the text himself. The third project, Suarès's text for *Passion* (1939), begun in 1927, finally appeared in a book that had been fraught with similar difficulties, many due to changes in plans by the artist and lack of the special Montval paper that Vollard had decreed the only proper material for Rouault's images.

The tour de force of Vollard's and Rouault's association was to have been the elephantine book *Miserere et guerre*, Rouault's great work, begun in 1922 and nearly complete in 1927. However, when it finally appeared in 1948 (under Rouault's imprint of L'Etoile Filante) it had only a short introduction by Rouault, alluding to the tremendous problems he had had rescuing the gouaches and prints from the Vollard estate (plates 56–57). Nevertheless, Rouault wrote, "If injustice has been shown Ambroise Vollard, let us agree that he had taste and a keen desire to make beautiful books without breaking any speed records, but it would have taken three centuries to bring to perfection the various works and paintings with which, in utter disregard of earthly limitations, he wished to burden the pilgrim."[9]

Parallèlement by Paul Verlaine with lithographs by Pierre Bonnard, the first book Vollard published, has long been considered the earliest *livre d'artiste* in the modern sense (plates 8–9). This point of view has been taken principally by those who do not consider *Yvette Guilbert* a full-fledged book. However, Bonnard's lithographs to Verlaine's poetry, printed mostly in pale pink in the margins, have their conceptual origins in Toulouse-Lautrec's work. It was Vollard's idea to publish the poetry of Verlaine, who died before it was possible to issue the book. The dealer had cast about for an illustrator, hoping first to attract Lucien Pissarro, the

son of the painter Camille Pissarro, who mistrusted Vollard. Ultimately, Vollard settled on Bonnard, taking the imaginative step of inviting a painter who had done a few prints to work on a fairly costly project. The type was set, and Bonnard made drawings around the blocks of type. After he re-created the drawings on lithographic stones, changes both in the position of the type and the tonalities of the lithographs were made. The images that surround the poems suggest their meaning or impulse while expanding upon the general aura that pervades each thematic section. According to Vollard, once it was discovered that some of Verlaine's poems intended for the book had been banned in France, the emblem of the French Imprimerie Nationale had to be removed from the title page, and a new title page substituted. From the beginning, it appears that Vollard always found himself delayed by one thing or another.

Vollard was often accused of procrastinating, but he had more than a few excuses, among them the financial difficulties of the Depression. He completed few of the books he began, but, fortunately, most of those that were awaiting the right paper, or the printer's time, or a new font of type, were published by others. While he published several books by Bonnard (including *Almanach illustré du Père Ubu* by Jarry and two books by himself), he issued only one of the three books he had started with Marc Chagall during the 1920s, while those by Georges Braque and André Dunoyer de Segonzac, begun in the early 1930s, were completed well after World War II. After his bad experiences dealing with contemporary writers (Flaubert, Verlaine, and Suarès), Vollard preferred the well-dead, from Virgil to Honoré de Balzac. Picasso agreed to illustrate Balzac's *Le Chef-d'oeuvre inconnu*, but in filling the book with loose plates that had individual merit as prints but were inconsistent with the book's format it seems clear that he had little if any interest in how the completed book would appear. Only one of the etchings he contributed made direct contact with Balzac's theme of the obsessive painter, and a selection of abstract drawings (made years before the book was planned), placed by the book's editor in an isolated section of the preliminary pages, may have been an attempt to contribute, in some way, a concordance with the subject. Another commission, Picasso's *Eaux fortes originales pour textes de Buffon*, was published by one of the executors of Vollard's estate. All the books, with the exception of the planned *Miserere et guerre*, were designed in a folio format. Bonnard's *Parallèlement* and *Daphnis et Chloé* were the smallest of the deluxe books, basically because they were the first completed, while the Redon took its larger, more imposing form from Vollard's subsequent decisions about luxurious style. For all his good intentions regarding the art element in his books, Vollard knew he had to appeal to the fine book collector who might be persuaded to acquire a classic text, well printed in hand-set type on sumptuous paper, notwithstanding that the pictorial material adorning the pages might be considered too modern. What might have been Vollard's most important contribution to the art of the book, the first with Picasso's own writings, remains unfinished. Only a few weeks before Vollard was killed in a motor accident Picasso had been working in Roger Lacourière's atelier on his first color prints for this book (plates 90–91).

In contrast to the perceptible conservatism of Vollard (who, for example, deserted Picasso at the outset of the artist's invention of Cubism), Daniel-Henry Kahnweiler enjoyed the challenge and excitement of working with avant-garde artists and writers. When, as a young man, he arrived in Paris from Germany, he too was expected to pursue an economically sound profession. Instead, he began to sell art and meet the members of the new bohemia. His idea of commissioning an artist and writer to create a book together bore its first fruit in *L'Enchanteur pourrissant* (1909), Apollinaire's first book with provocative woodcuts by his friend André Derain (plates 12–13). Both were associated with Kahnweiler (Apollinaire had written a preface for his Braque exhibition, and Derain had been under contract to the dealer since 1907). The energetically carved woodcuts were the full-fledged legacy of Jarry's and Gauguin's formative work in the medium. Fully realized from African influences and holding together the text as tightly as the woodcuts in fifteenth-century block books, Derain's prints extended Apollinaire's story about the rotting body of Merlin into further unexplored territory, implied but not completely described verbally.

Kahnweiler's debut in the bedeviled territory of artists' books included an element that was traditional: a publisher's device, or logo. Like Aldus Manutius and many subsequent printer-publishers, Kahnweiler relished the idea of having a symbol placed on the title pages of his books that would identify them (and imply their serious connection with the past). Derain designed the twin-shell motif (a play on the word *coquille*, which means both shell and typographical error—two *coquilles* were the limit of errors a publisher could accept, according to an old adage). In the original device, Kahnweiler's initials, HK (he used only "Henry" rather than his hyphenated first name when he was young), were in the center (figure 9). They were dropped when, after World War I, his gallery was called La Galerie Simon, and after World War II, La Galerie Louise Leiris (the changes were deemed advisable because of his German nationality). The device, however, never ensured the sale of

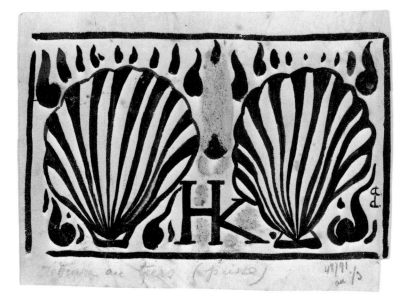

FIGURE 9: André Derain. Drawing for the Kahnweiler vignette for *L'Enchanteur pourrissant* by Guillaume Apollinaire. 1909. Brush and ink. Carlton Lake Collection, Harry Ransom Humanities Research Center, The University of Texas at Austin

Kahnweiler's books, and although, unlike Vollard, he clearly had no problems in issuing books, his dependence on avant-garde artists narrowed the market for them.

Kahnweiler ultimately published an exemplary array of books in a variety of formats, always first editions of texts and always specially adorned by contemporary artists. The adventures of Max Jacob's cleverly disguised alter ego, Victor Matorel, formed the basis of three books, two of which—*Saint Matorel* (1911) and *Le Siège de Jérusalem, grande tentation céleste de Saint Matorel* (1914)—were illustrated with Picasso's first Cubist etchings (plate 14). In these examples, primarily one guesses because Jacob was one of Picasso's friends, the artist created prints that were in context, if not easily identified as such. Because Jacob's writing style was cubistic—that is, with phrases set against each other, which by themselves lack the structure made comprehensible by their combination—Picasso's Cubist images become fascinating equivalents. Through their complexes of lines and planes, they evolve into figures and landscapes. Other Cubists—Braque, Juan Gris, and Henri Laurens—adorned Kahnweiler's books after World War I, accompanying texts by Erik Satie, Jacob, and Raymond Radiguet. The play *Les Pélican* (1921) by Radiguet is a domestic farce made even more inane by the sculptor Laurens's seven linear etchings (plates 124–125).

In 1924, only three years later, Kahnweiler was prepared to publish a book by André Masson, a young artist working in a new style, somewhat cubist in structure but full of figures that evoked the instability of remembered dreams rather than the fixedness of reality. That year André Breton produced the "First Surrealist Manifesto," proclaiming his thesis about depicting subconscious recollections. Masson's prints for Georges Limbour's *Soleils bas* (1924) and Michel Leiris's *Simulacre* (1925), both published by Kahnweiler, are the first Surrealist lithographs in books (plate 131).

In the early 1930s another major publisher of fine printing emerged in the person of a young Swiss bookseller with an interest in art, particularly that of the famous artists whose center of activity was Paris. Unlike Vollard and Kahnweiler, Albert Skira was not an art dealer, but he shared with Vollard an appreciation of the deluxe illustrated book and emulated his format to some degree. At the age of twenty-four, before he had had any experience in publishing, much less organizing the production of a work of art, Skira was audacious enough to ask Picasso to illustrate a volume of Ovid's *Les Métamorphoses* (plate 39). In his earliest contemporary art enterprises he was assisted in matters of content and design by Tériade, the former artistic director of the journal *Cahiers d'art*. Tériade introduced Skira to Matisse, and the result was the painter's first artist's book, *Poésies* by Stéphane Mallarmé of 1932 (plates 15–17). This astonishingly perfect debut, together with Picasso's *Les Métamorphoses* (1931), published a year earlier, set the elegant style of Skira's books. Both artists produced refined linear etchings that so perfectly balanced the typography that there must have been an incomparable rapport between the artists and their publisher to achieve this harmony. Neither book, however, had the spirit of experiment and daring that each artist was to achieve after World War II with books published by Tériade himself.

Tériade also helped Skira found and produce *Minotaure*, a Surrealist-oriented, illustrated journal, in 1933. The following year Skira published the acme of Surrealist books: Salvador Dali's illustrated *Les Chants de maldoror* (1934) by the comte de Lautréamont (plates 18–19). The text, which had served the early Surrealists as a historic example of their so-called method, was taken over several times by them for illustration, but it was the polished style of Skira that helped to make Dali's version memorable. The text of the author, whom Henry Miller called "a black messenger heralding the death of illusion and the nightmare of impotence to follow,"[10] is punctuated by forty-two etchings (thirty full-page) that are the sensational painter's most substantial contribution to the history of the artist's book. Controversial now, more because his direct involvement in creating the actual copper plates from which the illustrations were printed has been questioned than for his disturbing, bizarre visions, Dali's prints in *Les Chants de maldoror* represent Surrealist expression to many. (The year of their appearance Dali was temporarily expelled from the Surrealist group, supposedly for expressing sympathy for the Nazis.)

In 1943, Skira produced an exceptional book of color woodcuts by Derain, *Pantagruel* by François Rabelais. Its large format enclosed more than 180 prints reminiscent of fifteenth-century playing cards, all printed from blocks that had been hand colored before each impression. After World War II, Skira continued to issue artists' books while publishing his grand series of books reproducing paintings. With Masson he issued *Les Conquérants* by André Malraux in 1949 (plate 64). Masson and Malraux had been introduced to each other in 1921 by Kahnweiler, who later wrote that *Les Conquérants* was "among the most beautiful books of our times."[11] After Malraux completed his first stint as minister of information in Charles de Gaulle's government at the end of World War II, he added an afterword to this novel, one of his controversial documentary works from the 1920s (the one, in fact, that preceded his most famous literary endeavor, *La Condition humaine*). About the 1925 Canton uprising, *Les Conquérants*, narrated by a Russian anarchist adventurer, presented a new version of the hero, one who, according to Malraux's 1948 addition, "united within himself the aptitude for action, culture and lucidity."[12] Skira's book followed the popular reissue, and Masson contributed thirty-three aquatints, mostly in color, which erupt throughout the text like the flickering of film that intermittently slides off its sprockets, a fit commentary on the literary form that Malraux had devised under the influence of the Russian director Sergei Eisenstein's cinematic style.

Tériade, on his own, was the able publisher of several journals, the most memorable being *Verve*, which was profusely decorated by the best artists in France, as well as a series of colorful artists' books. It was, perhaps, the residual difficulties of World War II that suggested to him that instead of using typography (full fonts of type being nearly impossible to compile), the texts of his books should be handwritten. It also was his preference that the words be those of the artist. The first of these volumes was the greatest: *Jazz* by Henri Matisse of 1947 (plates 22–23). Combining printed images made from collages of colored paper with undulating

FIGURE 10: Fernand Léger. Study for *Les Trapézistes*, from *Cirque* by Fernand Léger. c. 1950. Gouache. Collection Georges Bauquier

black writing on crisp white pages, the total effect of *Jazz* was spectacular. Soon after, in *Le Chant des morts* by Pierre Reverdy (1948), Picasso created bold red ciphers along the margins and at the ends of stanzas written by the author (plate 63). Then, two years later, Fernand Léger, fresh from his years in America, created the text and lithographs for *Cirque* (figure 10; plates 20–21).

Léger's skill in organizing and designing books had not been given the elegant stage that Vollard and Skira had provided to his peers. His style, from its Cubist beginnings, was extremely compatible with the graphic requirements of book illustration. He had made a few lithographs, some black-and-white ones for *Lunes en papier* by André Malraux (1921), published by Kahnweiler, and single-color ones in 1927. Tériade seems to have speculated that the artist, whose paintings after World War II commanded a great deal of attention, could accomplish a complete book incorporating his own text. The result was Léger's engaging vision of the circus, from trapeze artists to performing bears.

Tériade's personal style for his books developed from both lack of material and a concept that might appeal to the artist. The style of Iliazd (Ilia Zdanevitch), the Georgian writer who brought his Constructivist ideas about typography to Paris, first appeared in books published under his imprint, Le Degré 41 (the latitude of Tblisi, Georgia, the town of his press, and the alcohol content of some brandy), in 1919. One of his first publications in France was a compendium of poems by twenty-one poets illuminated by twenty-three artists, *Poésie de mots inconnus* of 1949 (figure 11; plates 24–25). Reacting to the then-current activities of the French *lettriste* movement, Iliazd wished to show that the Russian avant-garde had done it first. On single sheets he printed the images and, in a distinctive sans-serif type designed by the English sculptor and engraver Eric Gill, the poems. The latter were often as much visual as verbal, making some sheets appear intriguing in their near illegibility. Besides the typography, Iliazd chose the soft but rough-textured, handmade

paper of the Auvergne upon which the type, etchings, woodcuts, and lithographs made distinctly different but brilliant impressions. He chose to enclose his books in vellum, and in this case, a second vellum wrapper was included for a normal book of sheets folded in quarters. It carried the warning *Ne coupez pas mes pages* (do not cut my pages), but, since each sheet was printed in only one direction, this prevented anyone from reading the page without unfolding it.

As Iliazd was at once the designer, publisher, and writer, he continued to pursue these roles in several of his subsequent publications. Picasso contributed etchings to several of them, the most unusual being *Pismo/Escrito*, a love letter of 1948 (plate 180). The etching printer Lacourière provided Picasso with sheets of paper marked with a line where they would be cut, to give the artist an idea of the size of the page on which his prints should be placed. Picasso misunderstood the marks, so that several of his prints fall in the areas that were to be trimmed, dividing the folded book sheets into full and one-third pages. This type of unexpected situation challenged Iliazd, whose page layouts consistently presented typography in unusual formats. His last book, *Le Courtisan grotesque* by Adrian de Monluc, illustrated by Joan Miró (1974), consisted of a text printed horizontally and vertically, like the warp and woof of woven fabric.

Iliazd's most unconventional typography, however, was incorporated into his most ambitious book, *65 Maximiliana, ou l'exercice illégal de l'astronomie* of 1964, written and illustrated by Max Ernst (plate 26). Not only is the type for the text made to fall into patterns, at times surrounding color etchings by the artist, but Ernst created a pseudotext of letterlike symbols that mimics the typeset text and alludes to the encoded mysteries of Ernst Wilhelm Tempel's work in astronomy. The large pages rarely duplicate each other in layout, although those that contain central etchings reestablish a motif that, like chapter headings, orients the viewer-reader.

These pages also recall those of a book issued a year earlier by another poet-publisher, Pierre André Benoit, *La Lunette farcie* by Jean Dubuffet in 1963 (plates 98–99). PAB, as he preferred to be known and impressed his books (he was usually the printer of prints and text), issued four books by Dubuffet between 1962 and 1964, but *La Lunette farcie* was the largest. Each central print (color lithograph) is surrounded by the artist's writing of his own, mostly inane, text. The color prints evolved from an enormous series of lithographs titled *Phenomènes* (1958–62), which, in their chance abstraction, evoke the undefined spaces of the universe, much as Ernst's do.

PAB, who worked in Alès in southern France, sent plates to artists in order to provoke them into making books with him. He often added poems to these prints, but also would mix together a small text with a few plates. When he asked the Dada writer Tristan Tzara for a poem, the result was a series of lines that, placed on revolving discs of paper, could be read in several ways. Accompanied by drypoints by Picasso, Tzara's *La Rose et le chien* (1958) is a modern adaptation of the astrolabe form (see figure 1; plate 182). It also relates to a textual form that, in the late twentieth century, has become an infatuation with texts that consist of multiple narrations

FIGURE 11: Alberto Giacometti. Page from *Poésie de mots inconnus* by various authors. Paris: Le Degré 41, 1949. Etching, with three poems by Alexei Kruchenykh. The Museum of Modern Art, New York. Louis E. Stern Collection

from which the reader makes selections (presently a formula best utilized through the hypercard computer program).

There have been, and continue to be, many other prominent publishers of artists' books who have concentrated on the major artists of the School of Paris. Gérald Cramer, a print dealer in Geneva, commissioned Joan Miró to collaborate with the poet Paul Eluard on what became one of the most original and beautiful books of the century, *A toute épreuve* of 1958 (plates 27–29). He later was to publish several books with etchings and woodcuts by Marc Chagall, and, looking away from France, *Elephant Skull*, a monumental book of etchings by the venerable British sculptor Henry Moore, of 1970 (plate 192). Aimé Maeght, who became one of the most powerful art dealers in Paris after World War II, had begun his professional career as a designer in a lithographic printing house. By one means or another, after he became an art dealer, he found ways to publish the works of writers and artists. Eventually, he was to own his own printing establishment. At first he published poetry and then information about the works of artists he exhibited. Each issue of Maeght's elegant journal, *Derrière la miroir*, was devoted to one artist, who created lithographs for the covers and the pages in between the articles, which were written by some of the most prominent authors of the time. Maeght also published deluxe artists' books and kept his artists busy making lithographs and occasionally prints in other mediums at his print workshops, for which his son Adrien was responsible. He took over Braque's prints made for one of Vollard's projects, *Théogonie* by Hesiod (plates 40–41), finally completed with some new etchings in 1955, and produced several other volumes by the artist. Among the many artists who were given the complete attention of Maeght's Arte printers (named for his first gallery, in Cannes) in the pursuit of their own perfect *livre de peintre* were Miró, Antoni Tàpies, Eduardo Chillida, and Pierre Alechinsky, with texts by Tristan Tzara, Octavio Paz, and Jacques Dupin, among others. In 1947 Maeght's publishing division produced a special edition of *Le Surréalisme en 1947, exposition internationale du surréalisme*, notable for its special cover containing a Readymade by Marcel Duchamp, a foam-rubber "falsie" (plate 193).

While the major publishers of artists' books pursued their profession in or around France, dependent upon the creative efforts of the artists in its capital of culture, publishers in other parts of Europe had greater difficulty. With the exception of Cranach Presse in Weimar, there were few who wanted or were able to publish the deluxe artist's book *à la française*. Germany, where there were many graphic artists, produced a myriad of books, but compendiums and periodicals were the preferred sites of artists' prints. Paul Cassirer published books in Berlin by Ernst Barlach, Marc Chagall, and Oskar Kokoschka; while Kurt Wolff, best known as Germany's premier publisher of Expressionist literature and one of the first to issue series of books with reproductions of art, published artists' books by Kokoschka, Ernst Ludwig Kirchner, George Grosz, Paul Klee, and Frans Masereel before he escaped from the Nazis. In America, his Pantheon Books published Chagall's first color prints in *Four Tales from the Arabian Nights* in 1949 (plates 47–48).

In the United States there had been many efforts to publish artists' books,

foremost being the work of the Limited Editions Club, founded in 1929. Most of the books issued were appreciated primarily for the fine printing of respectable texts. In the 1930s the Club had commissioned Matisse to illustrate James Joyce's *Ulysses*, and when his etchings were inconsistent with the text there were complaints. The freedom that artists needed to have to make books their own form of art did not truly arrive in America until after World War II. The unspoken competition of the expatriate European artists, many of whom made prints in New York during the 1940s, partly led to that freedom. However, it was mainly expressed in the paintings of Abstract Expressionists, who were rarely encouraged to apply their vision to the graphic arts.

No single publisher who could tempt American artists into making books emerged until the late 1950s when Tatyana Grosman, the Russian-born wife of an émigré painter, began Universal Limited Art Editions (U.L.A.E.). The daughter of a newspaper publisher, she loved literature and dedicated herself to the task of motivating American artists and writers to make books for her. Her first effort, *Stones* by the poet Frank O'Hara and the painter Larry Rivers (1960), did not have a normal format (few did). The thirteen lithographs that make up this "book" were drawn and written on lithographic stones by artist and writer together in the form of a dialogue. The loose sheets were enclosed in a folder of dark blue paper made from denim blue jeans, with each cover hand painted by the artist (plate 30). Later publications would include a book without words printed on sheets of plexiglass—*Shades* by Robert Rauschenberg, 1964—and a book so large it was housed in a large drawer in a wood case—*A la pintura/To Painting* by Rafael Alberti, illustrated by Robert Motherwell, 1972 (plates 31 and 186).

The 1960s saw the emergence of many print publishers in Europe and America, a good number of whom would produce books. Paul Cornwall-Jones, associated first with Editions Alecto and later with Petersburg Press in London, produced books with David Hockney, Jim Dine, Jasper Johns, and Francesco Clemente, using printers in New York, Paris, and Stuttgart. A new concept of artists' books, which placed the entire book object in the creative control of the artist, arose at about the same time, and the finely printed limited edition with artists' etchings and lithographs took on a different meaning in this context. Such deluxe books, together with the genre of the press book that emerged at the end of the nineteenth century, continue to represent the tradition begun then, their publishers as selective if not as daring. If, as several late twentieth-century publishers prefer, artists draw and paint their pages instead of making repeatable prints for them, the book form seems to be on its way back to its manuscript origins at just the time when the computer has produced another, more practical, form for carrying words and images.

BOOKS, HAVING BEEN DEVISED at first to carry words, have generally been considered the objects of authors. The component contributed by artists, like that of the typesetter and page designer, is there to enhance (or, given the opportunity, sabotage) the author's intent. Although it is artists' books we speak of, the inference is that books are the vehicles and their content is a mass of words written by somebody. Those words are often in place before any discussion with the artist occurs, partly because publishers may have chosen them. However, that task has not been exclusive to publishers. Writers and artists have long commingled, and their friendships often have been the bases for artists' books.

The work of the nineteenth-century poet Stéphane Mallarmé is the axle upon which the presumption rides that an author and artist might collaborate as equals. He and Edouard Manet planned the French edition of Edgar Allan Poe's *The Raven* (1875), with Manet's lithographs and Mallarmé's translation. However, the most significant of Mallarmé's writings to both artists and writers of the twentieth century was his poem *Un Coup de dés jamais n'abolira le hasard* (first published in a magazine in 1897). The words of the poem, originally written out on music staves, were set in various sizes of type, and the lines of type were separated from the standard block-form stanza, both deviations meant to give the reader impressions of different sounds and emphases within an imposed time-space format. In Mallarmé's words, "A tremendous burst of greatness, of thought, or of emotion, contained in a sentence printed in large type, with one gradually descending line to a page, should keep the reader breathless throughout the book and summon forth his powers of excitement. Around this would be smaller groups of secondary importance, commenting on the main sentence or derived from it, like a scattering of ornaments."[13] The Futurist writer and leader Filippo Tommaso Marinetti's concept of "words at liberty," flinging his words of many sizes and shapes across the page, is an offshoot of Mallarmé's experiment. Using Mallarmé's poem itself, in 1969 the Belgian Conceptual artist Marcel Broodthaers paid homage to the French writer's contribution to freedom of the word in a transcription of its form without its words in his book of the same title (plate 114). Mallarmé's idea of physically surrounding a main thought with secondary material that extends the main story in several directions describes, to some extent, what writers have tried to do in writing fiction for the computer.

Among the writers whose orbit included artists, Guillaume Apollinaire could be considered the first of this century to be an active instigator of art through his pen. Apparently it was he who prodded Daniel-Henry Kahnweiler into publishing his first book. By promoting it as worthy of comparison with Aldus Manutius's *Hypnerotomachia Polifili*, published in Venice in 1499 (figure 12), Apollinaire disclosed his acquaintance with the finest books with which he aspired to compete. A captivating character, Apollinaire could write quatrains about the greatest and least beasts with a shrewd wit one day, poems that formed pictures (his *calligrammes*,

FIGURE 12: *Hypnerotomachia Polifili*. Venice: Aldus Manutius, 1499. Woodcut. The New York Public Library, Astor, Lenox, and Tilden Foundations, Rare Books and Manuscripts Division

begun in 1914 and certainly influenced by Mallarmé) the next, and criticism every day. His *Poet assassiné*, published in 1916, was obliquely about the group of writers and artists with whom he was associated. Well after he died, Raoul Dufy illustrated his friend's semiautobiographical and wildly metaphorical tale of the murder of poetry (1926). Much later, for the fiftieth anniversary of Apollinaire's death, Jim Dine did the same for the first English translation, *The Poet Assassinated*, using photomontages to simulate the writer's disjunctive narrative (plate 169).

Apollinaire was an admirer of Giorgio de Chirico, who had included the writer's shadow in a 1914 painting, *Portrait of Guillaume Apollinaire*, in the Musée National d'Art Moderne, Centre Georges Pompidou, Paris, which was to be reproduced as the frontispiece of the writer's projected anthology "Et moi aussi, je suis peintre." Among his poems, "Ocean de terre" was dedicated to de Chirico, and its evocation of a house in the middle of the ocean surrounded by an earthly octopus parallels the Adriatic atmosphere with which de Chirico suffused Apollinaire's *Calligrammes* in its 1930 publication (plate 133).

In Russia, before the revolution of 1917, there had been a revolution of another sort. Marinetti found, during his visit to St. Petersburg and Moscow in 1914, a Cubo-Futurist, or "Transrational," movement that had a strong group of writers within it. A poetic language, *ʒaum* (a word probably coined by the writer Alexei Kruchenykh combining a prefix, meaning beyond, and *um*, meaning reason—that is, transrational), had developed and covered the pages, between sketches by artists such as Kasimir Malevich and Olga Rozanova, of their cheap booklets (mostly published between 1912 and 1914). The most published poets of this group were Kruchenykh and Velimir Khlebnikov. Two of their earliest booklets were *Mirskontsa* (*Worldbackwards*) and *Slovo kak takavoe* (*The Word as Such*), of 1912 and 1913, respectively, both accentuating through their titles the irrationality of order and meaning. Against this background the illustrations emphasize a reordering of objects and space as dictated by the methods of the Cubists and Futurists.

Because the majority of artists' books were published in France, at least until recently, most of the authors have also been French (although, like Apollinaire, not always French-born). Tristan Tzara was the liveliest member of the Dada revolution, having even given it its name. Among the artists who were part of the actions that erupted at the Cabaret Voltaire in Zurich in 1916, Jean (Hans) Arp and Marcel Janco, for example, produced equally unconventional objects when they embellished Tzara's contributions to the Dada library, *Vingt-cinq poèmes* (1918), with woodcuts by Arp (plates 129–130), and *La Première Aventure céléste de Mr. Antipyrine* (1916), with color woodcuts by Janco (plates 127–128). The title of the latter is a play on the subtitle of Max Jacob's *Le Siège de Jérusalem, grande tentation céleste de Saint Matorel* of 1914, which Jacob had called "aventures célestes de Matorel" in a letter to Tzara in early 1916.[14] Tzara went to Paris, where he presented, at the famous March 27, 1920, *Manifestation Dada*, his Mr. Antipyrine, with the future leaders of the Surrealist movement in major roles: André Breton playing the title character, and Paul Eluard and Louis Aragon in other roles. The collection of his poems, written over a period of three years, was filled with brutal sounds, many

emulating the noises of the street (paralleling, he noted in a letter to the collector Jacques Doucet, the different materials used in the pictures of Picasso, Matisse, and Derain). After he moved to Paris, Tzara (whom Aragon called "un adolescent sauvage") discarded the harsher, declamatory temper of his work, transforming it into a more surrealist form before he became a member of Breton's anointed Surrealist group in 1929. Kahnweiler published his *Mouchoir de nuages* in 1924 with Cubist illustrations by Juan Gris. His poetic anthology *L'Antitête* (1933), containing work from 1916 to 1932, was one of several works by Tzara "illustrated" by Picasso, while other artists such as Ernst, Masson, Matisse, and Miró contributed to some of Tzara's first editions.

By far the most esteemed and art-involved Surrealist writer after André Breton, the philosophical maestro of the movement, was Paul Eluard. With Breton, whom he met in 1919, Eluard participated in most of the activities of the Surrealists until 1938, when he definitively broke their ties after serving with him as co-editor of Albert Skira's magazine *Minotaure* in 1937. When Eluard was a teenager he was confined to a sanatorium in Davos for two years; there he developed his considerable gift for poetry and met the young Russian woman called Gala who later became his wife. The first important artist to illustrate his books was Max Ernst, with whom he and Gala formed a *ménage à trois* during the 1920s (Eluard's *Au défaut de silence* of 1925 included Ernst's drawings of Gala). In 1930 Gala went to live with Salvador Dali just after he had been "named" a Surrealist and Eluard's *A toute épreuve* was published. This was the poem upon which Miró would later lavish his most intense and enduring decoration; this work was planned in the 1950s with Eluard, during the author's last days, and was published in 1958. Between these two publications, Eluard's *Facile* (1935) appeared with photographs by another old friend, Man Ray (plate 137). The love poems were structured by Man Ray, who surrounded them with solarized and dimly lit photographs of their inspiration, Eluard's sensuous second wife, Nusch. Because the lines of poetry fit the contours of Nusch's nude figure so neatly, there has been some question as to whether Eluard and Man Ray were creating in tandem, instead of the artist working around the completed verses. The beautiful Nusch was the subject of illustration again, this time in etchings by Picasso for a collection of Eluard's poems, *La Barre d'appui* of 1936 (plates 139–140).

During his long association with Surrealist artists, Eluard was only a sometime advocate of automatism, writing without preplanned structure or concepts. This type of blind acceptance of the subconscious ordering of thoughts seems antithetical to the extremely visual orientation of his writing, yet became reconciled by its reoccurring theme of revelation or envisioning. Certainly, his collection of poems dedicated to artists, *Voir* (1948), which reproduced their paintings (many of which he had collected), and his poem "Les Yeux fertiles" (1936), display his visual proclivities. In his poem "Georges Braque," Eluard wrote: "A man with roving eyes describes the sky of love."[15]

In the next generation of writers, the Frenchman whose work had the greatest international cultural impact was Jean-Paul Sartre. His examination of reality in his theoretical proposition of Existentialism was enthusiastically endorsed

by those whose creativity had been compromised by the economic and political burdens of the 1930s. Following in the post-Surrealist footsteps of those who, like Eluard, felt that writers and artists should engage in the sociopolitical events of their times, Sartre participated in several arenas of radical discourse between the 1940s and his death in 1980. He did not so much mingle with artists as exist among them and, in one brilliant episode, acted in the clandestine first performance of Picasso's play *Le Désir attrapé par la queue* in 1944. Among the few artists about whom Sartre wrote extensively and with whom he collaborated on books was the painter Wols, whom he called "a poor devil."[16] This chronically ill and alcoholic artist expressed the intensity of an anguished age in impulsive nests of fine drypoint lines. In *Visages, précédé de portraits officiels* of 1948 (plate 144) and *Nourritures* (1949), Wols gave to Sartre's slim poetry a hyperreality. A later work, *Un Soleil, un Viet-Nam* (1967), one of many politically motivated texts in which writers have collaborated with sympathetic artists, united Sartre with Matta, a like-minded Surrealist painter (plate 65). Sartre was a member of the Bertrand Russell War Crimes Tribunal, which at the time of the American intervention in Vietnam was holding conferences of its membership of European intellectuals throughout Europe, specifically to condemn the "American massacre." Sartre's attempt to organize one of their meetings in France with participants who were unwelcome there was rejected by President Charles de Gaulle in 1967. A year later there would be even more associations of writers and artists as the student revolution in Paris catalyzed into action all those who demanded justice in every sector.

Few writers have had as prolonged or defining relationships with artists as Apollinaire, Breton, and Eluard. In France the interrelations of authors and writers continue to this day. From the 1930s into the 1950s Georges Hugnet and René Char regularly participated in books illustrated by their friends. Since that time writers such as Michel Butor and André du Bouchet have done the same. Undoubtedly, this situation has had to do with the place and time of their activities as well as the mutual sympathy and respect of one creative means for another.

In Germany the events that scattered the potential of publishing had the same effect on writers and artists. The great authors whose work was published first in Germany, such as Thomas Mann, Max Brod, and Hermann Hesse, seem to have evolved the details of their styles to make further definition superfluous. Kasimir Edschmid was the best known of the German Expressionist writers, with several novels in print, before Max Beckmann made drypoints for his *Die Fürstin* of 1918 (plate 126). Kurt Wolff, who had published many of Edschmid's works, also issued the one slim volume that exhibited what might have been had artists taken the initiative: Georg Heym, who drowned in 1912, left behind a poem that Ernst Ludwig Kirchner designed into one of the few Expressionist books, *Umbra vitae* of 1924 (plate 190). In Germany it was frequently the foreign-born artist who also did the writing—the Austrian Oskar Kokoschka, the Russian Vasily Kandinsky, and the Hungarian László Moholy-Nagy—making an alliance of word and image in one person.

After World War II new groups of artists and writers came together to

locate and voice their common interests. The center of art activity, having moved to New York, was strengthened as American writers associated themselves with outspoken painters and sculptors. At first, as had been the case in Paris, the writers occupied themselves with translating the new artistic forms and grouping them into what might be identified as a movement. Two of the young poets, John Ashbery and Frank O'Hara, moved among the second wave of Abstract Expressionists. Their poetry was expressive in the sense of quick changes in mood and perception, and face-offs between multiple conversations and interior responses. With Kenneth Koch and James Schuyler they were invited by the poet Daisy Aldan to participate in an extension of her publication, *Format*, which consisted of portfolios of poems with screenprints. In four bound volumes, each devoted to the work of one of the poets and embellished with screenprints by one of her painter friends, these colorful books were boxed together and published in 1960 under the imprint of Tiber Press, founded in New York by Aldan, Richard Miller, and Floriano Vecchi. Tiber Press had been issuing screenprinted greeting cards before Vecchi supervised the printing of the screenprints for the four books (the texts were printed in Germany). Ashbery, who was living in France, contributed a group of six *haibun* (a Japanese form consisting of prose with a haiku, a seventeen-syllable poem, at the end), which were illuminated by the action-filled abstract screenprints of Joan Mitchell, another American who lived mainly in Paris. The volume was titled *The Poems* (plate 165). O'Hara, who was also a curator at The Museum of Modern Art, contributed "Odes" to the Tiber Press set, enhanced by his friend Michael Goldberg's screenprints. Koch was paired with Alfred Leslie, and Schuyler with the painter Grace Hartigan, who had made screenprints for *Format* as early as 1954 and was a close friend of nearly all of this group and particularly O'Hara, until she married and moved to Baltimore in 1960 (plate 166).

O'Hara was also involved in an artist-poet project of much longer gestation, *21 Etchings and Poems* (1960), begun in Stanley William Hayter's New York Atelier 17 in 1951 (plates 163–164). Peter Grippe, who directed the workshop after Hayter reopened his Atelier 17 in Paris, also organized the group of twenty-one etched broadsides. Each consisted of a handwritten poem by one of the authors, illuminated by the work of an artist. O'Hara's poem was enhanced by a powerful abstraction by the American painter Franz Kline. Both American and European artists and writers were included in the set, but one aspect of its importance was that it was the site both of Kline's only print (albeit a photoetching of a collage) and Willem de Kooning's first print. O'Hara worked frequently with artists, both in collaborations of poems with drawings and paintings and in exhibiting their work at the Museum. After his untimely death in 1966, the memorial collection of his poems *In Memory of My Feelings* (1967), published by The Museum of Modern Art, was illustrated by thirty artists.

Another group collaboration surrounded the poetry of one man, Walasse Ting, a Chinese artist whose thoughts are conveyed in a raunchy Pidgin English. His project, *1¢ Life* (1964), was organized with the American painter Sam Francis, and both European and American artists were invited to illustrate his poems

(plates 167–168). This undertaking is the single instance in which artists of two essentially contradictory philosophies of art were brought together in one unexpectedly cohesive book. The gamut ranged from Francis, a California-based Abstract Expressionist, to Antonio Saura, his Spanish counterpart, to expressionist painters Pierre Alechinsky and Karel Appel, and to nearly all the Pop artists, from Dine to Andy Warhol. Altogether, twenty-eight artists made sixty-two lithographs, almost all in brilliant color, for *1¢ Life*, a vibrantly fresh addition to the library of modern artists' books.

Artists as Authors

WHEN GAUGUIN HAD GONE TO BRITTANY IN 1894 he got into a brawl. During his convalescence there he was visited by his friend Alfred Jarry, who wrote three poems dedicated to the disabled artist. That summer Jarry's first book appeared and he also began his most important text, *Gestes et opinions de Dr. Fausteroll, pataphysicien*. His title character is thought to be based upon Gauguin, and one section, "L'Isle de fragrance," is also dedicated to him. In the case of artists' books, it is rare to find the author as artist (for example, Jarry, and later, Henri Michaux). There are, however, many artists who have felt, as Gauguin did, that their words might enhance their images. Some were entirely functional and gifted wordsmiths, like Vasily Kandinsky, who extended his words with pictures. Rouault, Matisse, and Léger were more than capable of putting into words the color and expression of their art.

At what point is the painter inspired to write rather than simply paint? From the beginning, it seems, there have been masters and students, craftsmen and apprentices, and, finally, artists who wished to pass on to others the ideas that formed the foundations of their art. Many books have as their subject this educational intent. The first important artist to write about and illustrate such ideas was Albrecht Dürer; his treatise on human form (figure 13), first published in Germany

FIGURE 13: Albrecht Dürer. *Della simmetria de i corpi humani, libri quattro*. Venice: Domenico Nicolini, 1591. Woodcuts. Collection Arne and Milly Glimcher

in 1528, is a model of artists' how-to books. The group of artists who were teachers at one of the most remarkable educational experiments of the twentieth century, the Bauhaus in Weimar and, later, in Dessau, also contributed to this library. Important dissertations on art making and the philosophies of the artists who taught there were written by Kandinsky, Paul Klee, and Moholy-Nagy, or were made into exclusively visual form by Josef Albers many years later. In all cases, they put these ideas into books that were aesthetically and formally part of their art. One of the most significant examples of this type of book, consisting of only four pages of text and thirty-four lithographs, is Kasimir Malevich's *Suprematism: 34 Risunka* of 1920 (plates 73–74). In 1913 the Russian artist made his jump from Cubo-Futurism to geometrical abstraction by creating a black square as the curtain design for *Pobeda nad solntsem* (*Victory over the Sun*), an opera by Mikhail Matiushin and Alexei Kruchenykh. He gave a name to his theory of nonobjective art in 1915, defining it as *Suprematism*, a word he created. After the Russian Revolution he further explained Suprematism in his 1919 booklet *O novikh sistemach v iskusstve* (*On New Systems in Art*), printed and published by El Lissitzky in Vitebsk. Also in 1919 he was invited to teach his method at the Vitebsk Svomos (Popular Art Institute), and the following year, as part of the transformation of the educational system, he became a member of the collective Unovis (Affirmation of the New Art) there, gathering around him a number of pupils and creating the series of drawings that demonstrated the principles of Suprematism. The Bauhaus was supposed to publish a later example of his writings, "Suprematism and the Additional Element in Art," but instead issued his *Die gegenstandslose Welt* (*The Nonobjective World*) in 1927.

Other artists have contributed to the understanding of their work by publishing their sketchbooks or explanations of specific works. One of the most provocative Surrealist images was a mechanical doll constructed by the German artist Hans Bellmer. In 1936 the French edition of a booklet about the doll, *La Poupée*, included Bellmer's text about his fascination with young girls, printed on pink paper, and pasted-in photographs of his doll in various stages of construction, destruction, and dress (plates 141–142). Marcel Duchamp's endeavor in this area, *La Mariée mise à nu par ses célibataires, même* (the *Green Box*), published in 1934, is made up of precise reproductions of all his notes for the large sculpture of the same name made between 1913 and 1923 (plate 78). Its torn scraps of various papers, filled with quickly jotted thoughts, which simply were placed in a green "suede" paper-covered box, express Duchamp's goal of communicating the sequences of a creative process. Similar in intent to Dürer's treatise of 1528, Duchamp's work is as edifying. Perhaps more significant is the attitude embodied in the form. Since his Dada beginnings, Duchamp's willingness to transgress the accepted forms of art inevitably provided models for later artists. The *Green Box* is both the model for so-called object books (those works of the last quarter of the twentieth century that include texts in nontraditional containers) and the most valuable prototype for the Artist's Book, as it came to be identified after the 1950s.

Another form of artist-as-author-and-illustrator emulates that of the collaboration of author and illustrator. Rarely are artworks developed simultaneously

with texts. Kandinsky was eager to disseminate his ideas through his own philosophical tract *Uber das Geistige in der Kunst* (*Concerning the Spiritual in Art*) of 1912, and in editing with Franz Marc the illustrated almanac *Der blaue Reiter* (1912). He added to these literary accomplishments a book of poems, *Klänge* (1913), illustrated with his preabstract woodcuts (plates 83–85). Like *L'Enchanteur pourrissant*, which preceded it by only four years, the overall story of *Klänge* is about "days of yore," populated by knights on horses going through the forest. Unlike the earlier book, in which Derain added images to Apollinaire's text, the artist and writer were one; Kandinsky was now in control of the entire design, including his illustrations, which run the gamut from an early fairy-tale style to nearly realized abstractions evolving from his compositions of riders charging up hills. It was he who chose the type and determined which illustrations would be in color. In his apocalyptic print of the *Large Resurrection* (plate 84) Kandinsky's forceful cutting and color combine to relay his message of the spirituality that resides in art.

Less pedantic, intellectual, and certainly less self-disciplined than Kandinsky was the Austrian Oskar Kokoschka. As a student he was given his first book-design assignment, which resulted in an adult fairy tale of 1908 titled *Die träumenden Knaben* (plate 35). The unsold copies were reissued in 1917 by Kurt Wolff. Kokoschka wrote his tale about young love with an autobiographical twist, calling the female character Lilith, the name of his Swedish girlfriend. Commissioned by the Wiener Werkstätte and published at the time of the 1908 *Kunstschau* in Vienna, it consisted of full-page color lithographs framed with black outlines and, to one side, the narrative presented in a form of free, uncapitalized, and unpunctuated verse. The style of the images makes the book's dedication to Gustave Klimt, the respected painter of the Vienna Secession movement, quite logical; Kokoschka's tapestries, in a similar style of black outlined color forms, were also shown at the exhibition. Simultaneously, the artist was working on a play in a quite different, brashly extremist vein, completing four clashing, discordant ink drawings of the protagonists. The play, *Mörder Hoffnung der Frauen*, was performed at the 1909 *Kunstschau* and created a near riot (figure 14). A symbolic drama about a woman's domination over a weakened male who regains strength from their sexual intercourse and murders her, it was made into a book with reproductions of the drawings by the publisher of the journal *Der Sturm* in Berlin in 1916 (plates 86–87) and transformed into an opera by Paul Hindemith the following year. Kokoschka painted over the drawings in three copies of the 1916 publication, creating three different visions of the two characters. One of the important features of the performance was the dramatic use of lighting, and Kokoschka's coloring variants reflected the range of emotional impact he sought in the changing lights.

A booklet of just eight sheets, the English painter David Bomberg's *Russian Ballet* (1919) is an example of a not-yet-successful artist's attempt to expand awareness of his work by publishing images that resemble his paintings (plate 82). Six color lithographs, closer in style to his Mud Bath paintings than to those he did of dancers (such as his wife), were given a cloisonné effect, amplified by their placement on pages uncluttered with text. Facing the prints is a similarly pristine

FIGURE 14: Oskar Kokoschka. Poster for *Mörder Hoffnung der Frauen*. Vienna: Internationale Kunstschau, 1909. Lithograph. The Museum of Modern Art, New York. Purchase fund

page, the upper part of which is devoted to Bomberg's poetic evocation of the dance, printed in block letters. He wrote and printed the entire work, aided by his wife, who sewed the pages together. The impetus for creating this work was the appearance in London of Serge Diaghilev's Ballets Russes, and Bomberg's plan to sell it at the theater; when this was prohibited, it was sold at Henderson's Bomb Shop on Charing Cross Road.[17]

The challenge to an artist who adds writing to his or her own images is to find among the thoughts that need formal fulfillment those that must be expressed in words. Most often the words are autobiographical or instructive. Although Marc Chagall's first publication of *Mein Leben* (1923) did not include the text that he had written, the twenty etchings related specific incidents in his early life and stories regarding events he had heard about (plates 88–89). Like the woodcuts for *Noa Noa*, Chagall's prints exist on their own, but his tales from the *shtetl* where he grew up (finally published in 1931) actually enhance them, making the famous fiddler on the roof or the boy held upside down actualities rather than fantasies. In 1963 when David Hockney made a series of etchings inspired by William Hogarth's *The Rake's Progress* (1733–35), he depicted himself as the rake, not in London but in the seductive city of New York (plate 102). Although his recounting of the story is different from Hogarth's in most details, his rake, too, lands in Bedlam—not the prison but among a singing group dressed like prisoners. Hockney is himself as he shifts the old moralizing fiction into the Pop environment of the 1960s, just as the male in Kokoschka's version of the age-old battle of the sexes is the shaven-headed Oskar himself, modernizing the theme into his personal psychodrama.

If the personality of the writer is identifiable in the writing, then certainly the artist who is known by his or her images is easily trapped into revealing more of the same in writing. The wild and wondrous prints of Matisse's *Jazz* (1947), so full of movement and color, seem to represent the antithesis of the old and infirm artist who made them (plates 22–23). He accompanied his prints with a text that is about his interests and his art, arranged in the undulating arabesques of his own handwriting. Full of wisdom and imagery, it is primarily the way that his words are written rather than their content that complements the pictures that punctuate them. In both cases, the images and the text are the products of a person whose experiences and ideas have been pondered and carefully arranged, yet the differing spirit that they present requires an unceasing readjustment of the reader's and viewer's disposition. It is this situation that is found in the most engaging artist-author collaborations and is what Picasso must have been after in 1938 when he undertook a long period of writing, which he hoped would culminate in a book designed, illustrated, and written by himself.

There is no title known for the book of Picasso's writings that Vollard agreed to issue. It is probable that the publisher was entirely unaware of the content of the text, although Picasso's secretary, Jaime Sabartés, had typed out many parts from the artist's carefully written and partially edited transcripts of word sketches. Previous to this project, Picasso's only fully realized published text accompanied his anti-Franco etchings, *Sueño y mentira de Franco* (*Dream and Lie of Franco*)

(plates 60–61). It has been suggested that Picasso's decision to write about a political theme at that time (1937) was inspired by Eluard's poem about the Spanish Civil War, "November 1936," published in December 1936 in the journal *L'Humanité*. There is every reason to believe that Vollard had read Picasso's long, surrealistic stream-of-consciousness sentence, which pairs symbolic representations with a driven, unpunctuated excitement. While the two cartoon-strip images that make up the *Dream and Lie of Franco* are also filled with metaphoric symbols for the hated dictator and his exploits, because of the familiar context in which they are composed a minimum of information is needed to interpret the actions represented. In the accompanying text, Picasso used words in a predominantly unfamiliar context, making interpretation and subsequent ordering for understanding totally subjective. Although most of his literary choices for publication were conservative, Vollard's personal fascination with the works of Jarry may have led him to recognize something in Picasso's unique style of writing that was worth encouraging.

A year before Picasso etched *Dream and Lie of Franco* he met the artist-photographer Dora Maar. It was she who took documentary photographs of the creation of Picasso's famous painting *Guernica* (1937), and her face, like those of other women with whom he had extended liaisons, became a frequent image in the artist's work. In spring 1939, as he was continuing his work on the book of his writings, he decided to begin the etchings to decorate them (plates 90–94). At Roger Lacourière's workshop, where Rouault's color aquatints had been printed for nearly a decade but had only just been published, Picasso finally made his first real color prints. He had already tried to add color to a few black-and-white etchings in 1935, including his important *Minotauromachy*, as he proofed them. The technique he used in 1939, however, was not the same. He began each print with a basic drawing in aquatint, which was built up by adding plates with etched lines and more brushed aquatint into multicolored images. The color etchings and aquatints of the head of Dora Maar were to be full-page plates, and other, narrow vertical engravings of a full-length female nude remained in black-and-white, undoubtedly meant to be printed alongside the text (figure 15). The process of correcting and adding to the color proofs required the artist to address the colored inks that were used. One of the many stories about this unique book project concerns Picasso's fascination with the printing inks and his using them to draw directly on paper, thereby interrupting his concentration on this printmaking project. It is true that he left the print shop for Antibes, on the Mediterranean coast, at the beginning of summer, but circumstances other than the heat of the season or the dawn of war ended this project for all time: Vollard died after an automobile accident on July 22, 1939. Although the six color plates of Dora Maar had been editioned by 1942, and other books planned by Vollard that were incomplete at his death were later published, the prints and the manuscript for this project remained packed away in one of Picasso's studios until after his death. The incomparable literary style of Picasso was developed during the preparation of this book project, finally to be revealed in other works for his album *Poèmes et lithographies*, completed in 1949 but not published until 1954.

Jean Dubuffet, a French wine merchant who had started out to be an artist,

FIGURE 15: Pablo Picasso. *Standing Nude I*, state I. April 25, 1939. Engraving. Baer 656. Marina Picasso Collection, Jan Krugier Gallery, New York

returned to that calling during World War II. In his forties during the war, he and his writer friends discovered in the drawings of children and the insane the simplicity of intent and depiction that defined for them a creative honesty in sharp contrast to the dishonesty that they felt had enveloped European culture since the beginning of the century. Somewhat earlier, several Danish artists had taken a similar approach, looking at so-called primitive and folk arts as models for their elemental, painterly style. The youngest artist among them, Asger Jorn, was later influential in the establishment of a postwar group called, after the names of their hometowns, the CoBrA (*Co*penhagen, *Br*ussels, *A*msterdam) in 1948. Both he and Dubuffet wrote texts for their own books.

Jorn's, written during his convalescence from tuberculosis in 1951, *Held og hasard/Dolk og guitar* (*Health and Hazard/Dagger and Guitar*), was a compilation of his thoughts about art (plate 97), centered on the question, What is aesthetics? He wrote it during the disintegration of the CoBrA movement, while planning its last exhibition. The text incorporates some of Jorn's ideas, which were to have an impact on his subsequent association with the Italian artist Enrico Baj. Jorn's strangely titled book is both autobiographical and philosophical, its margins filled with many color woodcuts that act as a visual gloss on Jorn's discourse. While the CoBrA artists continued to use the imagery that was developed during the movement's existence, decorating many volumes with the charmed snake that was their signet, and with ghosts and masks, Jorn's prints in this book define those forms, much as words find their places in dictionaries, once they have found their agreed usage. Jorn was an articulate and dedicated essayist until his death in 1973.

Jean Dubuffet was primarily interested in transmitting the sense and roots of his art in word-forms. He illustrated books written by his friends Francis Ponge, Michel Tapié, Jean Paulhan, and Eugène Guillevic, among others, but when he wrote his own texts, he wrote phonetically, or naively. His first attempt at this was a mimeographed pamphlet titled *Ler dla canpane* (1948); this was followed by *Anvouaiaje par in ninbesil avec de zimaje* and *Labonfam abeber par inbo nom* of 1950 (plate 143). The third title is a booklet of drawings of men and women copulating, with appropriate text entirely obfuscated by the breaking up of the phonetically reproduced words. The author Dubuffet identified himself only as *inbo nom* (*un bon homme*), and, once deciphered, the sexual encounters are about *la bonne femme à bébé*, or the woman with child. In this instance, Dubuffet joins an age-old tradition of making "dirty" books. Pornographic pictures and texts are much older than books themselves, but the book form has always been a perfect container for hiding such material from general view. Because Dubuffet's inspiration at this time was the art of children, their unaffected attitudes toward codes of conduct and representation were taken wholesale. Unlike the usual sexual encounters in brothels, which found their way into books with prints by Masson, Jules Pascin, and Picasso, to name the most prolific in this area among twentieth-century artists, Dubuffet's couples defy prurient context by being simple, floating, child-drawn men and women having sex. The language Dubuffet uses in his text is argot, the slang that a kid of the streets might hear and speak. Because of the naive context, Du-

buffet's porn is closer to a sexy limerick or a rap song than other x-rated examples.

When sex has been a matter of art, symbolic representations have tended to outnumber graphic ones. After the advent of the type of Artist's Book that developed out of the attitudes about art that were to evolve into Conceptual art, sexual mores were only occasional subjects. Because this book form developed in a period of openness about sexual matters, it rarely reverted to what once was called pornography, except in radical statements about society. The two following examples of how artists have put their magnifying glasses up to the world and viewed it differently are by British artists.

The first, an early form of the ensuing Artist's Book, is Eduardo Paolozzi's *Metafisikal Translations* of 1962 (plate 100). An admirer of Ernst's and Dubuffet's collage prints, Paolozzi took parts of some old engraved advertisements and illustrations, melded them into pseudomechanical objects, and accompanied them with his own so-called metaphysical clarifications. The book, from cover to cover, has been handled by the artist in the same way he has constructed his sculptures of iron pipes, fitting rings, and other fixtures of the mechanical age. Both book and sculpture have the disjointed, wry aspect of Pop art, even though they are made from materials of, or developed in, earlier decades.

The second British book, *Side by Side* (1972), is by two artists known only by their first names, Gilbert & George (plate 101). Their work falls into a category that, since the late 1950s, has been one in which artists perform within their own created environment. The Happenings of the 1950s and early 1960s were understood to have been neo-Dada manifestations, while the form that has been called Performance art has frequently been confused with the long-established theatrical form of monologue. In the case of the Happening, a setting established the action, and occasionally posters, programs, and other relics remained to be collected or to document the event. Gilbert & George are noteworthy among the Performance artists for having surrounded their Actions with an abundance of ephemeral publications and invitations, as well as documents of Actions they might have taken without an audience. *Side by Side* is a book in three parts, which they called "a contemporary sculpture novel . . . based on plans, intentions, and experience. The form being abstract air brushes and the expression pure sculpture."[18] The chapters are "With Us in the Nature," "A Glimpse into the Abstract World," and "The Reality in Our Living." The first part of the book records their rambles in the countryside, and the third records their existence "Underneath the Arches" (a romantic song used in their performances as "Living Sculpture"). Designed in the style of a kind of public-schoolboy romanticism, the overexposed photographs in the first section, showing them together "in the nature" at spots along their path, are paired with the slight literature of a vanity novel of the 1920s. At about this time British artists Richard Long and Hamish Fulton began to center their art on taking walks of varying lengths and documenting them in photographs and books. The products of their walks focused on time and space as real experiences, while Gilbert & George's walks were fictional and quite possibly also a witty commentary on the boredom of objectivity as the basis of Conceptual art.

THE RAPPORT BETWEEN AN ARTIST AND A TEXT, chosen or given, and the success of the artist's solution, no matter how well supported or produced, is a major criterion for assessing the importance of many artists' books. Having traced the influence of the author as an associate of the artist and the publisher as an activator and motivator, how the artist approaches another work of art, that of a writer, is a special facet of the medium that must be studied on its own. Is Bonnard's the ideal fulfillment of Verlaine's verse, or have his soft pink, scribbly lithographs confused the poet's lyricism with cozy informality? Have Matisse's pristine etchings of threadlike lines placed opposite equally fine lines of poetry set, like Verlaine's, in italics, so carefully controlled the environment of Mallarmé's poetry that its complex textures are repressed? Bonnard's *Parallèlement* and Matisse's *Poésies* by Mallarmé have long been considered the quintessential artists' books in the French style (plates 8–9 and 15–17). Both have been given these laurels on two counts: the perfection of the aesthetic quality of their pages and the excellence of the artist's contribution. Because the texts were already written, the publisher took the part of the writer, first by selecting the specific text, then proffering it to a chosen artist, and then deciding how it should be set, what the page size should be, and so on. While it is clear that many of the decisions regarding layout were made in conjunction with the artist, the publisher and his associates played a major, and perhaps restricting, role.

Both Vollard and Skira hoped to combine their choice of artists with texts that would appeal to collectors of books. Not only was Vollard unsuccessful with *Parallèlement* because of his problem with printing a forbidden text, but more so because he thought that lithographs by Bonnard would be appealing. The medium alone was a mistake, as at that time collectors preferred their illustrations to be finely engraved on wood or copper, not crayon sketches. Skira's *Poésies* sold poorly as well because the Depression decimated the number of book collectors and because Matisse was unknown as an illustrator.

There were (and continue to be) collectors' clubs, which commissioned and published similar books with more conventional illustrations and layouts, so places on the typical collector's shelves would be filled with those books to which he or she subscribed through clubs before venturing into less proven acquisitions. Such clubs, along with print clubs, were organized during periods when discretionary money was abundant, in the 1890s, 1920s, and 1950s. Studying the books issued by these clubs reveals their conservatism, and so the lack of financial success of Bonnard's and Matisse's books is not a clue to their achievement as artists' books.

When Count Harry Kessler sought to produce the perfect book, he began with the writing of the ancient Virgil and the art of Aristide Maillol, whose figurative sculptures and drawings were endowed with the ideal contours of classic antiquity yet conceived within the confines of a strict geometric form. After Kessler took Maillol to Greece, the artist slowly began to create the woodcut images that, twenty years later, would adorn pages designed by Edward Gordon Craig. Like Apollinaire, Kessler envisioned *The Eclogues* of Virgil to be a worthy, modern successor

to Aldus Manutius's *Hypnerotomachia Polifili*, but unlike Derain, Maillol seems to have paid considerable attention to fifteenth-century formal qualities, confining his similarly simple, linear woodcuts to analogous rectangular enclosures (plate 38). The thought that an Italian Renaissance form of presenting antiquity would be appropriate to ancient Roman poetry arose from suggestions undoubtedly made by the publisher to the right artist, who dealt with the problems of illustration without deviating from his own aesthetic vocabulary.

Another vision of Virgil was initiated by Vollard when he commissioned André Dunoyer de Segonzac to illustrate *Les Géorgiques* (plates 43–44), a mammoth task. The artist ultimately made 119 etchings of rolling fields and vineyards comparable to the author's Italian *campagna*, which filled two large volumes. Created in the informally representational style of an artist who began to illustrate books immediately after World War I, the Virgil might be viewed as the book most likely to appeal to the book-club member. There is little space between representation and inspiration; that is, Segonzac approached the text in a literal way. And yet his etchings are complementary, not tied to this or that image in the verse. He put Virgil's poetry into a lyrical environment evocative of the one from which it arose in the first century B.C.

Segonzac completed and published his book himself in 1947. Since then, except for a handful of books by authors mainly of his generation, rarely have artists been paired with dead authors. Until this point the books by dead authors described have had decorations that were essentially figurative. After World War II and the ascendancy of abstraction in painting, more instances of images that could not possibly be mistaken for illustrations occurred. However, until the excited economic conditions that supported luxurious book production in the earlier decades resumed in the 1970s and 1980s, most artists' books were based on the works of living authors. France continued to lead in the publication of the style of book made famous there earlier, but by the 1970s a few publishers elsewhere were banking on proven texts to carry the less established images of artists. In the tradition of the book club, Sidney Shiff of the Limited Editions Club in New York asked Ellsworth Kelly to add his terse forms to Mallarmé's *Un Coup de dés jamais n'abolira le hasard* (plates 158–159). The resulting pages have the poem set as Mallarmé intended; they are separated from Kelly's black-and-white forms by blank pages. In this way it appears that the artist has emphasized his respect for the integrity of the poet's design while offering his visual complement without intrusion. Kelly's interpretation in 1992 extends the visual modulations that Mallarmé sought, not obliterating them and leaving only their forms, as Marcel Broodthaers had done. Rather than convert Mallarmé's lines of poetry into linear images, as Matisse did, Kelly took their mass and transferred it into a new mass.

A final example, one in which the artist was committed to the text of a cherished writer, is Francesco Clemente's *The Departure of the Argonaut* by Alberto Savinio of 1986 (plate 176). Again, there is a question of how close the artist came to the author's vision, but, in addition, Clemente's encroachment upon the words themselves is a powerful statement of the artist's vision superseding that of the

author. If it were not known that Clemente had chosen a favorite text of an esteemed author, the impression would be of a battle between text and image in several instances. There are series of text pages decorated with only marginal images and others in which the text faces the traditional full-page plates, but those where the artist has covered both pages of text with translucent monocolored images are by far the most vivid and committed to the spirit of the passages they accompany.

The question of the aptness of translation has always been a provocative one, and in studying these and other artists' books it must be raised, for in all those cases in which the artist cannot communicate with an author, the artist is no different from the translator who changes the author's words into another language. The artist's style, choice of medium, decisions of layout, and placement of the pictorial elements are all basically translations, in that they enhance, diminish, or alter in a myriad of ways, the meaning of the author. For example, if one reads a line in one's own language, written in one's own time and therefore in a known idiom, it is likely that one's understanding of the line will be fairly close to what the author intended (even then, the reader has already accumulated a mass of experiences, likes and dislikes, that will modulate if not drastically alter what the author meant and implied). When, however, that line is in a foreign language, which the reader must encounter in translation, it is the translator's understanding that is conveyed. So, when the artist's understanding of a text—when he or she actually confronts it—is presented along with the text, inevitably it is modified and shaded with varying degrees of comprehension. Since illustration is not intended, what the artist does in such books does not entirely affect the word-for-word reading of a text, but it has a tremendous burden to carry, for it transforms the entire intent of the piece into the artist's language. For this reason alone, the perfect alliance of text and picture is, above all, the artist's, and then that of the artist and author in collaboration. Artists' books are just that—the work of the artist whose imagery, rather than being subsumed by the text, overcomes it by translating it into a language that has more meanings than words alone can convey.

Artists without Authors

TRADITIONALLY, ARTISTS HAVE TAKEN still another path that has given them authority over the book form. They have bound together series of images with no other text than captions or dispensed with words entirely. It is not a recent tendency, since sets of pictures, united by their themes or by an implied concept, had been the substance of books before printing. In the block books of the fifteenth century, such as *Ars Moriendi* and *Apocalypsis Sancti Johannes* (figure 16), the written portions were secondary to the pictorial parts of the woodcuts. When Goya created his *Los caprichos* in 1799, the eighty aquatints were bound together. They did have aphoristic captions, often worded in ways meant to confuse the censors, but that also added further dimension to the viewer's notion of what was represented. Similarly, George Grosz's 1923 bound volume of reproductions of watercolors and drawings, *Ecce Homo* (plates 107–108), is captioned throughout, but in his case the ironic tone did not prevent authorities from fining the artist six thousand marks for

FIGURE 16: *Apocalypsis Sancti Johannes.* Germany, c. 1470. Woodcut. The Pierpont Morgan Library, New York

FIGURE 17: Lyonel Feininger. *Cathedral*. 1919. Woodcut. The Museum of Modern Art, New York. Gift of Mrs. Julia Feininger

his blasphemies and from expurgating several plates. Prints alone have frequently conveyed stories without the need of words. Kandinsky put together a series of woodcuts in 1903, which he titled *Stikhi bez slov* (*Poems without Words*). In 1919 Kurt Schwitters reformulated his Dada collages of cast-off papers into a pamphlet, *Die Kathedrale* (plates 104–105), a few pages of lithographs made from transfers of pieces of leather and other materials interspersed with words in several languages. Each printed page faced a blank one, presenting Schwitters's printed versions of collages as separate compositions. In the same year, Lyonel Feininger made a woodcut of a cathedral as the cover of the second Bauhaus program, illustrating Walter Gropius's aim to create "the cathedral of the future" (figure 17). In 1920 at another experimental school, the Popular Art Institute in Vitebsk, El Lissitzky designed his *Pro dva kvadrata* (*About Two Squares*), a children's booklet in which simple geometric forms and a minimum of inventively arranged letters conveyed the story, published in 1922 (plate 71). The Belgian Frans Masereel specialized in picture books, and his *La Ville* (1925) is typical of the non-narrative use of images connected by a single subject (plate 106). In one hundred woodcuts, Masereel conveyed the gaiety and oppression of urban life of the 1920s, particularly seen through the artist's political bias. Max Ernst's five-part collage novel, *Une Semaine de bonté, ou les sept éléments capitaux* (1934), is the Surrealist's adaptation of such a book without words (plates 109–110). He had placed an introductory paragraph in each part, meant to clue the viewer in to the sequences of Freudian-fraught reproductions of his collages made from cheap wood-engraved illustrations. Divided into days of the week, the subjects of each day are related to their alchemical symbols, a frequent source used by the Surrealists, as well as to introductory quotations by Arp, Eluard, and Benjamin Péret.

In another instance, arising from artists' use of the book form as a sketchbook, a series of images that have a single concept advanced in repetitive shapes or structures unencumbered by narrative or directions covers all but the title page. František Kupka's *Quatre histoires de blanc et noir* (1926) is a modern example of this concept. Each sheet is an abstract woodcut emphasizing the contrast of black and white (plates 68–70). The artist has grouped his compositions into four stories, unified by an underlying structure, but it is not possible to apply any further context to them. Kupka, known historically as a pioneer abstractionist, in this instance has also pioneered a significant change in artists' books by curtailing the verbal prominence.

In 1934 Bruno Munari designed a tin book with Tullio d'Albisola, whose best-known book, also of tin, was made with the Futurist poet Filippo Tommaso Marinetti (plate 183). However, Munari's books of abstract collages, cutouts, and folded sheets of paper were mainly books without words. Combinations of letter forms, which enlivened his pages, were later joined by exclusively geometric ones. During the 1950s Munari made a series of unique cut-and-pasted collage pamphlets that he called *libri illeggibile* (plate 184). These books, in which the only printing was a typewritten slip containing a few words about when and where the book was

made, were also precursors of the type of book the German-born Dieter Roth was to make in Iceland during the late 1950s and early 1960s. At first, depending upon the seriality of book pages to dominate, he composed his ideas into several series of cutouts, which revealed in each turn of the page a transformation within a set of geometric patterns. He then began to make books from preprinted materials taken from the refuse of commercial printers. These overprinted sheets, magazine advertisements, or tremendously enlarged photo-offsets meant for billboards were bound into thick paperbacks and made up a separate series, titled alphabetically (*Bok 3c*) or by content (*Daily Mirror Book*), and issued in 1961 in variously sized editions, containing parts of the same but not identical found sheets (plate 111). They were foremost in the development of what were later internationally dubbed *bookworks*. Eventually, the Conceptual artists made the Artist's Book their primary object of creativity.

Significantly, the photographic books of Walker Evans, and particularly his *American Photographs* (1938), became models for most sequential presentations of diverse but linked photographic reproductions in book form (plate 116). Each photograph was placed on the right-hand page, as were full-page plates in most artists' books; the facing left-hand page was blank except, possibly, for the photograph's title. This austere composition defined the book as a kind of gallery in which full attention was dictated by the picture, unencumbered by disturbances in its surroundings, save for a polite, generally factual label. Without this prototype and its subsequent dominance in the composition of books illustrated with photographs and reproductions of artworks, it is unlikely that the new style of Artist's Book would have been so quickly a dominant factor in artistic production. With the Artist's Book *Twentysix Gasoline Stations* (1963) by the California artist Edward Ruscha, in which all but one photograph faces a blank page, this style, which was largely a new artistic attitude rather than a new book form, was established (plate 117). The photographs taken by the artist of a series of buildings, identical in function and similar in setting, were chosen for their identity rather than their setting, form, or extended meaning. In a similar way, Ruscha treated other sets of places and things in booklets without words.

Another American, Sol LeWitt, devised an art from simple sets of instructions, so that large walls could be covered with drawings executed by others simply following his orders. He, too, was interested in sets, this time sets of lines of certain lengths, colors, and directions. Like Ruscha, he produced photographic booklets with sets of things, but his systematic examination of how the simplest form, a straight line, could be manipulated into complexity by multiplication generated his most notable books (plates 76–77).

The Artist's Book of the genre covered above has already had a prolific history, noteworthy in its earliest years for the presence and influence of unconventional events and materials produced by the international collaborative movement known as Fluxus, initially led by George Maciunas. Beginning in 1963 the movement's adherents created numerous printed cards, broadsides, booklets, and a miscellany of objects, often boxed together and issued as yearbooks, that comprised the

neo-Dada substance of their enterprise. While they created a loose community that was productive of new attitudes toward what could be called art as well as many of the sorts of items that would fill it (some of the contributors were Dick Higgins, Yoko Ono, Nam June Paik, Ben Vautier, Daniel Spoerri, and Wolf Vostell, who produced spaces or situations that imitated or were part of real life and incorporated some printed items), books were not notable components. There was a great deal of printing associated with Fluxus, but it was meant to be ephemeral and "at best transitional (a few years) & temporary until such time when fine art can be totally eliminated (or at least its institutional forms) and artists find other employment."[19]

When artists who had graphic-design training and experience or a literary background became attracted to the book form, or when dealers became involved with artists whose tendency was to produce such works, the appearance of artists' books became more and more frequent. Letterpress or offset printers were available everywhere to print small items if they did not require complex designs, and the advent of desktop publishing via the computer blew open the doors of opportunity to anyone who wanted to realize his or her ideas in ink on paper.

The same spirit of utter freedom from convention that motivated the Fluxus artists was personified by Robert Rauschenberg, the uniquely uninhibited American whose collages of found objects in the 1950s heralded the inception of Pop art. He frequently included photographs torn from newspapers and magazines on the flat parts of his canvases, and in 1962 began to make paintings onto which these black-and-white news photographs were screenprinted. When he began to make prints at Universal Limited Art Editions, he, like every other artist, was asked by Tatyana Grosman to make a book. Having discovered the attraction of layering image over image in printing, he designed an object consisting of five movable panels of plexiglass, each of which had been covered with lithographs, placed into an open framework that contained a sixth panel fixed on one end. This was the title page for *Shades* (1964), and engraved on the frame was the publisher's justification and dedication to the artist's son (plate 186). Except for the words *Shades* and *Rauschenberg* on the title panel, there is no text. Unlike the contemporary works of Roth, Ruscha, and, later, LeWitt, Rauschenberg's book depends on the accepted form of a book for its context, and then offers an aspect of viewing it (changing the order and directions of the "illustrations") that destroys that form. From this work of Rauschenberg's there followed considerable interest in transforming the conventional book into an object, usually by surrounding it, defacing it, or making it, like *Shades*, into a sculpture.

The printing fervor that erupted in the 1970s and 1980s was inclusive rather than exclusive. The Artist's Book, easy to acquire and look at, was meant to be inexpensive and unlimited. Special companies were established to sell and distribute them, many exhibitions took place in galleries, libraries, and museums, which offered collectors and others the opportunity to see (though rarely to read) the vast range of concepts, and the interest in making books spread exponentially. At the same time, quite a few artists turned away from the organized, structural, systematized, cerebral atmospheres of Conceptual and Minimal expressions and

returned to expressive painting. One of these so-called Neo-Expressionists, Anselm Kiefer, devoted a significant part of his creative time to producing books. The basic materials of many of his mostly unique, large volumes are photographs and woodcuts, all of which were manipulated through tearing, pasting, painting, or covering with mud and sand. His *Der Rhein* is a massive book without words, and the only one that he has produced in more than one copy (plate 162). Using the same woodcuts to form passages in his canvases, Kiefer manipulated prints as he would a brush with paint, first coating his woodblocks with uneven daubs of viscous ink, then printing them by hand and without the fastidious care of the hired professional printer. Finally, for his books, he pasted them onto paper boards, each open set of pages containing one composition. In *Der Rhein* the procession of views of the compelling river, passages energetically hacked into the wood and printed in black on white paper, convey the mystery and power contained in its ceaseless flow. The writer Peter Schjeldahl has described the book as "a work of visual art, with affinities to music and film. It is *about* 'bookness.' . . . It yields a theatrical experience having almost nothing in common with normal reading."[20] Kiefer, with his profound understanding of the power contained in the book form, has made sequences of pages into revelations without words. To come upon the same prints in a two-dimensional framework, presented in a single picture, is to have one instant impression that might initiate many others should the viewer take the time. A book demands both time and involvement, and each turn of the page is the beginning of another impression.

SUBJECTS
Fables

SOME OF THE ENCHANTMENT OF BOOKS comes from the variety of ways in which the same subject is treated by different artists. It is possible to go back to the earliest compilations of vellum manuscript sheets and find some themes or stories that are revived century after century—into the present. The types of texts that have captivated audiences for the longest time are those that have to do with the mysteries of life. Into this category fall religious texts alongside others that, through parable or observation, give similarly useful instruction in good behavior. Purely religious subjects have not been among the most inspiring to modern artists. They have, however, been used to clothe apprehensions about modern society's proclivity to doom. This manner of artistic commentary has long been succinctly displayed in the many bestiaries, fables by Aesop, and natural histories in which animals are endowed with the qualities and foibles of humans. In the last hundred years, when the sciences have seemed to stifle fantasy, the desire to observe human frailties in insects, birds, and beasts has not died.

At the end of the nineteenth century Jules Renard wrote his own version of *Histoire naturelle*, the title of a notable eighteenth-century masterpiece by Georges-Louis Leclerc, the comte de Buffon. One edition of Renard's book has remained equally notable for its incomparable lithographs of a variety of animals by Henri de

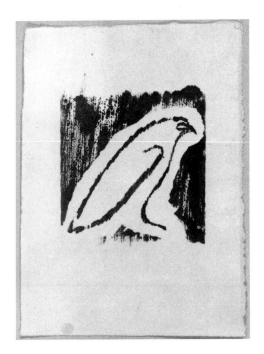

Toulouse-Lautrec (plate 49). Typical of the text is Renard's ode to pomposity in his poem about a peacock: "Surely he must be getting married to-day. It ought to have been yesterday. He was all dressed up and ready. Only the bride was missing. She never came. . . . His marriage is put off til to-morrow. And, not knowing what to do for the rest of the day, he moves toward the stairway. He climbs the steps with an official tread, as if they were temple steps. He lifts his train, burdened with all the eyes that have centered upon it. Then he goes through the whole ceremony again."[21] Toulouse-Lautrec's frustrated peacock stands on a wall that rises above the letters naming him, looking wistfully after a peahen. In every case, the drawing gives character to the text before it is possible to read Renard's wry vignettes. In contrast, the verse in Apollinaire's *Le Bestiaire*, dealing with a peacock, appears below a woodcut of the proud bird: "When he spreads his tail, this bird Who drags his plumage on the grass May grow in beauty But he also bares his ass."[22]

Le Bestiaire, ou cortège d'Orphée was Apollinaire's second contribution to the development of twentieth-century illustrated books. The idea had emerged around 1907 when Picasso cut two woodblocks, depicting an eagle (figure 18) and a chicken. Once, Vollard had pressed his painters to work in other mediums, and hoped to issue a woodcut album. This may have been the impetus for Picasso, Derain, Matisse, and Maurice de Vlaminck to make their woodcuts, which date around this year. In any case, it was Raoul Dufy, rather than Picasso, who gave this theme his best efforts. The entire title, *Le Bestiaire, ou cortège d'Orphée*, incorporates the figure of Orpheus as an intermittent conductor, leading off, with appropriate verses, sections of Dufy's full-page and extremely fanciful images of the beasts, captioned by Apollinaire's witty poems about them (plates 50–51). At first Apollinaire titled his work *La Marchande des quatre saisons, ou le bestiaire mondain*, and half of his verses were published under this title in 1908. Dufy took the lead in designing the book, which more than any other mimics block books of the fifteenth century, thereby providing an emblematic context for Apollinaire's homilies.

While there are no manuscripts that can be connected to Aesop, the fables attributed to him may exist in a manuscript as early as the fourth century B.C. Certainly in the West, among the many fables known, Aesop's seem to be the longest lasting. Medieval Europe apparently relished the idea that animals might be given specifically human traits, both virtues and vices. Aesop's fables were first printed as an ensemble in 193 woodcuts published in 1476–77 in Ulm. In the twentieth century they have continued to be nearly as popular a subject as they were in earlier centuries since the tales flexibly conformed to the humor and educational quirks of each age. In Alexander Calder's version of 1931, continuous wiry lines outline the principals of each fable, playful as his wire circus sculptures, as they act out their morality tales (plate 52). The paper upon which Calder's drawings appear contains nearly imperceptible delicate red and blue threads, forming a lively base for his lines and refreshing Sir Roger L'Estrange's 1692 version of the text.

An even shorter set of only twelve of Aesop's fables was created by Antonio Frasconi, the Uruguayan-born artist whose work in woodcut was a stimulant to many artists seeking a voice in printmaking during the 1950s. Part of the impetus

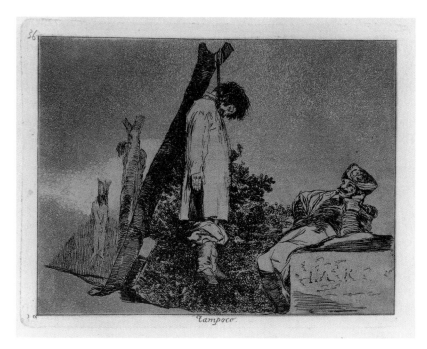

FIGURE 19: Francisco de Goya. *Not (in this case) Either* (c. 1810–20), plate 36 from *Los desastres de la guerra* by Francisco de Goya. Madrid: Real Academia de Nobles Artes de San Fernando, 1863. Etching, aquatint, engraving, and drypoint. The Museum of Modern Art, New York. Louis E. Stern Collection

shaping his work arose from his distress over social inequities: therefore, Frasconi's *12 Fables of Aesop* was given a particularly localized view, populated with typically American farmers and their aphoristic barnyard beasts (plate 53). The transposition possibilities of Aesop's tales lie, of course, in their enduring substance. The bestiaries that evolved from these stories, whether treated as individual homilies like Buffon's and Apollinaire's, or as narratives, like George Orwell's *Animal Farm* (1945), continue to capture the interest of a populace unimpressed by moralistic tales but still capable of projecting its own vision and sense of values into such stories about animals.

Conflicts

IN THIS CENTURY MANY ARTISTS HAVE FOUND themselves committed to political and social causes. Using their imagery to arouse interest in a situation, there is no doubt that they understand their power. War, a frequent occurrence in modern times, is a subject that has not been avoided by modern artists. The Dadaists and proponents of *Neue Sachlichkeit* (New Objectivity) in Germany wanted its atrocities to be broadcast for the purpose of making those who could not imagine such horrors unwilling to repeat them. Not yet completely distanced from this sort of reality by newsreels containing the specters and sounds of war, postwar audiences were presented with portfolios of images emphasizing the immoral and unspeakable. While Francisco de Goya, a century earlier, was unable to have his etchings dedicated to the disasters of war (*Los desastres de la guerra*) printed during his lifetime, they existed in printed form since 1863 and were inevitably used as examples emphasizing the gruesome and repulsive (figure 19), which formed a basis of the satiric tone of the works of German artists Otto Dix (particularly in his album of etchings without text, titled *Der Krieg*, of 1924) and

George Grosz in his several series of drawings compiled into albums and books.

Another album, this one by Georges Rouault, consisting of fifty-eight black-and-white aquatints, *Miserere*, had been planned as *Miserere et guerre*, and one discarded aquatint contains that title. Many more sets of prints for this extraordinary project (including some to be in color) were made between the end of World War I and the death of Vollard in 1939. Two prints included in the version published by Rouault in 1948, one with the word *Miserere* and the other with *Guerre*, were evidently meant to be half titles (figures 20 and 21). Images of the Passion of Christ are intermixed with others that refer to the participants and conditions of World War I. The large images on paper over two feet on one side, developed by the artist into prints from paintings he made for this purpose, evolved into awesome power. Rouault's intensely religious motivation, which imbued all his works, from portraits to landscapes, from mourning madonnas to Veronica's veil, endowed them with a presence that would seem entirely outside that of the modern were it not for the satirical vein in his work. The titles he gave his *Miserere* plates, for example, "Who Does Not Paint Himself a Face?" (a self-portrait) and "The Nobler the Heart, the Less Stiff the Collar" (a soldier), have the poetry and power of Goya's *Los desastres de la guerra* and transcend the German inclination to emphasize the gory details of reality (plates 56–57).

Rouault's *Miserere* is rooted in the history of the artist's book because of its overlay of literary commentary through captions. Despite its unwieldy size, its single-plate imagery illustrates the artist's chosen theme by reaffirming the sacred in the midst of the profane. Coincidental with Rouault's early thoughts about creating a group of works about the tragedy of war and suffering, Natalie Gontcharova in Russia produced an album of lithographs titled *Vojna* (*War*) in 1914. The war and the revolutionary inclinations in Russia were synthesized in the writing of Kruchenykh and the artistic compositions of his wife, Olga Rozanova, in their book

FIGURE 20: Georges Rouault. *Have Mercy upon Me, Oh God, According to Thy Loving Kindness* (1923), plate 1 from *Miserere* by Georges Rouault. Paris: Edition de L'Etoile Filante, 1948. Aquatint over photogravure. The Museum of Modern Art, New York. Louis E. Stern Collection

FIGURE 21: Georges Rouault. *They Have Ruined Even the Ruins* (1926), plate 34 from *Miserere* by Georges Rouault. Paris: Edition de L'Etoile Filante, 1948. Aquatint over photogravure. The Museum of Modern Art, New York. Louis E. Stern Collection

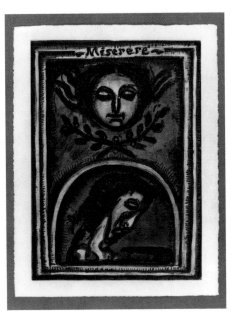

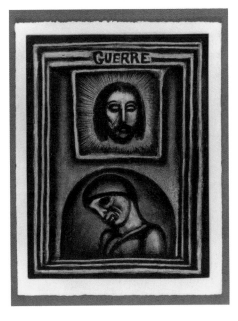

titled *Vojna* of 1916 (plates 54–55). Her nine woodcuts, as well as a title-page collage and one page on which woodcuts and colored paper are arranged and pasted together, depict scenes of fighting, allegorical figures, and, in the combined collage, an execution, a falling figure, an airplane, and daggers of bright color, all in a conflicting dynamism. The transition from Cubism to Constructivism and Suprematism takes a significant step in this book, which, nevertheless, retains a considerable amount of recognizable figuration. As with the work of Kandinsky, the *lubok*, or folk-art print, is an essential part of Russian illustration, so while the direction of Rozanova's work in *Vojna* was toward the abstract, with its use of excited aerial forms, the unsophisticated "roots" of the Russian peasant were not yet ready to be discarded.

Literature about the war to end all wars was profuse, and artists provided sketches that gave added dimension to the expanding lore of survival. Segonzac provided his first illustrations to what was considered the foremost French literary work based on World War I, Roland Dorgelès's *Les Croix de bois* of 1921 (plate 58), issued two years after the first edition was runner-up to Marcel Proust's *A la recherche du temps perdu* for France's most prestigious prize for literature. Dorgelès, who was the popular choice for the Prix Goncourt, was understandably bitter, writing that this monstrous farce had to come to something, so that by having his text illustrated by Segonzac, he "united my name with that of the greatest witness of our war."[23] Segonzac had been in the trenches, and his experiences put down in the sketchiness of drypoints more than adequately convey the transitory nature of such a life, from the boredom of waiting to the terror of attack. At the same time, Segonzac's unemotional work echoes the sangfroid of the French, who, in the aftermath of winning a war, went on to a decade of careless frivolity. Segonzac's drypoints subsequently embellished lighter subjects, such as *Bubu de Montparnasse* and *Tableau de la boxe*.

The war in Spain in the 1930s cast its shadow over the politically concerned in both Europe and America. Idealists in many areas of the arts were involved directly in fighting for or in helping the Republican cause. Two sets of prints directly concerned this crisis: the first was Picasso's pair of etched "comic strips," *Dream and Lie of Franco* (1937), which he published in a very large edition to aid the anti-Fascist cause (plates 60–61). His unsavory depiction of Franco is more dreadful in its confrontation with the beauteous face personifying the trampled people of Spain. Allegory is an important device for making a strongly felt opinion even stronger, in that it allows the imagination of the viewer or reader to come to even further conclusions about what is implied or meant. Picasso was the master of this, particularly when he directed his raucous wit against serious enemies.

The second work made to aid Spain consisted of two small portfolios of prints and was the product of a group of sympathetic artists, grouped together by Stanley William Hayter. The first portfolio was *Solidarité* by Paul Eluard (1938); *Fraternity* by Stephen Spender (1939) was the second (plate 59). In the latter, a French translation by Louis Aragon was appended; besides Hayter's contribution, there were engravings by a group of artists living in England and Paris, including John Buckland-Wright, Dalla Husband, Vasily Kandinsky, and Joan Miró. All the

prints were made in Hayter's Atelier 17 in Paris, shortly before World War II forced him to move to New York, where he relocated his workshop. Diverse in style, although Surrealism pervaded most of the black-and-white prints, *Fraternity* was one of a myriad of group publications whose purpose was the raising of money for a cause. Spender's poem was stirring; the prints were somewhat relevant and, for the most part, good examples of their makers' work. At the close of the 1930s, *Fraternity* signaled the end of an era. Its publisher established his workshop in New York in 1940: drawing both French refugees and American painters together, it became a catalyst for the relocation of the center of art from Paris to New York in the second half of this century.

At the halfway point in the century covered here, all creative life in Europe was interrupted by war. The catastrophic rifts in the social fabric caused by World War I and the Russian Revolution were minor in comparison with those of the next world war. There were economic and social upheavals after the Great War, and the response of artists to the horrors of war was at first the belligerence of anger and subsequently a retreat into the subconscious. The realization that mankind could destroy itself, which accompanied the end of World War II, was previously inconceivable; one reaction in art was that many artists sought in ancient sources and pure abstraction the consolations of the inner spirit.

It was therefore not surprising to find religious images in Jacques Villon's color etchings for André Frénaud's *Poèmes de Brandebourg* of 1947 (plate 62). The series of color etchings of the Magi relate to two poems in Frénaud's anthology of works created just before and during the Nazi occupation. In retelling the tale of the Three Kings, Frénaud wrote that they arrived too late, the Massacre of the Innocents had begun. Yet by following the star they continued to hope that the Savior of mankind existed, as those prisoners of the Germans to whom Frénaud dedicated his poems must have done.

In allegory or in Picasso's medieval brackets and flourishes in blood red that surround Pierre Reverdy's late poem, *Le Chant des morts* (1948), the subject was not too difficult to comprehend, even though Picasso's work was stringently nonfigurative (plate 63). During the 1940s he used similar markings to form the structures of nearly abstract paintings, such as *The Kitchen* (1948), in the collection of The Museum of Modern Art, and to accentuate straight and angular passages in his figurative paintings. These two books do not comment on war as those after World War I did. As a subject, war had become too horrible. The many publications associated with the Vietnam and Algerian wars and the student revolution were rarely more than posters and broadsides, and there seemed to be no sustained memory of these events that inspired afterward or that begged for an artist's viewpoint.

The word *war* became "mediaized"; society turned to making "war" on those things that did it harm, such as crime and drugs. In this context, the documentary approach of Phillip Greer's *Flash–November 22, 1963* (1968), with screenprints by Andy Warhol, makes this situation entirely vivid (plate 194). The images, taken from the television broadcast of the assassination of President John F. Kennedy and transformed by the artist by color changes and emphasis on the poor

definition of the video medium, are combined with text that appears like the teletype report of the events. Communications theoretician Marshall McLuhan identified the television image as cool, that is, not involving viewers' imaginations sufficiently to heat them up. Warhol's mastery of cool imagery made of *Flash* the definitive book of the horrible event dissembled.

The advent in the 1970s of Neo-Expressionist facture and imagery reintroduced the subjects, mainly disguised or allegorized, of universal disaster. After almost fifty years, the diffusion of memories of the Holocaust of the 1940s and the continued questioning of its reality found the imagery of recollection in examples of the Artist's Book by Christian Boltanski and Annette Lemieux. Stories that paralleled the most wrenching upheavals of peoples' lives, beginning with the Revelation of Saint John—The Apocalypse—were inevitable vehicles for this approach. At the moment of some of the heaviest Nazi bombing raids in 1941 and the opening of the Eastern Front, while he was in precarious exile in the Netherlands, Max Beckmann received a commission to make transfer drawings for lithographs to accompany this text (incredibly, published in Nazi Germany in 1943). Arching over the details of the saint's vision of the destruction and redemption of mankind is Beckmann's own iconography, interpretive, yet in his unique language (plate 66). A work completed during the incertitudes of survival in a war is infinitely different from one created in peace. Forty years later, Jim Dine's *The Apocalypse, The Revelation of Saint John the Divine* (1982) converted the images of skulls, hands, horses, and other motifs that make up the traditional illustrations of the text into jagged woodcuts (plate 67). Created not in the brash rebelliousness of the 1960s but in the burgeoning moral dilemma of the 1980s, Dine's imagery has been dramatically augmented as he has capitalized on the unlimited capacity of the Apocalypse to be relevant in times of disquiet and skepticism.

Classical and Other Tales

If the Apocalypse is an eternal vehicle for the ultimate journey of the soul, other classic literature has been extremely useful in giving the artist respite from too many forays into the unknown. A few instances will suffice, beyond what has already been stated, about the propensity of publishers to pair artists with uncontroversial texts, to demonstrate the degrees to which such writings can support artistic interpretation in the twentieth century. Understandably, the revival of interest in ancient Greece that accompanied Sir Arthur John Evans's excavations and discoveries in Crete set the stage for Braque's nearly interminable work (begun in 1932; published in 1955) on *Théogonie*, by the Greek poet Hesiod. The seventeen etchings that he first made of that number of gods were left in the printer's shop when their ever hopeful publisher, Vollard, died in 1939. At the time that Braque made the etchings he was creating sculptures in the same archaic Greek style. Far removed from his Cubist period, Braque used an endless, looping line to define his Athenas and Gaias, surrounding their light figures with a framework of sketches, doodles, and other fantasies, known as remarques (figure 22). These were to be dispensed with when the plates were finally placed within the context of a book in the

FIGURE 22: Georges Braque. Plate 15 from *Théogonie* by Hesiod. 1932. Etching, with remarques. Vallier 20, O. The Museum of Modern Art, New York. Louis E. Stern Collection

FIGURE 23: Henri Matisse. Maquette for *Pasiphaé, chant de Minos (Les Crétois)* by Henry de Montherlant. 1944. Letters and designs in pencil on the 1938 edition of the text, published by Grasset, Paris. Bibliothèque Nationale de France, Département des Livres Imprimés

1950s (plate 40). At that point, Braque had to return to the same subjects to complete the book, providing in the same mode a frontispiece and cover. His reverting to this older style after twenty years had inevitable repercussions in his concurrent choice of subjects and their execution in both painting and prints.

Unlike Braque, who literally went through two classic periods, Matisse's association with the ancient past was through the conduits of James Joyce and Henry de Montherlant. When he was asked by the Limited Editions Club in 1934 to illustrate a new edition of Joyce's *Ulysses* (a text that had been banned in America from 1920 to 1933), he prepared a series of drawings and soft-ground etchings that most have agreed were based on Homer's work, not Joyce's. Each print is essentially linear, with soft shading along each contour, and the compositions are tightly fitted into rectangular borders, very similar to Picasso's compositions for *Les Métamorphoses*, by the Roman poet Ovid, published three years earlier (plate 39). Their effect of slight relief, however, is a new departure for this type of figurative representation, which the artist usually rendered in simple lines, emphasizing flatness. In another book dedicated to a story from antiquity, this time de Montherlant's retelling of the tale of Pasiphaë, *Pasiphaé, chant de Minos (Les Crétois)* of 1944, Matisse definitely had an interest in the text (figure 23; plate 42). From the time that he took up the first edition of the book and sketched into it images for those passages he found most inspiring to the long task of cutting linoleum blocks for both the full-page prints as well as for the initials and borders that would decorate the pages of text, he dedicated himself to a broadening visual vocabulary. To the female heads, nudes, and foliage of which he was the master, were added Minoan bulls and other Cretan figures appropriate to the tale. In all, Matisse prepared 121 linoleum cuts for the black-and-white plates and ornaments, and well over 150 initials and borders that were to be printed in red. About half of these cuts were used, but the discarded blocks were printed posthumously and have provided considerable insight into Matisse's method of realizing his ideal form—not spontaneously, but with inexhaustible dedication. Pasiphaë, the queen of Minos who gave birth to the Minotaur after her encounter with a god in the form of a bull, as retold in theatrical form by a modern French author, immediately stimulated Matisse, and he never replaced the images that he had originally sketched with others.

Four years after Matisse's *Pasiphaé*, Marc Chagall's first color lithographs appeared in *Four Tales from the Arabian Nights* (1948), in the unexpurgated version of the stories as told by Sir Richard Francis Burton in 1885–88. In fact, only a few lines of each story were used to introduce Chagall's illustrations (plates 47–48). For an artist who had already etched a considerable number of plates for the Bible as well as for classics by Nikolai Gogol and Jean de La Fontaine, the challenge of another famous text was merely one of imagining an ideal context. That Chagall chose to find a way to make his illustrations have the appearance of a magic chest of jewels from which the clever Scheherazade fabricated her bewitching tales was a major decision in his career as a graphic artist. Since the late nineteenth century there had not been much interest in color lithography, and only Léger and Dufy in France and Emil Nolde in Germany had produced interesting work in the medium.

With the stimulus of a colorful subject and the availability of a printer who would translate his gouaches into color prints, Chagall was prepared to pursue the adornment of yet another old-fashioned text. Chagall's additions to Albert Carman's color separations provided accents that reinstated his authority over the final state of the lithographs. Chagall's *Four Tales from the Arabian Nights*, Derain's gallant attack on Rabelais's *Pantagruel*, and Matisse's *Jazz* were three formidable examples of how the now traditional artist's book could be refreshed.

While classical subjects have remained stimuli for illustration, they have joined a field of prodigious diversity that characterizes the subject matter of recent artists' books. Once the French style of the *livre d'artiste* was assimilated by American publishers, tried-and-true texts were often suggested by them to American artists. Robert Motherwell, whose two artist's books with texts by contemporary writers were made with his print publishers, created as his last book, in 1988, James Joyce's *Ulysses*, commissioned by Arion Press in California. Arion was also to publish *Poems* by William Butler Yeats, the only book illustrated by the California painter Richard Diebenkorn, issued in 1990, and other, even older, texts embellished by artists such as Shusaku Arakawa and John Baldessari. In many more instances, however, publishers have brought writers and artists together, either to collaborate directly, as O'Hara and Rivers, or Alain Robbe-Grillet and Robert Rauschenberg, did or to mutually agree on a previously written text, as Samuel Beckett and Jasper Johns did. In most cases, artists chose the text if the publisher wanted to work with them, and those texts were most likely to be pertinent to the artist's work, as was Rafael Alberti's ode to color, *A la pintura*, to Motherwell in 1972, or the philosopher Ludwig Wittgenstein's *On Certainty/Uber Gewissheit*, about "counting alternatives," to Mel Bochner in 1991 (plates 31 and 160).

The audacity of artists to conceive of illustrating the works of philosophers is only a part of the diversification of subject matter in recent artists' books. The Conceptual artists were theoreticians and the Minimal artists were process-oriented, both attributes of the philosopher. Abstract imagery was equally disposed to abstract thought, so the Spanish abstract sculptor Eduardo Chillida parried Martin Heidegger's treatise *Die Kunst und der Raum/L'Art et l'espace* of 1969 (plate 150); one member of the German Gruppe Zero, Günther Uecker, nailed down a variety of theoretical texts on light in *Vom Licht* of 1973 (plate 149); and in the field of linguistics, the Italian painter Enrico Baj tilted with Raymond Queneau's *Meccano, ou l'analyse matricielle du langage* of 1966 (plate 185), as adeptly as Bochner did with Wittgenstein. It might be surmised that Uecker and Baj, by using actual implements like nails and gears to create the embossed and printed imagery, applied a "nuts and bolts" commentary to the texts.

MAKING BOOKS

THE APPEARANCE OF ARTISTS' BOOKS depends upon the level of independence and control of each participant. As has already been noted, Ambroise Vollard's books took on a familiar look over time. They were always comparatively

large in format, particularly those prepared in the 1920s, and wide margins surrounded both text and plates. Vollard and his sometime editor, Maurice Heine (an expert on the marquis de Sade), supervised the preparation of each element, undoubtedly making arrangements with each party. Artists usually made their prints as single plates that could be slipped between folios. In that way, they did not have to be involved in the layout of each page. Early on, artists were asked to prepare drawings, as well, for insertion at the beginning and end of chapters. These could be reduced or enlarged when they were made into wood engravings, depending upon the space available. Preparation of these blocks, which were type-high and would be set up with the type for printing, was given to the superb artisan Georges Aubert. Certain typefaces and papers were preferred by Vollard, and the paper wrappers of most books were not elaborately decorated, specifically because collectors of expensive volumes preferred to have their books bound in leather by a fine French binder. Often the book was acquired because it offered an occasion to commission a binding to be added to a library of bindings. The interior of the book was meant to inspire the binder, and the collector's concern was that the result would be distinctive. The publications of Skira followed this tradition, and it is extremely unusual to find a French artist's book issued with a decorated cover or binding until after World War II.

Artists were given more control over the appearance of smaller books, such as Daniel-Henry Kahnweiler's early publications. As Apollinaire's *L'Enchanteur pourrissant* was the first, it was designed to have vellum covers, similar to those ancient books admired by the writer. Longer texts, like Max Jacob's three volumes of the mysterious adventures of Victor Matorel, were simply designed to resemble current popular novels, and in two of them Picasso's Cubist etchings were single plates inserted, by means of tabs, into the texts. They were sewn together between plain, typographical paper covers. The seemingly casual manner of designing books with no overall form that was recognizably the publisher's was actually Kahnweiler's way of encouraging artists to make books. Although in 1921 five of the six thin books he published were identical in size, several of them and a few later books, for example, Henri Laurens's book *Les Pélican* and others by Fernand Léger, Juan Gris, and André Masson, had prints on their covers relating to those inside. The diversity of shape, size, paper, and typography resulted from Kahnweiler's own taste and priorities (Kahnweiler used only four printers for the twenty-eight books he published between 1911 and 1939), but undoubtedly reflected the involvement of the artist in the overall design. It was not unusual to have images on covers of pamphlets and thin books (as defined in the trade, a *book* has at least forty-eight pages), since they were not considered valuable investments that might require full leather bindings.

How much input each artist had in these and later books is difficult to ascertain when the artist is not known for graphic design as well. In *La Prose du Transsibérien et de la petite Jehanne de France* (1913), given its colorful setting on a vertical foldout format by Sonia Delaunay-Terk, there can be no doubt that the artist who had designed bookbindings and other decorative objects, as well as the concerned

author Blaise Cendrars, were responsible for its appearance (plates 118–119). They called it the first simultaneous book, that is, an object unified by the simultaneity of opposites coming together. Cendrars organized the printing, with his poem reading down one side in a variety of types and Delaunay-Terk's colored arcs and blocks on the other, printed in pochoir (stencil), extending into and linking the verses. A map of the route of the Trans-Siberian Railway heads the right half of the sheet, and the title page information heads the left, so that when the entire folding sheet is closed, it appears on the top. Cendrars's longtime Polish girlfriend provided the money for printing 150 copies (fewer seem to have been completed) and Editions des Hommes Nouveaux is given as the publisher, a suitable name for a "poet-typographer and a typographer-artist."[24]

Cendrars was the author of another text that reflected his and many artists' romance with film. *La Fin du monde, filmée par l'ange N.D.*, which he produced with Fernand Léger in 1919 (plates 120–121), was a somewhat different enterprise from his work with Delaunay-Terk. Instead of a simultaneous creation of type and image, Léger embraced Cendrars's words, attempting through the Cubist idiom to simulate the filmic procession of moving forms. The pictorial matter is made from line-block reproductions of drawings made by Léger to fit into the text and colorful abstract images printed, like Delaunay-Terk's, by pochoir. Interspersed throughout the text, set in a decorative type similar to that used for titles in silent films, are the bright pochoirs consisting of letters or geometric forms printed without black, contrasting with the predominantly black-and-white images on the text pages.

Malerei, Photographie, Film (1925) by László Moholy-Nagy, one of the books produced by the Bauhaus, is another example in which image and design are controlled by the image-maker (figure 24; plate 72). He has chosen the order of his pictures, in this case photographs, as well as created a unique setting for his text and

FIGURE 24: László Moholy-Nagy. *Malerei, Photographie, Film* by László Moholy-Nagy. Munich: Albert Langen Verlag, 1925. Relief halftone reproductions of photographs. The Museum of Modern Art Library, New York

another selection of images. More possible when the artist is the author, and when the subject is discourse, books such as this one may conjoin references, diagrams, and other instructive facts and directions. In the section on film Moholy-Nagy designed narrow columns outlined in black for the text and photographs, in imitation of strips of film. The section on photography consists mainly of his own images on facing pages. Besides its appearance as an album of works in the medium, the section conveys—through the images and their juxtaposition—ideas about various aesthetic problems. For instance, the structure of movement can be examined in paired photographs of a phonograph record and a time-lapse night scene in which the movement of headlights is recorded. The typography, which is so much a part of the personality of Moholy-Nagy's book, was completely changed for the second edition, which was issued by another publisher.

When it is impossible to observe in the actual publication the variety of problems encountered in the process of its creation or the frequently unexpected means by which they were solved, it is occasionally possible to uncover them in memoirs, letters, and recorded conversations. There are letters between Matisse and Tériade or his assistant, Angèle Lamotte, that clearly record the determined attempts to translate Matisse's collages for *Jazz* into the printed form for which they were constructed. Tériade enthusiastically relayed to the artist the positive virtues of a printing method that replaced the imperfect four-color process, one that could be adapted to print solid, individual colors. But the method—stereotypes, or line blocks—unfortunately was not able to produce the brilliance of tone that made the collages so dazzling and seductive. Through trial and error, it was finally decided to create the prints with brush and stencil, using the same gouache colors as those painted on the papers from which the collages were made. The artist contributed in every sense to the format of the book, from his insistence on the perfection of the color and the appearance of his initials on the cover to the arabesques in his handwritten text. Matisse's attention to his books has been well documented, by others and by himself, in his article, "How I Made My Books," in 1946.[25]

Foirades/Fizzles (1976) by Samuel Beckett was Jasper Johns's first attempt at matching his images with a text in a book (plates 173–174). His work in prints has been known for its inventiveness as well as its important place in the artist's oeuvre. When Johns first began to make prints at Universal Limited Art Editions in 1960, Tatyana Grosman asked him to create a book. As with *Stones*, there were no restrictions on format, and Johns's project, a series of ten lithographs sequentially displaying the numbers zero to nine and housed in a wood box with a single-page introduction by art historian Robert Rosenblum was his response. That set of prints, titled *0–9* (1963), extended the set of paintings and drawings devoted to stenciled number forms that the artist had begun in the 1950s.

Another of Johns's projects at U.L.A.E. was to be a set of lithographs incorporating some existing poetry of Frank O'Hara. Two compositions were completed before the poet's tragic death in 1966. When Johns responded to Vera Russell's idea for a book to be published by Petersburg Press, the artist was in the process of completing sets of lithographs based on an imposing four-panel painting (*Untitled*

1972) at Gemini G.E.L. in Los Angeles. The content of the four panels, a compendium of motifs, some new, like the sets of hatchings in the first panel, and others already employed in previous paintings, was treated in a number of ingenious ways in the prints. In 1975, when Johns had completed the second set of prints after *Untitled 1972*, he began to work on his book. Samuel Beckett had been asked for a new text, but finally offered an unpublished story. Johns's reaction to the text, printed in both French and English, was to organize elements from *Untitled 1972* in the form of etchings dispersed throughout the book, adding five etchings of his stencil-style numbers to define the sections of the book. The fourth panel of *Untitled 1972* included casts of body parts, and each of these objects is translated into one or more full-page print, which, at the outset of the designing of the book, was to have had a streak of ink extending from it across the text page to its right. Five double-page prints, usually following plates of the individual body parts, would have acted as connectors for these streaked pages had they not been abandoned for technical reasons. Because it does not relate formally to *Untitled 1972*, one of the double-page prints, which lists the names of the body parts as well as the things like socks and floor appended to them in both languages, is particularly noteworthy. It is a list that could be mistaken for a table of contents of the visual elements in the book were it not for the recombining of the words, forward and backward, which enmeshes the words in their own forms and makes them nearly illegible.

A page of sketches reveals the artist's involvement in the shape of the book, working out the accordion folds and corresponding position of endpapers that give the book its oriental form (figure 25). The only color in the book appears in the endpapers, which are etchings of hatchings printed in secondary colors and another pattern that repeats the motifs of the second and third panels of *Untitled 1972*, popularly called flagstones for recognition purposes, printed in red, black, and cream. A linen box housing the paper-covered book is lined in a color lithograph of hatchings. Inserted at the side of the box is a purple silk tape ending in a tassel meant to facilitate removal of the book, its appearance reaffirming the oriental format. In the hands of the Parisian master printer Aldo Crommelynck, Johns's etchings facing or sharing space with texts have acquired a deft quality of carrying on a dialogue with the surrounding typography. The parts of the book entrusted to typographer (Fequet et Baudier, Paris) and binder (Rudolf Rieser, Cologne) benefited from the supervision of Russell, the editor of the publication and the muse behind the entire project.

Naming the professionals and their contributions to a book on the page known as the *colophon* (the last words in a book), which also might contain information regarding the size and makeup of the edition, is a long tradition of book printing. Supporting the printers and binders whose names appear are always many more whose names never get published, though occasionally they succeed their supervisors or found their own firms. Authors rarely have business with most of these people, unless the printer is both editor of the text and publisher. In many cases, artists who actively have entered into the planning and realization of books for which they have provided both images and design, often have known, relied

FIGURE 25: Jasper Johns. Sheet of sketches for *Foirades/Fizzles* (detail). c. 1975. Pencil with pen and brush and ink. Collection the artist

upon, and respected these book artisans. When Apollinaire referred to an Aldine book as a model that he felt he and Derain had profitably followed, he was submitting for examination a standard of quality in presenting words and images on a page that the Aldine *Hypnerotomachia Polifili* historically represented. Manutius was the first to put an identifying device or logo in his books, thereby not only taking responsibility for his product but also distinguishing it from other, perhaps inferior or imitative, publications. Before prints were hand-signed, artists frequently presented their initials in a framework or calligraphic style that was easily identified. There have been few modern publishers who have had pictorial devices (Derain's device for Kahnweiler and Maillol's for Cranach Presse are exceptional; figure 26) but most have had distinctive typographical styles for their names. These styles are often the creations of graphic and type designers, and their use of a specific type not only reflects the preferences of the publishers but also their own. Part of the reason for this is that typographers and printers who set type for luxurious books specialize in certain typefaces or fonts. The heavy black of Rouault's books, for example, was printed from Plantin type, which Henri Jourde's printing firm, Aux Deux Ours, had available. Jourde's type had to balance the weight of the predominantly black wood engravings that appeared in Rouault's and Redon's books for Vollard. While the decision to use one type or another is made by designers who answer to the publisher (and possibly the artist), it is improbable that the refined Garamond italics that were used in Bonnard's *Parallèlement* and Segonzac's *Les Géorgiques* would be found in Jourde's (while the Imprimerie Nationale, to which Vollard returned many times after his contretemps regarding *Parallèlement*, was a major repository of fine, classical types of this sort). After each war there were crises regarding type due to the lack of metal, and the persistence with which private presses had new typefaces designed became less and less relevant in an age when hand-typesetting soon became an archaic practice. The publishers of artists' books of the French variety, however, continued to use the distinguished old types and occasionally turned to some of the newer, usually rather eccentric fonts. Books such as those of the Russian avant-garde and the Conceptual artists were produced with the least amount of interest in refined typography, with handwritten or typewritten mimeographed pages, rubber-stamped letters and words, or any of the many sorts of photo-offset processes available commercially. In the face of the proliferation of electronic and computer-generated printed material, it is not difficult to appreciate the devotion some of the contemporary printer-publishers have to type and letterpress.

The type layout gives a book its continuity of character, and the title page ordinarily announces the style it will follow. A publishing house's established style, however, is frequently used to identify its imprint or a series of titles, so that its standard title page design might not seem appropriate to the subject and artistic content of a book. For instance, once Derain's design for Kahnweiler's vignette was given a place on the title pages of his publications, all subsequent title pages had to incorporate it, thereby somewhat limiting the designer in choices of surrounding type. Title pages occasionally become the territory of the artist involved in the book, who

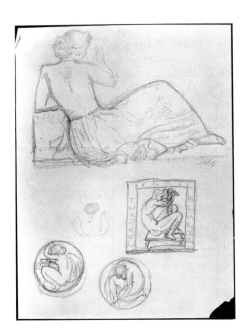

FIGURE 26: Aristide Maillol. Sketches, including publisher's vignette, for final page of *The Eclogues* by Virgil. c. 1912–25. Pencil. Bequest of Philip Hofer, Department of Printing & Graphic Arts, Houghton Library, Harvard University

might design a vignette to appear below the title. The past century was not a fertile one for the kind of highly decorated title page that made the opening of a new book a miraculous experience in earlier times. William Morris's revivalism necessitated ornate title pages, while Aubrey Beardsley's aestheticism was previewed on the sensuous illustration that bordered the title of his *Salome, a Tragedy in One Act*. Few artists, however, felt that the title page itself was their province, preferring their images as frontispieces, standing opposite the type-filled title. When artists did become involved in the design of their books, the resulting nonimage elements were striking, as in Oskar Kokoschka's *Die träumenden Knaben*, El Lissitzky's *About Two Squares*, and František Kupka's *Quatre histoires de blanc et noir* (plate 68).

Beyond the title page of those books containing individual prints, the artists of several books also produced smaller designs, often decorative elements in a style and medium coherent with the larger prints. Vignettes (head- or tailpieces that introduced or closed sections of the text), running borders at the tops and/or bottoms of successive pages, and initials at the beginning of sections or stanzas, were occasionally artists' contributions to the design of their books. In Henry van de Velde's *Also sprach Zarathustra*, where the design of title page and text is entirely his creation, the type style, initials, and decorative inserts within the lines of type join together to present the words in such an elegant manner as to influence the understanding of their meaning (plate 34). Matisse's use, in his *Pasiphaé, chant de Minos (Les Crétois)*, of red initials and bands, each of which he cut specially to balance the black type and white-on-black full-page prints, was partly to emulate the illuminated initials in medieval manuscripts and early printed books, but also to enliven the pages. His relentless recutting of these elements and his instructions as to how the bands should be printed and in what red so as not to disturb the harmony of the black-and-white pages are documented in the several maquettes of this beautiful book. Braque, too, made etched initials and repeated mid-line designs for his *Milarepa* as integral parts of the pages that faced single-page plates of birds (plate 46). Like van de Velde's devices, Braque's interruptions of the rounded Della Robbia type stressed his interpretation of the text. Again, balance between the decorative elements, type, and images was achieved by the artist's sophisticated sense of composition. Another way artists have improved the typographical substance of their pages is by creating a continuous pattern or image that associates a part of the text, a chapter, for instance, with the artistic concept. In Francesco Clemente's *The Departure of the Argonaut* a set of formal representations of signal flags of the sort used on ships lines up in the side margins of every other page in the chapter devoted to the author's first view of the harbor of Taranto and the troop ship that would take him to battle (the flags spell *Savinio*). In another instance, Clemente has drawn knots, which fall in the marginal space between facing pages (the gutter), different for each opening, and which establish an additional running theme within the text.

The printers of imagery, the lithographers and etchers in particular, have been fundamental to the retention of old methods, but in many ways this has been considered by the artists whose work they enable as both a blessing and a challenge. Auguste Clot, Fernand Mourlot, and Roger Lacourière, all Parisian printers of the

famous images of Redon, Matisse, Chagall, and Picasso, among many, were part of a tradition that continues, not only in France but all over Europe, in America, and even in Japan and Israel. The earliest books to contain both prints and type (the first was *Der Edelstein* by Ulrich Boner, printed in 1461) combined the arts of type and block making. Although different artisans prepared them, they were both relief mediums that could be printed together. Once the medium used for the image could not be printed by the same means as type, a different technique of printing on a different press was required. This separation became more complicated when the technique that prepared the matrix required one skill and the printing of it another. At various times in the history of printmaking, the artist-creator of the image prepared the matrix alone (a common practice in the current century), that is, drawing the lithograph on stones or plates, engraving and etching copper plates, and so on. Still, the specialists in the printing of these mediums often worked closely with preparators of lithographs and etchings, to the extent that they transferred the artists' images to lithographic stones or used the various etching techniques to create lines and tones that the artists wanted. They also went beyond this assisting role, creating separate stones and plates for colors (when the artist was technically unskilled or unwilling), and even producing entire images on stones or plates, following the artists' drawn plans.

In the preparation of books, many occasions present themselves for the skilled printmaker to edit if not create the artist's work, usually because of changes in format during the process of making such a complicated object. Also, since the nineteenth century, photographic techniques have made it possible to produce printing matrices that merely reproduce images. These techniques are reliable tools for artists and artisans to use in making screenprints, for example, ones that include photographs (such as those by Warhol), or in initiating a composition that would be worked on further by hand (such as those by Rouault). Part of so many painters' fascination with printmaking in the past thirty years has come from the seemingly endless possibilities of combining late twentieth-century technology with traditional techniques. And this is only in the area of hand printing, where at least one pair of hands is needed to ink the matrix, a few others to prepare the press and paper, and another to actually print. Books that artists design but that do not include hand printing are far more numerous: such artists, for the most part photographers or makers of artists' books, essentially provide images (drawn, painted, or photographed) and layouts (which they may prepare or have prepared) to printers whose modicum of creative input may consist of what papers and inks they are prepared to provide. Artists who choose to use computer-graphic programs (desktop publishing) do not have to rely upon anyone but themselves.

Once the building blocks of the individual pages of a book have been amassed—the type, images, and layout that unify them—the choice of paper and binding functions as the last, and ultimately defining, decision regarding the appearance of the book. Books that are essentially photographic normally are printed on a coated paper. Because producing books with photographic images is usually accomplished on high-speed presses, the paper must be compatible with

this method, so its primary characteristics are homogeneity, smoothness, and a propensity to lie flat. Because it is cut and trimmed after printing, its edges are similarly smooth and flat. The papers for books containing lithographs and etchings, however, are normally called handmade, although they may be produced by machines using methods that simulate hand-making. In the French style of illustrated book, Arches and Van Gelder are two commonly used papers, both produced by manufacturers who have been making paper in France and the Netherlands since the eighteenth century. Both papers are made from nonwood materials, like linen or cotton rags, and are produced in varying tones from white to cream. Their texture is derived from the interlacing of fibers, as wet pulp made from these materials is drained on a screen (with a parallel pattern of wires, such screens create *laid* paper, without the pattern, they create *wove* paper). The wet paper is pressed between felt pads to drain off excess water, and in some cases is flattened between metal rollers. Certain printing methods prefer more texture than others, so thicker, textured paper is more frequently used for woodcuts and deeply etched plates, while flatter paper (for example, Arches) is preferred for lithographs. The choice, as mentioned, must be made not only for appearance but for practicality, and if text is included on pages containing intaglio prints, the paper must be strong enough to be printed twice. The silken paper made in Japan from mulberry or *gampi* pulp as well as the truly handmade rag paper from Auvergne were favorite papers in the publications of Iliazd, who used Auvergne paper for every printing technique in his *Poésie de mots inconnus*.

When the French style is followed, it is still acceptable to leave a book unbound. Iliazd, who was both publisher and creative designer, made covers for his books in the same vellum that appealed to Apollinaire for its ancient origins. However, Iliazd had Picasso make an etching for the vellum cover of his *Pismo/Escrito* (1948), while, twenty-three years later, Henry Moore decorated the entire vellum cover of *Elephant Skull* with an etching that imitated the cracks in the bone of the magnificent relic that inspired him. These covers, which enclosed loose folded pages, were meant to deter future owners from binding the books. Although Iliazd's vellum was loose and could have been the skin of a bound book, he still exacted control when he included a separate wrapper to enclose the folded pages of *Poésie de mots inconnus*, commanding the binder not to cut the pages. In recent years fine books that include prints, like *Foirades/Fizzles*, have been bound in ways that also would prevent the collector from either taking them apart or rebinding them.

The tradition of French-style books included the assumption that the buyer would commission a distinctive (usually fine leather) binding for each addition to his or her collection. In Paris, Paul Bonat was known for his Surrealist bindings, while Rose Adler, Henri Creuzevault, and Pierre Legrain were some of the most distinguished artisans to bind these costly books. They created fresh designs inspired by a book's artistic and literary content, executing them in colored leather inlays and producing covers that were occasionally more interesting than the material they contained. Such bindings, like frames for paintings or pedestals for sculpture, have always been created after the completion of the works

and have only a complementary relationship to the process initiated by the artist, author, or publisher.

There are, however, other publishers' bindings that are meant to reveal on the outside of the book the content within. When the pages of books are stitched, stapled, or glued, the paper covers usually include more than just the title. As in popular paperbacks, an image attracts interest in these meant-to-be-popular books, and where part of the content is an artist's work, the cover is also. Nearly all the books by the Russians Malevich, Rozanova, and El Lissitzky, as well as less pretentious French works like Léger's *La Fin du monde*, have illustrated covers, as do other artists' books destined for mass distribution. In addition, during the past forty-five years more artists have taken an interest in the exteriors of their books, so that while they may not be sewn into a fine binding, the paper covers of books by Henri Michaux, Jean Dubuffet, Pierre Alechinsky, Nicolas de Staël, and Wifredo Lam, all published in Paris, contain important lithographic, etched, or woodcut images.

It goes without saying that one of the central elements of the late twentieth-century Artist's Book, entirely the product of an artist, is the cover, which is given serious attention. It, after all, is not only the frame for the enclosed work of art, but the label that identifies it. Few artist's books are thick enough to provide space on their spines for a title, so most are displayed on sales racks with their covers showing. While Edward Ruscha preferred to print his covers with the simplest type announcing the title and no more, Marcel Broodthaers reproduced the typical late nineteenth-century style of paperback cover-title when he created his version of Mallarmé's *Un Coup de dés jamais n'abolira le hasard* (plate 114), placing his work into its original historical setting. When Dieter Roth's early books were reproduced by Hansjörg Mayer, limited editions of each were given special bindings designed by the artist. A corrugated board, colored yellow and cut away to reveal two signed miniature books, surrounds the revamped 1970 edition, *Daily Mirror* (plate 195; originally, *Daily Mirror Book* of 1961). These special bindings made each volume into a book object at a time when many artists and craftspeople were viewing the book as a subject for weaving, sculpting, and nearly anything but reading.

Before leaving the subject of bindings, mention should be made of a few publishers' bindings that transcended the material they were meant to protect. Marcel Duchamp's foam-rubber breast on the folder containing the exhibition publication *Le Surréalisme en 1947, exposition internationale du surréalisme* was one of the first examples of a nontraditional cover that proliferated on magazines and popular books soon afterward (plate 193). In the late 1960s a series of object books began to be published in Paris by Le Soleil Noir in which a sculpture was designed by an artist to contain a specific edition. For example, a leather-bound copy of Otto Hahn's *Portrait d'Antonin Artaud* (1968) accompanied by metal and plastic oval disks created by Lucio Fontana were confined within a painted wood sculpture (figure 27). Jim Dine's version of Oscar Wilde's *The Picture of Dorian Gray* (1968) was issued by Petersburg Press in several different bindings designed by the artist, one a relief sculpture of a bleeding heart covered in red fake snakeskin. This trend, which amplifies the artist's supremacy over the entire publication, continues.

FIGURE 27: Lucio Fontana. *Portrait d'Antonin Artaud* by Otto Hahn. Paris: Le Soleil Noir, 1968. Five metal and plexiglass multiples in painted wood box. The Museum of Modern Art, New York. Monroe Wheeler Fund

A recent example is the American artist Barbara Kruger's cover for horror novelist Stephen King's *My Pretty Pony* (1988), a story about the nature and meaning of time (figure 28; plate 175). The cover, made of brushed stainless steel, is embellished not with a title or image but with a working digital clock. Its appearance, unusual weight, and uncompromising industrial sturdiness sets the stage for Kruger's choice of images: disastrous encounters of horses and men. Incorporated into each black-and-white lithograph of an enlarged news photograph is Kruger's customary red band with a word or words and the additional element of a digital clock, also printed in red. These prints form a counterpoint to King's old-fashioned tale of a boy who has been caught in a game of hide-and-seek due to the unfairly rapid counting of the child who was "it." The boy's ailing grandfather, who is living on borrowed time, tells his grandson the proper method of even counting—by adding the phrase "pretty pony" between each number—and there follows a series of observations and flashbacks that reiterate the nature and vagaries of real time.

The twentieth-century artist's book, as a physical entity, has been, like other art forms of the period, a chameleon in some aspects but ever likely to return to the shape into which tradition has molded it. At the end of the century there are writers and artists who have mastered the computer. Using its capabilities for storing information and images as well as its possibilities for interaction, they have created stories and series of images with multiple itineraries that allow the reader-viewer to enter into a creative partnership with them. Because the owners of home computers have or will have, in principle, access to anything that has ever been printed, it is only moments before the artist's use of the computer's wide-ranging capabilities transcends the printed page forever. The ultimate artist's book will be an unlimited publication, available to be seen and even kept on a CD-ROM, but no longer an object to be held, touched, wondered at, and treasured.

LINKING THE ARTS

IN THIS DISCUSSION of various aspects of artists' books, the choices of contents and the materials that produced them have taken precedent over the way this particular art form has fit into artists' total creative production. What often is lost in reviewing the origins of this or that book is its relevance to the artist's other works. In the case of Paul Gauguin's *Noa Noa*, the idea for a book arose from the artist's experiences as well as from the paintings they inspired. The disappointment of failing to publish the book he had envisioned influenced the work he was to do on his return to Tahiti. It is not difficult to imagine that his mural painting *Where Do We Come From? What Are We? Where Are We Going?* (1897–98), now in the Museum of Fine Arts, Boston, may have been a monumental effort to replace the book, which was intended to make his work understood and endure, with a painting that would command equal immortality. But more likely it was his last writing project, *Avant et après* (1903), that confirmed his ability to record in writing as well as images his impressions and acceptance of his life in Polynesia. When Kurt Wolff undertook its publication in 1918 he wrote, "The manuscript contained twenty-nine drawings . . . all of them were related to the text, which I found both interesting in content and lively in style. It revealed Gauguin to have been a talented writer."[26]

Kokoschka had an intense literary predilection, which can be seen in most of his work. He gave to many of the male figures in his books his own features and, from 1912 to 1915, to the women, those of his lover, Alma Mahler. Their obvious portraiture in *Die gefesselte Kolumbus* (1913), *Die chinesische Mauer* (1914) by Karl Kraus, and *O, Ewigkeit—Du Donnerwort (Bachkantate)* of 1914 underscores the autobiographical character of Kokoschka's work in all mediums. It is unthinkable that he would have been able to contain his theatricality and verbal expression without the possibility of realizing it in some sort of narrative printed form. During the 1960s and 1970s he illustrated seven classic texts, most of which, like Aristophanes' *The Frogs* and William Shakespeare's *King Lear*, were plays. Whereas other artists were swept into the printing house by admiring dealers and publishers, Kokoschka needed no encouragement.

Matisse, whose devotion to the book form was considerably more productive than has been described here, worked out an entirely new method and style in his later years based on his efforts to make colorful illustrations for *Jazz*. His first collage from hand-colored papers was for the cover of *Verve*, from which the idea for a book of such collages arose. His method of cutting shapes and pinning them together on the wall, devised when he was confined to his bed after an operation, was at once the diverting activity given to a bedridden child and an exercise in concentration. At times Matisse would draw a shape on the paper and cut around it. In one of the *Jazz* collages, now in the collection of the Musée National d'Art Moderne, Centre Georges Pompidou, Paris, seemingly abstract shapes, dubbed *Forms* by the artist, still retain traces of the drawing that reveals them to be female figures with their arms around their heads. The colors applied to the papers are bright, and their contrast with the mat black encountered both in the collages and in the writing

FIGURE 28: Barbara Kruger. Cover for *My Pretty Pony* by Stephen King. New York: Library Fellows of the Whitney Museum of American Art, 1988. Stainless steel. Library of the Whitney Museum of American Art, New York

forming the text pages of the book is similar to the contrast Matisse was to achieve a few years later in the Chapel of the Rosary at Vence. There the brilliant stained glass of the window (worked out in the same collage technique) contrasted with the black images on the white tile walls. By perfecting this medium, which he could use in his bed in order to create a book, Matisse had mastered a means that would allow him to devote most of his creative activity in his old age to collage until the end of his life. Extraordinary installations, such as *The Swimming Pool* (1952–53) in The Museum of Modern Art, New York, and *Large Decoration with Masks* (1953) in the National Gallery of Art, Washington, D.C., reveal the enchantment that Matisse could provoke by cutting up color.

No other artist in the twentieth century produced more artist's books than Pablo Picasso. He worked on many of them out of friendship for writers—Max Jacob, Paul Eluard, Jean Cocteau, and Paul Reverdy, among many. Following his failed first effort to create his own book a few years after he had announced his intention to give up painting and devote himself to writing (at which time Gertrude Stein curtly suggested he should stick to his brush), he continued to write. Part of getting through World War II was finding ways to be entertained, which resulted in Picasso's play *Le Désir attrapé par la queue* being performed by his friends behind closed doors. Never without a project, especially those he did not seek, Picasso's life was filled with requests to provide prints for charity, group portfolios, frontispieces, and for many acquaintances who were both printers and publishers. It may have been that his will to create was never satisfied, for no space exists between the tens of thousands of paintings, sculptures, ceramics, drawings, and prints, both individual and in books, that made up his life. Because of this, a great variety of kinds of books can be found among the almost 150 titles to which he contributed, including about forty-five that can rightly be called Picasso's artist's books. Others, like eight small books published by Pierre André Benoit (PAB), each containing one engraving on celluloid, were given their text by Benoit in response to the print Picasso had sent to him. Picasso's books range in size from the tiniest pages (1 3/16 by 1 9/16 inches), for *Temperature*, published by PAB in 1960, to the formidable size (13 1/4 by 19 1/2 inches) of *La Tauromaquia* by José Delgado of 1959, with twenty-six aquatints and one etching, Picasso's answer to Goya's famous Bullfight series of about 1816.

In 1927, before he made his many works showing the Minotaur, Picasso had attempted to illustrate the same subject—the art of bullfighting—but never completed the prints. For Picasso the Spaniard, the encounter of bull and horse was a central element in the dictionary of his imagination. In the image of the Minotaur, a favorite mythological beast of the Surrealists, he found a significant entry into his artistic vocabulary. It began with his construction for the cover of Albert Skira's magazine, *Minotaure* (1933), now in the collection of The Museum of Modern Art. The aberrant creature, subsequently featured in a long series of prints, was the subject of Picasso's most important etching, *Minotauromachy* (1935). It became transformed into a faun (still a half-beast with horns, but now with a human face) in 1936, and in this new and happier guise populated prints and paintings made in Antibes in the 1940s—in Ramón Reventós's *Dos contes: El centaure picador/El capvespre d'un*

faune (1947) and Picasso's own *Poèmes et lithographies* (1954), and in his innovative linoleum cuts of 1959. In the books he embellished, he treated the many classical subjects of art, from birth to death, from gods to the lowly. At the end of his life nearly all his paintings, drawings, and prints were allegories touching on these subjects.

Today, Antoni Tàpies and Georg Baselitz are two artists who have a natural affinity for books, both being prodigious book collectors. Tàpies has transferred his passion for fine old books into creating his own, nearly thirty artist's books since 1963. Aware of the many forms books have taken, Tàpies has worked against the norm, making his books closely resonate to the forms of his painting. In *El pà a la barca* (1963) by Joan Brossa, printed in Barcelona, he has implied the destitute state of life under Francisco Franco by tearing pages, gluing a folded piece of scratch paper marked with a secret sign on another page, and otherwise illuminating pages of reproduced typewritten text in the most unconventional manner (plate 181). Later books would also incorporate torn paper and, even more often, the embossed signs that vitalize his material paintings. Over several decades, Tàpies's paintings have shown his bibliophilic inclination, marked as they are with anonymous apostrophes and quotes, like the marginal annotations of an admiring or scholarly reader.

Unlike Tàpies, who has been given many opportunities to make books by several publishers, including his art dealers who issue his prints as well, Baselitz has been a solitary printmaker when he has not been painting or sculpting. In the book-filled German castle that is his home and studio, he has his own etching press, and in recent years has taken to making prints for texts. His earliest woodcuts emulated sixteenth-century chiaroscuros, but the old technique was merely an apparatus upon which to fit his discordant view of humans, animals, and birds. These he made drift into segments and then into spatial relationships that were contrary to the expected, or more plainly, upside down. This formal means of composition, abstracting familiar forms by contradiction, is informed by assumptions that have their basis in historical and anthropological studies. The single book that Baselitz created totally, *Malelade* (1990), has its foundation in a specific German folk culture, and its text consists of words and phrases in the archaic language of its members (plate 103). The book's milieu is that of the barnyard, and thirty-nine scratched plates (drypoints with woodcut or etching added to some) contain images of animals, sometimes with childlike writing or only writing. During the time he made this and two other books, these animals, often divided or contained by crossed lines that might represent fences, cages, or charts, also inhabited Baselitz's paintings.

Artists whose adventures in making books have been unorthodox or restricted to one or two experiences may still invest their unique works with some measure of those encounters. It would be impossible to imagine that any work an artist does would not continue to influence, if not enhance, subsequent work, but specific influences in the case of working on a book are worth mentioning when they appear to produce a definitive impact. When Rauschenberg made his book *Shades* out of printed sheets of plexiglass, to be turned like pages (except that they could also be turned upside down and backward) he was taking the already overlapping photographic images found in his drawings and prints several steps further.

He was to continue this exploration in unique works, producing out of mechanically revolving printed plastic disks a set of large sculptures titled *Revolvers* in 1967. Five years later he created another book out of a number of printed plastic sheets, these fixed in a metal armature, incorporating Native American imagery and poetry, titled *Opal Gospels* (1972–73).

Louise Bourgeois created her first book in 1947 in the first decade of her career as a sculptor. She did not return to this art form until 1990. This occurred after her tremendous gifts of vision and invention, which had long probed the darker zones of sexuality, coincided with an awareness of the contemporaneous reality of her inspiration. In two of the three versions of Arthur Miller's short story *Homely Girl, a Life* (1992) Bourgeois contributed drawings and drypoints, mostly of flowers, that come between the pages of text. In the third version, she invaded the text, some lines of which are emphasized by being printed in red, while color photographs of pairs of eyes fall open between certain spreads, partially covering the text (plates 178–179). The drawings and prints, although not directly following the text, take on a symbolic relationship to the main character's development. The photographs relate to the many references in the text about seeing as well as to the blindness of the man to whom the girl is no longer homely. They are also deeply disturbing reflectors of an unstated story. Bourgeois's installation piece *Cell (Eyes and Mirrors)* of 1989–93, in the Tate Gallery, London, is one of several works in which sculptures of eyes, a prominent motif in her work of the 1980s, are sequestered in a manner that suggests something one must not reveal.

Once books are actively integrated into the whole of an artist's production, there is no longer a question of extending the discoveries evolving from making a book into other facets of creativity. Artists have recently been involved in designing their exhibition catalogues, and depending upon the degree of their involvement, this has given them another outlet for their creativity as well as experience in the articulation of their ideas in book form. Gallery owners have proudly published these catalogues—no longer exclusively a listing of the artist's works and reproductions of them in a concurrent exhibition—which have increasingly taken the form of the Artist's Book. The proximity that these usually modest publications have to continuing work in paintings, sculptures, installations, and performances dictates the measure of the role they take in the artist's creative structure. A. R. Penck's *Standarts*, published by the Galerie Michael Werner in conjunction with two other dealers of Penck's paintings, Fred Jahn and Bernd Klüser, is a compendium of signs, which are treated as units in a visual language (plate 115). Printed on one side of 150 newsprint sheets in red and blue, and bound together as a paperback, Penck's book is a dictionary that states and defines by example the content of his paintings. Like others mentioned earlier, it is a how-to textbook as well, but as a series of often repetitive and sequential signs of a visual vocabulary in a book, it becomes a literary or poetic extension of the artist's total conception of art.

In another instance, the work of Joseph Beuys was seamless in that there was no difference in attitude or method when the application was to books or other objectified works that arose from his lifework. He designed rubber stamps, one of

which was round and enclosed a cross within a circle containing the word *Haupt-strom* (main current) and other electrical symbols. This stamp was applied to most of his printed and multiple works beginning in 1969. Its form and message identified the author as well as impressed each work with further content. In *Die Leute sind ganz prima in Foggia* (1974) each page was screenprinted with what appears to be a cut-out typewritten communication from the artist, stamped with this sign, which attaches it to the whole of Beuys's work (plate 79). The form Beuys gave this object was that of a scrapbook, a collection of souvenir statements related to performances and installations. The shapes and sizes of these excerpts visually energize frequently incomprehensible texts.

Perhaps it will come as no surprise to learn that the most recent book in this survey took many years to complete, is published by a young man who loves books and, like several of his predecessors in his profession, asked a genius to allow him to help create this work. John Cage's *The First Meeting of the Satie Society*, published by Osiris, the imprint of Benjamin Shiff, in 1992, was actually completed at the end of 1993 (plates 187–188). Plans for its publication began shortly after Cage first performed a work of the same name in Germany on March 31, 1985. Best known as an avant-garde composer and musician, Cage devoted much time and energy in his later years to applying chance operations to printmaking and writing "mesostic" poems, a complex form based on a string of words that runs vertically through the text. The seven books and one folder housed in a metal and cracked-glass valise contain eight sets of mesostics, based on quotations by Erik Satie, Henry David Thoreau, James Joyce, Marcel Duchamp, and others. The books are enhanced with prints, burnt monotypes, drawings, and collages by Stephen Bastian, Jasper Johns, Sol LeWitt, Robert Rauschenberg, Robert Ryman, Michael Silver, and Cage himself. Cage had intended to complete the folder with drawings, but at the time of his death in 1992 he had not done so. Merce Cunningham, Cage's longtime friend and associate, completed the project with his own drawings in 1993. The resulting books, softly bound, gently printed, slouch against each other in the valise, where they are seen behind the broken glass. Satie and Duchamp, the composer and artist most admired by Cage, also symbolize artistic freedom to many generations of twentieth-century artists. They made commonplace sounds, objects, and events meaningful. In their honor, Cage, who did the same for silence, invented and orchestrated the making of this extraordinary composition.

CONCLUSION

COMPARING SOME RECENT ARTISTS' BOOKS with those of one hundred years ago, it is possible to see immense differences as well as startling similarities. When Ellsworth Kelly took up Mallarmé's *Un Coup de dés jamais n'abolira le hasard* in 1992, he examined it in terms of his own concept of placement of art in space. No text could have better matched Kelly's ideas, for the isolation that Mallarmé's verses required matched that which he demanded for his own paintings. The problem of creating spaces within a book in which the solitude of an image could be preserved

is, indeed, contradictory to the book form, which motivates the reader to continue turning pages. Kelly needed to arrest that movement, and so he added blank pages before and after his solid black forms. Whereas Toulouse-Lautrec had placed his images within the text block, directly confronting its meaning with a visual counterpoint, Kelly emphasized the visuality of Mallarmé's text by taking territory in its midst, taking his chance that his "throw" of image would balance Mallarmé's.

Because Kelly's paintings, drawings, and prints are well known, his single effort in creating an artist's book has the factor of familiarity unavailable to younger, less established artists. Like numerous young artists in the late nineteenth century who contributed to the many ephemeral publications of the time, it is not unusual for the newer artists of our time to devote their talents to low-cost artists' booklets and pamphlets. The ease of production and publication by oneself, made possible by magnetic printing and the computer, has increased this form of art by making the means accessible to anyone. As has always been the case, only a few artists are given the opportunity to use the traditional print techniques in necessarily limited-edition books. Nevertheless, the abundance of recent exhibitions devoted to artists' books of all kinds, those special endeavors that have occupied the creative work time of so many, is a clear example of how much the book form has become a symbol of a turning point in our culture. Just when electronics have called into question the privacy of possession, these multidimensional creations reaffirm the human need to embrace objects worthy of dedicated attention, admiration, and affection.

NOTES

1 Philip Hofer to Iris Barry, unpublished letter of April 18, 1935.

2 Monroe Wheeler, *Modern Painters and Sculptors as Illustrators* (New York: The Museum of Modern Art, 1936), p. 13.

3 Ibid., p. 11.

4 Ibid., p. 23.

5 Gaston Davenay, "From Day to Day—Yvette Guilbert," *Le Figaro* (August 16, 1894).

6 Paul Gauguin to Charles Morice, letter of May 2 or 9, 1894, quoted in Elizabeth Mongan, Eberhard W. Kornfeld, and Harold Joachim, *Paul Gauguin: Catalogue Raisonné of His Prints* (Bern: Galerie Kornfeld, 1988), p. 47.

7 Paul Gauguin [and Charles Morice], *Noa Noa* (Munich: R. Piper & Co. Verlag, 1926); facsimile of manuscript in the Louvre, unpaginated. (My translation.)

8 John Harthan, *The History of the Illustrated Book: The Western Tradition* (London: Thames and Hudson, 1981), p. 228.

9 Georges Rouault, "Preface by the Artist," *Miserere*, trans. Monroe Wheeler (New York: The Museum of Modern Art, 1952), unpaginated.

10 Henry Miller, "Let Us Be Content with Three Little Newborn Elephants," in *Stand Still Like the Hummingbird* (New York: New Directions, 1962), p. 169.

11 Albert Skira, *Vingt ans d'activité* (Geneva and Paris: Editions Albert Skira, 1948), p. 20. (My translation.)

12 Michel Cazenave, *Malraux* (Paris: Editions Balland, 1985), p. 118. (My translation.)

13 Stéphane Mallarmé, "The Book: A Spiritual Instrument" ("Le Livre, instrument spirituel," 1895), in Mary Ann Caws, ed., *Selected Poetry and Prose* (New York: New Directions, 1982), p. 83. (My translation.)

14 Max Jacob to Tristan Tzara, letter of February 26, 1916, quoted in Henri Béhar, ed., *Tzara: Oeuvres complètes* I (Paris: Flammarion, 1977), p. 639.

15 Paul Eluard, "Georges Braque," trans. David Gascoigne, in Willis Barnstone, ed., *Modern European Poetry* (New York, Toronto, London: Bantam Books, 1966), p. 30.

16 Jean-Paul Sartre, "Doigts et non-doigts," in *Wols* (New York, Paris, Geneva: Alexander Iolas, 1965), unpaginated.

17 Richard Cork, *David Bomberg* (New Haven and London: Yale University Press, 1987), p. 327; see ch. 5, n. 79.

18 Gilbert & George, *Side by Side* (Cologne and New York: König Brothers, 1972), introduction.

19 George Maciunas to Tomas Schmit, letter of January 1964, in Jon Hendrick, *Fluxus Codex* (Detroit: The Gilbert and Lila Silverman Fluxus Collection; New York: Harry N. Abrams, 1988), p. 37.

20 Peter Schjeldahl, "Reading the Rhine" (unpublished manuscript, 1988), p. 1. Courtesy the author.

21 Jules Renard, *Hunting with "The Fox,"* trans. T. W. Earp and G. W. Stoner (Oxford: B. Cassirer, 1948), p. 21.

22 Guillaume Apollinaire, *Bestiary, or the Parade of Orpheus*, trans. Pepe Karmel (Boston: David Godine, 1980).

23 *Roland Dorgelès, de Montmartre à l'Académie Goncourt* (Paris: Bibliothèque Nationale, 1978), p. 94, entry 276.

24 Arthur A. Cohen, *Sonia Delaunay* (New York: Harry N. Abrams, 1975), p. 30.

25 Henri Matisse, "Comment j'ai fait mes livres," in *Anthologie du livre illustré par les peintres et sculpteurs de l'école de Paris* (Geneva: Albert Skira, 1946), pp. xxxi–xxiii.

26 Michael Ermart, ed., *Kurt Wolff: A Portrait in Essays and Letters* (Chicago and London: The University of Chicago Press, 1991), pp. 38–39.

PLATES

In the captions to the following plates, most information given about editions, printers, and papers has been taken from the title, colophon, or justification pages of the books themselves. Additional data come from the catalogues raisonnés of the artists' work and from the collection records of the owners of the individual volumes.

Throughout the captions, brackets enclose information that does not appear on the book itself. Pagination is indicated in italics and in parentheses when the leaves or sheets are not included in the numbered page count. All measurements give height before width. Full references for the catalogues raisonnés cited in the entries can be found in the Bibliography. Additional information on the works, such as translations of print titles, can be found in the Catalogue of the Exhibition.

PAUL GAUGUIN
French. 1848–1903

Noa Noa

AUTHOR: Paul Gauguin.

The idea of creating a book about his impressions of Tahiti and the art he made there was clearly in Gauguin's mind when he was on his way back to France in 1893. He began the manuscript shown here after his arrival, and the woodcuts to illustrate it in 1894. An already edited manuscript, augmented by the collaborating author Charles Morice, which Gauguin took with him on his second trip to Tahiti in

1895, remained with him until his death in 1903. It contained blank pages for additional poems by Morice and the woodcuts that Gauguin had left in France to be inserted when the book Noa Noa *was published. As time passed without its publication, Gauguin pasted later prints onto the blank pages, and drew and watercolored over parts of the writing, perhaps in final frustration. This manuscript, now in the Musée du Louvre, was first reproduced in 1926.* Noa Noa *never appeared as Gauguin envisioned it, but its history and artifacts have continued to inspire artists to create illustrated books.*

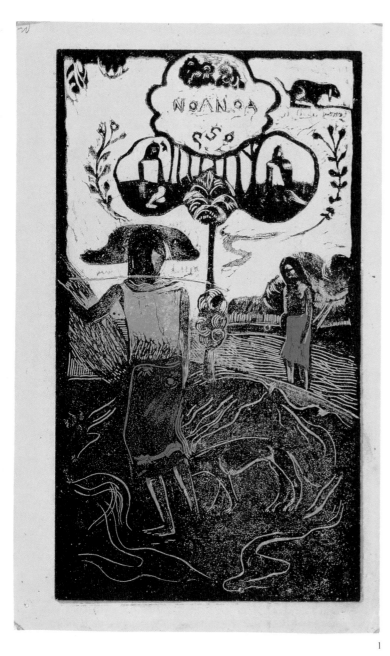

2

Noa Noa. [1894]. Autograph manuscript (detail of inside cover). 15¾ x 10¼" (40 x 26.1 cm), irreg. The Resource Collections of the Getty Center for the History of Art and the Humanities

Noa Noa. [1893–94]. Woodcut, in color with stencils, on tan wove Japan paper. 14¹/₁₆ x 8⅛" (35.7 x 20.7 cm). Printed by Louis Roy, Paris. Kornfeld 13. The Museum of Modern Art, New York. Lillie P. Bliss Collection

1

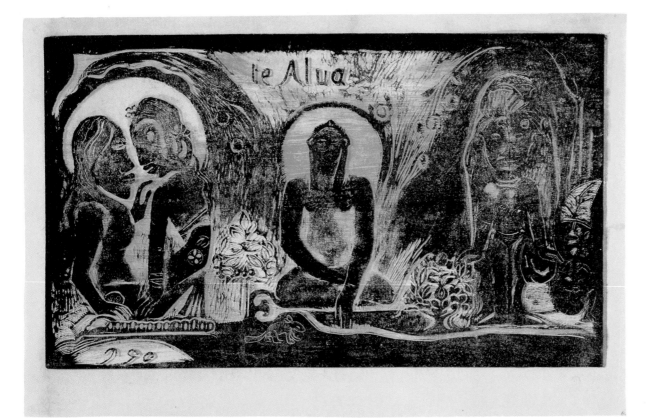

3

Te Atua. [1893–94]. Woodcut, in color, on tan
wove Japan paper. 8¹⁄₁₆ x 14" (20.4 x 35.5 cm).
Printed by Gauguin. Kornfeld 17. The Museum
of Modern Art, New York. Gift of Abby Aldrich
Rockefeller

Noa Noa by Paul Gauguin [and Charles Morice
(French. 1861–1919)]. Munich: R. Piper & Co.
Verlag, 1926. Facsimile of autograph manuscript
with collotype reproductions of the artist's
watercolors, pen-and-ink drawings, woodcuts,
and photographs. 12⅛ x 9⅛" (30.8 x 23.2 cm).
The Museum of Modern Art Library, New York

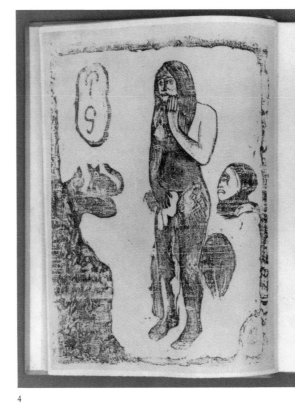

4

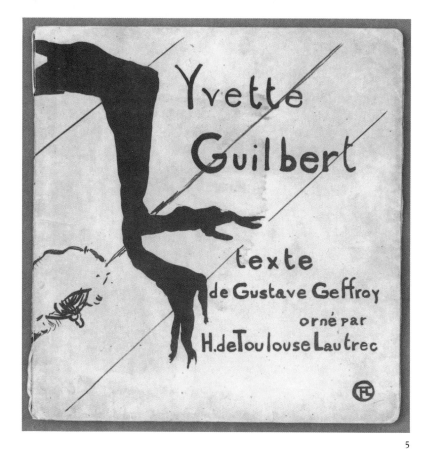

HENRI DE
TOULOUSE-LAUTREC
French. 1864–1901

Yvette Guilbert

AUTHOR: Gustave Geffroy (French. 1856–1926).
PUBLISHER: Paris: L'Estampe Originale [André Marty], 1894.
PAGINATION: 22 unnumbered folios (including flyleaves).
PAGE SIZE: 14¾ x 15⅛" (37.5 x 38.5 cm), irreg.
IMAGES: 16 lithographs, in color, and 1 transfer lithograph (front cover), in black, on ivory laid Arches paper (except cover).
IMAGES SHOWN: Above, cover, 15 x 16⅛" (38.2 x 41 cm), irreg.; opposite, bottom, 9¾ x 3⁹⁄₁₆" (24.8 x 9 cm), irreg.
HOUSING: Publisher's ivory wove Japan paperboard cover, with transfer lithograph on front, bound with ivory ribbon; quarter beige linen over marbleized paperboard folder with flaps, lined with ivory paper; marbleized paperboard slipcase; clear plexiglass exterior slipcase with brown linen edging.
EDITION: More than 100: numbered 1–100 (this copy, no. 90); approximately 6 *hors-commerce*, reserved for author.

PRINTERS: Plates, Edw. Ancourt, Paris; text, Frémont.
CATALOGUES RAISONNÉS: Delteil 79–95. Wittrock 69–85.
COLLECTION: The Museum of Modern Art, New York. Louis E. Stern Collection

The publisher of this book had planned to produce a series on the singers of the Parisian cafés concerts, but this was the first and only publication completed. It gave Toulouse-Lautrec the opportunity to depict Yvette Guilbert, who had not always been pleased with the way he portrayed her. Nevertheless, in his lithographs for this book the artist changed the intent of illustration from depicting parts of a narration to enhancing it by providing his own vision of the subject—in this case, aspects of the daily life of the performer. Geffroy's text uses Guilbert as a point of departure for his examination of the condition of her primary audience, the Parisian worker.

6

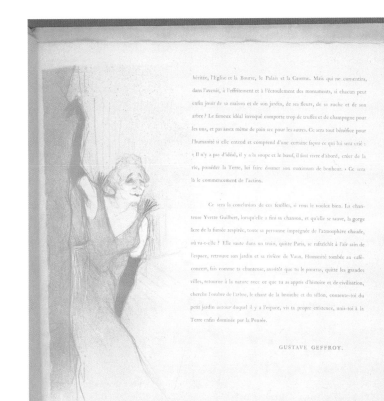

7

Above, *Yvette Guilbert*. [1894]. Proof without text. Lithograph, in color on ivory laid Arches paper. 11¹³⁄₁₆ x 5⅞" (30 x 15 cm), irreg. Delteil 89. Wittrock 79. The Museum of Modern Art, New York. Vincent D'Aquila and Harry Soviak Bequest

SÉGUIDILLE.

Brune encore non eue,
Je te veux presque nue
Sur un canapé noir
Dans un jaune boudoir,
Comme en mil huit cent trente.

Presque nue et non nue
A travers une nue
De dentelles montrant
Ta chair où va courant
Ma bouche délirante.

27

8

PIERRE BONNARD
French. 1867–1947

Parallèlement

AUTHOR: Paul Verlaine (French. 1844–1896).
PUBLISHER: Paris: Ambroise Vollard Editeur, 1900.
PAGINATION: 152 pages: (*8*), 1–139, (*5*).
PAGE SIZE: 11⅛ x 9⅜" (29.5 x 23.9 cm), irreg.
IMAGES: 110 lithographs (including supplementary frontispiece), in color; 8 ornamental woodcuts (cut by Tony Beltrand) and 2 line-block reproductions (title page and wrapper front), in black; on ivory wove Holland Van Gelder paper (except wrapper) (executed 1897–1900).
IMAGES SHOWN: Above, left page, 5⅘₁₆ x 7⅞" (13.5 x 20 cm), right page, 9⅛ x 8½" (23.2 x 21.6 cm); opposite, left page, 9¾ x 8⅞" (24.7 x 22.5 cm), right page, 4¾ x 4⅛" (12 x 11.7 cm); all irreg.
HOUSING: Full red leather binding with red leather *doublures*, and original buff wove paper wrapper with duplicate line block of title-page ornament (replacing original printer's vignette) on front bound in; in red leather two-part slipcase; made by G. Mercier in 1930.

EDITION: More than 200: 10 numbered 1–10 on China paper, with supplementary suite; 20 numbered 11–30 on China paper; 170 numbered 31–200 on Holland paper; 1 or more *hors-commerce* (this copy, inscribed "exemplaire d'auteur éditeur/*Vollard*").
PRINTERS: Lithographs, Auguste Clot, Paris; text, L'Imprimerie Nationale, Paris.
TYPOGRAPHY: After 1540 Garamond roman.
CATALOGUES RAISONNÉS: Bouvet 73 (frontispiece not catalogued). Roger-Marx 94. Floury 40.
COLLECTION: The Museum of Modern Art, New York. Louis E. Stern Collection

LES PASSIONS.....

Ces passions qu'eux seuls nomment encore amours
Sont des amours aussi, tendres & furieuses,
Avec des particularités curieuses
Que n'ont pas les amours certes de tous les jours.

Même plus qu'elles & mieux qu'elles héroïques,
Elles se parent de splendeurs d'âme & de sang
Telles qu'au prix d'elles les amours dans le rang
Ne sont que Ris & Jeux ou besoins érotiques.

Que vains proverbes, que riens d'enfants trop gâtés,
— «Ah! les pauvres amours banales, animales,
Normales! Gros goûts lourds ou frugales fringales,
Sans compter la sottise & des fécondités!»

119

9

This was Vollard's first published book. He insisted in his autobiography that he had once seen Verlaine and from that moment had the idea to issue a book of his poems. He perpetuated a story about his problems with the French national printing house to the effect that it refused to have its symbol on the title page because some poems in the selection had been banned in France in 1868. The six lesbian poems, "Les Amies," had in fact been published in Paris in the first (unillustrated) edition of Parallèlement in 1889. Undoubtedly, Vollard's gift for telling tales was important to his success as an art dealer, and whatever the reason for the lack of the symbol in many, but not all, of the copies of his edition of Parallèlement, *the aura of the illicit was surely meant to attract book collectors.*

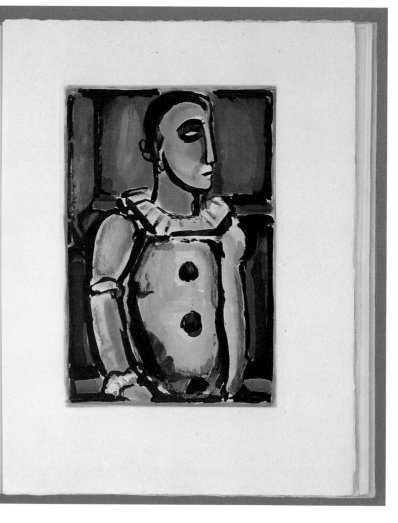

Des démagogues effrontés,
Des bons apôtres et des drôles
Qui promettent aux humains
Plus de beurre que de pain.

A pratiquer certain art, disait le vieux maître, c'est
un lion à dompter chaque matin, on recommence sans
hésiter le lendemain jusqu'à la mort, alors vous dira-t-on
encore raté, ce qui peut être vrai. *Miserere!*

Poète, en un instant, peut deviner
Ce que de savants ingénieurs
Ou de très reluisants mécaniciens
En un siècle mettront au point.

Terre d'Ombre, tel paysage dépouillé aurais-tu donc
fixé en hiver plus souvent qu'au printemps, sans préciser
à quelle heure il fut peint? C'était l'heure picturale, ose
donc le supposer un instant.

Tu chantes pouilles, triste avare,
Heure picturale, c'est bientôt dit.
Dons parfois louches ou abolis,
Heure picturale, dites-moi,
Tous peuvent s'en réclamer.

Chant délirant tenait le petit noir aux entrailles, mais il
beuglait à faux, snobs lui ayant appris à dérailler trop tôt.
Il aurait si bien su moduler en sourdine la chansonnette
du « Serpent à sonnettes » qu'il aurait nuancée de façon

122

10

GEORGES ROUAULT
French. 1871–1958

Cirque de l'étoile filante

AUTHOR: Georges Rouault.
PUBLISHER: Paris: Ambroise Vollard Editeur, 1938. First edition.
PAGINATION: 184 pages: (*8*), [1–2], 3–168, [169], (*7*); 17 plates *hors-texte*.
PAGE SIZE: 17⁵⁄₁₆ x 13³⁄₁₆" (44 x 33.5 cm), irreg.
IMAGES: 17 aquatint and lift-ground aquatint and etchings, many with drypoint and/or roulette, in color; 74 wood engravings (including table of plates) by Georges Aubert, after Rouault's drawings, in black; on cream laid Montval paper (executed 1926–38).
IMAGE SHOWN: *Pierrot*, 12¼ x 8⁷⁄₁₆" (31.2 x 21.4 cm).
HOUSING: Publisher's buff wove paper wrapper, with wood-engraved ornament on front, around cream wove paper; publisher's interior cream wove paper wrapper, used initially to house *hors-texte* plates; red linen solander box lined with beige linen; quarter brown leather

over red linen slipcase, made by Gerhard Gerlach for Louis E. Stern.
EDITION: 280: 35 numbered 1–35 on Imperial Japan paper; 215 numbered 36–250 on Montval paper (this copy, no. 171, with inserted variant title-page folio); 5 *hors-commerce*, numbered I–V on Imperial Japan paper; 25 *hors-commerce*, numbered VI–XXX on Montval paper.
PRINTERS: Etchings, Roger Lacourière, Paris; text, Aux Deux Ours, Paris.
TYPOGRAPHY: Plantin.
CATALOGUES RAISONNÉS: Chapon and Rouault 240–256. Chapon, pages 140–161.
COLLECTION: The Museum of Modern Art, New York. Louis E. Stern Collection

About twelve years after asking his friend André Suarès to write a text on the circus, the last of Rouault's three or four attempts at creating this book was published. With a new title and text by the artist, the seventeen color plates were given a painterly effect through a process new to Rouault. Where he had formerly worked over photogravures made after his gouaches and paintings, this time he drew the heavy black outlines with sugar-lift aquatint. After he hand-colored the black-and-white proofs, the master printer Lacourière re-created the colored areas in aquatint, altering the values and tones as Rouault suggested.

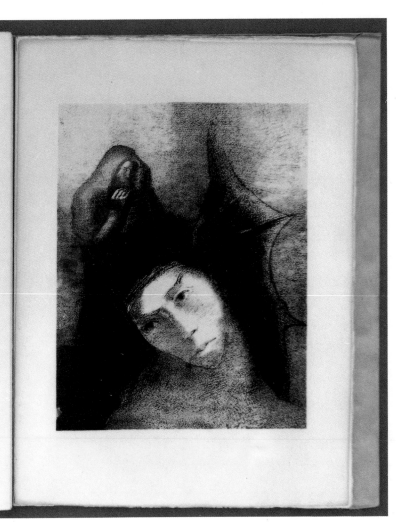

fentiras augmenter ta joie, d'après cette découverte du monde, dans cet élargiſſement de l'infini.

ANTOINE. — Ah! plus haut! plus haut! toujours!

Les aſtres ſe multiplient, ſcintillent. La Voie lactée au zénith ſe développe comme une immenſe ceinture, ayant des trous par intervalles; dans ces fentes de ſa clarté, ſ'allongent des eſpaces de ténèbres. Il y a des pluies d'étoiles, des traînées de pouſſière d'or, des vapeurs lumineuſes qui flottent & ſe diſſolvent.

Quelquefois une comète paſſe tout à coup; — puis la tranquillité des lumières innombrables recommence.

Antoine, les bras ouverts, ſ'appuie ſur les deux cornes du Diable, en occupant ainſi toute l'envergure.

Il ſe rappelle avec dédain l'ignorance des anciens jours, la médiocrité de ſes rêves.

Les voilà donc près de lui ces globes lumineux qu'il contemplait d'en bas! Il diſtingue l'entre-croiſement de leurs lignes, la complexité de leurs directions. Il les voit venir de loin, — & ſuſpendus comme des pierres dans une fronde, décrire leurs orbites, pouſſer leurs hyperboles.

Il aperçoit d'un ſeul regard la Croix du ſud & la Grande Ourſe, le Lynx & le Centaure, la nébuleuſe de la Dorade, les ſix ſoleils dans la conſtellation d'Orion, Jupiter avec ſes quatre ſatellites, & le triple anneau du monſtrueux Saturne! toutes les planètes, tous les aſtres que les hommes plus tard découvriront! Il emplit ſes yeux de leurs lumières, il ſurcharge ſa penſée du calcul de leurs diſtances; — puis ſa tête retombe.

Quel eſt le but de tout cela?

176

11

ODILON REDON
French. 1840–1916

La Tentation de Saint Antoine

AUTHOR: Gustave Flaubert (French. 1821–1880).
PUBLISHER: [Paris]: Editions Ambroise Vollard, [1938].
PAGINATION: 232 pages: (8), [1–2], 3–205, [206], (18); 22 plates *hors-texte*.
PAGE SIZE: 17½ x 12¹⁵⁄₁₆" (44.5 x 33 cm), irreg.
IMAGES: 22 lithographs, in black on ivory China paper mounted on ivory wove Arches paper; 16 wood engravings (including duplicate on wrapper front) and 5-page wood-engraved table of plates by Georges Aubert, after Redon's drawings, in black on cream wove Arches paper (except wrapper) (lithographs executed 1896; wood engravings executed c. 1910).
IMAGE SHOWN: *Antoine: Quel est le but de tout cela? Le Diable: Il n'y a pas de but!*, 12⅛ x 9¾" (30.8 x 24.8 cm).
HOUSING: Publisher's tan wove paper wrapper, with duplicate wood engraving on front, around cardboard and cream wove paper; quarter black leather over gray linen solander box, lined with gray paper, made by Gerhard Gerlach for Louis E. Stern.
EDITIONS: Book: 220: 25 numbered 1–25 on Marais paper; 185 numbered 26–210 on Arches paper (this copy, no. 97); 10 *hors-commerce*, numbered I–X on Arches paper; portfolio (1896): 50.
PRINTERS: Lithographs, Auguste Clot, Paris; text and wood engravings, Henri Jourde, Paris.
CATALOGUE RAISONNÉ: Mellerio 134–140, 142–157.
COLLECTION: The Museum of Modern Art, New York. Louis E. Stern Collection

Flaubert's first magnum opus, retelling the temptations that afflicted Saint Anthony, was completed over twenty-five years before its publication in 1874. The mystical trials were compelling subjects for Redon, who made three sets of illustrations in which he tried to fathom their symbolic content. The last and largest series of lithographs on the temptations was commissioned by Vollard and issued in 1896, many decades before they were incorporated into book form after the artist's death.

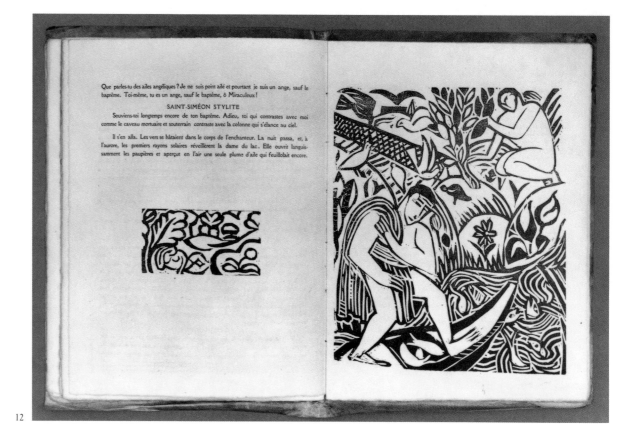

12

13

ANDRÉ DERAIN
French. 1880–1954

L'Enchanteur pourrissant

AUTHOR: Guillaume Apollinaire (Guillaume Apollinaire de Kostrowitsky; French, born Italy. 1880–1918).
PUBLISHER: Paris: Henry Kahnweiler Editeur, 1909. First edition.
PAGINATION: 42 unnumbered folios.
PAGE SIZE: 10⁷⁄₁₆ x 7⁷⁄₈" (26.5 x 20 cm).
IMAGES: 32 woodcuts (including head- and tailpieces, pictorial initials, and first printing of publisher's vignette), in black on ivory laid Arches paper.
IMAGES SHOWN: Above, left page, 1¹⁵⁄₁₆ x 3⅝" (4.9 x 9.2 cm), right page, 8¼ x 6¹⁵⁄₁₆" (21 x 17.7 cm); left, 5⅛ x 1⅝" (13.1 x 4.2 cm); all irreg.
HOUSING: Publisher's vellum binding with cream laid endpapers; full red leather solander box with cutout windows displaying reproductions of woodcuts on front and back, lined with cream laid paper, made by Gerhard Gerlach for Louis E. Stern.
EDITION: 106: 25 numbered 1–25 on Antique Shidzuoka paper; 75 numbered 26–100 on Arches paper (this copy, no. 59, signed); 4 numbered I–IV for printers and/or authors; 2 marked 0 and 00, deposit copies.
PRINTER: Paul Birault, Paris.

CATALOGUES RAISONNÉS: Adhémar 32. Hilaire, page 185.
COLLECTION: The Museum of Modern Art, New York. Louis E. Stern Collection

Because the woodcut imagery that Derain devised for Apollinaire's tale is inspired by African carvings, it might be argued that this book marks the true origin of the modern artist's book. It shares with avant-garde painting of the time concerns about representation, but uses figurative imagery in full-page plates and figurative initials as decorations in a traditional manner. Nevertheless, the bold forms of black against white accentuate the revolutionary intent of Derain's illustrations.

PABLO PICASSO
Spanish. 1881–1973

Saint Matorel

AUTHOR: Max Jacob (French. 1876–1944).
PUBLISHER: Paris: Henry Kahnweiler Editeur, 1911. First edition.
PAGINATION: 52 unnumbered folios (including flyleaves).
PAGE SIZE: 10 7/16 x 8 11/16" (26.5 x 22 cm), irreg.
IMAGES: 4 etchings, 1 with drypoint, in black on ivory laid Holland Van Gelder paper (executed 1910–11).
IMAGE SHOWN: *Mademoiselle Léonie sur une chaise longue*, 7 13/16 x 5 9/16" (19.8 x 14.2 cm).
HOUSING: Publisher's cream wove Japan paper binding; quarter black leather with brown decorative paperboard solander box, lined with cream paper, made by Gerhard Gerlach for Louis E. Stern.
EDITION: 106: 15 numbered 1–15 on Shidzuoka paper; 85 numbered 16–100 on Van Gelder paper (this copy, no. 94, signed); 4 numbered I–IV on Van Gelder paper for printers and/or author; 2 *hors-commerce*, marked o and oo, deposit copies.

PRINTERS: Plates, Eugène Delâtre, Paris; text, Paul Birault, Paris.
CATALOGUES RAISONNÉS: Cramer 2. Geiser and Baer 23–26.
COLLECTION: The Museum of Modern Art, New York. Louis E. Stern Collection

This, the first volume of Jacob's trilogy on the vicissitudes of his semiautobiographical fictional character, Victor Matorel, is also the debut of Picasso's Cubist printmaking. In 1910, during a summer spent with his mistress Fernande Olivier and the painter André Derain in Cadaqués, Catalonia, he created these etchings in the Analytic Cubist style. It was to Kahnweiler's credit that he made this his second publication, at a time when Picasso's Cubist work was unappreciated (and nearly unknown) in Paris.

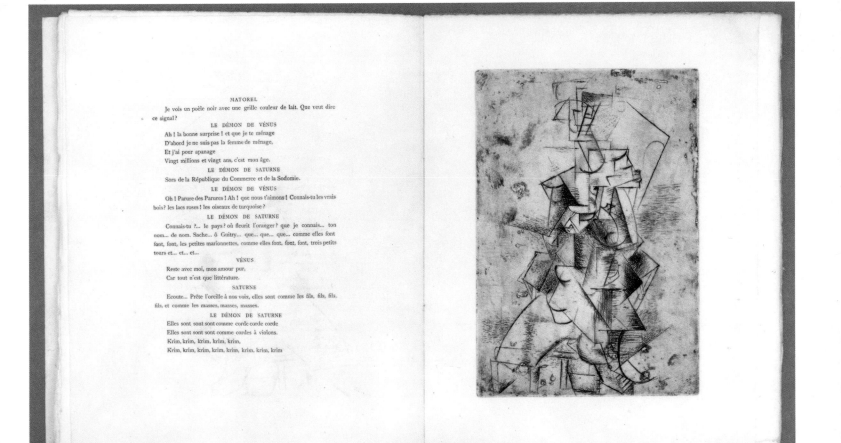

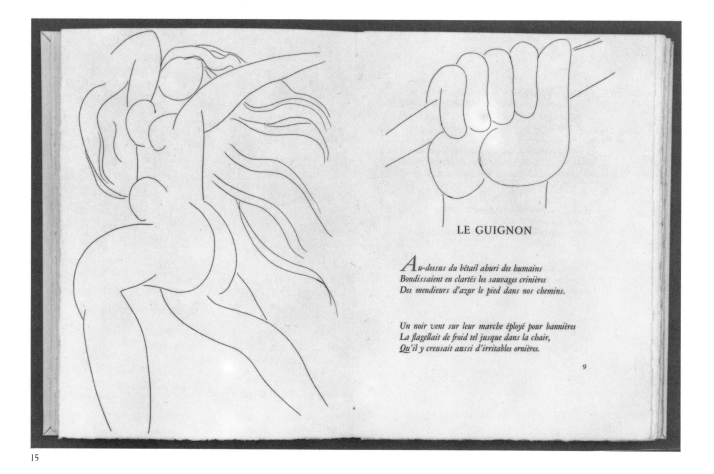

LE GUIGNON

Au-dessus du bétail ahuri des humains
Bondissaient en clartés les sauvages crinières
Des mendieurs d'azur le pied dans nos chemins.

Un noir vent sur leur marche éployé pour bannières
La flagellait de froid tel jusque dans la chair,
Qu'il y creusait aussi d'irritables ornières.

9

15

HENRI MATISSE
French. 1869–1954

Poésies

AUTHOR: Stéphane Mallarmé (French. 1842–1898).
PUBLISHER: Lausanne: Albert Skira & Cie, Editeurs, 1932.
PAGINATION: 176 pages: (*8*), [1–4], 5–153, (*15*); 1 plate *hors-texte* and 1 added plate.
PAGE SIZE: 12¹⁵⁄₁₆ x 9¹³⁄₁₆" (33 x 25 cm).
IMAGES: 29 etchings (including head- and tail-pieces), in black on ivory wove Arches paper; 1 added etching with remarques, in black on cream wove Japan paper (executed 1930–32).
IMAGES SHOWN: Above, left page, *Le Guignon*, 12¹¹⁄₁₆ x 8¾" (32.2 x 22.2 cm), right page, head-piece, 6⅛ x 7¹³⁄₁₆" (15.5 x 19.8 cm); opposite, above, *Le Cygne*, 11¹⁵⁄₁₆ x 8¾" (30.3 x 22.3 cm), below, *La Chevelure*, 12⅛ x 9¼" (30.8 x 23.5 cm); all irreg.
HOUSING: Publisher's ivory wove Japan paper wrapper; quarter black leather over red linen solander box and slipcase, lined with gray paper, made by Gerhard Gerlach for Louis E. Stern.
EDITION: 145: 5 numbered 1–5 on Imperial Japan paper, with 2 supplementary suites and drawing; 25 numbered 6–30, with supplementary

suite; 95 numbered 31–125 on Arches paper (this copy, no. 87, signed, with dedication to Louis E. Stern by Marie Harriman, includes an added plate); 20 *hors-commerce*, numbered I–XX, reserved for collaborators.
PRINTERS: Plates, R. Lacourière, Paris; text, Léon Pichon.
CATALOGUE RAISONNÉ: Duthuit 5.
COLLECTION: The Museum of Modern Art, New York. Louis E. Stern Collection

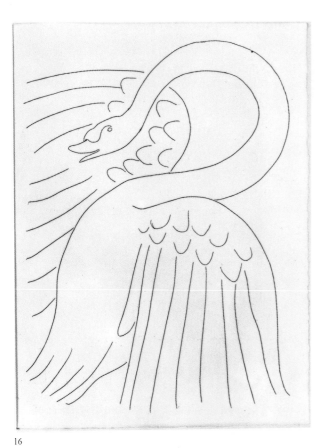

When Skira decided to publish fine books decorated by artists his first choice was Picasso, who seemed to never want to finish his interpretation of Ovid's Métamorphoses. However, Matisse was full of visions of his trip to the South Seas, always able to spin out his seductive linear drawings, and fully prepared to endow Mallarmé's poetry with perfect harmony. The publication of Skira's most beautiful book coincided with the lean years of the Depression, and to promote sales Marie Harriman, a dealer and the first wife of the New York governor and diplomat Averell Harriman, added her imprint to several copies, which she sold to her American clients.

16

Ses purs ongles très haut dédiant leur onyx,
L'Angoisse, ce minuit, soutient, lampadophore,
Maint rêve vespéral brûlé par le Phênix
Que ne recueille pas de cinéraire amphore

Sur les crédences, au salon vide : nul ptyx,
Aboli bibelot d'inanité sonore
(Car le Maître est allé puiser des pleurs au Styx
Avec ce seul objet dont le Néant s'honore).

Mais proche la croisée au nord vacante, un or
Agonise selon peut-être le décor
Des licornes ruant du feu contre une nixe,

Elle, défunte nue en le miroir, encor
Que, dans l'oubli fermé par le cadre, se fixe
De scintillations sitôt le septuor.

128

17

18

SALVADOR DALI
Spanish. 1904–1989

Les Chants de maldoror

AUTHOR: Comte de Lautréamont (Isidore Ducasse; French. 1846–1870).
PUBLISHER: Paris: Albert Skira Editeur, 1934.
PAGINATION: 216 pages: (*4*), [1–4], 5–206, [207], (*5*); 30 plates *hors-texte*.
PAGE SIZE: 12¹³⁄₁₆ x 10" (32.5 x 25.5 cm).
IMAGES: 42 etchings (including head- and tailpieces), 5 with *roulette*, in black on ivory wove Arches paper.
IMAGE SHOWN: Above, 8⅞ x 6¾" (22.5 x 17.1 cm).
HOUSING: Publisher's cream wove paper wrapper; quarter red leather over green linen solander box, lined with green paper, with black leather Man Ray *ex-libris* set in, made by Gerhard Gerlach for Louis E. Stern.
EDITION: 210: 40 numbered 1–40, with supplementary suite; 160 numbered 41–200 (this copy, no. 57, signed); 10 *hors-commerce*, numbered I–X, reserved for collaborators.
PRINTERS: Plates, Roger Lacourière, Paris; text, Philippe Gonin, Paris.
COLLECTION: The Museum of Modern Art, New York. Louis E. Stern Collection

This version of a text revered by the Surrealists was the first book to which Dali gave his undivided attention. Recent research has questioned his involvement in the production of the etchings, and from drawings and proofs it appears that Dali's images were assisted by the skill of professional printers. Nevertheless, the images are from the artist's most intense and inventive period, making this his major contribution to the modern artist's book.

19

Above, drawing for plate 29 of *Les Chants de maldoror*. [1932–33]. Pencil on paper, 8½ x 6¼" (21.5 x 15.8 cm). Graphische Sammlung Staatsgalerie Stuttgart

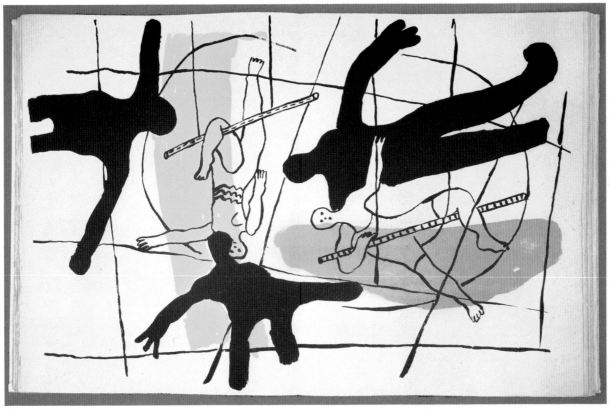

20

FERNAND LÉGER
French. 1881–1955

Cirque

AUTHOR: Fernand Léger.
PUBLISHER: Paris: Tériade Editeur, 1950. First
edition.
PAGINATION: 128 pages: (8), [1–4], 5–110,
[111], (9).
PAGE SIZE: 16½ x 12⁹/₁₆" (42 x 32 cm), irreg.
IMAGES: 83 lithographs (including title page,
head- and tailpieces, and pictorial initials), 49 in
black and 34 in color on ivory wove Arches
paper (except wrapper).
IMAGES SHOWN: Above, 16⁷/₁₆ x 24½" (41.8 x
62.2 cm), irreg.; right, 13 x 2¹⁵/₁₆" (33.1 x 7.5 cm),
irreg.
HOUSING: Publisher's ivory wove paper wrap-
per, with lithographs in black and yellow on
front and back; quarter brown leather over black
linen solander box and slipcase, lined with yellow
paper, probably made for Louis E. Stern.
EDITION: 300: 280 numbered 1–280 (this copy,
no. 69, signed); 20 *hors-commerce*, numbered
I–XX.
PRINTER: Mourlot Frères, Paris.
BOOK DESIGNER: Fernand Léger.
TYPOGRAPHY: Manuscript.
CATALOGUE RAISONNÉ: Saphire 44–106.
COLLECTION: The Museum of Modern Art,
New York. Louis E. Stern Collection

*The image of figures flying through space, as
in the trapeze artists of Léger's fanciful circus,
is one of several motifs that join with some
previously formed into paintings to make this
happy book. The sketched arm that hangs down
alongside his writing about these performers
captures in its weak lines the uneasy depen-
dence they must experience in their work.*

L'acrobate disparait
légèrement
sans bruit, comme
il est apparu;
dans l'ombre, une
figure à l'envers
qui se balance
doucement,
une bouche qui devient
centre d'une figure,
le battement des
paupières dans
cette face
angoissé

21

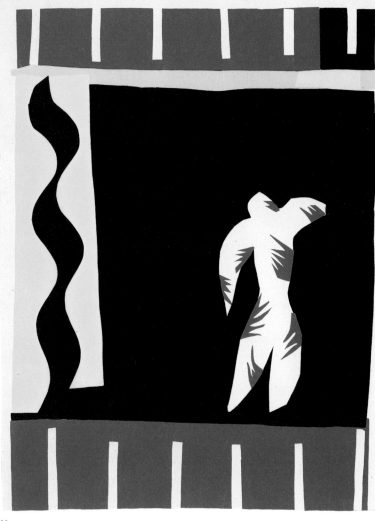

22

HENRI MATISSE
French. 1869–1954

Jazz

AUTHOR: Henri Matisse.
PUBLISHER: [Paris]: Tériade Editeur, 1947.
First edition.
PAGINATION: 164 pages: (4), [1–8], 9–146, (14).
PAGE SIZE: 16½ x 12¹¹/₁₆" (42 x 32.2 cm), irreg.
IMAGES: 20 pochoirs in color (executed
1946–47); reproductions (wrapper front and
back, table of images, and 15 ornaments) in
black; on ivory wove Arches paper.
IMAGES SHOWN: Above, *Le Clown*, 16³/₁₆ x
11¹⁵/₁₆" (41.1 x 30.3 cm), irreg.; opposite, *Les
Codomas*, 16⁷/₁₆ x 25½" (41.7 x 64.8 cm), irreg.
HOUSING: Publisher's ivory wove paper wrap-
per with reproductions of drawings on front and
back; black linen solander box, lined with cream
paper, and quarter black and red leather over
black linen slipcase, made by Gerhard Gerlach
for Louis E. Stern.

EDITIONS: Book: 270: 250 numbered 1–250
(this copy, no. 132, signed); 20 *hors-commerce*,
numbered I–XX; portfolio without text: 100
numbered 1–100.
PRINTERS: Pochoirs, Edmond Vairel; wrapper,
ornaments, and text, Draeger Frères, Paris.
BOOK DESIGNER: Henri Matisse.
TYPOGRAPHY: Artist's manuscript.
CATALOGUE RAISONNÉ: Duthuit 22 and
22 bis.
COLLECTION: The Museum of Modern Art,
New York. Louis E. Stern Collection

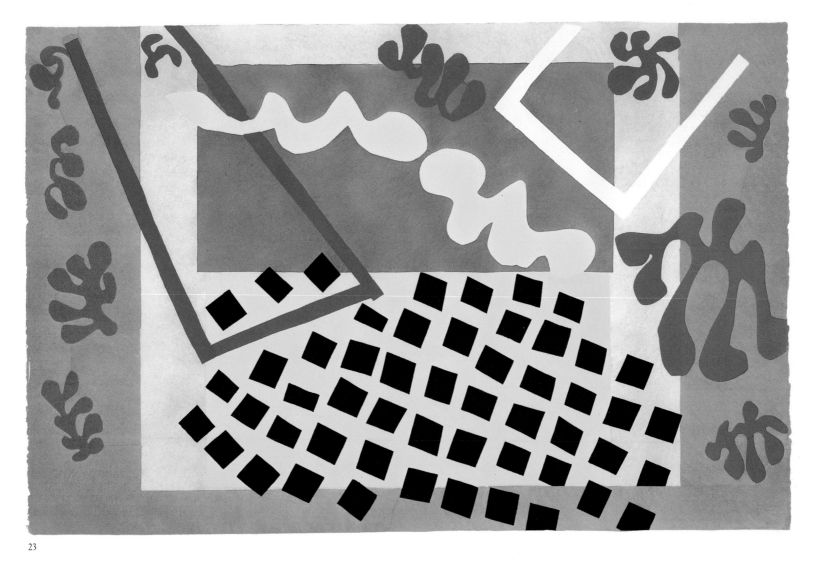

23

With his brilliant colors and bold shapes spread over pairs of generous pages, Matisse produced a new type of artwork in Jazz. Its appearance in portfolio format allowed it to be exhibited on walls instead of in glass cases, and ultimately younger artists tried to emulate its bright, flat colors. Because the stencil technique (in this case, pochoir) was largely a commercial one, it easily appealed to those who later chose advertisements and other consumer-graphics as their subjects. Many of Matisse's own subjects in Jazz came from popular entertainment forms, so the distance between the sources in 1947 and Pop art of the 1960s was not that extreme.

JEAN (HANS) ARP, GEORGES
BRAQUE, CAMILLE BRYEN, MARC
CHAGALL, OSCAR DOMINGUEZ,
SERGE FÉRAT, ALBERTO
GIACOMETTI, ALBERT GLEIZES,
RAOUL HAUSMANN, HENRI
LAURENS, FERNAND LÉGER,
ALBERTO MAGNELLI, ANDRÉ
MASSON, HENRI MATISSE, JEAN
METZINGER, JOAN MIRÓ, PABLO
PICASSO, LÉOPOLD SURVAGE,
SOPHIE TAEUBER-ARP, EDGARD
TYTGAT, JACQUES VILLON, WOLS

Poésie de mots inconnus

AUTHORS: Various.
PUBLISHER: Paris: Le Degré 41 [Iliazd], 1949.
First edition of some texts.
PAGINATION: 29 folios: (2), [1], 2–26, (1).
PAGE SIZE: 12¹³⁄₁₆ x 9¹³⁄₁₆" (32.5 x 25 cm), irreg.
IMAGES: 7 woodcuts, 4 in black, 3 in color; 1
linoleum cut, in color; 6 etchings (1 with engrav-
ing and 1 with aquatint), in black; 2 engravings,
in black; 3 drypoints, in black; 2 aquatints (1 with
soft-ground etching), 1 in black, 1 in color; and
6 lithographs (2 transfer), 3 in black, 3 in color;
on cream laid Ile de France paper.
IMAGES SHOWN: Left, Miró (Spanish. 1893–
1983), Untitled, lithograph, with poem, "Toto-
vaca," by Tristan Tzara (Samuel Rosenstock;
French, born Romania. 1896–1963), 9¾ x 6⅞"
(24.7 x 178.5 cm), irreg.; right, Wols (Otto

Alfred Wolfgang Schulze; German. 1913–1951),
Figure, drypoint, with excerpts from play by
Iliazd (Ilia Zdanevitch; Russian. 1894–1975),
6⁵⁄₁₆ x 4⁷⁄₁₆" (16.1 x 11.3 cm).
HOUSING: Publisher's vellum wrapper for
folded sheets, with line-block reproduction after
drawing by Georges Ribemont-Dessaignes; pub-
lisher's two cream wove Auvergne paper interior
wrappers under exterior wrapper of vellum
around cream wove Auvergne paper; publisher's
quarter vellum over brown paperboard solander
box, lined with cream paper.
EDITIONS: Book: 158: 115 numbered 1–115
(this copy, no. 44); 41 *hors-commerce*, numbered
I–XLI, reserved for collaborators and friends;
2 *hors-commerce*, marked A–B, deposit copies;
portfolio: 13 numbered 13/1–13/13, 10 on China
paper and 3 on wove paper.
PRINTERS: Chagall etching, Paul Haasen,
Paris; other intaglio prints, Lacourière, Paris;
lithographs, Mourlot Frères, Paris; woodcuts,
linoleum cut, and text, Imprimerie Union, Paris.
BOOK DESIGNER: Iliazd.
TYPOGRAPHY: Gill.
CATALOGUES RAISONNÉS: Miró: Cramer 19,
Mourlot 88. Wols: Grohmann LII.
COLLECTION: The Museum of Modern Art,
New York. Louis E. Stern Collection

When, in the late 1940s, the poet, book de-
signer, and publisher Iliazd gathered together
poetry and art from his many friends for this
book, he continued his confrontation with the
lettristes, *a French movement begun in 1946
that appeared to imitate his own and Futurist
experiments made earlier in the century. He
gave proofs of the poems to the artists, who
sketched their planned images in the areas
allotted to them. The book's sheets were meant
to be folded in quarters, but not cut, requiring
the reader to unfold and refold each one. The
element of discovery in this process was not
necessarily attractive to careful book collectors,
many of whom never allowed their copies
to be folded.*

24

25

MAX ERNST
American, born Germany. 1891–1976

65 Maximiliana, ou l'exercice illégal de l'astronomie

AUTHOR: Max Ernst.
PUBLISHER: Paris: Le Degré Quarante et Un [Iliazd], 1964. First edition.
PAGINATION: 60 folios, each 2-folio signature numbered 1–30.
PAGE SIZE: 16¹⁄₁₆ x 12" (40.8 x 30.5 cm).
IMAGES: 28 etchings, 9 with aquatint, and 6 aquatints, most in color; line-block reproductions, after the artist's "secret writing," drawings, and collages, in black and in color; on buff wove Antique Japan paper.
IMAGES SHOWN: Left page, 5½ x 4½" (14 x 11.4 cm), right page, 5 x 2¹⁵⁄₁₆" (12.7 x 7.4 cm).
HOUSING: Publisher's parchment wrapper with design, after Ernst, stamped in black on front, over 2 cream wove paper wrappers, over interior gray-green laid paper wrapper, over folded blank ocher laid paper folios and folded blank gray-green laid paper folios at front and back; publish-er's beige linen slipcase with design, after Ernst, stamped in black on spine.
EDITION: 75: 65 numbered 1–65 (this copy, no. 45, signed); 10 numbered I–X.
PRINTERS: Etchings, Georges Visat and Louis Lemoine, Paris; text, Louis Barnier and Raymond Billior, Imprimerie Union, Paris.
BOOK DESIGNER: Iliazd.
TYPOGRAPHY: Gill.
CATALOGUE RAISONNÉ: Spies and Leppien 95.
COLLECTION: The New York Public Library, Astor, Lenox, and Tilden Foundations. Spencer Collection. Gift of Dorothea Tanning

The unusual title, 65 Maximiliana, *refers to a planetoid the astronomer Ernst Wilhelm Tempel discovered in 1861 and named in honor of Maximilian II, King of Bavaria; it later was renamed Cybele. A periodically appearing comet is named after Tempel himself.*

27

Above, woodblock (for plate at right) from
A toute épreuve. [c. 1947–58]. 13 x 9¹³⁄₁₆″ (33 x
24.9 cm). The Museum of Modern Art,
New York. Gift of Gérald Cramer in honor
of Riva Castleman

28

29

JOAN MIRÓ
Spanish. 1893–1983

A toute épreuve

AUTHOR: Paul Eluard (Eugène Grindel; French. 1895–1952).
PUBLISHER: Geneva: Gérald Cramer, [1958].
PAGINATION: 52 unnumbered folios.
PAGE SIZE: 12⁹⁄₁₆ x 9¹³⁄₁₆" (32 x 25 cm).
IMAGES: 79 woodcuts (including wrapper front): 3 in color; 1 in black; 63 with collagraph, in color; 2 with collagraph, in black; 6 with collagraph and collage, in color; 3 with collagraph, in color, with collage; 1 with collagraph, in black, with collage; mostly on ivory wove Arches paper (executed 1947–58).
IMAGES SHOWN: Opposite, right, 12⁹⁄₁₆ x 6¹¹⁄₁₆" (32 x 17 cm); above, left page, 8⁵⁄₁₆ x 9³⁄₁₆" (21.2 x 23.3 cm), right page, 11¾ x 8" (29.8 x 20.4 cm); all irreg.
HOUSING: Publisher's cream laid Auvergne Richard de Bas paper wrapper with woodcut on front; publisher's cream wove paper interior wrapper; beige linen solander box lined with

gray paper; quarter multicolored leather over yellow paperboard slipcase, made by Gerhard Gerlach for Louis E. Stern.
EDITIONS: Book: 130: 6 numbered 1–6, with 2 supplementary suites, color separations for 1 print, woodcut fragment with gouache additions, and woodblock; 20 numbered 7–26, with supplementary suite and woodcut fragment with gouache additions; 80 numbered 27–106 (this copy, no. 27, signed); 24 *hors-commerce*, numbered I–XXIV, reserved for collaborators; portfolio of 4 prints with wide margins: 30 numbered 1/30–30/30.
PRINTERS: Plates, Atelier Lacourière, Paris; text, Fequet et Baudier, Paris.
BOOK DESIGNERS: Gérald Cramer, Joan Miró, and Paul Eluard.
TYPOGRAPHY: Didot, set by Fonderies Deberny et Peignot.
CATALOGUES RAISONNÉS: Cramer 49. Dupin 161–234.
COLLECTION: The Museum of Modern Art, New York. Louis E. Stern Collection

An artist whose paintings might include rope, stones, sand, and myriad bird, animal, and human forms (whose images might well have been found in mail-order catalogues) could be expected to be inventive when asked to make a book around the poem of a good friend, using a medium he had never tried. His response was to use planks of wood, plastic wood, wire, old wood engravings, and bark paper to achieve the truly exuberant embellishments that dance on the pages of this perfectly produced book.

30

LARRY RIVERS
American, born 1923

Stones

AUTHOR: Frank O'Hara (American. 1926–
1966).
PUBLISHER: [West Islip, N.Y.]: Universal
Limited Art Editions, [1960]. First edition.
PAGINATION: 14 folios: (*1*), 1–12, (*1*).
PAGE SIZE: 18¹¹⁄₁₆ x 23⅝" (47.5 x 60 cm), irreg.
IMAGES: 13 lithographs (including title page),
in black on white wove Douglas Howell paper
(executed 1957–60); 1 oil drawing (inscribed
"MoMA" on wrapper).
IMAGE SHOWN: *Will We Ever Get*, 12¹¹⁄₁₆ x
18¹³⁄₁₆" (32.3 x 47.8 cm), irreg.
HOUSING: Publisher's blue, rough, wove paper
wrapper, with oil drawing on front, in ivory
paperboard folder with ivory ribbon tie, lined
with ivory linen.
EDITION: More than 30: 25 numbered I–XXV
(this copy, no. I, signed); 5 artist's proofs,
marked A–E; several trial proofs.
PRINTER: Robert Blackburn at Universal
Limited Art Editions, West Islip, N.Y.
BOOK DESIGNERS: Frank O'Hara and Larry
Rivers.
TYPOGRAPHY: Author's manuscript.

CATALOGUE RAISONNÉ: Sparks Rivers 11–24.
COLLECTION: The Museum of Modern Art,
New York. Gift of Mr. and Mrs. E. Powis Jones

*Rivers and O'Hara collaborated much more
closely on their book than other artists and writ-
ers previously had done. The sheets for* Stones
*were the result of conversations that were con-
ducted with lithographic crayons on the litho-
graphic stones that gave the work its title.
O'Hara wrote a few words (backward, since
they would reverse in printing) on the stone,
and Rivers replied to them by drawing what he
felt would carry on or complete the poem.*

ROBERT MOTHERWELL
American. 1915–1991

A la pintura / To Painting

AUTHOR: Rafael Alberti (Spanish, born 1902). Trans. by Ben Belitt.
PUBLISHER: West Islip, N.Y.: Universal Limited Art Editions, 1972.
PAGINATION: 24 unnumbered folios.
PAGE SIZE: 25⁹⁄₁₆ x 37¹⁵⁄₁₆" (65 x 96.5 cm).
IMAGES: 19 aquatints and/or lift-ground aquatints (most with etching, soft-ground etching, and/or line block), 1 etching, and 1 soft-ground etching (2 in black and 19 in color) on ivory wove J. B. Green paper (executed 1968–72).
IMAGE SHOWN: *Blue 1–3*, 18⅛ x 10¾" (46 x 27.3 cm).
HOUSING: Unbound without wrapper. Publisher's white-formica-laminated wood box with clear plexiglass top, brass handles, and sliding drawer with brass nautical fittings, designed by Motherwell.
EDITION: 50: 40 numbered 1/40–40/40 (this copy, no. 1/40, signed); 8 artist's proofs, numbered 1/8–8/8; 2 publisher's proofs, numbered 1/2–2/2.
PRINTERS: Plates, Donn Steward at Universal Limited Art Editions, West Islip, N.Y.; text, Juda Rosenberg.
TYPOGRAPHY: Set by Esther Pullman.
CATALOGUES RAISONNÉS: Belknap 82–102. Sparks Motherwell 15–38.
COLLECTION: The Museum of Modern Art, New York. Gift of Celeste Bartos

In following Alberti's ode to the glories of color, Motherwell varied one of his familiar compositions that he called Opens to emphasize the diverse perceptions of each hue. Each flat sheet is a single composition, containing one or two aquatints juxtaposed with stanzas of the poem printed in English and Spanish in separate colors. The artist conceived of these large sheets resting in a box, the top of which is transparent and allows them to be seen and displayed, one at a time.

Blue Azul

1
Blue was; and then painted itself into Time.

 Llegó el azul. Y se pintó su tiempo.

2
How many blues make a Mediterranean?

 ¿Cuántos azules dio el Mediterráneo?

3
Venus, oceanic mother-of-blues.

 Venus, madre del mar de los azules.

31

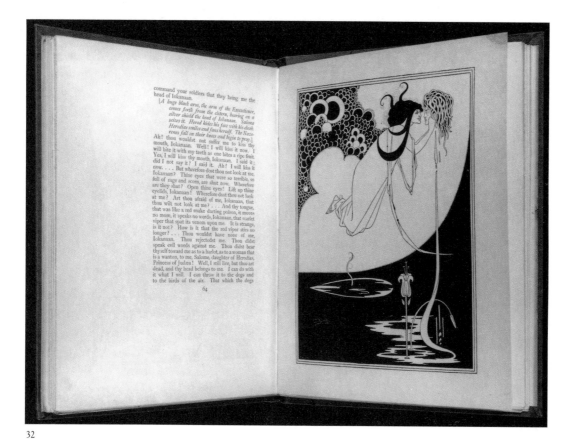

32

AUBREY BEARDSLEY
British. 1872–1898

Salome, a Tragedy in One Act

AUTHOR: Oscar Wilde (British. 1854–1900).
Trans. from French by Lord Alfred Bruce
Douglas.
PUBLISHERS: London: Elkin Mathews & John
Lane; Boston: Copeland & Day, 1894. First
English edition.
PAGINATION: 88 pages: (4), [1], 2–66, [67],
(17); 10 plates *hors-texte*.
PAGE SIZE: 8½ x 6⅛" (21.6 x 16.8 cm).
IMAGES: 13 line-block reproductions after
drawings (including title page, list of illustra-
tions, and tailpiece), in black on cream wove
paper.
IMAGE SHOWN: 6¾ x 4¹³⁄₁₆" (17.1 x 12.2 cm).
HOUSING: Publisher's green silk binding with
gold-leaf design, after Beardsley, stamped on
front, back, and spine; cream wove endpapers.
EDITION: 600: 500 regular; 100 large deluxe, for
English ed., bound in green silk (this copy).
PRINTERS: Plates engraved by Carl Hentschel;
text and plates printed by T. and A. Constable,
Edinburgh.
COLLECTION: The New York Public Library,
Astor, Lenox, and Tilden Foundations.
Henry W. and Albert A. Berg Collection

*This book's publication year is the same as
that of Toulouse-Lautrec's* Yvette Guilbert.
*Beardsley was only twenty-two years old when
he made his drawings for Wilde's play; but,
like the French artist, he was already notorious,
estranged from the society of his birth, and an
instinctive and superb draftsman. He created
a unique style that was to symbolize for
many the epitome of late nineteenth-century
exoticism.*

EDWARD BURNE-JONES
British. 1833–1898

WILLIAM MORRIS
British. 1834–1896

*The Works of Geoffrey Chaucer,
Now Newly Imprinted*

AUTHOR: Geoffrey Chaucer (British. c. 1343–1400).
PUBLISHER: Hammersmith [London]: Kelmscott Press, [1896].
PAGINATION: 567 pages: (6'), [i], ii, [iii], [1], 2–554, (4).
PAGE SIZE: 16⅛ x 11⅛" (42.2 x 28.2 cm), irreg.
IMAGES: 87 wood engravings, after drawings by Burne-Jones (cut by W. H. Hooper); and wood engravings, after designs by Morris, including ornamental title page, 87 frames (many repeats), 117 borders (many repeats), 34 words (11 repeats), and 2,057 initials (many repeats); in black on ivory laid paper (executed 1893–96).

IMAGES SHOWN: Each page, Morris, decorative border, 14⅞ x 10⁵⁄₁₆" (37.8 x 26.2 cm), right page, wood engraving, after Burne-Jones, 5⅛ x 6⅝" (13 x 16.8 cm).
HOUSING: Full red leather binding with ivory laid endpapers, made by Gerhard Gerlach for Louis E. Stern.
EDITION: 437: 12 on vellum, including 4 *hors-commerce*; 425 on paper (this copy).
PRINTER: William Morris at Kelmscott Press, Hammersmith, London.
BOOK DESIGNER: William Morris.
TYPOGRAPHY: Chaucer, designed by Morris.
CATALOGUE RAISONNÉ: Peterson A40.
COLLECTION: The Museum of Modern Art, New York. Louis E. Stern Collection

The germ that inhabits the enthusiast who must have a printing press, must design a new font of type, must find new and better (or old and better) papers, and must make beautiful books is only slightly different from, though less potent, perhaps, than that infecting the artist. Morris, on whose press this imposing volume was printed, nearly overwhelmed the pictorial areas he made available to the work of his friend Burne-Jones with his decorative letters, borders, and page designs. Morris's revivalist, neo-medieval vision pervades this work and provides an evident contrast with volumes dominated by the work of modern artists.

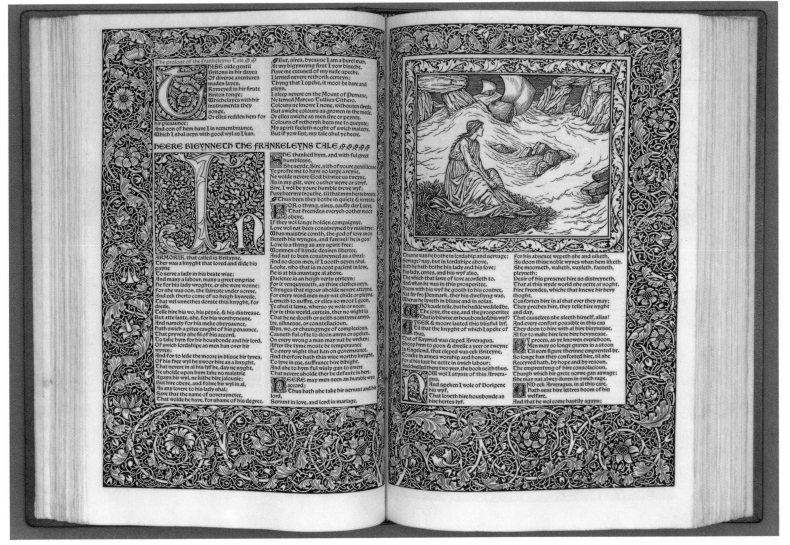

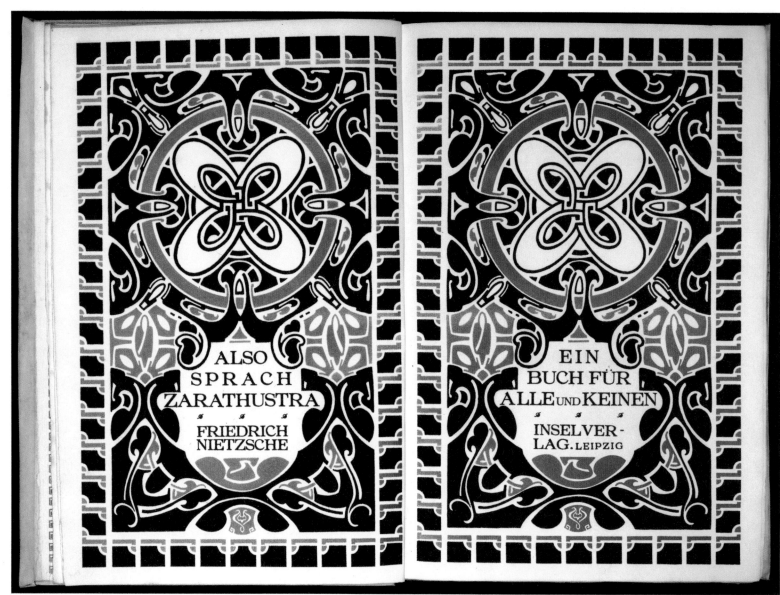

34

HENRY VAN DE VELDE
Belgian. 1863–1957

*Also sprach Zarathustra, ein Buch für Alle
und Keinen*

AUTHOR: Friedrich Nietzsche (German. 1844–
1900).
PUBLISHER: Leipzig: Insel Verlag, 1908.
PAGINATION: 170 pages: (6), [1–4], 5–160,
[161], (3).
PAGE SIZE: 14⅛ x 10⅛" (37 x 25.4 cm).
IMAGES: Line-block reproductions, after designs
by van de Velde, in color on ivory wove paper.
IMAGE SHOWN: Title spread, each page, 13¹¹⁄₁₆ x
8¹¹⁄₁₆" (34.8 x 22.1 cm).
HOUSING: Publisher's Japanese vellum binding,
with designs, after van de Velde, gilt-stamped on
front and spine; ivory wove endpapers.

EDITION: 530: 100 numbered 1–100, bound in
leather; 430 numbered 101–530, bound in Japa-
nese vellum (this copy, no. 190).
PRINTER: W. Drugulin, Leipzig.
BOOK DESIGNER: Henry van de Velde.
TYPOGRAPHY: Designed by George Lemmen.
COLLECTION: The New York Public Library,
Astor, Lenox, and Tilden Foundations. Spencer
Collection

*The Belgian architect and designer created
two books devoted to the texts of Friedrich
Nietzsche,* Ecce Homo *and this one. The inter-
lacings of letter forms in the refined version of
Art Nouveau that characterized van de Velde's
work are given their most opulent presentation
on the title page of* Also sprach Zarathustra.

OSKAR KOKOSCHKA
British, born Austria. 1886–1980

Die träumenden Knaben

AUTHOR: Oskar Kokoschka.
PUBLISHER: Leipzig: Kurt Wolff Verlag, 1917.
(First edition, Vienna: Wiener Werkstätte, 1908;
unsold copies reissued 1917.)
PAGINATION: 10 unnumbered folios.
PAGE SIZE: 9⁷⁄₁₆ x 10¹³⁄₁₆" (24 x 27.5 cm).
IMAGES: 8 transfer lithographs, in color (exe-
cuted 1906–08), and 2 line-block reproductions,
after drawings (front cover and half-title page),
in black, on cream wove paper.
IMAGE SHOWN: *Das Mädchen Li und ich*, 9⁷⁄₁₆ x
10⁷⁄₈" (24 x 27.7 cm).
HOUSING: Publisher's beige linen cover bound
with black cord, with reproduction, after
Kokoschka, mounted on front; cream endpapers.
EDITION: Wiener Werkstätte: 500: 275 num-
bered 1–275, reissued in 1917 (this copy, no. 54).
PRINTER: Berger und Chwala, Vienna.
CATALOGUES RAISONNÉS: Wingler and Welz
22–29. Arntz 1–8.
COLLECTION: The Museum of Modern Art,
New York. Louis E. Stern Collection

*Commissioned by the workshop from which the
most important products of Viennese Art
Nouveau, or Jugendstil, originated, the student
artist Kokoschka created this tale of young love.
Most copies remained unsold, and they were
taken by a commercial publisher nine years
later and reissued with new covers.*

35

AND GOD SAID LET THERE BE
LIGHTS IN THE FIRMAMENT OF THE
HEAVEN TO DIVIDE THE DAY
FROM THE NIGHT AND LET THEM
BE FOR SIGNS AND FOR SEASONS
AND FOR DAYS AND YEARS » AND
LET THEM BE FOR LIGHTS IN THE
FIRMAMENT OF THE HEAVEN TO
GIVE LIGHT UPON THE EARTH AND
IT WAS SO » AND GOD MADE TWO
GREAT LIGHTS THE GREATER LIGHT
TO RULE THE DAY AND THE LESSER
LIGHT TO RULE THE NIGHT HE
MADE THE STARS ALSO

36

PAUL NASH
British. 1889–1946

Genesis

AUTHOR: Bible.
PUBLISHER: Soho [London]: The Nonesuch
Press, 1924.
PAGINATION: 30 unnumbered folios (including
flyleaves).
PAGE SIZE: 10⁷⁄₁₆ x 7½" (26.5 x 19 cm), irreg.
IMAGES: 12 wood engravings, in black on cream
laid Zanders paper.
IMAGE SHOWN: *The Sun and the Moon*, 4⁷⁄₁₆ x
3⁷⁄₁₆" (11.3 x 8.8 cm).
HOUSING: Publisher's black linen binding with
closed-bolt pages; cream endpapers.
EDITION: 375 numbered 1–375 (this copy,
no. 75).
PRINTER: Curwen Press, London.

TYPOGRAPHY: Neuland, designed by Rudolf
Koch.
CATALOGUES RAISONNÉS: Fletcher 42–53.
Postan w42–w53.
COLLECTION: The Museum of Modern Art,
New York. A. Conger Goodyear Fund

*Adding images to the Bible has generally been
the work of illustrators attempting to make the
events and characters adaptable to contempo-
rary life. Nash made abstract compositions to
illustrate the daily transformations related in
the first chapter of Genesis and to evoke the
atmosphere of the beginning of the world and
its inhabitants.*

BEN SHAHN
American, born Lithuania. 1898–1969

The Alphabet of Creation

AUTHOR: Moses de Léon (Moses ben Shem Tov de Léon).
PUBLISHER: New York: Pantheon, 1954.
PAGINATION: 24 unnumbered folios and 1 bound supplementary drawing.
PAGE SIZE: 10¹³⁄₁₆ x 6¹¹⁄₁₆" (27.5 x 17 cm).
IMAGES: 43 line-block reproductions, after brush- or pen-and-ink drawings; supplementary brush- and pen-and-black-ink drawing (frontispiece); on ivory wove Umbria paper.
IMAGES SHOWN: Left page, drawing, 3¹³⁄₁₆ x 3¹⁄₁₆" (9.7 x 7.8 cm), irreg., right page, 2¾ x 4" (7 x 10.2 cm), irreg.
HOUSING: Publisher's beige linen binding with design, after Shahn, mounted on front; ivory wove endpapers; publisher's brown paperboard slipcase.
EDITION: 550: 50 numbered 1–50 on Umbria paper, with supplementary drawings (this copy, no. 1); 500 numbered 51–550 on Rives paper.

PRINTER: The Spiral Press, New York.
TYPOGRAPHY: Emerson.
CATALOGUE RAISONNÉ: Prescott, page 231.
COLLECTION: The Museum of Modern Art, New York. Louis E. Stern Collection

Shahn's screenprints were potent carriers of social commentary in the 1940s. He brought to his art making a committed sense of morality as well as an interest in the symbols and stories of the Bible. This well-designed publication of the Hebrew alphabet was printed at America's illustrious Spiral Press.

37

ARISTIDE MAILLOL
French. 1861–1944

The Eclogues

AUTHOR: Virgil (Roman. 70–19 B.C.). Trans. by J. H. Mason.
PUBLISHER: London: Emery Walker Limited [for Cranach Presse], 1927.
PAGINATION: 127 pages: (8), [1–3], 4–110, [111], (8).
PAGE SIZE: 12¹⁵⁄₁₆ x 9¹¹⁄₁₆" (33 x 24.6 cm), irreg.
IMAGES: 44 wood engravings (including Cranach Presse publisher's vignette); 3 ornaments (including 1 repeat); and 16 initials (ornamented by Maillol and cut by Eric Gill, 3 repeats); in black on ivory laid Maillol paper (executed 1912–25).
IMAGE SHOWN: *Tityrus Playing on His Pipe*, 3⅝ x 4¹⁄₁₆" (9.2 x 10.3 cm).
HOUSING: Quarter beige linen over blue paperboard binding, ivory laid endpapers.

EDITIONS: English: 264: 200 numbered 1–200 on Maillol paper (this copy, no. 22, uncut); 25 *hors-commerce*, numbered 201–225 on Maillol paper; 6 marked A–F on vellum, including 1 *hors-commerce*; 25 numbered I–XXV on Imperial Japan paper; 8 *hors-commerce*, numbered XXVI–XXXIII; German (1926): 304; French (1926): 292.
PRINTER: Cranach Presse, Weimar.
BOOK DESIGNER: Count Harry Kessler.
TYPOGRAPHY: Title page, Eric Gill; roman, after Nicolas Jensen, designed by Edward Prince; italic, Edward Johnston.
CATALOGUES RAISONNÉS: Rewald 8–52. Guérin 15–58.
COLLECTION: The Museum of Modern Art, New York. Henry Church Fund

This is the first of several classic books illustrated by the sculptor. The pages of his equally admired, small Daphnis et Chloé *by Longus of*

1937, like The Eclogues, *were based on the Italian Renaissance design in which a picture is placed within a square or rectangle above a well-designed block of type. Both books share the clarity that linear images and type of the proper design and weight give to a page.*

PABLO PICASSO
Spanish. 1881–1973

Les Métamorphoses

AUTHOR: Ovid (Roman. 43 B.C.–A.D. 18). Trans. by Georges Lafaye.
PUBLISHER: Lausanne: Albert Skira Editeur, 1931.
PAGINATION: 412 pages: (*4*), [1–6], 7–394, [395], (*13*); 15 plates *hors-texte*.
PAGE SIZE: 12¹³⁄₁₆ x 10¼" (32.5 x 26 cm), irreg.
IMAGES: 30 etchings, in black on cream laid Arches paper (executed 1930–31).
IMAGE SHOWN: *Chute de Phaéton avec le char du soleil*, 8¹¹⁄₁₆ x 6¹¹⁄₁₆" (22.7 x 17 cm), irreg.
HOUSING: Publisher's cream wove Japan paper wrapper; gray-brown linen solander box lined with gray paper; quarter red leather over gray-brown linen slipcase, made by Gerhard Gerlach for Louis E. Stern.
EDITION: 145: 5 numbered 1–5 on Imperial Japan paper, with 2 supplementary suites and drawing; 25 numbered 6–30 on Imperial Japan paper, with supplementary suite; 95 numbered 31–125 on Arches paper (this copy, no. 79, signed); 20 *hors-commerce*, numbered I–XX, reserved for collaborators.
PRINTERS: Plates, Louis Fort, Paris; text, Léon Pichon, Paris.
CATALOGUES RAISONNÉS: Cramer 19. Geiser and Baer 143–172.
COLLECTION: The Museum of Modern Art, New York. Louis E. Stern Collection

In this, Picasso's first serious attempt to follow a text and provide an alternate vision of it, he exploited his innate talent for organizing line into compositions. Even where he depicted the movement of horses, they appear as if in a classic frieze, and their activity does not rupture the picture plane. The tragic moments of Ovid's tales, from Phaeton's fall to Eurydice's fatal snakebite, are depicted in the artificial poses of a tableau vivant.

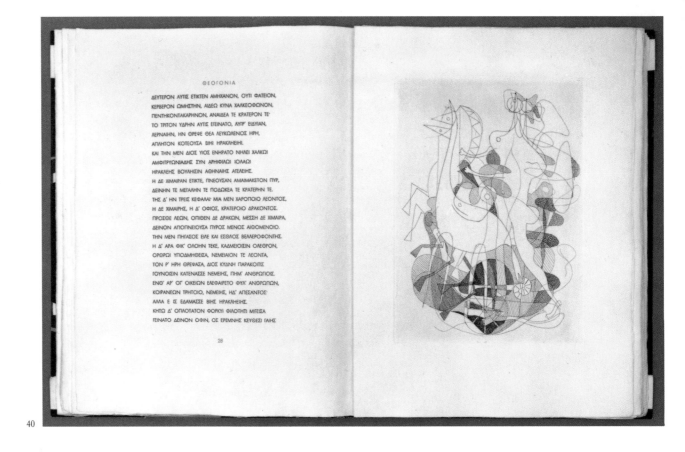

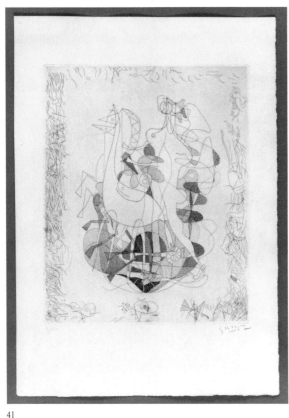

Left, plate from *Théogonie* by Hesiod (from suite). 1932. Etching with remarques. 14⁷⁄₁₆ x 11¹³⁄₁₆" (36.7 x 30 cm). Vallier 20 f. The Museum of Modern Art, New York. Louis E. Stern Collection

GEORGES BRAQUE
French. 1882–1963

Théogonie

AUTHOR: Hesiod (Greek, 8th century B.C.).
PUBLISHER: Paris: Maeght Editeur, 1955. (Commissioned by Vollard.)
PAGINATION: 90 pages: (6), [1–6], 7–77, [78], (6).
PAGE SIZE: 17½ x 13¼" (44.4 x 33.7 cm), irreg.
IMAGES: 14 etchings (2 with aquatint), 1 aquatint, and 3 photogravures, in black; 1 etching and aquatint, in color; 1 etching and aquatint, in color with varnish (wrapper front); on ivory wove Auvergne paper (except wrapper) (executed 1932–55).
IMAGE SHOWN: Above, 11⅞ x 8¾" (30.1 x 22.2 cm).
HOUSING: Publisher's cream wove paper wrapper, in black with etching and aquatint on front; black paperboard folder; black paperboard slipcase with pasted pieces of torn, painted papers; protective plexiglass case, probably made for Louis E. Stern.
EDITION: 150 numbered 1–150 (this copy, no. 31, signed).
PRINTER: Fequet et Baudier, Paris.
TYPOGRAPHY: Europe.
CATALOGUE RAISONNÉ: Vallier 23.
COLLECTION: The Museum of Modern Art, New York. Louis E. Stern Collection

Hesiod's guide to the gods was a perfect setting for Braque's interest in archaic Greek figures, which may have been ignited by his association with the Greek publisher and art critic Christian Zervos. Zervos was to publish a number of Braque's preparatory drawings in his journal Cahiers d'art in 1932, at which time Braque had completed sixteen prints. He still had not finished his work for the book by 1939 when Vollard, who had commissioned it, died. Portfolios of the prints with remarques around their edges were put together, but before the book could be completed by Aimé Maeght in 1955, three plates were lost. New plates were made photographically from early printings, all the remarques on the existing plates were removed, and other plates (frontispiece, cover, and two decorative text images) were added by the artist.

HENRI MATISSE
French. 1869–1954

Pasiphaé, chant de Minos (Les Crétois)

AUTHOR: Henry de Montherlant (French. 1896–
1972).
PUBLISHER: [Paris]: Martin Fabiani Editeur,
1944.
PAGINATION: 136 pages: (4), [1–8], 9–121,
[122–125], (7).
PAGE SIZE: 12¹³⁄₁₆ x 9¾" (32.5 x 24.8 cm).
IMAGES: 50 linoleum cuts (including head- and
tailpieces and in-text plates), in black; 1 linoleum
cut (wrapper), in color; 13 linoleum-cut orna-
mental bands and 84 linoleum-cut initials
(1 repeat), in color; on ivory wove Arches paper
(executed 1943–44).
IMAGE SHOWN: *Fraîchie sur des lits de violettes,*
9⅝ x 7¹⁄₁₆" (24.5 x 18 cm).
HOUSING: Publisher's ivory wove Arches paper
wrapper with continuous linoleum cut on front
and back; publisher's quarter ivory linen over
cream paperboard folder, lined with ivory paper;
in red-and-tan linen slipcase.

EDITION: 250: 30 numbered 1–30 on Antique
Japan paper, with supplementary suite; 200
numbered 31–230 on Arches paper (this copy,
no. 159); 20 *hors-commerce*, numbered I–XX on
Arches paper.
PRINTER: Fequet et Baudier, Paris.
CATALOGUE RAISONNÉ: Duthuit 10.
COLLECTION: The Museum of Modern Art,
New York. Louis E. Stern Collection

*A contemporary retelling of the story of
Pasiphaë and the Minoan bull was the impetus
for one of Matisse's most intensive printmaking
experiences. Working with linoleum, a fairly
easy material to use, Matisse cut many blocks
of each image to achieve the perfect flow of line
and relationship of forms. Intent on matching
the spirit and ambience of the classic tale,
Matisse took as his model ancient Greek black-
ground vase painting.*

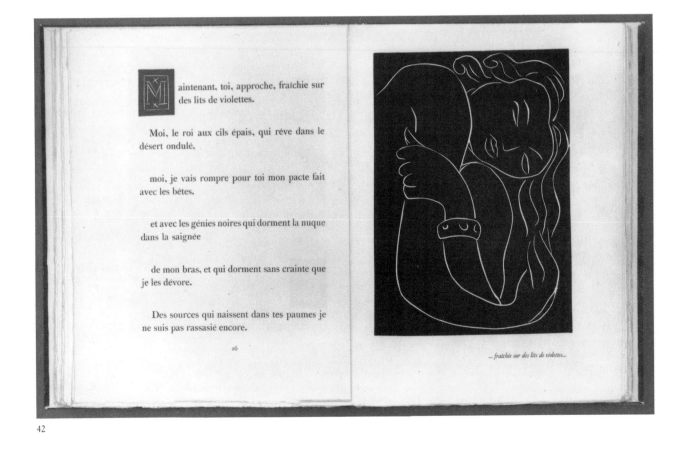

... fraîchie sur des lits de violettes...

42

43

44

ANDRÉ DUNOYER DE
SEGONZAC
French. 1884–1974

Les Géorgiques

AUTHOR: Virgil (Roman. 70–19 B.C.). Trans.
by Michel de Marolles.
PUBLISHER: [Paris: André Dunoyer de
Segonzac], 1944 [1947]. (Commissioned by
Vollard.)
PAGINATION: 2 vols. I: 212 pages: (4), [1–9],
10–201, [202–204], (4); II: 232 pages: (4), [1–9],
10–213, [214–216], (12).
PAGE SIZE: 17¹⁵⁄₁₆ x 13⅜" (45.5 x 34 cm).
IMAGES: 118 etchings (including title pages), 26
with drypoint, and 1 drypoint, in black on cream
wove Arches paper (executed 1933–46).
IMAGES SHOWN: Above, *Les Grands Chênes*,
11½ x 9⅝" (29.2 x 24.4 cm); left, *Nu étendu au
bord du golfe*, 3⅜ x 6⁵⁄₁₆" (8.6 x 16 cm), irreg.
HOUSING: 2 unbound volumes, each in publish-
er's cream wove Arches paper wrapper; 2 quarter
red leather over beige linen solander boxes, lined
with beige paper, made by Gerhard Gerlach for
Louis E. Stern.
EDITION: 275: 50 numbered 1–50, with supple-
mentary suite; 200 numbered 51–250 (this copy,
no. 214); 25 *hors-commerce*, numbered I–XXV.
PRINTERS: Plates, Jacques Frelaut at

Lacourière, Paris; text, Imprimerie Nationale,
Paris.
TYPOGRAPHY: Garamond, chosen by Vollard.
CATALOGUE RAISONNÉ: Lioré and Cailler
863–981.
COLLECTION: The Museum of Modern Art,
New York. Louis E. Stern Collection

*During the 1920s Segonzac illustrated many
contemporary texts with etchings that seemed to
capture the spirit of the times. His popularity
attracted Vollard, who commissioned this two-
volume publication filled to the brim with
deftly executed etchings of the countryside, its
produce, and its seasons.*

KURT SELIGMANN
American, born Switzerland. 1900–1962

The Myth of Oedipus

AUTHOR: Retold by Meyer Schapiro (American, born Russia, 1904).
PUBLISHER: New York: Durlacher Bros.–R. Kirk Askew, Jr., 1944. First edition.
PAGINATION: 28 pages: (2), [1–8], 9–17, [18], (8); 6 plates *hors-texte*.
PAGE SIZE: 22¹³⁄₁₆ x 15⁹⁄₁₆" (58 x 39.5 cm), irreg.
IMAGES: 6 etchings and 1 line-block reproduction, in black on ivory wove Whatman paper.
IMAGE SHOWN: *The Childhood of Oedipus*, 17¾ x 11¹¹⁄₁₆" (45.1 x 29.7 cm).
HOUSING: Publisher's ivory laid paper wrapper.
EDITION: More than 50: 50 numbered 1–50 (this copy, no. 10, signed); several unnumbered copies.
PRINTERS: Plates, Kurt Seligmann, New York; text, H. G. Kallweit.
TYPOGRAPHY: Bodoni.

CATALOGUE RAISONNÉ: Mason 117–122.
COLLECTION: The Museum of Modern Art, New York. Gift of Henry Church

With twisted, writhing figures Seligmann used the Surrealist idiom to intensify the ancient tragedy of Oedipus, the lover of his mother and murderer of his father. Seligmann began to make etchings of single figures—vampires, aviators, magicians, and others—in the early 1930s. Their bodies were constructions, odd objects in the tradition of Archimboldo and designers of tarot cards. Later in the decade the artist began to wind his figures in drapery, giving them the appearance of baroque ghosts.

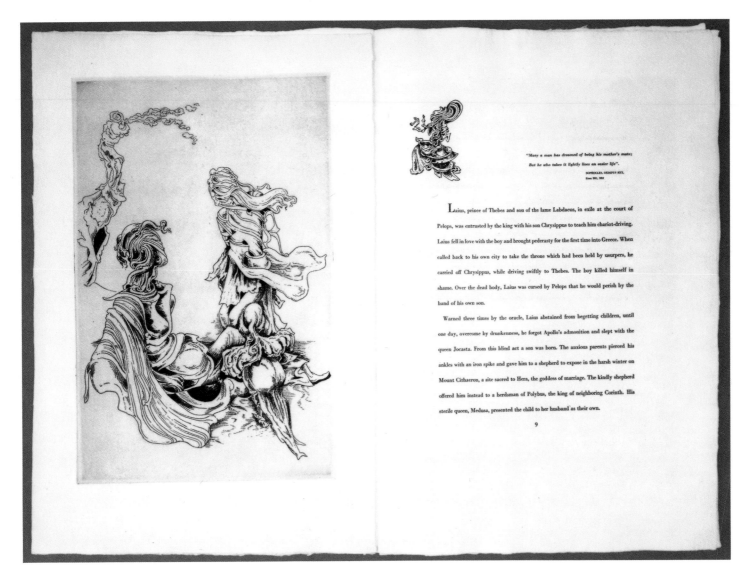

45

Je me prosterne aux pieds de Marpa de la Falaise-Du-Sud ▪▪▪ Qu'il bénisse le mendiant pour qu'il achève sa retraite au désert ▪▪▪▪ Les services rendus par mes donatrices ▪▪▪ Assureront leur salut et le mien ▪▪▪▪ Ce corps difficile à obtenir facile à détruire ▪▪▪ A retrouvé la santé grâce à la nourriture ▪▪▪▪ Le suc de la terre étroite ▪▪▪ Et la pluie de l'immensité bleue ▪▪▪ Sont un présage de profit pour les créatures ▪▪▪ Et l'essence de ce présage est la religion des dieux ▪▪▪▪ Mon corps subtil nourri par mon père et ma mère ▪▪▪ Et l'enseignement du saint lama ▪▪▪ Sont le présage de mon entrée en religion des dieux ▪▪▪ Et l'essence de ce présage est ma persévérance ▪▪▪▪ Cette grotte rocheuse dans la vallée déserte ▪▪▪ Et ma piété sincère ▪▪▪ Présagent la réalisation

GEORGES BRAQUE
French. 1882–1963

Milarepa

AUTHOR: Milarepa (Tibetan, 6th century).
Trans. by Jacques Bacot.
PUBLISHER: Paris: Maeght Editeur, 1950.
PAGINATION: 26 unnumbered folios.
PAGE SIZE: 9⅛ x 13¹⁄₁₆" (23.2 x 33.2 cm), irreg.
IMAGES: 4 aquatints (3 with etching), 1 soft-ground etching, and 6 etched initials (some repeated), in black on ivory laid Auvergne Richard de Bas paper.
IMAGE SHOWN: 7¹¹⁄₁₆ x 12¹¹⁄₁₆" (19.5 x 32.2 cm), irreg.
HOUSING: Publisher's full cream vellum wrapper, lined with buff paper; quarter black leather over red paperboard solander box, with reproduction on front, made by Gerhard Gerlach for Louis E. Stern.
EDITION: 110: 10 numbered 1–10, with supplementary suite of prints; 90 numbered 11–100 (this copy, no. 26, signed); 10 *hors-commerce*.
PRINTERS: Plates, Georges Braque with Jean Signovert, Paris; text, Fequet et Baudier, Paris.
TYPOGRAPHY: Della Robbia; ornament designed by Braque.

CATALOGUE RAISONNÉ: Vallier 63.
COLLECTION: The Museum of Modern Art, New York. Louis E. Stern Collection

The songs of the Tibetan monk Milarepa are set against Braque's flying birds, a motif that pervades his work after World War II. The birds seem indifferent to the wormlike initials the artist designed for the text.

MARC CHAGALL
French, born Russia. 1887–1985

Four Tales from the Arabian Nights

AUTHOR: Excerpts from ancient Persian, Indian, and Arabian tales. Trans. by Sir Richard Francis Burton, 1885–88.
PUBLISHER: New York: Pantheon Books, Inc., [1948].
PAGINATION: 2 parts. Book: 4 unnumbered folios and 13 plates in numbered wrappers; supplementary suite: 166 plates.
PAGE SIZE: 16⅟₁₆ x 12⅟₁₆" (43.1 x 33 cm).
IMAGES: 12 lithographs, in color; 16 photolithographic reproductions, after drawings (including duplicate on wrapper front), in black; 1 supplementary lithograph and 166 progressive proofs, in color; on cream laid paper.
IMAGES SHOWN: Left, 7⅝ x 4½" (19.4 x 11.4 cm); right, 14¹³⁄₁₆ x 11¼" (37.6 x 28.6 cm).
HOUSING: Book: publisher's ivory paperboard wrapper with reproduction on front; supplementary suite: publisher's quarter ivory linen over ivory paperboard wrapper; both in quarter brown leather over beige linen solander box and slipcase, lined with beige paper, made by Gerhard Gerlach for Louis E. Stern.
EDITION: 111: 90 numbered 1–90; 10 numbered I–X, with supplementary lithograph and proofs (this copy, no. X, signed); 11 dedicated *hors-commerce*, marked A–K, with supplementary lithograph and proofs.
PRINTERS: Plates, Albert Carman, City Island, N.Y.; text, Meriden Gravure Company, Meriden, Conn.
BOOK DESIGNER: Jacques Scheffrin.
CATALOGUE RAISONNÉ: Mourlot 36–48.
COLLECTION: The Museum of Modern Art, New York. Louis E. Stern Collection

Although Chagall had created etchings for La Fontaine's fables and the Bible before World War II, they had not been published before his escape from the Nazis to America. Enamored of exotic tales, he was inspired by those of The Arabian Nights *to produce his first color prints. To make them, he had his gouaches professionally transferred to plates, after which he made corrections and additions. Only a few words introduce each color print as a reminder of which story is depicted. The magic of each tale is in the picture.*

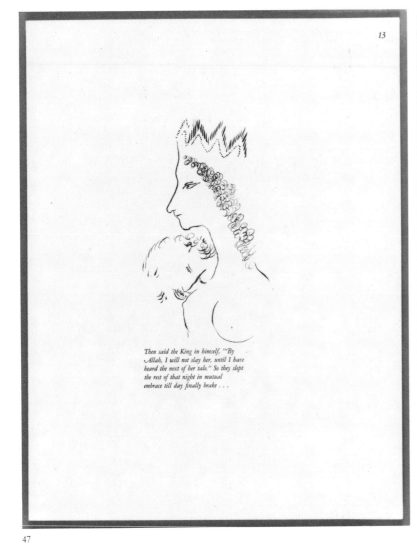

Then said the King in himself, "By Allah, I will not slay her, until I have heard the next of her tale." So they slept the rest of that night in mutual embrace till day finally brake . . .

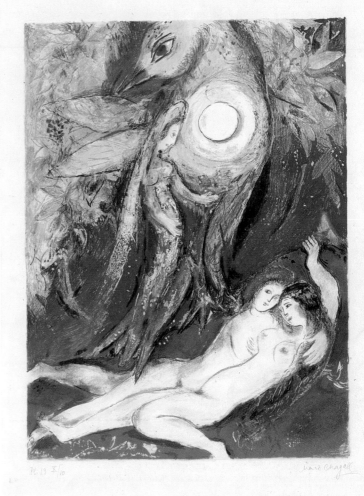

47

48

HENRI DE TOULOUSE-LAUTREC
French. 1864–1901

Histoires naturelles

AUTHOR: Jules Renard (French. 1861–1910).
PUBLISHER: Paris: H. Floury Editeur, 1899.
First edition.
PAGINATION: 50 unnumbered folios (including flyleaves).
PAGE SIZE: 12½ x 8⅞" (31.7 x 22.5 cm).
IMAGES: 23 transfer lithographs (including wrapper front), in black on cream wove Rives BFK paper (except wrapper) (executed 1897).
IMAGE SHOWN: *Le Chien*, 9⅛ x 7¹¹⁄₁₆" (23.2 x 19.6 cm), irreg.
HOUSING: Publisher's cream wove Japan paper binding, with lithograph on front; half burgundy leather over marbleized paperboard folder with flaps, lined with cream paper; marbleized paperboard slipcase with burgundy edging.
EDITION: 100 numbered 1–100 (this copy, no. 36).

PRINTERS: Plates, Henry Stern, Paris; text, Ch. Renaudie, Paris.
CATALOGUES RAISONNÉS: Delteil 297–320. Wittrock 202–224.
COLLECTION: The Museum of Modern Art, New York. Louis E. Stern Collection

Toulouse-Lautrec had drawn animals since his childhood. Although he had become famous through his representations of Parisian café life, he looked forward to making drawings for the introductory pages to each of Renard's contemporary animal fables. Unfortunately, his manner of portraying the animals did not strictly illustrate the text, and the author was displeased. Several years passed before the book was finally published.

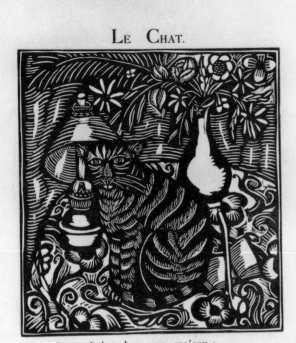

LE CHAT.

Je souhaite dans ma maison :
Une femme ayant sa raison,
Un chat passant parmi les livres,
Des amis en toute saison
Sans lesquels je ne peux pas vivre.

50

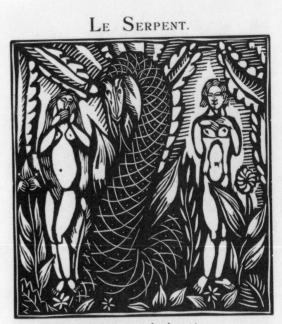

LE SERPENT.

Tu t'acharnes sur la beauté.
Et quelles femmes ont été
Victimes de ta cruauté !
Ève, Eurydice, Cléopâtre ;
J'en connais encor trois ou quatre.

51

RAOUL DUFY
French. 1877–1953

Le Bestiaire, ou cortège d'Orphée

AUTHOR: Guillaume Apollinaire (Guillaume
Apollinaire de Kostrowitsky; French, born Italy.
1880–1918).
PUBLISHER: Paris: Deplanche, Editeur d'Art,
1911.
PAGINATION: 40 unnumbered folios.
PAGE SIZE: 12¹³⁄₁₆ x 10" (32.5 x 25.5 cm), irreg.
IMAGES: 39 woodcuts (including ornament;
5 pictorial initials, 1 repeated; head- and tail-
pieces), in black on ivory wove Holland paper.
IMAGES SHOWN: Left, *Le Chat*, 8⅛ x 7⁹⁄₁₆"
(20.6 x 19.2 cm); right, *Le Serpent*, 7¹⁵⁄₁₆ x 7⅝"
(20.3 x 19.4 cm).
HOUSING: Publisher's ivory vellum binding,
with ivory laid flyleaves; full black leather solan-
der box with reproductions inset on front and
back, lined with cream paper. made by Gerhard
Gerlach for Louis E. Stern.
EDITION: 122: 29 numbered 1–29 on Imperial
Japan paper; 91 numbered 30–120 on Holland
paper (this copy, no. 116, signed); 2 *hors-*

commerce, with canceled proofs for deposit
copies.
PRINTER: Gauthier-Villars, Paris.
CATALOGUE RAISONNÉ: Courthion 2.
COLLECTION: The Museum of Modern Art,
New York. Louis E. Stern Collection

*In this first bestiary of the twentieth century,
each group of animals introduced by the
legendary poet-musician Orpheus is repre-
sented through the voice of its inimitable
author, Apollinaire.*

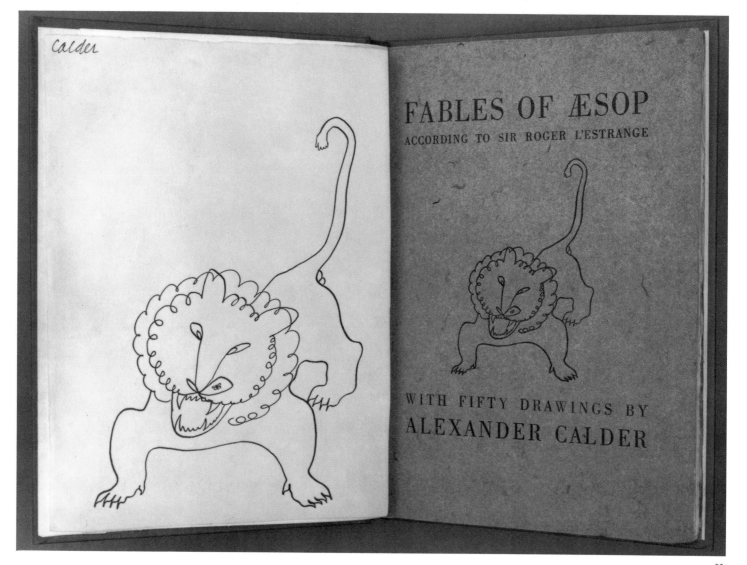

ALEXANDER CALDER
American. 1898–1976

Fables

AUTHOR: Aesop (Greek. c. 620–560 B.C.).
Trans. by Sir Roger L'Estrange, 1692.
PUBLISHERS: Paris: Harrison; New York:
Minton, Balch and Company, [1931].
PAGINATION: 138 pages: (*10*), 1–124, (*4*);
unbound drawing.
PAGE SIZE: 9¹³⁄₁₆ x 7¹¹⁄₁₆" (25 x 19.5 cm), irreg.
IMAGES: 52 line-block reproductions, after pen-
and-ink drawings on ivory, with colored-thread,
laid Guarro Spanish paper; 1 supplementary pen-
and-ink drawing (reproduced as a headpiece on
page 13 and on cover of regular edition) on
cream wove paper.
IMAGES SHOWN: Left side, *A Gnat Challenges
a Lyon* (drawing), 9¹³⁄₁₆ x 7¼" (24.9 x 18.4 cm);
right side, cover of regular edition, 4½ x 3³⁄₁₆"
(11.4 x 8.1 cm).

HOUSING: Publisher's ivory, with colored-
thread, laid Guarro Spanish paper binding,
boards, and endpapers.
EDITIONS: 665: 595 numbered 1–595 on
Auvergne paper, 425 reserved for American
distribution; 50 numbered I–L on Guarro paper,
with supplementary drawing, 30 reserved for
American distribution (this copy, no. II, signed);
20 *hors-commerce.*
PRINTER: Aimé Jourde, Paris.
BOOK DESIGNER: Monroe Wheeler.
TYPOGRAPHY: French Round Face.
COLLECTION: The Museum of Modern Art,
New York. Gift of Monroe Wheeler

*Limited-edition copies of this earliest Calder
book contained his original drawings for the
illustrations. The lion with a gnat on his nose
was used on the jacket of the regular edition of
Aesop's Fables.*

ANTONIO FRASCONI
Uruguayan, born Argentina, 1919

12 Fables of Aesop

AUTHOR: Aesop (Greek. c. 620–560 B.C.).
Retold by Glenway Wescott.
PUBLISHER: New York: The Museum of
Modern Art, 1954. First edition.
PAGINATION: 20 unnumbered folios.
PAGE SIZE: 10½ x 7½" (26.6 x 19 cm).
IMAGES: 17 linoleum cuts (including slipcase),
15 in black and 2 in color on ivory wove Rives
paper.
IMAGE SHOWN: *The Starved Farmer and His
Fat Dogs*, 8¹/₁₆ x 13⁹/₁₆" (20.5 x 34.4 cm), irreg.
HOUSING: Publisher's quarter red linen over
cream paperboard binding, with reproduction on
front and back and ivory wove endpapers; pub-
lisher's black paperboard slipcase with linoleum-
cut label mounted on front.

EDITION: 1,000: 975 numbered 1–975; 25 *hors-
commerce*, marked A–Y (this copy, marked A,
signed).
PRINTER: The Spiral Press, New York.
BOOK DESIGNER: Joseph Blumenthal.
TYPOGRAPHY: Emerson.
COLLECTION: The Museum of Modern Art,
New York

*After he moved to the United States in 1945,
Frasconi used his printmaking skill to create
books, many of which were commercially pub-
lished. In 1950 he produced a portfolio of four-
teen woodcuts titled* Some Well-Known Fables,
*which probably encouraged the publication of
this book by The Museum of Modern Art four
years later in both clothbound and paperbound
editions.*

The Starved Farmer and His Fat Dogs

One severe winter an unfortunate farmer, to provide
for his starving women and children, had to slaughter
all his livestock: first his sheep, then his goat, then
his cow. Meanwhile his dogs had a good life under the
table, wolfing down the titbits, gnawing the bones. But
when the last bit of cow was served, they took to the
tall timber.

"Mutton is good eating," they said to themselves;
"goat is not bad; cow is edible. And dog," they con-
cluded, "a man can eat dog if he's hungry enough."

OLGA ROZANOVA
Russian. 1886–1918

Vojna

AUTHOR: Alexei Kruchenykh (Russian. 1886–
1969).
PUBLISHER: [St. Petersburg: Olga Rozanova
and Alexei Kruchenykh, 1916]. First edition.
PAGINATION: 16 unnumbered folios.
PAGE SIZE: 15⅛ x 11⅞" (38.5 x 30.2 cm).
IMAGES: 10 woodcuts (1 with collage), 3 in
black and 7 in color, most on cream wove paper;
1 collage (cover).
IMAGES SHOWN: Left, *Airplanes over the City*,
15⅛ x 11¹⁵⁄₁₆" (38.5 x 30.3 cm), irreg.; right,
Excerpt from a Newspaper Bulletin, 14⅝ x 10⅛"
(37.1 x 25.7 cm), irreg.
HOUSING: Publisher's brown wove paper cover,
with woodcut lettering and collage, bound with
staples.
EDITION: 100 announced (this copy without
cover).
TYPOGRAPHY: Woodcut text.

COLLECTION: The Museum of Modern Art,
New York. Prints and Illustrated Books
Endowment Fund, Abby Aldrich Rockefeller
Fund (by exchange), Mary Ellen Meehan Fund,
Riva Castleman Fund, Purchase, and Purchase
(by exchange)

*The recurring theme of war in literature and art
was particularly compelling to Russians when
their involvement in World War I was termi-
nated by the conflicts of their revolution. The
horrors of the war, reported in newspapers, and
the new terror of attack from the sky are em-
phasized in Rozanova's borrowings of news
items and visions of airplanes that accompany
the short poems of her husband. The Russian
Cubo-Futurist style, well-illustrated in the col-
lage that combines woodcuts filled with vigor-
ous diagonal cuts and colored paper, provides a
dynamic mode of presenting war's heroes and
victims.*

GEORGES ROUAULT
French. 1871–1958

Miserere

AUTHOR: Georges Rouault.
PUBLISHER: Paris: Edition de L'Etoile Filante,
1948. (Commissioned by Vollard.)
PAGINATION: 188 unnumbered folios.
PAGE SIZE: 25¹⁵⁄₁₆ x 19¾" (66 x 50.2 cm), irreg.
IMAGES: 58 aquatints and lift-ground aquatints
over photogravure, with drypoint, roulette, etch-
ing, and/or soft-ground etching, in black on
cream laid Arches paper (executed 1922–27).
IMAGES SHOWN: Left, *Plus le coeur est noble,
moins le col est roide*, 23⅛ x 16⅝" (58.7 x 42.3 cm);
right, *Qui ne grime pas?*, 22¼ x 16⅞" (56.5 x
42.8 cm).
HOUSING: Publisher's quarter cream vellum
over red-brown linen folder, with flaps and brass
fastener, lined with cream paper.
EDITION: 450: 425 numbered 1–425 (this copy,
no. 266); 25 *hors-commerce*, numbered I–XXV.
PRINTERS: Plates, Jacquemin, Paris; text,
Aulard, Paris.

CATALOGUES RAISONNÉS: Chapon and
Rouault 54–111. Chapon, pages 74–99.
COLLECTION: The Museum of Modern Art,
New York. Louis E. Stern Collection

*Rouault responded to the devastation of land,
humanity, and hope produced by World War I
with a combination of reverence and despair.
His plan to create a series of prints that inter-
twined episodes from the life of Christ with the
recent experience of war included visionary and
satiric titles for each image. In the tradition of
Goya's series of prints of more than a century
earlier, which had similarly ironic titles, the
fifty-eight plates of Miserere form a strongly
linked visual narrative enhanced by the author-
artist's salient commentary.*

56

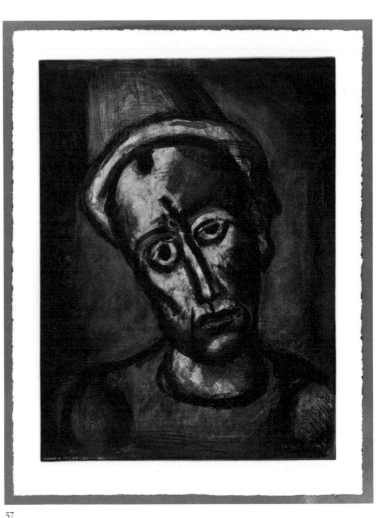

57

176 rivés, fixes d'angoisse, sur la tranchée allemande d'où jaillis-
saient les flammes courtes et droites des mausers. Puis des
rafales d'obus avaient troué la compagnie, les mitrailleuses
avaient fauché des rangées d'hommes, et de la masse frémis-
sante qui chargeait, tragique, silencieuse, il ne restait que ces
vingt hommes blottis, ces blessés qui se traînaient, geignant,
et tous ces morts...

 Gilbert, entre deux explosions, avait entendu le camarade
s'écrier : « Ah ! c'est fini ! » Le blessé s'était encore traîné quel-
ques mètres, comme une bête écrasée, et il était mort là, dans
un sanglot. Etait-ce triste ? A peine... Dans ce champ pauvre
aux airs de terrain vague, cela faisait un cadavre de plus, un
autre dormeur bleu qu'on enterrerait après l'attaque, si l'on
pouvait. A quelques pas, sous un tertre crayeux, des Boches
étaient enfouis : leur croix servirait pour les nôtres, un calot
gris sur une branche, un calot bleu sur l'autre.

 — Alors, qu'est-ce qu'on va foutre ? demanda Hamel dont la
manche déchirée laissait couler un peu de sang. Tu ne vois pas
qu'ils nous laissent en rade ?

 — Mais non, dit Gilbert. Le deuxième bâton va certainement
sortir, mais on doit attendre que l'artillerie prépare.

 — Et s'ils tirent trop court, ça sera encore pour nos gueules.

 Cachée dans les hautes herbes, la tranchée allemande se
devinait à peine, derrière la toile barbelée des araignées de fer.
Les Allemands ne tiraient plus, et leurs canons même se tai-
saient. Seuls quelques 210 essoufflés passaient très haut, avec
un glouglou de bouteille qui se vide, et allaient tomber sur le
village, empanachant les ruines d'un lourd nuage d'usine.

 Couchés au bord de l'entonnoir, quelques soldats guettaient,
l'œil au ras de l'herbe ; les autres discutaient, entassés dans
le trou.

 — Tu crois qu'on va remettre ça pour enlever leur troisième
ligne ?

 — Peut-être bien. A moins qu'on creuse une tranchée ici.

 — Sans charre, c'est pas avec ce qu'il reste de poilus qu'ils
espèrent attaquer.

58

ANDRÉ DUNOYER DE
SEGONZAC
French. 1884–1974

Les Croix de bois

AUTHOR: Roland Dorgelès (Roland Lécavelé;
French. 1886–1973).
PUBLISHER: Paris: Editions de la Banderole,
[1921].
PAGINATION: 286 pages: (*4*), 1–278, (*4*); 10
plates *hors-texte*.
PAGE SIZE: 9¾ x 7¼" (24.7 x 18.4 cm).
IMAGES: 10 drypoints (executed 1919–20) and
66 line-block reproductions, after drawings (exe-
cuted 1914–18), in black on tinted Lafuma paper.
IMAGE SHOWN: 4³⁄₁₆ x 6⅛" (10.7 x 15.6 cm).
HOUSING: Publisher's blue-gray paper wrapper,
with line-block reproduction of publisher's
vignette, in black on front, and line-block repro-
duction, in black on back.
EDITION: 600: 1 numbered 1 on Old Japan

paper; 20 numbered 2–21 on Imperial Japan
paper; 60 numbered 22–81 on Holland paper,
519 numbered 82–600 on tinted Lafuma paper
(this copy, no. 358, signed).
PRINTERS: Plates, Xavier Havermans; text,
L'Imprimerie Coulouma, Argenteuil.
CATALOGUE RAISONNÉ: Lioré and Cailler
2–11.
COLLECTION: Gift of Philip Hofer, Depart-
ment of Printing & Graphic Arts, Houghton
Library, Harvard University

*During World War I the artist sketched in the
trenches and elsewhere. On more than one occa-
sion many of his drawings were lost during
battle. The etchings he later made for this book
add a denser, more memorializing aspect to the
soldiers, whose bodies, dead and alive, he
sketched.*

JOHN BUCKLAND-WRIGHT,
STANLEY WILLIAM HAYTER,
JOSEF HECHT, DALLA HUSBAND,
VASILY KANDINSKY, RODERICK
MEAD, JOAN MIRÓ, DOLF RIESER,
LUIS VARGAS

Fraternity

AUTHOR: Stephen Spender (British, born
1909). French trans. by Louis Aragon.
PUBLISHER: [Paris: Stanley William Hayter],
1939.
PAGINATION: 13 unnumbered folios.
PAGE SIZE: 8⅞ x 6⅜" (22.5 x 16.2 cm), irreg.
IMAGES: 8 engravings (including slipcase
front), 1 with aquatint and roulette, 1 with soft-
ground etching; 1 drypoint; 1 etching; in black on
ivory laid Montval paper.
IMAGES SHOWN: Above, Hayter (British.
1901–1988), *España*, 5 x 3½" (12.8 x 8.9 cm);
below, Kandinsky (French, born Russia. 1866–

1944), Untitled, 5 x 3¼" (12.8 x 8.3 cm).
HOUSING: Publisher's cream laid Montval paper
wrapper (title page and colophon) under green
paperboard folder, lined with cream paper; pub-
lisher's green paperboard slipcase, with engrav-
ing by Hayter mounted on front.
EDITION: 113: 1 numbered 1, with supplemen-
tary states, manuscript, and drawings; 100
numbered 2–101 (this copy, no. 9, signed);
12 *hors-commerce*, marked A–L, reserved for
collaborators.
PRINTERS: Plates, Atelier 17 and Henri Hecht,
Paris; text, Gonzalo More, Paris.
CATALOGUES RAISONNÉS: Hayter: Black and
Moorhead, 127. Kandinsky: Roethel 202.
COLLECTION: The Museum of Modern Art,
New York. Abby Aldrich Rockefeller Fund

*The international response to the Spanish Civil
War included Picasso's painting* Guernica *and
publications, some of which were used to raise
funds for the Republican side. Poems about
brotherhood and solidarity, subjects that recur
whenever there is a revolution, provided the
inspirational words that accompanied rallying
images such as Hayter's engraving titled*
España *in this work.*

FALL OF A CITY

All the posters on the walls
All the leaflets in the streets
Are mutilated, destroyed or run in rain,
Their words blotted out with tears,
Skins peeling from their bodies
In the victorious hurricane.

All the names of heroes in the hall
Where the feet thundered and the bronze throats roared,
FOX and LORCA claimed as history on the walls,
Are now angrily deleted
Or to dust surrender their dust,
From golden praise excluded.

All the badges and salutes
Torn from lapels and from hands
Are thrown away with human sacks they wore
Or in the deepest bed of mind
They are washed over with a smile
Which launches the victors when they win.

All the lessons learned, unlearnt;
The young, who learned to read, now blind
Their eyes with an archaic film;
The peasant relapses to a stumbling tune
Following the donkey bray;
These only remember to forget.

But somewhere some word presses
In the high shelf of a skull, and in some corner
Of an irrefrageable eye
Some old man's memory jumps to a child
—Spark from the days of energy
And the child hoards it like a wicked toy.

STEPHEN SPENDER

59

60

PABLO PICASSO
Spanish. 1881–1973

Sueño y mentira de Franco

AUTHOR: Pablo Picasso.
PUBLISHER: [Paris]: Pablo Picasso, [1937]. First edition.
PAGINATION: 5 unnumbered folios.
PAGE SIZE: 22⅝ x 15⅛" (57.5 x 38.5 cm), irreg.
SHEET SIZE: 14¹⁵⁄₁₆ x 22½" (38 x 57.2 cm).
IMAGES: 2 etching and lift-ground aquatints, in black on *chine collé* on cream wove Imperial Japan paper.
IMAGES SHOWN: Each, 12½ x 16⅝" (31.7 x 42.2 cm).
HOUSING: Publisher's cream wove paper wrapper around cream wove paper; gray linen box with red leather fastener, lined with black paper, possibly made for Louis E. Stern.
EDITION: More than 1,030: 150 numbered 1/150–150/150 (this copy, no. 47/150, signed)

chine collé on Imperial Japan paper; 850 numbered 151–1,000 on Montval paper; 30 numbered 1/XXX–30/XXX *chine collé* on Antique Japan paper; several *hors-commerce*.
PRINTER: Plates, Roger Lacourière, Paris.
TYPOGRAPHY: Artist's manuscript.
CATALOGUES RAISONNÉS: Cramer 28. Baer 615–616.
COLLECTION: The Museum of Modern Art, New York. Louis E. Stern Collection

61

The two nine-part compositions Picasso created
to raise money for the Spanish Republicans
were issued in a folder containing the artist's
own text. Picasso's images of the polyp, or low
form of life that represents the dictator Franco,
and the suffering beauty, who represents the
Spanish people, are full of satire. The individ-
ual panels parade along in the derisive dis-
harmony that also propels his two-page-long
single sentence that never speaks of the conflict
but, rather, of images in conflict.

JACQUES VILLON
French. 1875–1963

Poèmes de Brandebourg

AUTHOR: André Frénaud (French, born 1907).
PUBLISHER: [Paris]: NRF [Nouvelle Revue Française], 1947. First edition.
PAGINATION: 80 pages: [1–10], 11–77, [78], (2).
PAGE SIZE: 11 x 8¹¹⁄₁₆" (28 x 22 cm), irreg.
IMAGES: 6 soft-ground etchings with aquatint, drypoint, and/or engraving, in color on ivory wove Marais paper.
IMAGE SHOWN: 9⅛ x 8¼" (23.2 x 20.9 cm), irreg.
HOUSING: Publisher's cream wove paper wrapper; light-green paperboard folder, lined with ivory paper; green linen slipcase, probably made for Louis E. Stern.
EDITION: 190: 20 numbered 1–20, with supplementary suite; 150 numbered 21–170 (this copy, no. 111, signed, and inscribed with dedication to Louis E. Stern by Villon); 8 *hors-commerce*, numbered I–VIII, with supplementary suite, reserved for collaborators; 12 *hors-commerce*, numbered IX–XX, reserved for collaborators.

PRINTERS: Plates, G. Leblanc, Paris; text, Jourde et Allard, Paris.
TYPOGRAPHY: Caslon.
CATALOGUES RAISONNÉS: Auberty and Pérussaux 367–372. Ginestet and Pouillon E505–510.
COLLECTION: The Museum of Modern Art, New York. Louis E. Stern Collection

One of the master etchers of this century, Villon made some of the most colorful aquatints of the beautiful ladies of the belle époque *during the early 1900s. Shortly thereafter Cubism transformed his visual vocabulary into black and white. Only after World War II, still creating in the Cubist mode, did he return to color for the etchings in this book.*

PABLO PICASSO
Spanish. 1881–1973

Le Chant des morts

AUTHOR: Pierre Reverdy (French. 1889–1960).
PUBLISHER: Paris: Tériade Editeur, 1948. First edition.
PAGINATION: 136 pages: (4), [1–6], 7–117, [118–123], (9).
PAGE SIZE: 16½ x 12⁹⁄₁₆" (42 x 32 cm).
IMAGES: 123 lithographs (including wrapper), in color on cream wove Arches paper (executed 1946–48).
IMAGES SHOWN: Left page, 2⅜ x 11⁹⁄₁₆" (6 x 29.4 cm), irreg., right page, 15⅞ x 11⁹⁄₁₆" (40.4 x 29.4 cm), irreg.
HOUSING: Publisher's cream wove Arches paper wrapper with continuous lithograph on front and back; quarter burgundy over black linen solander box, lined with cream paper, probably made for Louis E. Stern.
EDITION: 270: 250 numbered 1–250 (this copy, no. 148, signed); 20 *hors-commerce*, numbered I–XX.

PRINTERS: Plates, Mourlot Frères, Paris; text, Draeger Frères, Paris.
BOOK DESIGNER: Pablo Picasso.
TYPOGRAPHY: Author's manuscript.
CATALOGUES RAISONNÉS: Cramer 50. Mourlot 117.
COLLECTION: The Museum of Modern Art, New York. Louis E. Stern Collection

Having already made several artistic statements about war, Picasso chose to enhance Reverdy's mourning stanzas with rubrics, the red marginalia added by scholars to old manuscripts that commented or expanded upon the text. For his marks, Picasso surrounded the handwritten text with the branched and knotted bands that delineated forms in his paintings of the time.

ANDRÉ MASSON
French. 1896–1987

Les Conquérants

AUTHOR: André Malraux (French. 1901–1976).
PUBLISHER: Paris: Albert Skira, [1949].
PAGINATION: 246 pages: [1–14], 15–222, [223],
(9).
PAGE SIZE: 14¹³/₁₆ x 11¹/₁₆" (37.7 x 28.1 cm).
IMAGES: 33 lift-ground aquatints, 9 in black and
24 in color on ivory wove Marais paper (exe-
cuted 1948–49).
IMAGES SHOWN: Left page, 10¼ x 8⁹/₁₆" (26.1 x
21.8 cm), right page, 5⅞ x 7¹³/₁₆" (15 x 19.8 cm).
HOUSING: Publisher's ivory wove paper wrap-
per enclosing ivory wove paper support; pub-
lisher's ivory paperboard folder and slipcase,
lined with ivory paper.
EDITION: 165: 25 numbered 1–25, with 2 supple-
mentary suites and drawing; 125 numbered 26–
150 (this copy, no. 38, signed); 15 *hors-commerce*,
numbered HCI–HCXV.

PRINTERS: Plates, Roger Lacourière, Paris;
text, Georges Girard, Paris.
TYPOGRAPHY: Renaud.
CATALOGUE RAISONNÉ: Saphire 250–285.
COLLECTION: The Museum of Modern Art,
New York. Gift of Mr. and Mrs. Ralph F. Colin

*In 1921 Daniel-Henry Kahnweiler met Masson
at the suggestion of Max Jacob and became
his dealer. That same year he commissioned
Malraux's first published text (illustrated by
Léger) and introduced Masson to the author.
Twenty-eight years later Masson created brisk
aquatints that enliven the pages of Malraux's
newly revised text.*

MATTA (ROBERTO SEBASTIAN
ANTONIO MATTA ECHAURREN)
Chilean, born 1911

Un Soleil, un Viet-Nam

AUTHOR: Jean-Paul Sartre (French. 1905–1980).
PUBLISHER: Paris: Comité Viet-Nam National, 1967. First edition.
PAGINATION: 12 unnumbered folios.
PAGE SIZE: 11¾ x 8¹³⁄₁₆" (29.9 x 22.4 cm).
IMAGES: 7 lithographs: 6 in color and 1 (wrapper front) in black, on ivory wove Arches paper (except wrapper).
IMAGE SHOWN: Wrapper, 11⅛ x 8⅞" (29.5 x 22.5 cm), irreg.
HOUSING: Publisher's yellow laid paper wrapper with lithograph on front.
EDITION: 2,000.
PRINTER: Michel Cassé, Paris.
TYPOGRAPHY: Author's manuscript.
CATALOGUE RAISONNÉ: Sabatier 163–169.
COLLECTION: The Museum of Modern Art, New York. Purchase

65

Matta was one of several artists working in France during the late 1960s who incorporated political subjects into their work. His numerous prints included the series Judgments, *about the Nuremberg trials of the major Nazis, and when the student uprisings of 1968 occurred, his posters covered Paris. Many artists produced ephemeral works during the periods of demonstrations, and this booklet by an activist author and a concerned artist had no other purpose than to emphasize their opposition to American policies in Vietnam.*

MAX BECKMANN
German. 1884–1950

Apokalypse

AUTHOR: Bible.
PUBLISHER: Frankfurt am Main: Bauersche
Giesserei, 1943.
PAGINATION: 77 pages: [1–6], 7–76, [77].
PAGE SIZE: 15⅜ x 11¾" (39 x 30 cm).
IMAGES: 27 lithographs, in black, 16 with water-
color additions; on cream laid paper (executed
1941–42).
IMAGE SHOWN: 13⁹⁄₁₆ x 10½" (34.5 x 26.6 cm).
HOUSING: Full brown-red leather binding;
cream laid endpapers and double binder's leaves.
EDITION: At least 41: 5 numbered 1–5, with
hand coloring by the artist; 19 numbered 6–24,
most with hand coloring; 7 unnumbered, with
hand coloring (this copy, signed); 10 unnum-
bered, uncolored.
PRINTER: Bauersche Giesserei, Frankfurt am
Main.
TYPOGRAPHY: Legend, designed by F. H. E.
Schneidler.
CATALOGUES RAISONNÉS: Hofmaier 330–

356. Jannasch 9. Gallwitz 287.
COLLECTION: National Gallery of Art,
Washington, D.C. Gift of Mrs. Max Beckmann

*In his version of the Revelation of Saint John
the Evangelist, Beckmann altered or reinter-
preted the symbols that have traditionally
accompanied the text. In this plate, about the
beast and the false prophet, a woman represents
the seven-headed horned beast, accompanied
by a second horned beast, who has been inter-
preted as the false prophet. Shown below is an
authoritarian male exhorting another to follow
the false prophet, while a third (either one
who would not follow or one who would not
believe) lies dead. Nearly all of the copies of
Beckmann's* Apokalypse *were hand colored, but
it is not certain that more than a few were col-
ored by the artist. The colophon reads, in part:
"This book was printed in the first year of the
Second World War, as the visions of the apoca-
lyptic seer became dreadful reality."*

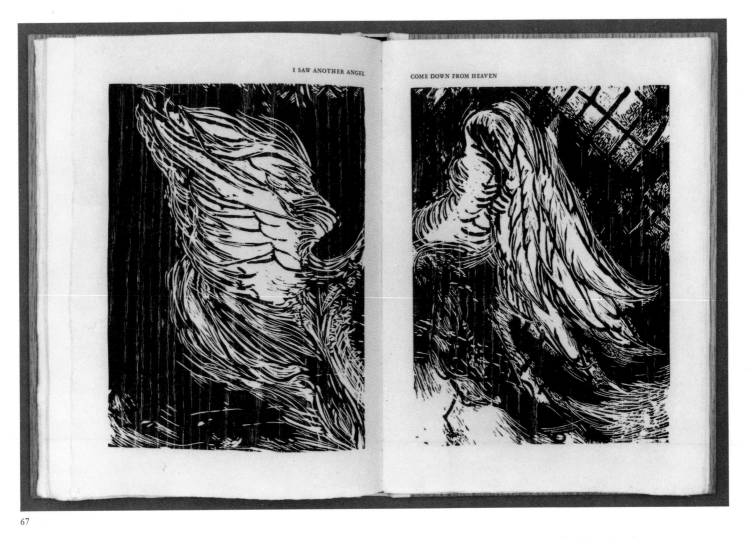

67

JIM DINE
American, born 1935

The Apocalypse, The Revelation of Saint John the Divine

AUTHOR: Bible, King James version, 1611.
PUBLISHER: San Francisco: The Arion Press, 1982.
PAGINATION: 36 unnumbered folios (including flyleaves).
PAGE SIZE: 15 x 11¼" (38.2 x 28.5 cm), irreg.
IMAGES: 29 woodcuts, in black on ivory wove Auvergne Richard de Bas paper.
IMAGES SHOWN: Left page, *I Saw Another Angel*, right page, *Come Down from Heaven*, each 11¾ x 8⅞" (29.8 x 22.5 cm), irreg.
HOUSING: Publisher's quarter ivory leather over stained-oak-veneer plywood-board binding.
EDITION: 165: 150 numbered 1–150 (this copy, no. 5, signed); 15 *hors-commerce*.
PRINTER: The Arion Press, San Francisco.
TYPOGRAPHY: Monotype Garamond, Hadriano, and Stempel Garamond.

CATALOGUE RAISONNÉ: D'Oench and Feinberg 141.
COLLECTION: The Museum of Modern Art, New York. Purchase

For his interpretation of the many symbols of the Apocalypse, Dine moved beyond the expressionistic figuration and the classical still-life objects of skulls and small sculptures that had entered his work after 1970. Movement in the forms of a horse racing toward the viewer in one plate and the beating wings of an angel in another is implied by the vigorous lines the artist cut into the woodblocks.

68

69

70

FRANTIŠEK (or FRANK) KUPKA
Czech. 1871–1957

Quatre histoires de blanc et noir

AUTHOR: František Kupka.
PUBLISHER: Paris: [František Kupka], 1926.
PAGINATION: 56 unnumbered folios, including supplementary suite.
PAGE SIZE: 12¹⁵⁄₁₆ x 9¹⁵⁄₁₆" (33 x 25.3 cm).
IMAGES: 29 woodcuts (including variant of title page on wrapper front, ornamental initial, and colophon tailpiece); supplementary suite of 26 woodcuts, in black on ivory wove Arches paper (except wrapper).
IMAGES SHOWN: Above left, title page, 7¹⁵⁄₁₆ x 5¹⁵⁄₁₆" (20.1 x 15.1 cm); above right, 8 x 6¹⁄₁₆" (20.4 x 15.4 cm); left, ornamental initial C, 1⅛ x⅞" (2.8 x 2.3 cm); all irreg.
HOUSING: Publisher's cream wove paper wrapper, with woodcut in black on front; quarter black leather over blue linen solander box, lined with cream paper.
EDITION: 300: 100 numbered 1–100, with supplementary suite of first states (this copy, no. 94); 200 numbered 101–300.
PRINTER: G. Kadar, Paris.
COLLECTION: The Museum of Modern Art, New York. Gift of Mr. and Mrs. Alfred H. Barr, Jr.

Kupka's lapidary etchings, which embellished several books of classical texts made during the early years of this century, are part of the foundation of the decorative characteristics encountered in this book. Essentially creating a guidebook to his exploration of abstract line and form, the artist put into contrasting black and white the elements from which his Synchromist paintings were composed.

EL LISSITZKY (LAZAR MARKOVICH LISSITZKY)
Russian. 1890–1941

Pro dva kvadrata

AUTHOR: El Lissitzky.
PUBLISHER: Berlin: Skythen, 1922.
PAGINATION: 10 unnumbered folios (including flyleaves).
PAGE SIZE: 10¹⁵⁄₁₆ x 8¾" (27.9 x 22.2 cm).
IMAGES: 12 line blocks (including front cover), 5 with relief halftone, and 1 relief halftone (back cover), 6 in black and 7 in color on cream wove paper (except cover) (executed 1920).
IMAGES SHOWN: Left page, 8¹⁄₁₆ x 5¹¹⁄₁₆" (20.5 x 14.5 cm), irreg., right page, 8⁹⁄₁₆ x 6½" (21.8 x 16.6 cm), irreg.
HOUSING: Publisher's cream cardboard binding with line block on front and relief halftone on back.
EDITION: More than 50: 50 numbered 1–50, signed; unknown quantity unsigned and unnumbered (this copy).
PRINTER: E. Haberland, Leipzig.
COLLECTION: The Museum of Modern Art, New York. Gift of Philip Johnson, Jan Tschichold Collection

Devoted to what he called "book building," El Lissitzky made his first book in 1905 when he was fifteen. Between 1916 and 1920 he designed parts of several books, but the idea of constructing pages, using letter forms, instead of rows of words, and placing them in space with geometric forms originates in this children's book. Taking Kasimir Malevich's concept of the economy of the purely planar figure of a square, El Lissitzky confronted two squares in a revolutionary fable: a red square for the good new order and a black one for the bad old ways.

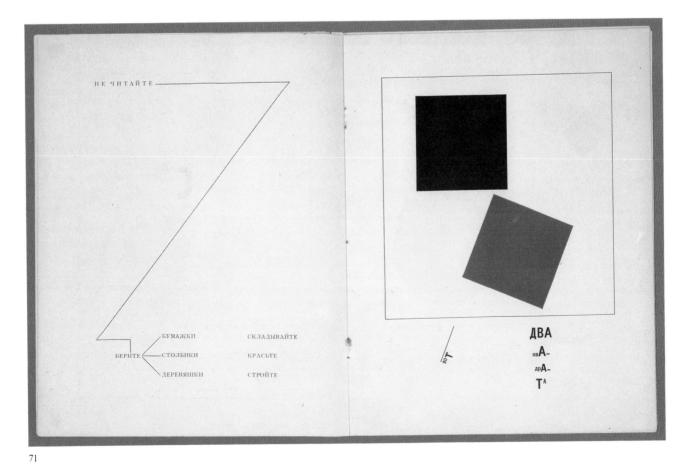

71

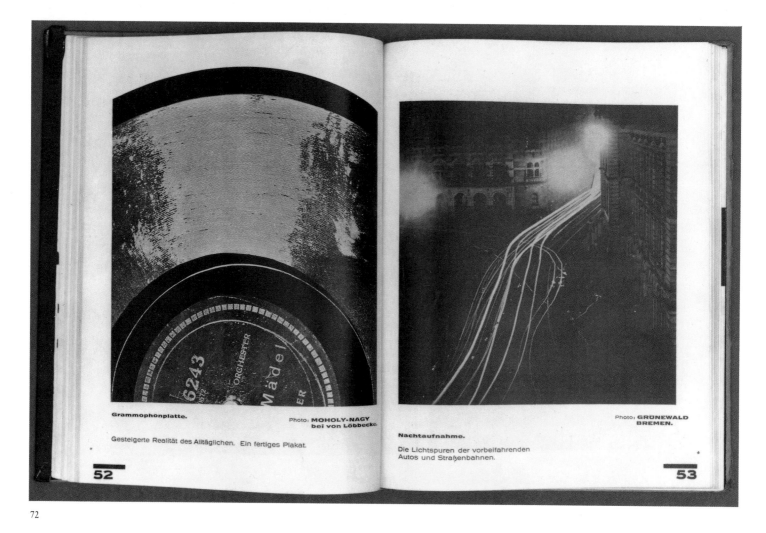

Grammophonplatte.

Photo: **MOHOLY-NAGY**
bei von Löbbecke.

Gesteigerte Realität des Alltäglichen. Ein fertiges Plakat.

52

Photo: **GRÜNEWALD**
BREMEN.

Nachtaufnahme.

Die Lichtspuren der vorbeifahrenden
Autos und Straßenbahnen.

53

LÁSZLÓ MOHOLY-NAGY
American, born Hungary. 1895–1946

Malerei, Photographie, Film

AUTHOR: László Moholy-Nagy.
PUBLISHER: Munich: Albert Langen Verlag,
1925. (Bauhausbücher 8.) First edition.
PAGINATION: 136 pages: (2), [1–4], 5–133, (1).
PAGE SIZE: 9¹⁄₁₆ x 7¹⁄₁₆" (23 x 17.9 cm).
IMAGES: Relief halftone reproductions, after
photographs by various artists, in black on ivory
wove paper.
IMAGES SHOWN: Left page, Moholy-Nagy,
Grammophonplatte, 6¹¹⁄₁₆ x 5¹⁵⁄₁₆" (17 x 15.1 cm),
irreg., right page, Grünewald, *Nachtaufnahme*,
6⅛ x 5⅞" (15.5 x 14.9 cm).
HOUSING: Publisher's full yellow linen binding
with geometric design, after Moholy-Nagy,
stamped in red on front and back; black wove
endpapers.
EDITION: Unknown.
PRINTERS: Relief halftone reproductions,
Dr. Von Löbbecke u. Co., Erfurt; text,
Ohlenroth'sche Buchdruckerei, Erfurt.

BOOK DESIGNER: László Moholy-Nagy.
COLLECTION: The Museum of Modern Art
Library, New York

*This book, as much as any work from the early
1920s, set a style of typography and picture
presentation for the following three decades. As
a teacher at the Bauhaus, Moholy-Nagy was
committed to transmitting his ideas about de-
sign to his students, and this volume is filled
with examples of photographs by several
photographers juxtaposed with type to accom-
plish this.*

KASIMIR MALEVICH
Russian. 1878–1935

Suprematism: 34 Risunka

AUTHOR: Kasimir Malevich.
PUBLISHER: Vitebsk: Unovis, 1920. First edition.
PAGINATION: 40 pages: 1–4, [5–40].
PAGE SIZE: 8⁹⁄₁₆ x 7⁷⁄₁₆" (21.7 x 17.9 cm).
IMAGES: 34 lithographs and 1 woodcut (cover, by Malevich?), in black on cream wove paper (except cover).
IMAGES SHOWN: Left, cover, 8¹¹⁄₁₆ x 7³⁄₁₆" (22 x 18.8 cm); right, 10⅞ x 8" (27.6 x 20.2 cm), often reproduced horizontally.
HOUSING: Publisher's light-gray paper cover (detached), with woodcut in black on front.
EDITION: Unknown.

PRINTER: Unovis Art Workshops, Vitebsk (presumably under the supervision of El Lissitzky).
TYPOGRAPHY: Artist's manuscript.
CATALOGUE RAISONNÉ: Karshan 37–71.
COLLECTION: Cabinet des Estampes, Musée d'Art et d'Histoire, Geneva

Most of Malevich's nonfigurative prints are printed in this book. While it was created as a textbook for his students in Vitebsk, the compilation of lithographic drawings (probably transferred to stone) is a survey of the essential elements of the dynamic movement through space and time that the artist called Suprematism.

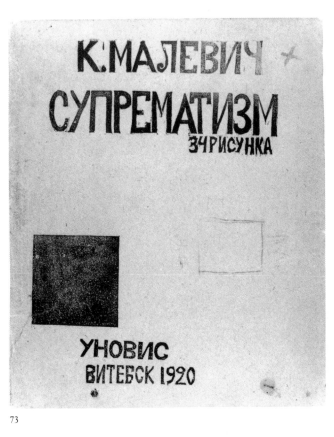

73

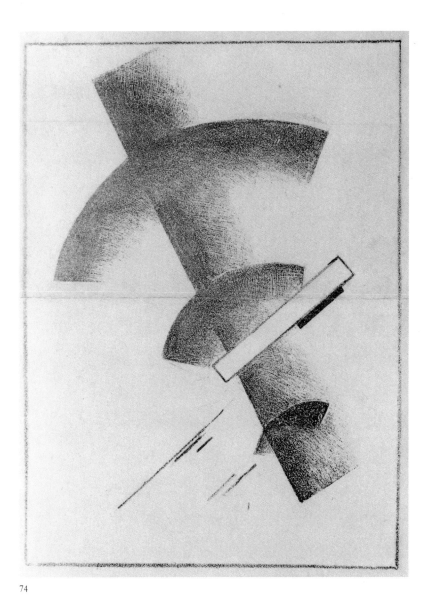

74

75

JOSEF ALBERS
American, born Germany. 1888–1976

Formulation: Articulation

AUTHOR: Josef Albers.
PUBLISHERS: New York: Harry N. Abrams, Inc.; New Haven: Ives-Sillman, Inc., 1972.
PAGINATION: 2 vols. I: 73 unnumbered folios; II: 66 unnumbered folios.
PAGE SIZE: 15 x 20⅛" (38.1 x 51 cm).
IMAGES: 127 screenprints: 121 in color and 6 in black, on white wove Mohawk Superfine paper (executed 1970–72).
IMAGE SHOWN: 6¼ x 17¼" (15.8 x 43.9 cm).
HOUSING: Publisher's light-gray linen folders lined with cream paper, in gray linen slipcases; made in the Netherlands.
EDITION: 1,000 numbered 1–1,000 (this copy, no. 358, signed).
PRINTERS: Plates, Sirocco Screenprinters, New Haven; text, Eastern Press, New Haven.
BOOK DESIGNER: Norman Ives.
COLLECTION: The Museum of Modern Art, New York. Gift of The Josef Albers Foundation

After retiring from his position of chairman of the Art Department of Yale University in New Haven, Connecticut, Albers and his former students Norman Ives and Sewell Sillman set about making screenprints of Homage to the Square, *his series of painted compositions. Ives and Sillman also produced Albers's famous teaching guide,* Interaction of Color, *containing screenprint reproductions of his and his students' color compositions.* Formulation: Articulation *is a printed compendium of Albers's compositional repertoire produced by the three men.*

SOL LEWITT
American, born 1928

*Six Geometric Figures and All Their
Combinations*

AUTHOR: Sol LeWitt.
PUBLISHER: New York: Parasol Press, Ltd.,
1980.
PAGINATION: 2 vols. I: 64 unnumbered folios;
II: 64 unnumbered folios.
PAGE SIZE: Each volume, 9⅟₁₆ x 9⅟₁₆" (23 x
23 cm).
IMAGES: I: 63 etchings; II: 63 etchings; in black
on white wove Somerset paper.
IMAGES SHOWN: Top, vol. I, 7⅞ x 7⅞"
(20 x 20 cm); bottom, vol. II, 7⅞ x 7¹⁵⁄₁₆"
(20 x 20.1 cm).
HOUSING: I: publisher's black linen binding,
black wove endpapers with double flyleaves; II:
publisher's white linen binding, white wove end-
papers with double flyleaves; both in publisher's
black linen slipcase; made by Crown Point Press,
Oakland.
EDITION: 4: 1 numbered 1/1 (this copy, signed);
3 artist's proofs.
PRINTER: Crown Point Press, Oakland.
CATALOGUE RAISONNÉ: Singer E26.
COLLECTION: The Museum of Modern Art,
New York. Gift of Allen Skolnick

*Every set of elements within LeWitt's sculp-
tures, wall drawings, and books is positioned
by the artist's a priori, fixed rules. Completion
of any composition is dependent upon the num-
ber of variations possible within the set. This
pair of bound books is filled with etchings based
on sets of simple geometric forms, one volume
printed black on white, the other white on
black.*

76

77

139

78

MARCEL DUCHAMP
American, born France. 1887–1968

*La Mariée mise à nu par ses célibataires, même (*the *Green Box)*

AUTHOR: Marcel Duchamp.
PUBLISHER: Paris: Edition Rrose Sélavy [Duchamp], [1934].
PAGINATION: 94 documents.
SHEET SIZE: Various, 2¹¹⁄₁₆ x 3¹³⁄₁₆" (7.4 x 9.7 cm) to 12⅜ x 9½" (31.4 x 24.2 cm).
IMAGES: 94 collotype reproductions on various papers of original drawings and notes (executed 1911–15).
IMAGE SHOWN: Box with several documents: box, 13 x 11¹⁄₁₆ x 1" (33 x 28 x 2.5 cm).
HOUSING: Unbound, without wrapper, in publisher's green "suede" paperboard solander box, lined with green "suede" paper.
EDITION: 320: 300 numbered 1/300–300/300 (this copy, no. 64/300); 20 numbered I/XX– XX/XX, of which 10 are *hors-commerce*, with supplementary manuscript or drawing.
PRINTER: Vigier et Brumssen, Paris.
CATALOGUE RAISONNÉ: Schwarz 293.
COLLECTION: The Museum of Modern Art, New York. Purchase

*Two decades after he made the first studies for his masterpiece of the same name—*The Bride Stripped Bare by her Bachelors, Even (*the* Large Glass)—*Duchamp produced the* Green Box *containing reproductions of the notes he had made before creating the work. In 1966 the English artist Richard Hamilton published a reproduction of the box. This inspired other artists, influenced by Duchamp's Dadaist ideas, to assemble compendiums of diverse, usually found, materials in boxes.*

JOSEPH BEUYS
German. 1921–1986

Die Leute sind ganz prima in Foggia

AUTHOR: Joseph Beuys.
PUBLISHERS: [Heidelberg]: Edition Staeck;
[Naples]: Modern Art Agency; and [Milan]:
Studio Marconi, 1973 [1974].
PAGINATION: 78 unnumbered folios.
PAGE SIZE: 12⅜ x 8¾" (31.5 x 22.2 cm).
IMAGES: 75 screenprints, in color on gray-
brown heavy wove paper.
IMAGE SHOWN: ¹³⁄₁₆ x 8⁵⁄₁₆" (2.1 x 21.1 cm).
HOUSING: Publisher's gray-brown paperboard
binding, with adhesive spine and screenprinted
title, in white, on front.
EDITION: 220: 180 numbered 1/180–180/180
(this copy, no. 17/180, signed); 40 artist's proofs,
numbered I/XL–XL/XL.
CATALOGUE RAISONNÉ: Schellmann 100.
COLLECTION: John Gibson

*During his lifetime Beuys produced numerous
objects and incidental printed materials that
are normally categorized as ephemera. As with
most artists whose installations and perform-
ances are never repeated the same way twice,
Beuys relied on printed statements, photo-
graphic records, and other reproducible items
to sustain the memory of these impermanent
works of art. This book*, Die Leute sind ganz
prima in Foggia (The People Are Terrific in
Foggia), *reprises an exhibition of snippets of
typewritten lists and schemes for his Actions.*

79

ALFRED JARRY
French. 1873–1907

Les Minutes de sable mémorial

AUTHOR: Alfred Jarry.
PUBLISHER: [Paris]: Mercure de France, [1894].
First edition.
PAGINATION: 236 pages: (*10*), [I], II–IX, [X], [1–5], 6–210, (*6*); 9 plates *hors-texte*.
PAGE SIZE: 5¼ x 4⁵⁄₁₆" (13.4 x 10.9 cm), irreg.
IMAGES: 11 woodcuts (including frontispiece ornament and wrapper front): 2 in black and 9 in color; 1 line-block reproduction of pen-and-ink drawing, in black; on cream laid Arches paper (except wrapper).
IMAGES SHOWN: Top, 2¹⁵⁄₁₆ x 2⅜" (7.4 x 6 cm), irreg.; bottom: 1¹³⁄₁₆ x 2⅛" (4.7 x 5.4 cm).
HOUSING: Quarter brown leather over clear-plastic-covered black paperboard binding with windows onto cream laid endpapers (printed purple), with single binder's leaves, made by H. Mercher; publisher's black wove paper wrapper with woodcut, in gold on front, bound in; ivory paper slipcase printed in black pattern.
EDITION: 216: 197 on Arches paper (this copy); 19 on green, red, or yellow Ingres paper.
PRINTER: C. Renaudie, Paris.
COLLECTION: The Museum of Modern Art, New York

These two images from Jarry's first published book, so different in character, show an almost abstract composition of an owl in front of a window and three caricatures with a fourth floating above them (possibly the first representation of Jarry's famous character Ubu). Although both refer to incidents in the text, their inconsistency of approach to illustration forecasts the spirit of freedom from convention in later artists' books.

80

81

Methodic discord startles

82

DAVID BOMBERG
British. 1890–1957

Russian Ballet

AUTHOR: David Bomberg.
PUBLISHER: London: Henderson's, 1919. First edition.
PAGINATION: 8 unnumbered folios (including flyleaves).
PAGE SIZE: 8⁷⁄₁₆ x 5⁵⁄₁₆" (21.4 x 13.5 cm), irreg.
IMAGES: 6 lithographs, in color on cream wove paper.
IMAGE SHOWN: 4 x 3⅞" (10.2 x 9.8 cm).
HOUSING: Artist's cream wove paper binding.
EDITION: Unknown, probably about 100.
PRINTER: David Bomberg, London.
COLLECTION: The Museum of Modern Art, New York. Gift of Peter Selz

This homemade booklet coincides in time with the cheaply produced publications of the Russian Cubo-Futurists, but the artist's blank verse does not compare with the importance of the texts in that group's editions. There is some possibility that Serge Diaghilev, whose ballet company was its inspiration, was involved in the planning of the publication, but ultimately he did not agree to its sale in the theater.

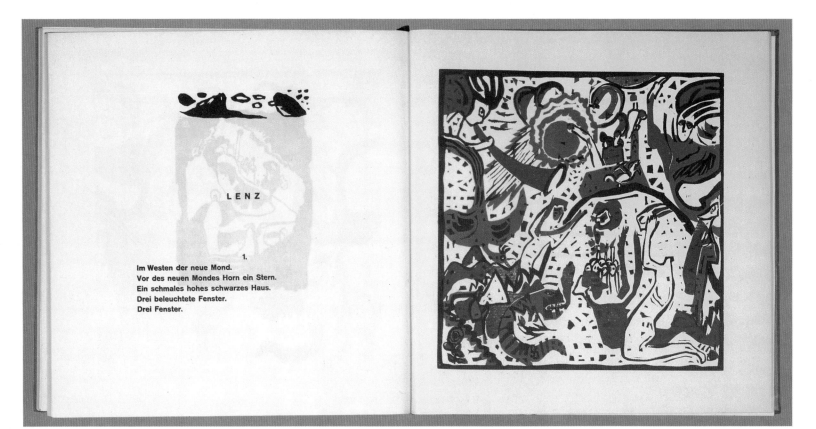

VASILY KANDINSKY
French, born Russia. 1866–1944

Klänge

AUTHOR: Vasily Kandinsky.
PUBLISHER: Munich: R. Piper & Co. Verlag,
[1913]. First edition.
PAGINATION: 59 unnumbered folios.
PAGE SIZE: 11¹⁄₁₆ x 10⁷⁄₈" (28.1 x 27.7 cm).
IMAGES: 56 woodcuts, 12 in color and 44 in
black on cream laid Holland Van Gelder paper
(executed 1907–12).
IMAGE SHOWN: Above, *Grosse Auferstehung*,
8⅝ x 8⁹⁄₁₆" (21.9 x 21.7 cm).
HOUSING: Publisher's quarter purple linen
binding over pink paperboard, with design by
Kandinsky stamped in gold leaf on front and
back; gray-green wove endpapers and red ribbon
bookmark; black and red linen slipcase with
clear-plastic insets on front and back.
EDITION: 300 numbered 1–300 (this copy,
no. 264, signed).

PRINTERS: Color woodcuts, F. Bruckmann,
A.G., Munich; text and black-and-white wood-
cuts, Poeschel & Trepte, Leipzig.
CATALOGUE RAISONNÉ: Roethel 71–74, 85,
95–140, 142–146.
COLLECTION: The Museum of Modern Art,
New York. Louis E. Stern Collection

*Between the time he created extraordinary
hand-colored woodcuts of medieval ladies in
1903 and 1913, Kandinsky formed* Der Blaue
Reiter *(The Blue Rider) group with Franz
Marc and wrote* Concerning the Spiritual in Art.
*The blue rider was Saint George, a favorite of
the Russians. In this pivotal book, which
includes some of Kandinsky's earliest abstract
compositions, Saint George and other knights
on horseback are shown searching magic moun-
tains for truth. The illustration called* Grosse
Auferstehung *(Large Resurrection) accompanies
Kandinsky's poem about spring.*

85

Klänge der Posaunen (Grosse Auferstehung). [1910–11]. Watercolor, India ink, and pencil on thin cardboard. 12¾ x 12¾" (32.5 x 32.5 cm). Städtische Galerie im Lenbachhaus, Munich

Grosse Auferstehung, proof of the black block for *Klänge*. [1911]. Woodcut, in dark-gray-yellow-brown on buff laid paper. 8⅛ x 8¹¹⁄₁₆" (21.9 x 22 cm). Roethel 138. The Museum of Modern Art, New York. Johanna and Leslie J. Garfield Fund

84

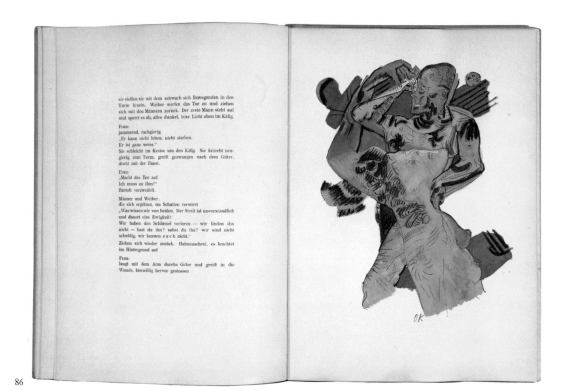

86

87

Oskar Kokoschka
British, born Austria. 1886–1980

Mörder Hoffnung der Frauen

AUTHOR: Oskar Kokoschka.
PUBLISHER: Berlin: Verlag Der Sturm, [1916].
PAGINATION: 12 unnumbered folios.
PAGE SIZE: 13⁷⁄₁₆ x 9¾" (34.1 x 24.8 cm).
IMAGES: 5 line-block reproductions, after pen-and-ink drawings: title page and 4 plates with gouache additions on cream wove paper (drawings executed 1907–08; gouache additions to reproductions 1916).
IMAGES SHOWN: Each, 9¹⁵⁄₁₆ x 7⁹⁄₁₆" (25.2 x 19.2 cm), irreg.
HOUSING: Copy no. 1: publisher's brown paperboard binding with pale-blue wove endpapers; in quarter navy leather over blue linen solander box, lined with cream paper. Copy no. 3: red linen binding with publisher's brown paperboard cover mounted on front; blue laid endpapers.
EDITION: 100: 3 numbered 1–3, with gouache additions (these copies, nos. 1 and 3, signed); 97 numbered 4–100.
PRINTER: Druckerei für Bibliophilen, Berlin.
CATALOGUES RAISONNÉS: Not in Arntz. Not in Wingler and Welz.
COLLECTION: The Museum of Modern Art, New York. Purchase (no. 1) and Louis E. Stern Collection (no. 3)

In 1909, a year after he first showed his works in the annual art exhibition in Vienna, Kokoschka presented the violent and extremist play printed in this book. The drawings that constitute the illustrations were first reproduced in 1910, but here, in two of the three copies on which Kokoschka painted, the ways he envisioned his characters as the stage lighting transformed their flesh evokes the original presentation of the play.

MARC CHAGALL
French, born Russia. 1887–1985

Mein Leben

AUTHOR: Marc Chagall.
PUBLISHER: Berlin: Paul Cassirer, 1923.
PAGINATION: 20 folders (each containing 1
print) and title-page/table-of-contents folder.
SHEET SIZE: Various, 10¹³⁄₁₆ x 8¹¹⁄₁₆" (27.5 x
22 cm) to 17⅛ x 13⅛" (43.5 x 33.4 cm).
IMAGES: 20 etchings, 17 with drypoint, in black,
on cream wove Japan paper (executed 1922).
IMAGES SHOWN: Left, *Haus des Grossvaters*,
8¼ x 6⁵⁄₁₆" (21 x 16 cm); right, *An der Staffelei*,
9¾ x 7½" (24.8 x 19 cm).
HOUSING: Portfolio, with each print in protec-
tive folder, inside publisher's vellum box with
gold-leaf design, after Chagall, on front, lined
with blue-green paper.
EDITION: 110: 26 numbered 1/110–26/110 on
Japan paper (this copy, no. 6, signed, embellished
in 1946 with watercolor on title page and dedica-
tion to Louis E. Stern by Chagall); 84 numbered
27/110–110/110 on wove paper.

CATALOGUE RAISONNÉ: Kornfeld 1–20.
COLLECTION: The Museum of Modern Art,
New York. Louis E. Stern Collection

*Chagall's autobiographical prints were meant
to be accompanied by his own text, which was
first issued eight years later. This particular
portfolio of the prints was located in China
after World War II, when Chagall was helping
his American adviser, Louis E. Stern, amass a
collection of his illustrated books. At that time,
the artist decorated its title page with a
watercolor.*

88

89

PABLO PICASSO
Spanish. 1881–1973

Prints and Manuscripts for a Book Project

AUTHOR: Pablo Picasso.

Jotting down phrases and sets of words that he planned to organize into a book, Picasso evidently was encouraged by Ambroise Vollard to pursue its design. The artist had devised a style of reproducing a manuscript with marginal decorations in 1936, when he decorated Paul Eluard's poem "Grand Air." As he worked on prints for his own writings, he made several nude figures that, because of their narrow for-mat, seem to have been intended for margins. The more important compositions, however, were his first color prints: portraits of Dora Maar. He created seven color aquatints of her face before several events—including Vollard's sudden death and the general disarray that accompanied the outset of World War II—derailed the project.

90

Tête de femme no. 1: Portrait de Dora Maar.
[January–June, 1939]. Aquatint and drypoint, in color, on ivory laid Montval paper. 11¹¹⁄₁₆ x 9⁹⁄₁₆" (29.8 x 23.7 cm). Baer 648Ce (*Bon à tirer*). Collection E. W. Kornfeld, Bern

91

Tête de femme no. 4: Portrait de Dora Maar.
[April–May, 1939]. Aquatint, in color, on ivory laid Montval paper. 11⁷⁄₈ x 9⁹⁄₁₆" (30.1 x 24 cm). Baer 652D. The Museum of Modern Art, New York. Gift of Mrs. Melville Wakeman Hall

92

Autograph manuscript, dated April 28–May 1, 1938, in India ink on Arches paper. 10¹/₁₆ x 6⅞" (25.5 x 17.5 cm). Musée Picasso, Paris

93

94

Nu debout I, state IV. [April 27, 1939]. Engraving and aquatint, in black on ivory laid Montval paper. 11⅛ x 3¾" (29.5 x 9.6 cm). Baer 656 IVa. Marina Picasso Collection, Jan Krugier Gallery, New York

Petit Nu debout and *Nu debout I*, state III. April 27, 1939. Engraving, and engraving and aquatint, in black, both on the same sheet of ivory laid Montval paper. 11⅛ x 2" (29.6 x 5.1 cm) and 11⅛ x 3¾" (29.5 x 9.6 cm). Baer 657b and 656IIIb. Marina Picasso Collection, Jan Krugier Gallery, New York

Plate 2

The solitary death of the Wool-
worth building.

Plate 2 Bourgeois

LOUISE BOURGEOIS
American, born France, 1911

He Disappeared into Complete Silence

AUTHOR: Louise Bourgeois.
PUBLISHER: New York: Gemor Press, [1947].
First edition.
PAGINATION: 27 unnumbered folios.
PAGE SIZE: 10 x 7" (25.5 x 17.8 cm), irreg.
IMAGES: 9 engravings, in black on ivory wove
paper (executed c. 1946).
IMAGE SHOWN: 6¹³⁄₁₆ x 5⁷⁄₁₆" (17.3 x 13.8 cm).
HOUSING: Unbound, without wrapper; publish-
er's beige linen folder with flaps, lined with
brown paper.
EDITION: Fewer than the projected 54: 15
numbered 1–15, hand-colored by Bourgeois
(none known); 29 numbered 16–44 (this copy,
no. 24, signed); 10 *hors-commerce*, marked A–J.
PRINTERS: Plates, Louise Bourgeois at Atelier
17, New York; text, Gemor Press, New York.

BOOK DESIGNER: Louise Bourgeois.
CATALOGUE RAISONNÉ: Wye and Smith
29–38.
COLLECTION: The Museum of Modern Art,
New York. Abby Aldrich Rockefeller Fund

*With her first engravings (made at Hayter's
Atelier 17 in New York) and first published
text, the sculptor advanced her Franco-
American Surrealist imagery. The concepts of
silence and disappearance defined for many
European refugees the wartime atmosphere of
the period that furnished the depths of the sub-
conscious from which Surrealist artists drew
their inspiration.*

HENRI MICHAUX
French, born Belgium. 1899–1984

Meidosems

AUTHOR: Henri Michaux.
PUBLISHER: [Paris]: Les Editions du Point du Jour, 1948. First edition.
PAGINATION: 104 pages: (2), [1–9], 10–95, [96–97], (5); double-page plate *hors-texte*.
PAGE SIZE: 9¹⁵⁄₁₆ x 7½" (25.2 x 19 cm), irreg.
IMAGES: 13 lithographs: 12 in black and 1 (wrapper) in color on ivory wove Johannot paper (except wrapper).
IMAGE SHOWN: Wrapper, 10 x 16½" (25.4 x 42 cm).
HOUSING: Publisher's ivory wove paper wrapper with continuous lithograph in dark green on front and back; in publisher's quarter light-green

paper over cream paperboard folder with green ribbon tie, lined with green paper.
EDITION: 297: 250 numbered 1–250 on Johannot paper (this copy, no. 213); 4 dedicated copies *hors-commerce*, numbered I–IV on Arches paper, with supplementary suite; 16 numbered V–XX on Arches paper, with supplementary suite; 1 unique on China paper, with supplementary suite; 26 *hors-commerce*, marked A–Z, reserved for collaborators.
PRINTERS: Lithographs, E. Desjobert, Paris; text, E. Aulard, Paris.
COLLECTION: The Museum of Modern Art, New York. Abby Aldrich Rockefeller Fund

A writer who usually accompanied his publications with his own drawings, Michaux has had equal renown as an artist. In this book, written shortly after the accidental death of his wife, his first lithographs convey the eerie world of a man who engaged his creative impulses by smoking peyote.

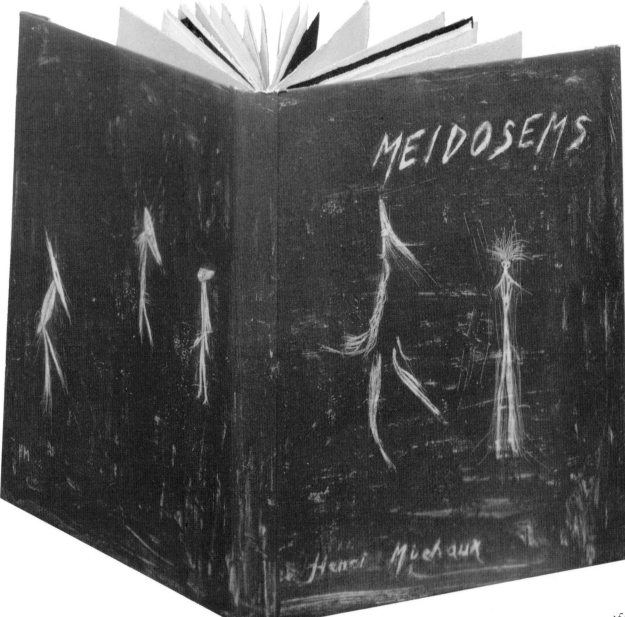

96

ASGER JORN
Danish. 1914–1973

Held og hasard/Dolk og guitar

AUTHOR: Asger Jorn.
PUBLISHER: Silkeborg: [Asger Jorn], 1952. First edition.
PAGINATION: 100 pages: (2), [1–5], 6–96, (2).
PAGE SIZE: 10¼ x 7⁹⁄₁₆" (26 x 19.2 cm).
IMAGES: 64 linoleum cuts and 1 monotype (cover) on ivory wove paper.
IMAGES SHOWN: Left page, above, 1⁵⁄₁₆ x 1¹³⁄₁₆" (3.4 x 4.7 cm), below, 2⅝ x 1⁷⁄₁₆" (6.7 x 3.7 cm), right page, 1⁷⁄₁₆ x 1¹¹⁄₁₆" (3.6 x 4.2 cm).
HOUSING: Monotype by Jorn on paper glued to cardboard glued to linen binding, ivory laid endpapers.
EDITION: 109: 25 numbered A1–A25 on imitation handmade paper; 60 numbered 1–60 on uncalendered "press E" paper; 24 numbered B1–B24 on calendered "press 44" paper (this copy, marked B, unnumbered, signed and inscribed "à Pierre Alechinsky amicalement" on front flyleaf).
PRINTERS: Asger Jorn, with Johs. Gregerson, at Emil Stecher, Silkeborg.
CATALOGUE RAISONNÉ: Van de Loo 123, pages 73–92.
COLLECTION: Pierre Alechinsky

The artists and writers of the CoBrA group frequently used commercial and fine print mediums to publicize and define their post–World War II form of expressionism. Elements from northern European folk art, such as Carnival masks, were combined with images of cobras by most of the artists, including Jorn. In this book, which Jorn wrote just as the group disbanded, his linoleum-cut CoBrA signs form hieroglyphic marginal notes to the text.

JEAN DUBUFFET
French. 1901–1985

La Lunette farcie

AUTHOR: Jean Dubuffet.
PUBLISHER: Alès and Paris: PAB [Pierre André
Benoit], 1962 [1963]. First edition.
PAGINATION: 8 unnumbered folios.
PAGE SIZE: 17 1/16 x 14 15/16" (43.4 x 38 cm), irreg.
IMAGES: 11 lithographs, 10 in color and 1
(wrapper) in black on ivory wove Arches
paper (except wrapper).
IMAGES SHOWN: Below, left page, 6 1/2 x 10"
(16.5 x 25.5 cm), irreg., right page, 10 5/16 x 6 5/16"
(26.2 x 16.1 cm), irreg.
HOUSING: Publisher's ivory wove paper wrap-
per with continuous lithograph on front and
back; publisher's black linen folder, with black
linen flaps and black ribbon tie, lined with ivory
paper.
EDITION: 55: 50 numbered 1–50 (this copy,
no. 35, signed); 5 *hors-commerce*.
PRINTERS: Plates, Jean Dubuffet; text,
Imprimerie Union, Paris.
TYPOGRAPHY: Hand-stenciled.
CATALOGUES RAISONNÉS: Schmitt 608–618.
Webel 882–895.
COLLECTION: The Museum of Modern Art,
New York. Gift of Mr. and Mrs. Ralph F. Colin

*The arrangement of letters around the images
forces the reader to turn the book in order to fol-
low the text. The images themselves are each
compounded of several lithographs made from
the chance procedures of spilling various liq-
uids, burning, scratching haphazardly, and
other unstructured ways of producing textures.*

Right, *La Lunette farcie*. [January 1962]. Auto-
graph manuscript, in pen and black ink, with oil
paint. 9 1/8 x 8 1/8" (23.2 x 20.7 cm). Bibliothèque
Nationale de France, Département des Livres
Imprimés

98

99

Close up Space monkey Grinning Pathos Distorted lunatic cat Whiff of anti-war
Bottom of rocket Hybrid mutant boiler head attached to winged clown's mask Hybrid in interior
Close up Ready made Technics room altered Hard diagonals Concave hexagons Series of punched
Squares Slots Slots containing circles Triangular edges to horizon tall and vertical Loco wheel altered
Jewellery on a wrist with watches Square clock face Clock of straw Expose gear box
Fabrication with naked mannikin Interior with unexplained object Generator containing a church arch
1913 modern interior with mirror added locomotive chassis with little boy Switch board with automatic projector
Presence in room skirted with chain 30's television Railway engine in screen Ship breaker's yard
Triangle of holes patterns Composite machine on village Perforated trimmings Interior with ready mades
Verticals-diagonals Stop Motor car detail Perpendicular lines
Ethnographic conglomerate overlaid with switchboard Pair of Africans are wearing gas mask Inkwell Loco
Phinx Transient details Index Embroidery paper imposed pattern stripe Modern facade Double fix
Anonymous Modern Object Gaudi Sagrad Familia under construction Drawing skyscrapers
Lady in New York Positive plate of chloride accumulator Slant pattern edging Printed circuit enlarged
Technicians grouped round base of space capsule Engraving of revolver Valve with nude mannikin
Interior out of scale events Boxers Camera Large tasseled lamp Skull from schliemann ikon
Round symbol in receding tiled room Wheel and fireplace Levels of banality Men driving bus front view
From Industrial design (US) Under water television Grappling device Philosophy round ready made as image
Collage ready made transformed or ready made altered Ready made Joined to invented section
Ready made enlarged Relationship between history science Concept of today obsolescence
View of power station from the air. Two details mechanical manual (wood and iron and electric, all metal)
Hexagonal pattern overlaid Square embroidery View of New York collage building altered Metal culture
Symbolism Perforated square (reminder of obsession) Fabricated object on dark ground

COMMENT

A cycle of changing references gathered together A collection of human artifacts Switch gear
Human hand factors assembled, edited, rearranged New analogies cross referenced and cross detailed
Uneasy animals distorted with tekno motors in banal settings Electro-motors in simple anachronism
Parade of the toy kingdom. Toy as war god. God as toy. Tin crucifix Tin king.

100

EDUARDO PAOLOZZI
British, born 1924

Metafisikal Translations

AUTHOR: Eduardo Paolozzi.
PUBLISHER: [London]: Eduardo Paolozzi,
1962. First edition.
PAGINATION: 24 unnumbered folios (including
flyleaves).
PAGE SIZE: 11¾ x 8³⁄₁₆" (29.8 x 20.8 cm).
IMAGES: 30 screenprints, in black on ivory
wove Cartridge paper.
IMAGES SHOWN: Left page, 4⅛ x 7⁷⁄₁₆" (10.5 x
18.9 cm), irreg., right page, 10⁵⁄₁₆ x 7½" (26.2 x
19.1 cm).
HOUSING: Artist's white wove paper binding.
EDITION: 200 (this copy, signed).
PRINTER: Kelpra Studio Limited, London.

TYPOGRAPHY: Stencil and manuscript.
CATALOGUE RAISONNÉ: Miles 13.
COLLECTION: The Museum of Modern Art,
New York. Given anonymously

*This book is related to an animated film
Paolozzi made two years earlier of book pages
illustrated with a variety of subjects. In this
work, the text begins with references to that
film alongside a strange intermix of nudes,
robots, and diverse graphics.*

GILBERT & GEORGE
(GILBERT PROESCH AND
GEORGE PASSMORE)
Italian, born 1943; British, born 1942

Side by Side

AUTHORS: Gilbert & George.
PUBLISHER: Cologne and New York: König Brothers, 1972.
PAGINATION: 188 pages: (13), 1–170, [171–172], (3).
PAGE SIZE: 7½ x 4¹⁵/₁₆" (19 x 12.5 cm).
IMAGES: Photolithographic reproductions of photographs on ivory wove paper (executed 1971–72).
IMAGE SHOWN: *On the Road*, 5¹/₁₆ x 3¹/₁₆" (12.8 x 7.8 cm).
HOUSING: Publisher's ivory linen binding printed in decorative pattern in brown and gray; ivory wove endpapers.
EDITION: 600 numbered 1–600 (this copy, no. 428, signed).

COLLECTION: The Museum of Modern Art, New York. Purchase

When Gilbert & George were primarily performance artists in the 1970s, their printed invitations, calling cards, and precious books were logical parts of their artworks. They called themselves "living sculptures" and wore gold greasepaint on their faces as they slowly moved like wound-down automatons to the sounds of the saccharine Edwardian song, "Underneath the Arches."

ON the ROAD

DAVID HOCKNEY
British, born 1937

A Rake's Progress

AUTHOR: David Hockney.
PUBLISHERS: London: Editions Alecto, in association with The Royal College of Art, 1963.
PAGINATION: 3 unnumbered folios; 16 plates *hors-texte*.
SHEET SIZE: 19 11/16 x 24 5/8" (50 x 62.5 cm), irreg.
IMAGES: 16 hard- and soft-ground etching and aquatints (1 with lift-ground aquatint), in color on ivory wove Barcham Green Crisbrook Royal Hotpress paper (executed 1961–63).
IMAGE SHOWN: *The Arrival*, 11 15/16 x 15 7/8" (30.3 x 40.4 cm).
HOUSING: Publisher's red linen folder with flaps, lined with cream paper; publisher's black linen slipcase, designed by Eric Ayers.
EDITION: 60: 50 numbered 1–50 (this copy, no. 10, signed); 10 artist's proofs.
PRINTERS: Plates, C. H. Welch, London; text, The Curwen Press, London.
TYPOGRAPHY: Times New Roman.
CATALOGUE RAISONNÉ: Brighton 17–32.

COLLECTION: The Museum of Modern Art, New York. Mr. and Mrs. Ralph F. Colin, Leon A. Mnuchin, and Joanne M. Stern Funds

The Royal College of Art encouraged Hockney to enlarge the set of occasionally autobiographical etchings he started in 1961—inspired by William Hogarth's famous set of prints, The Rake's Progress—*in order to make a book. Hockney's prints about his first trip to New York were first issued without text. In 1967 the college's Lion & Unicorn Press issued the book with poems by David Posner, an American poet, to accompany reproductions of Hockney's prints. One verse concludes, "If painting is a science of which/Pictures are the experiment,/ What you are given is what you have to prove."*

102

103

GEORG BASELITZ
(GEORG KERN)
German, born 1938

Malelade

AUTHOR: Georg Baselitz.
PUBLISHER: Cologne and New York: Michael Werner, [1990].
PAGINATION: 48 unnumbered folios (including flyleaves) and 41 glassine overlays.
PAGE SIZE: 20⅛ x 28¾" (51.2 x 73 cm).
IMAGES: 39 drypoints (3 with woodcut, etching, or monotype), 22 in black and 17 in color; 2 etchings, 1 in black and 1 in color; on ivory wove Zerkall paper (executed 1988–90).
IMAGE SHOWN: 13¹¹⁄₁₆ x 19½" (34.8 x 49.5 cm).
HOUSING: Publisher's full yellow leather binding, with interior stained gray, made by Mechthild Lobisch, Gauting; publisher's gray linen solander box lined with yellow and gray paper.
EDITION: 80: 60 numbered 1/60–60/60 (this copy, no. 5/60, signed); 10 numbered I/X–X/X; 10 marked A–J, with supplementary suite.

PRINTERS: Georg Baselitz and Till Verclas.
TYPOGRAPHY: Set by Wolfgang Schröder, Hamburg.
COLLECTION: The Museum of Modern Art, New York. Gift of The Cosmopolitan Arts Foundation

Each page of this book might be considered a simple sign or idea without meaning extended beyond its edges. The obscure peasant language is scratched on the plates with the same inventiveness as the images, providing the elements that make this a book instead of a set of prints.

104

105

KURT SCHWITTERS
German. 1887–1948

Die Kathedrale

AUTHOR: Kurt Schwitters.
PUBLISHER: Hannover: Paul Steegemann,
[1920]. (*Die Silbergäule*, vol. 41/42.)
PAGINATION: 8 unnumbered folios (including
flyleaves).
PAGE SIZE: 8¹³⁄₁₆ x 5⅝" (22.4 x 14.3 cm).
IMAGES: 8 transfer lithographs, in black, 1 with
collage (cover), on cream wove paper (except
cover).
IMAGES SHOWN: Left, cover, 8½ x 5⅝" (21.6 x
14.3 cm), irreg.; right, 8¹³⁄₁₆ x 5⅝" (22.4 x 14.3 cm),
irreg.
HOUSING: Publisher's brown wove paper
stapled binding, with lithograph and collage on
front and back and cream paper seal.
EDITION: c. 3,000.
PRINTER: Edler and Krische, Hannover.

COLLECTION: The Museum of Modern Art,
New York. Gift of Edgar Kaufmann, Jr.

*The collages for which Schwitters is well known
were made of bits of discarded papers—the
tickets, bills, and ephemera of daily life. In this
booklet, the bits are printing type, doodles, and
old shoe soles. Rebelling against traditional
forms and techniques, Schwitters used such
ephemera as the construction material for an
ideal building, or cathedral.*

FRANS MASEREEL
Belgian. 1889–1972

La Ville

PUBLISHER: Paris: Editions Albert Morancé, [1925].
PAGINATION: 111 unnumbered folios; supplementary suite of 98 plates.
PAGE SIZE: 11¹⁄₁₆ x 8¹¹⁄₁₆" (28.1 x 22 cm), irreg.
IMAGES: 101 woodcuts (including title page), in black on cream wove Imperial Japan paper; 1 variant woodcut (wrapper front), in color on cream laid paper; supplementary suite, in black on ivory laid China paper.
IMAGE SHOWN: 6⁷⁄₁₆ x 4⁷⁄₁₆" (16.3 x 1.3 cm).
HOUSING: Publisher's cream laid paper wrapper with duplicate woodcut on front and artist's monogram on back.
EDITION: 275: 50 numbered 1–50 on Imperial Japan paper, with supplementary suite (this copy, no. 17, signed); 200 numbered 51–250 on Arches paper; 25 *hors-commerce*, marked A–Z on Arches paper.
PRINTER: Aimé Jourde, Paris.
CATALOGUE RAISONNÉ: Avermaete B 14.
COLLECTION: The Museum of Modern Art, New York. Purchase

Beginning in 1916 Masereel began to produce books of woodcuts and caricatures, first in Geneva, where he illustrated works by a wide range of authors, including Walt Whitman, Stefan Zweig, and Maurice Maeterlinck, and from 1922 until 1940 in Paris, where La Ville *and other "picture books" were created. Although there is no narrative, the numerous woodcuts have been organized in series of related places and themes.*

106

GEORGE GROSZ
American, born and died Germany. 1893–1959

Ecce Homo

AUTHOR: George Grosz.
PUBLISHER: Berlin: Der Malik-Verlag, 1923.
PAGINATION: 91 folios: (4), 1–84, (3); 16 plates *hors-texte*.
PAGE SIZE: 13¾ x 9¼" (34.9 x 24.8 cm).
IMAGES: 100 photolithographic reproductions: 16 after watercolors, in color, and 84 after drawings, in black; on cream wove paper (executed 1915–22).
IMAGES SHOWN: Left, *Ecce Homo* (1921), 10½ x 7⅞" (26.7 x 20 cm), irreg.; right, *Dr. Huelsenbeck am Ende* (1920), 10⅜ x 7⅞" (26.3 x 20 cm), irreg.
HOUSING: Quarter brown leather over brown linen binding, with publisher's cream paper wrapper with reproduction of detail of watercolor on front, mounted on front and back; gray laid endpapers.
EDITIONS: 10,000 in 5 editions. Edition A (signed, reproductions of watercolors and drawings): 50 numbered I–L; edition BI (signed, reproductions of watercolors only): number unknown; edition BII (unsigned, reproductions of drawings only): number unknown; edition C

(bound, unsigned, reproductions of watercolors and drawings): number unknown (this copy); edition D (unsigned, reproductions of watercolors only): number unknown.
PRINTER: Plates, Dr. Selle & Co. A.G., Berlin.
CATALOGUE RAISONNÉ: Dückers S1.
COLLECTION: The Museum of Modern Art, New York. Louis E. Stern Collection

In the early part of his career as an artist, Grosz was associated with Dada artists in Germany. His criticism of post–World War I German society was expressed in several books devoted to reproductions of his drawings. Inevitably, the explicit representation of a debauched establishment meant frequent official harassment of the artist. By titling his work with the Latin phrase from the Passion, in which Christ is shown to the mob that condemns him, Grosz sharpened the bite of his skepticism.

109

MAX ERNST
American, born Germany. 1891–1976

Une Semaine de bonté, ou les sept éléments capitaux

AUTHOR: Max Ernst.
PUBLISHER: Paris: Editions Jeanne Bucher, 1934.
PAGINATION: 5 vols. I (*Le Lion de Belfort*): 22 unnumbered folios; II (*L'Eau*): 18 unnumbered folios; III (*La Cour du dragon*): 26 unnumbered folios; IV (*Oedipe*): 18 unnumbered folios; V (*Le Rire du coq/L'Ile de Paques*; *L'Intérieur de la vue*; *La Clé des chants*): 35 unnumbered folios.
PAGE SIZE: 10¾ x 8¹/₁₆" (27.3 x 20.5 cm).
IMAGES: 182 line-block reproductions, after collages, in black on cream wove Navarre paper (collages executed 1933–34).
IMAGES SHOWN: Above, left page, 7½ x 5½" (19.1 x 14 cm), right page, 7⁹/₁₆ x 5½" (19.2 x 14 cm).
HOUSING: Each volume has separate publisher's binding: I: purple wove paper cover; II: green wove paper cover; III: red wove paper cover; IV: blue wove paper cover; V: yellow wove paper cover; all in quarter green leather over green cloth solander box, lined with buff paper, made by Gerhard Gerlach for Louis E. Stern.
EDITION: 821: 16 numbered I–XVI on Arches paper, with 5 supplementary etchings; 800 numbered 13–812 on Navarre paper (this copy,

no. 715); 5 *hors-commerce*, marked 0–00000 on Arches paper, with 5 supplementary etchings.
PRINTER: Georges Duval, Paris.
CATALOGUE RAISONNÉ: Spies and Leppien 15.
COLLECTION: The Museum of Modern Art, New York. Louis E. Stern Collection

The largest of Ernst's inventive collage novels, this picture book in five volumes is filled with cut-up and reassembled wood engravings used for advertising and popular illustration, reproduced photomechanically. A few copies had additional etched frontispieces in each volume. For volume I, Ernst pressed cardboard boxes onto a plate covered with soft ground, then drew additions on paper over it. The impressions, having spread open the ground, allowed those areas to be etched with acid, forming the image shown here.

110

Above, *Le Lion de Belfort*, supplementary plate from *Une Semaine de bonté, ou les sept éléments capitaux*, vol. I. Paris: Editions Jeanne Bucher, 1934. Soft-ground etching on Arches paper. 7¹/₁₆ x 5⅛" (18 x 13 cm). Spies and Leppien 15I. The New York Public Library, Astor, Lenox, and Tilden Foundations. Spencer Collection

111

DIETER ROTH (DITER ROT)
Swiss, born Germany, 1930

Bok 3c

PUBLISHER: Reykjavík: Forlag Ed. [Dieter Roth and Einar Bragi], 1961.
PAGINATION: 265 unnumbered folios.
PAGE SIZE: 7¹⁵⁄₁₆ x 7⅞" (20.2 x 20 cm).
IMAGES: Offset lithographs, in color on ivory wove paper cut from run-up sheets.
IMAGE SHOWN: 7¹⁵⁄₁₆ x 15¾" (20.2 x 40 cm).
HOUSING: Full beige linen binding with green laid endpapers, enclosing publisher's paper front cover; black linen solander box with beige laid paper lining inside front and back.
EDITION: Approximately 40, numbered, of a projected edition of 100 (this copy, no. 17/100, signed "diter rot").
BOOK DESIGNER: Dieter Roth.
CATALOGUE RAISONNÉ: Roth 13.
COLLECTION: The Museum of Modern Art Library, New York

Much of Roth's earliest work was in the form of books, first geometric progressions of cut or imprinted pages, then collections of found printed paper, cut and bound into thick paperbacks. This is an example of the latter, containing overprinted sheets of color advertising.

CARL ANDRE, ROBERT BARRY,
DOUGLAS HUEBLER, JOSEPH
KOSUTH, SOL LeWITT, ROBERT
MORRIS, LAWRENCE WEINER

Untitled (Xerox Book)

PUBLISHER: New York: Siegelaub/Wendler,
1968.
PAGINATION: 180 unnumbered folios.
PAGE SIZE: 10¹⁵⁄₁₆ x 8�_5⁄₁₆" (27.9 x 21.2 cm)
IMAGES: 175 photocopies, 25 by each of the 7
artists, on white wove paper.
IMAGES SHOWN: Right, Kosuth (American,
born 1945), ⅛ x 3¹⁄₁₆" (.3 x 7.8 cm); below,
Andre (American, born 1935), left, 7⁷⁄₁₆ x 5"
(17.9 x 12.7 cm), irreg., right, 10 x 7¹³⁄₁₆"
(25.4 x 19.9 cm), irreg.
HOUSING: Publisher's ivory wove paper bind-
ing, clear-plastic dust jacket.
EDITION: 1,000 (unnumbered).
COLLECTION: The Museum of Modern Art,
New York. Gift of Mrs. Ruth Vollmer

*Using the serial possibilities of electrostatic
copying processes, the seven artists who con-
tributed to this work were able to transform
their drawings and objects by simply arranging
them on the surface of a Xerox machine and
printing them in sequence. As with the many
copies of letters that were the ordinary result of
photocopying, until artists started using it, bits
of dust and incomplete or solarized lines and
solids changed their fidelity to the typewritten
and drawn originals. In this work, those imper-
fections have been exploited by artists for whom
the process of art making itself was their subject.*

112

113

MARCEL BROODTHAERS
Belgian. 1924–1976

Un Coup de dés jamais n'abolira le hasard

AUTHOR: Stéphane Mallarmé (French. 1842–1898).

PUBLISHERS: Antwerp: Galerie Wide White Space; Cologne: Galerie Michael Werner, 1969.

PAGINATION: 12 unnumbered folios (including flyleaves).

PAGE SIZE: 12¹³⁄₁₆ x 9¹³⁄₁₆" (32.5 x 25 cm).

IMAGES: Photolithographs, in black on transparent paper.

IMAGES SHOWN: Left page, 5⅞ x 5⅞" (14.9 x 14.9 cm), irreg., right page, 7½ x 3⅛" (19.1 x 9.2 cm), irreg.

HOUSING: Publisher's ivory wove paper binding.

EDITIONS: Numbered: 100: 90 numbered 1–90 on transparent paper (this copy, no. 17); 10 numbered I–X on aluminum; catalogue: unknown, unnumbered, on ivory wove paper.

CATALOGUES RAISONNÉS: Werner 8. Jamar 32.

COLLECTION: The Museum of Modern Art, New York. Purchased with funds given by Howard B. Johnson in honor of Riva Castleman

A poet and Conceptual artist, Broodthaers created museumlike installations and catalogues for them as a way of analyzing the meanings of objects and information. In this "appropriation" of Mallarmé's poem, well known for its unique typographical rendering, the artist has obliterated the words but left the lines in their original placement and weight, thus emphasizing the historical consciousness of a known object.

114

115

A . R . P E N C K
(R A L F W I N K L E R)
German, born 1939

Standarts

PUBLISHERS: Cologne: Galerie Michael
Werner; Munich: Verlag Jahn und Klüser, 1970.
PAGINATION: 150 unnumbered folios (including flyleaves).
PAGE SIZE: 11⅛ x 7¹¹⁄₁₆" (29.6 x 19.5 cm).
IMAGES: 149 photolithographic reproductions
of drawings, in color on cream wove paper.
IMAGE SHOWN: 10⅛ x 6¹¹⁄₁₆" (25.7 x 17 cm),
irreg.
HOUSING: Publisher's quarter gray-green linen
over gray-green wove paper binding with photolithographs on front and back.
EDITION: 1,000.
COLLECTION: The Museum of Modern Art,
New York. Purchase

*When the Dresden artist Ralf Winkler took on
a pseudonym, he also traded his East German
Social Realism for a visual vocabulary that is
traditionally thought of as primitive or child-
like. This Artist's Book is a compendium of
signs that, together with human and animal
stick figures, Penck used in paintings and prints
to express his ideas in a repressed society.*

Walker Evans
American. 1903–1975

American Photographs

AUTHOR: Lincoln Kirstein (American, born 1907).
PUBLISHER: New York: The Museum of Modern Art, 1938. First edition.
PAGINATION: 208 pages: (*2*), [*1–188*], 189–198, (*8*).
PAGE SIZE: 8¾ x 7¾" (22.2 x 19.7 cm).
IMAGES: 87 relief halftone reproductions of photographs, in black on ivory wove paper.
IMAGE SHOWN: *Roadside Gas Sign* (1929), 4⅜ x 6⁵⁄₁₆" (11.1 x 16 cm).

HOUSING: Publisher's full black cloth cover, cream wove endpapers; yellow-gray wove paper dust jacket.
EDITION: 5,000.
PRINTER: The Spiral Press, New York. Plates made by Beck Engraving Company.
COLLECTION: The Museum of Modern Art, New York

The first edition of Evans's groundbreaking presentation of his photographs in book form contained no captions. The blank page that faces each of the sensitive realities the artist presents becomes its affective environment.

EDWARD RUSCHA
American, born 1937

Twentysix Gasoline Stations

AUTHOR: Edward Ruscha.
PUBLISHER: [Hollywood]: National Excelsior
Publication, 1962 [1963].
PAGINATION: 24 unnumbered folios.
PAGE SIZE: 7 x 5½" (17.8 x 14 cm).
IMAGES: 26 offset halftone reproductions, after
photographs, in black on ivory wove paper.
IMAGE SHOWN: *Union, Needles, California,*
4⅞ x 10½" (12.4 x 26.7 cm).
HOUSING: Publisher's ivory wove paper
binding.
EDITION: 400 numbered 1–400 (this copy,
no. 345).
PRINTER: The Cunningham Press, Alhambra,
Calif.
COLLECTION: The Museum of Modern Art,
New York

In his many bookworks, *the term that was
invented to define the type of booklet that he
published, Ruscha created sets of images that
had common denominators: all of one type of
place or ordinarily unremarkable object. For
example, the gasoline stations that stand at the
side of monotonous highways became the sub-
ject of the set of photographs that forms this
book. Parking lots and other familiar spaces
and things in the Los Angeles area were given
similar treatment in the cheap, unlimited edi-
tions with which Ruscha chose to exhibit his
ideas about popular culture in the 1960s.*

UNION, NEEDLES, CALIFORNIA

SONIA DELAUNAY-TERK
French, born Russia. 1885–1979

La Prose du Transsibérien et de la petite
Jehanne de France

AUTHOR: Blaise Cendrars (Frédéric-Louis
Sauser; French, born Switzerland. 1887–1961).
PUBLISHER: Paris: Editions des Hommes
Nouveaux [Blaise Cendrars], 1913. First edition.
PAGINATION: 4 joined sheets (formerly folded
once vertically and 21 times horizontally to fit
into wrapper).
SHEET SIZE: Four sheets, overall, 81⅛ x 14¼"
(207.4 x 36.2 cm), irreg.
IMAGE: Pochoir, in color on cream wove imita-
tion Japan paper.
IMAGE SHOWN: Right, 78⁵⁄₁₆ x 14¼" (199 x
36.2 cm), irreg.
HOUSING: Parchment wrapper painted by
Delaunay-Terk.
EDITION: Fewer than the projected 150: 8 num-
bered 1–8 on vellum; 28 numbered 9–36 on
Japan paper; 114 numbered 37–150 on imitation
Japan paper (this copy, no. 150, lacking wrapper);
published edition is thought to number only 60–
100, with approximately 30 wrappers produced.
COLLECTION: The Museum of Modern Art,
New York. Purchase

Now renowned for her fabric and clothing
designs, Delaunay-Terk was deeply involved
in the dynamics of color. This is clearly demon-
strated in her simultaneous creation of color
forms synchronized with the words of the poet
Cendrars, which begin conversationally by ask-
ing the "way to Montmartre."

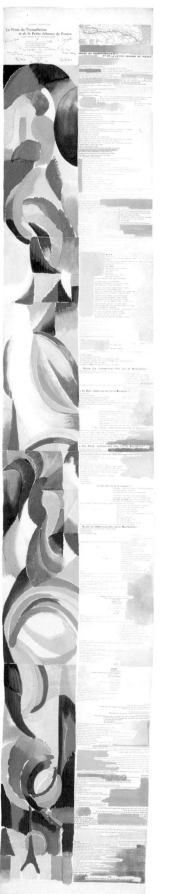

118

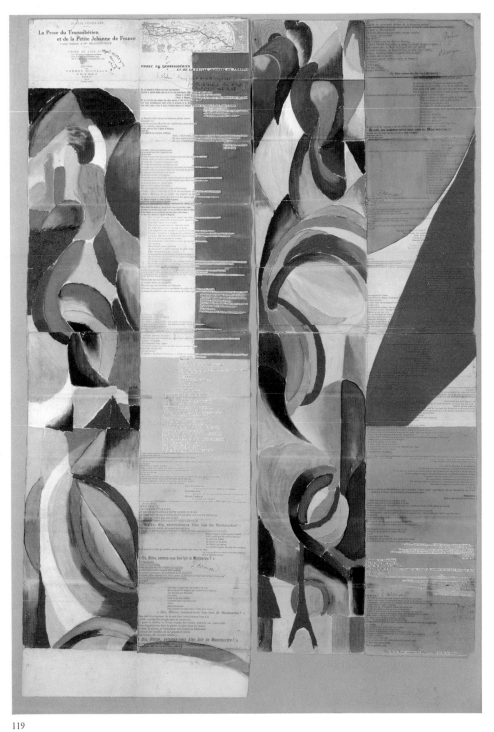

Separated sheets of annotated proof, with water-color, for *La Prose du Transsibérien et de la petite Jehanne de France*. 1913. 78¹³⁄₁₆ x 14⁷⁄₁₆" (199.5 x 36.7 cm) overall. Cabinet des Estampes du Musée d'Art et d'Histoire, Geneva

119

Dieu le père est à son bureau américain. Il signe hâtivement d'innombrables papiers. Il est en bras de chemise et a un abat-jour vert sur les yeux. Il se lève, allume un gros cigare, consulte sa montre, marche nerveusement dans son cabinet, va et vient en mâchonnant son cigare. Il se rassied à son bureau, repousse fiévreu-

31 Décembre

C'est le

FERNAND LÉGER
French. 1881–1955

La Fin du monde, filmée par l'ange N.D.

AUTHOR: Blaise Cendrars (Frédéric-Louis Sauser; French, born Switzerland. 1887–1961).
PUBLISHER: Paris: Editions de la Sirène, 1919.
PAGINATION: 30 unnumbered folios.
PAGE SIZE: 12⅜ x 9¹³⁄₁₆" (31.5 x 25 cm).
IMAGES: 22 pochoirs (including half-title, title page, chapter titles, and colophon), 6 with line-block reproductions of ink drawings, in color on ivory wove Lafuma paper (except wrapper).
IMAGES SHOWN: Above, 12⅜ x 17½" (31.4 x 44.4 cm), irreg.; opposite, 12⅜ x 9¹³⁄₁₆" (31.5 x 25 cm), irreg.
HOUSING: Brown linen binding; publisher's cream paper printed brown cover with line-block reproductions of ink drawings, in black, mounted on front and back; brown laid endpapers and double binder's leaves.
EDITION: 1,225: 25 numbered 1–25 on Rives paper; 1,200 numbered 26–1,225 on Lafuma paper (this copy, no. 313).
PRINTERS: Pochoirs, Richard, Paris; text, Frazier-Soye, Paris.
TYPOGRAPHY: Morland.
CATALOGUE RAISONNÉ: Saphire, page 299.
COLLECTION: The Museum of Modern Art, New York. Louis E. Stern Collection

28.

L'homme mort et les animaux domes-
tiques détruits, réapparaissent les espèces
et les genres qui avaient été chassés. Les
mers se repeuplent des baleines et la
surface de la terre est envahie par une
végétation énorme.

29.

On voit les champs en friche verdir et
fleurir furieusement. Une végétation
audacieuse s'épanouit. Les graminées
deviennent ligneuses ; les herbes folles,
hautes et fortes, durcissent. La ciguë est
légumineuse. Des arbustes apparaissent,
poussent. Les bois s'étendent, et l'on voit
les plaines d'Europe s'assombrir, se
recouvrir uniformément d'apalachine.

Cendrars's twentieth-century satire La Fin du
monde (The End of the World) *is organized like
a movie script and given a dizzying pictorial
environment by Léger. Compressing space in
the Cubist manner, Léger invokes a sense of
simultaneity with overlapping and repetitive
geometric and alphabetic forms.*

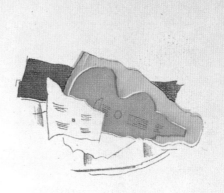

GEORGES BRAQUE
French. 1882–1963

Le Piège de Méduse

AUTHOR: Erik Satie (French. 1866–1925).
PUBLISHER: Paris: Editions de La Galerie
Simon [Kahnweiler], 1921. First edition.
PAGINATION: 18 unnumbered folios.
PAGE SIZE: 12¹³⁄₁₆ x 8¹⁵⁄₁₆" (32.5 x 22.7 cm).
IMAGES: 3 woodcuts, in color on ivory laid
Holland Van Gelder paper.
IMAGE SHOWN: 3⅛ x 5" (8 x 12.7 cm), irreg.
HOUSING: Publisher's cream wove paper bind-
ing, with transparent paper dust jacket embossed
with spider-and-web pattern; French marbleized
paperboard folder and slipcase, lined with buff
wove paper.
EDITION: 112: 10 numbered 1–10 on Imperial
Japan paper; 90 numbered 11–100 on Holland
Van Gelder paper (this copy, no. 52, signed);
12 *hors-commerce*, numbered I–X, o, and oo.
PRINTER: L'Imprimerie Birault, Paris.

CATALOGUE RAISONNÉ: Vallier 13.
COLLECTION: The Museum of Modern Art,
New York. Louis E. Stern Collection

Satie's one-act play, Le Piège de Méduse
(Medusa's Trap), *was first performed on May
24, 1921. Its outstanding prop was a giant
mechanical stuffed monkey, which performed
seven dances to Satie's music. The comedy is
one of constant confusion and conflicting sense,
centering around the baron Medusa's attempt
to trap a husband for his daughter. By contrast,
the geometrical clarity of Braque's delicately
colored Cubist woodcuts embellishes the text in
a traditional manner, heading each part with
compositions of musical instruments.*

JUAN GRIS (JOSÉ
VICTORIANO GONZÁLEZ)
Spanish. 1887–1927

*Ne Coupez pas mademoiselle, ou les erreurs
des P.T.T.*

AUTHOR: Max Jacob (French. 1876–1944).
PUBLISHER: Paris: Editions de La Galerie
Simon [Kahnweiler], 1921. First edition.
PAGINATION: 16 unnumbered folios (including
flyleaves).
PAGE SIZE: 12⁹⁄₁₆ x 8¹⁵⁄₁₆" (32 x 22.8 cm).
IMAGES: 4 lithographs, in color on cream laid
Holland Van Gelder paper.
IMAGE SHOWN: *La Cartelettre*, 10¼ x 7¹³⁄₁₆"
(26 x 19.9 cm), irreg.
HOUSING: Publisher's cream wove Japan paper
binding.
EDITION: 112: 10 numbered 1–10, with supple-
mentary suite; 90 numbered 11–100 (this copy,
no. 88, signed); 10 numbered I–X, reserved for
printers and /or authors; 2 *hors-commerce*, with

supplementary suite of canceled plates, deposit
copies.
PRINTERS: Plates, Charlot Frères, Paris; text,
Birault, Paris.
CATALOGUE RAISONNÉ: Kahnweiler 7–10.
COLLECTION: The Museum of Modern Art,
New York. Louis E. Stern Collection

*One of the Cubist painters associated with
Kahnweiler's Galerie Simon, Gris added prints
to several of the dealer's publications of first
editions, including a book by Gertrude Stein.*

HENRI LAURENS
French. 1885–1954

Les Pélican

AUTHOR: Raymond Radiguet (French. 1903–1923).
PUBLISHER: Paris: Editions de La Galerie Simon [Kahnweiler], 1921. First edition.
PAGINATION: 14 unnumbered folios.
PAGE SIZE: 12⁹⁄₁₆ x 8⅞" (32 x 22.5 cm).
IMAGES: 7 etchings (including wrapper front), 3 with drypoint, in black on cream laid Holland Van Gelder paper (except wrapper).
IMAGES SHOWN: Left, wrapper, 3¹⁵⁄₁₆ x 3¹⁵⁄₁₆" (10 x 10 cm); right, *Mademoiselle Charmant, "Vie Parisienne,"* 3⁵⁄₁₆ x 6⅝" (8.5 x 16.9 cm).
HOUSING: Gray linen binding, publisher's cream wove Japan paper wrapper with etching, in black, on front bound in at end; ivory endpapers, made by Gerhard Gerlach for Louis E. Stern.
EDITION: 112: 10 numbered 1–10 on Imperial Japan paper; 90 numbered 11–100 on Holland Van Gelder paper (this copy, no. 81, signed); 10 numbered I–X, reserved for printers and/or author; 2 *hors-commerce*, marked o and oo, with supplementary suite of canceled plates, deposit copies.
PRINTERS: Plates, Eugène Delâtre, Paris; text, Birault, Paris.
CATALOGUE RAISONNÉ: Völker 7.
COLLECTION: The Museum of Modern Art, New York. Louis E. Stern Collection

A two-act play by a teen-aged author about a foolish family named Pélican, this thin book is the Cubist sculptor Laurens's first attempt at printmaking as well as illustration. His figurative compositions, in the form of linear etched plaques, emulate the low-relief patterns of his sculpture. They also provide a defining structure to the pages of the irregularly spaced dialogue of the characters they depict.

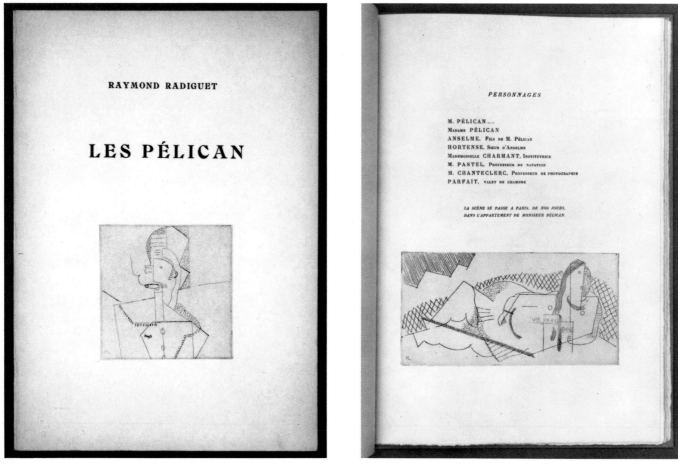

124

125

heisse Quellen und dein Hals erhebt sich und singt wirr wie im Fieber.

Siehe alles ist Jordan draussen und die Luft starrt von Posaunen, tausend eiserne Wogen rollen donnernd über dem Halbkreis rötlich umflammten Gebirges. Alles tönt Ephraim bis in die Ebene.

Schlanke Tänzerin Gottes, mit den üppigen Lenden im Feuer der Berufung Aufgerichtete, Rasende mit den Hüften, Königin langen Blutes, dein Mund singt heiser wie ein Wolf und glüht wie ein Stern.

Nie sah ich Hände, lang, braun und selten wie deine. Blaues Haar deiner Schläfen liegt um meine Kehle geschlungen und mein Mund saugt aus dem Eindruck der Kissen den Geruch deines Fleisches zurück, das dampft und scharf ist wie von den Tieren der Wüste. Die goldenen Siegel deiner schweren Brauen zucken vor Licht. Über uns rennt das rote Segel des Mondes. Auf den Spitzen deiner Finger glühen dunkle Flammen. Mein Herz schauert wild vor dir.

Hinter deiner heissen Stimme liegt eine, weich und flaumig bis zum Rasen der Verzückung, und

40

126

MAX BECKMANN
German. 1884–1950

Die Fürstin

AUTHOR: Kasimir Edschmid (German, 1890–1966).
PUBLISHER: Weimar: Gustav Kiepenheuer, 1918.
PAGINATION: 84 pages: [1–6], 7–81, [82], (2); 6 plates *hors-texte*.
PAGE SIZE: 12⅜ x 9¹/₁₆" (31.5 x 23 cm), irreg.
IMAGES: 6 drypoints, in black on cream wove Zanders paper (executed 1917).
IMAGE SHOWN: 7⅜ x 5⅛" (18.8 x 13 cm).
HOUSING: Publisher's full brown leather binding, with marbleized endpapers, made by E. A. Enders, Leipzig.
EDITION: 500: 10 numbered 1–10 on Zanders paper, with white leather binding and supplementary portfolio; 25 numbered 11–35 on Zanders paper, with white leather binding; 95 numbered 36–130 on Zanders paper, with brown leather binding (this copy, no. 72, signed); 370 on Holland paper, with silk binding.
PRINTERS: Plates, Carl Sabo, Berlin; text, W. Drugulin, Leipzig.

CATALOGUES RAISONNÉS: Hofmaier 111–116. Jannasch 4. Gallwitz 89.
COLLECTION: The Museum of Modern Art, New York. Louis E. Stern Collection

The embittered view of society that Beckmann developed during his hospital duty and subsequent nervous breakdown during World War I is reflected in the prints he contributed to Die Fürstin. Edschmid's poetic text about a hero's dreams is strangely coupled with Beckmann's Expressionist renderings of compressed arrangements of bodies in alienated pairings. Expressionist literature, of which Edschmid was a major proponent, was often restricted by the traditional forms in which it was written, so Beckmann's distorted compositions augmented the Expressionist quotient of the author's less radical text.

127

128

MARCEL JANCO
Israeli, born Romania. 1895–1984

La Première Aventure céléste de Mr. Antipyrine

AUTHOR: Tristan Tzara (Samuel Rosenstock; French, born Romania. 1896–1963).
PUBLISHER: [Zurich]: Collection Dada, 1916. First edition.
PAGINATION: 8 unnumbered folios.
PAGE SIZE: 8¹³⁄₁₆ x 5¹³⁄₁₆" (22.4 x 14.8 cm).
IMAGES: 7 woodcuts, 6 in color and 1 in black on ivory laid paper.
IMAGES SHOWN: Above, 6⅝ x 3¹¹⁄₁₆" (16.9 x 9.3 cm), irreg.; left, cover, 9¹³⁄₁₆ x 6½" (23.3 x 16.5 cm).
HOUSING: Publisher's gray wove paper binding.
EDITION: 510: 10 numbered 1–10, with wood-cuts with hand additions; 500 unnumbered copies with woodcuts in two colors (this copy).
PRINTER: J. Heuberger, Zurich.
COLLECTION: The Museum of Modern Art, New York. Purchase

When Janco went to Zurich to study architecture he met Arp and his own countryman Tzara. Together they constituted the core of Dada, bringing to the Cabaret Voltaire their tastes in art for exhibitions and their unconventional antics. After he and the other Dada artists went to Paris he became disenchanted, particularly with those who were inclined to the theories that would mature into Surrealism. He returned to his native Bucharest, where he remained until 1942 when he fled to Tel Aviv.

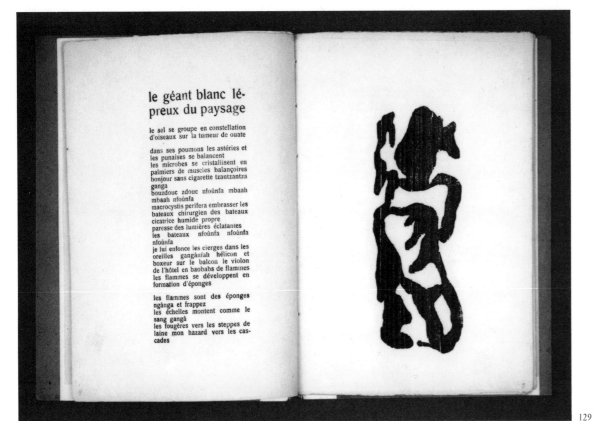

le géant blanc lé-
preux du paysage

le sel se groupe en constellation
d'oiseaux sur la tumeur de ouate

dans ses poumons les astéries et
les punaises se balancent
les microbes se cristallisent en
palmiers de muscles balançoires
bonjour sans cigarette tzantzantza
ganga
bouzdouc zdouc nfoùnfa mbaah
mbaah nfoùnfa
macrocystis perifera embrasser les
bateaux chirurgien des bateaux
cicatrice humide propre
paresse des lumières éclatantes
les bateaux nfoùnfa nfoùnfa
nfoùnfa
je lui enfonce les cierges dans les
oreilles gangànfah hélicon et
boxeur sur le balcon le violon
de l'hôtel en baobabs de flammes
les flammes se développent en
formation d'éponges

les flammes sont des éponges
ngànga et frappez
les échelles montent comme le
sang gangà
les fougères vers les steppes de
laine mon hazard vers les cas-
cades

129

JEAN (HANS) ARP
French, born Alsace. 1887–1966

Vingt-cinq poèmes

AUTHOR: Tristan Tzara (Samuel Rosenstock;
French, born Romania. 1896–1963).
PUBLISHER: Zurich: Collection Dada, 1918.
First edition.
PAGINATION: 26 unnumbered folios.
PAGE SIZE: 7¾ x 5⁵⁄₁₆" (19.7 x 13.5 cm), irreg.
IMAGES: 12 woodcuts (including duplicate on
cover), in black on cream wove paper (except
cover).
IMAGES SHOWN: Above, 5⅜ x 1¹⁵⁄₁₆" (13.6 x
5 cm), irreg.; right, 2⅜ x 2¹⁄₁₆" (6.1 x 5.3 cm), irreg.
HOUSING: Publisher's buff cardboard binding
with woodcut, in black on gold paper, mounted
on front.
EDITION: Unknown: includes 10 numbered
1–10 on Holland paper, signed.
PRINTER: Julius Heuberger, Zurich.
CATALOGUE RAISONNÉ: Arntz 16a–25b.
COLLECTION: The Museum of Modern Art,
New York. Purchase

The artist's experiences in a radical commu-
nity, centered in Ascona, Switzerland, during
1916–17, included drawing small bits of
nature, simplified into what he called "fluid
ovals" and other living forms. The woodcuts
that accompany Tzara's poems are Arp's first
works after he lived in Ascona, and are made
up of what might be described as biomorphic
elements. They also reflect an interest in the
"primitive," which Tzara evoked in his preface
about la poésie nègre.

tristan tzara
vingt-cinq poèmes

h arp
dix gravures sur
bois

collection dada
zurich

130

MUSICIENS EN VOYAGE

Les anciens bandits de Calabre
avaient des fusils à tromblon
chapeau d'artiste, manteau long
Ils se cachaient derrière un arbre

Moi qui voyais sur des images
leurs fusils passant la cachette
croyais entendre le ramage
de joueurs doux de clarinette.

Frères des merles, ces simples jouent
craintive dont pâlit la joue
ils ne vous couchent en joue
que pour vous jouer un air d'amour

131

ANDRÉ MASSON
French. 1896–1987

Soleils bas

AUTHOR: Georges Limbour (French. 1902–1970).
PUBLISHER: Paris: Editions de La Galerie Simon [Kahnweiler], 1924. First edition.
PAGINATION: 12 unnumbered folios.
PAGE SIZE: 9½ x 7½" (24.2 x 19 cm), irreg.
IMAGES: 4 drypoints (including front cover), in black on ivory laid Arches paper (except cover).
IMAGE SHOWN: 6³⁄₁₆ x 4¹¹⁄₁₆" (15.7 x 11.9 cm).
HOUSING: Publisher's cream wove Japan paper binding with etching on front; quarter black leather over navy linen solander box, lined with cream paper.
EDITION: 112: 10 numbered 1–10 on Imperial Japan paper; 90 numbered 11–100 on Arches paper (this copy, no. 88, signed, with dedication to Camille Dausse by Masson); 10 numbered I–X, reserved for printers and/or authors; 2 *hors-commerce*, marked 0 and 00, deposit copies.

PRINTERS: Plates, Charlot Frères, Paris; text, Leibovitz, Paris.
CATALOGUE RAISONNÉ: Saphire 1–4.
COLLECTION: The Museum of Modern Art, New York. Gift of Walter P. Chrysler, Jr.

Limbour and Masson were among the first members of the group that ascribed to André Breton's definition of Surrealism, issued in a manifesto of the same year as this book. Masson's airy lithographs attempt to portray the essential Surrealist premise of absolute reality, derived from resolving the differences between dream and reality.

YVES TANGUY
American, born France. 1900–1955

Dormir dormir dans les pierres

AUTHOR: Benjamin Péret (French. 1899–1959).
PUBLISHER: Paris: Editions Surréalistes, 1927.
First edition.
PAGINATION: 16 unnumbered folios (including
flyleaves).
PAGE SIZE: 8¾ x 6¹³⁄₁₆" (22.3 x 17.3 cm).
IMAGES: 15 line-block reproductions, after pen-
and-ink drawings (including title-page variant
on front cover), in black, 5 (including variant on
cover) with gouache additions on cream wove
Imperial Japan paper.
IMAGE SHOWN: Cover, 7⁷⁄₁₆ x 6⅛" (18.9 x
15.5 cm), irreg.
HOUSING: Publisher's beige wove paper bind-
ing, with reproduction and gouache additions on
front; full brown leather solander box, lined with
beige moiré cloth.
EDITION: 210: 10 numbered 1–10 on Imperial
Japan paper, with gouache additions (this copy,
no. 007, signed); 20 numbered 11–30 on Van

Gelder paper, with gouache additions; 175 num-
bered 31–205 on laid paper; 5 dedicated copies on
China paper, probably with gouache additions.
PRINTER: Editions Surréalistes, Paris.
COLLECTION: The Museum of Modern Art,
New York. Louis E. Stern Collection

The cover and illustrations of this first embel-
lishment of a Surrealist text by the artist are
reproductions of his drawings, which he has en-
hanced with white paint on the first copies. In
the year this book was published the self-taught
Tanguy introduced small biomorphic and
pebble forms into the barren landscapes that
characterized his compositions.

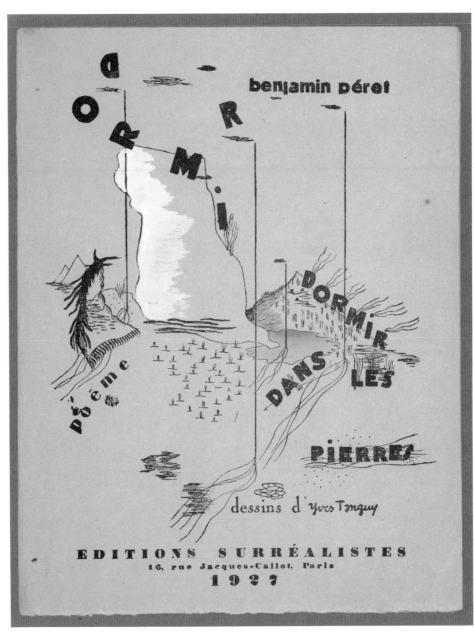

Calligrammes

AUTHOR: Guillaume Apollinaire (Guillaume Apollinaire de Kostrowitsky; French, born Italy. 1880–1918).

PUBLISHER: [Paris]: Librairie Gallimard, 1930.

PAGINATION: 276 pages: [1–14], 15–269, (7).

PAGE SIZE: 12¹³⁄₁₆ x 10" (32.5 x 25.5 cm), irreg.

IMAGES: 68 lithographs (including duplicates on title page and wrapper front), in black on ivory laid China paper.

IMAGE SHOWN: 6⅛ x 6¼" (15.5 x 15.8 cm), irreg.

HOUSING: Publisher's ivory laid China paper wrapper with duplicate lithograph on front; black cloth solander box with red leather insert on front, lined with cream paper, in quarter black leather over ivory Japan paperboard slipcase, made by Gerhard Gerlach for Louis E. Stern.

EDITION: 131: 6 numbered 1–6 on Whatman paper; 6 numbered 7–12 on Japan *nacré* paper; 88 numbered 13–100 on China paper (this copy, no. 74, signed); 31 *hors-commerce*, numbered I–XXXI, 1 reserved for the artist.

PRINTERS: Plates, Desjobert, Paris; text, Maurice Darantière.

CATALOGUE RAISONNÉ: Ciranna 17–82.

COLLECTION: The Museum of Modern Art, New York. Louis E. Stern Collection

*At the time he was painting his quintessential metaphysical works, de Chirico did not illustrate books, although his paintings were full of references to myths, and his brother, Alberto Savinio, was a writer. Despite his early friendship with authors such as Apollinaire before World War I and Jean Cocteau afterward, he did not begin to illustrate their texts until 1928 (*Le Mystère laïc *by Cocteau) and, finally in 1929, this version of Apollinaire's poetry.*

133

JOAN MIRÓ
Spanish. 1893–1983

Enfances

AUTHOR: Georges Hugnet (French. 1906–1974).

PUBLISHER: Paris: Editions Cahiers d'Art, [1933].

PAGINATION: 44 pages: (10), 1–29, (5) (including endpapers); 3 plates *hors-texte*.

PAGE SIZE: 11 x 8¾" (28 x 22.2 cm), irreg.

IMAGES: 3 etchings, in black on gray laid Ronsard paper (executed 1932–33).

IMAGE SHOWN: Above, 9¼ x 5⅞" (23.5 x 15 cm).

HOUSING: Publisher's gray laid Ronsard paper binding.

EDITION: 131: 5 numbered 1–5 on Imperial Japan paper, with supplementary manuscript page; 95 numbered 6–100 on Arches paper; 25 on Ronsard paper, marked A–Z, reserved for author (this copy, marked D, partially uncut); 4 *hors-commerce*, on Imperial Japan paper; 2 *hors-commerce*, marked o and oo, deposit copies.

PRINTERS: Plates, Roger Lacourière, Paris; text, Paul André, Paris.

CATALOGUES RAISONNÉS: Cramer 2. Dupin 10–12.

COLLECTION: The Museum of Modern Art, New York. Louis E. Stern Collection

Hugnet wanted to issue Enfances *in French and English, so he asked his friend Gertrude Stein to translate his poems. She finally wrote a totally different text, which she called "reflections" on the subject, but when she saw that Hugnet was not going to credit her as a co-author, she angrily published* Before the Flowers of Friendship Faded Friendship Faded: Written on a Poem by Georges Hugnet *two years before* Enfances *appeared.*

Gertrude Stein. *Before the Flowers of Friendship Faded Friendship Faded: Written on a Poem by Georges Hugnet.* Paris: Plain Edition, [1931]. Carleton Lake Collection, Harry Ransom Humanities Research Center, The University of Texas at Austin

JE rêve je te vois superposée indéfiniment à toi-même
Tu es assise sur le haut tabouret de corail
Devant ton miroir toujours à son premier quartier
Deux doigts sur l'aile d'eau du peigne
Et en même temps
Tu reviens de voyage tu t'attardes la dernière dans la
 grotte
Ruisselante d'éclairs
Tu ne me reconnais pas

136

ALBERTO GIACOMETTI
Swiss. 1901–1966

L'Air de l'eau

AUTHOR: André Breton (French. 1896–1966).
PUBLISHER: Paris: Editions Cahiers d'Art,
1934. First edition.
PAGINATION: 24 unnumbered folios.
PAGE SIZE: 11⅞ x 7⅟₁₆" (30.2 x 18 cm), irreg.
IMAGES: 4 engravings, in black on ivory laid
Montval paper.
IMAGE SHOWN: 6⅜ x 5⅜" (16.2 x 13.6 cm).
HOUSING: Brown cloth binding with publisher's
buff laid paper wrapper bound in; cream laid
endpapers.
EDITION: More than 345: 5 numbered 1–5 on
Japan *nacré* paper; 40 numbered 6–45 on

Montval paper (this copy, no. 11); 300 on wove
paper; several *hors-commerce*.
PRINTER: L'Imprimerie J. Grou-Radenez,
Paris.
CATALOGUE RAISONNÉ: Lust 76–79.
COLLECTION: The Museum of Modern Art,
New York. Louis E. Stern Collection

*The artist's first work was figurative, and when
he began to make sculptures under the influence
of Surrealism he continued to include references
to animals, birds, and people. His most impor-
tant Surrealist works date from the early 1930s,
and he was expelled from the Surrealist move-
ment a year after this book was published.*

MAN RAY (EMMANUEL RUDNITSKY)
American. 1890–1976

Facile

AUTHOR: Paul Eluard (Eugène Grindel; French. 1895–1952).

PUBLISHER: Paris: Editions GLM [Guy Lévis Mano], 1935. First edition.

PAGINATION: 14 unnumbered folios.

PAGE SIZE: 9⁹⁄₁₆ x 7⁷⁄₁₆" (24.2 x 18 cm).

IMAGES: 12 photogravure reproductions, after photographs, in black on cream wove paper.

IMAGES SHOWN: Left page, 9⁹⁄₁₆ x 7⁷⁄₁₆" (24.2 x 18 cm), right page, 3⅝ x 7⁷⁄₁₆" (9.2 x 18 cm), irreg.

HOUSING: Publisher's cream wove paper wrapper with reproduction on front.

EDITION: 1,225: 20 numbered 1–20 on Imperial Japan paper, with an original photograph signed by Man Ray; 1,000 numbered 21–1,020 on wove paper (this copy, no. 42); 205 *hors-commerce*: 5 numbered I–V with an original photograph signed by Man Ray, 200 numbered VI–CCV.

PRINTERS: Photogravures, Breger, Paris; text, Editions GLM, Paris.

COLLECTION: The Museum of Modern Art, New York

This is the second book collaboration by the artist and author and the first to include Man Ray's photographs. The cover of Facile *consists of a photograph of metal type spelling out the title and names of the authors. All the pages are photographs of Eluard's wife, Nusch, and the poems that complement them are placed within the space of the photographic image.*

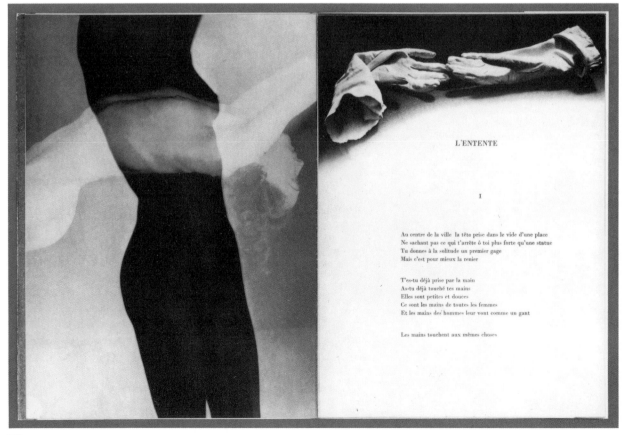

137

138

This sole example of the sculptor Brancusi's graphic contribution to a book is as important for the reproduction of his drawing as for the publication of Joyce's fragments from his not-yet-completed masterpiece Finnegans Wake. For their Black Sun Press, Harry and Caresse Crosby wanted Picasso to draw Joyce's portrait for the frontispiece, but he refused. Brancusi, who knew Joyce, made two attempts: the second, less representational, sketch was used. After setting the text the printer discovered that the last page contained only two lines. The author was quite willing to write more to save the awkward page.

CONSTANTIN BRANCUSI
French, born Romania. 1876–1957

Tales Told of Shem and Shaun, Three Fragments from Work in Progress

AUTHOR: James Joyce (Irish. 1882–1941).
PUBLISHER: Paris: The Black Sun Press, 1929. (First edition of working text for *Finnegans Wake*, 1939.)
PAGINATION: 90 pages: (*14*), I–XV, [XVI], 1–55, (*5*).
PAGE SIZE: 8³⁄₁₆ x 6½" (20.8 x 16.5 cm).
IMAGE: 1 photogravure reproduction of pen-and-ink drawing, in black on ivory laid Van Gelder paper.
IMAGE SHOWN: *Portrait of the Author*, 7¹⁄₁₆ x 4⅝" (18 x 11.8 cm), irreg.
HOUSING: Publisher's ivory laid Arches paper binding with ivory laid Van Gelder endpapers; in gold paperboard slipcase.
EDITION: 650: 100 numbered 1–100 on Japan paper; 500 numbered 101–600 on Van Gelder paper (this copy, no. 316); 50 *hors-commerce*.
PRINTER: The Black Sun Press, Paris.
TYPOGRAPHY: Caslon.
COLLECTION: The Museum of Modern Art, New York. Mary Ellen Meehan Fund

139

La Barre d'appui

AUTHOR: Paul Eluard (Eugène Grindel; French. 1895–1952).
PUBLISHER: Paris: Editions Cahiers d'Art, 1936. First edition.
PAGINATION: 16 unnumbered folios (uncut from four sheets).
PAGE SIZE: 8¼ x 6¼" (21 x 15.9 cm).
IMAGES: 3 etching and lift-ground aquatints, in black on Manufactures Impériales buff wove Antique Japan paper.
IMAGE SHOWN: Below, *Marie-Thérèse endormie au bord de la mer*, 6⅛ x 4⅛" (15.6 x 10.6 cm).
HOUSING: Publisher's cream wove paper wrapper covered in flower-petal-flecked Antique Japan paper, with printed Japan paper label pasted on front.
EDITION: 40 numbered 1–40 (this copy, no. 9, signed).
PRINTERS: Etchings, Roger Lacourière, Paris; text, Aimé Jourde, Paris.
CATALOGUES RAISONNÉS: Cramer 26. Baer 607 (state II).
COLLECTION: The Toledo Museum of Art. Purchased with funds given by Molly and Walter Bareiss in honor of Barbara K. Sutherland and with funds from the Mrs. George W. Stevens Fund

Above, four subjects for *La Barre d'appui*. [1936]. Etching and lift-ground aquatint, in black on buff wove Japan paper. 16½ x 12½" (42 x 31.7 cm). Baer 607Ib. The Museum of Modern Art, New York. Purchase

For Eluard's poem Picasso first etched three compositions on one plate, planning for them to be cut apart and inserted in the text at separate places. In the fourth segment of the plate he added an impression of his own hand. The two women depicted are Nusch Eluard and Picasso's mistress (asleep), Marie-Thérèse Walter.

140

HANS BELLMER
German. 1902–1975

La Poupée

AUTHOR: Hans Bellmer. Trans. by Robert Valençay.
PUBLISHER: Paris: GLM [Guy Lévis Mano], 1936. First French edition.
PAGINATION: 22 unnumbered folios.
PAGE SIZE: 6⅛ x 4½" (15.5 x 11.5 cm).
IMAGES: 10 photographs mounted on cream wove paper (executed 1934); 2 line-block reproductions, after drawings, in black on pink wove paper.
IMAGES SHOWN: Left, 2³⁄₁₆ x 1¼" (5.6 x 3.2 cm), irreg.; right, 4⅝ x 3⅛" (11.7 x 7.9 cm).
HOUSING: Tan linen binding, made by Brooklyn Binding Co., with gray speckled wove endpapers and single binder's leaves; publisher's light-tan wove paper wrapper bound in.
EDITION: 100: 5 numbered 1–5 on Japan paper; 20 numbered 6–25 on Normandy Vellum paper (this copy, no. 9, on pink paper); 80 [*sic*] numbered 26–100 on pink paper.
PRINTER: Text, GLM, Paris.
COLLECTION: The Museum of Modern Art, New York. Purchase

Although Bellmer produced a German edition of this book of photographs of his demountable female mannequin in 1934 (Die Puppe), *most existing German copies were made up from leftover sheets found after World War II. The photographs alone were published in France in 1934, while the book with a text in French appeared two years before Bellmer himself moved to Paris in 1938. A second book,* Les Jeux de la poupée, *with a text by Paul Eluard, containing hand-colored photographs of the mannequin in landscape and interior settings, was published in 1949.*

141

142

143

JEAN DUBUFFET
French. 1901–1985

Labonfam abeber par inbo nom

AUTHOR: Jean Dubuffet.
PUBLISHER: [Paris: Jean Dubuffet], 1950. First edition.
PAGINATION: 14 unnumbered folios.
PAGE SIZE: 11⅛ x 8¹¹⁄₁₆" (28.2 x 22 cm), irreg.
IMAGES: 6 photolithographic reproductions, after ink drawings, on cream laid Indochina paper.
IMAGE SHOWN: 10¼ x 8⅛" (26 x 20.6 cm), irreg.
HOUSING: Publisher's cream laid China paperboard binding with cream laid China endpapers.
EDITION: 50 (unnumbered).
PRINTER: Jean Fautrier or M. Mannequin, Paris.
TYPOGRAPHY: Artist's manuscript.
CATALOGUES RAISONNÉS: Arnaud 136. Webel 304–329.
COLLECTION: The Museum of Modern Art, New York. The Associates Fund

Influenced by the uninhibited pictures made by children, folk and self-taught artists, and the mentally ill, Dubuffet's images of people are candid and humorous. The artist's own texts are comparable in quality, as he writes them phonetically, breaking up words and attaching the syllables of some words to those of others.

WOLS (OTTO ALFRED
WOLFGANG SCHULZE)
German. 1913–1951

Visages, précédé de portraits officiels

AUTHOR: Jean-Paul Sartre (French. 1905–1980).
PUBLISHER: Paris: [Pierre] Seghers, 1948. First edition.
PAGINATION: 48 pages: [1–12], 13–41, (7), including flyleaves.
PAGE SIZE: 7½ x 4¹³⁄₁₆" (19 x 12.2 cm).
IMAGES: 4 drypoints, in black on ivory wove Marais Crèvecoeur paper.
IMAGE SHOWN: 5½ x 3¹⁄₁₆" (13.9 x 7.8 cm).
HOUSING: Publisher's ivory wove paper binding.
EDITION: 925: 15 numbered 1–15 on China paper; 900 numbered 16–916 on Marais Crèvecoeur paper (this copy, no. 590); 10 *hors-commerce*, marked "H.C.," reserved for artist and author.
PRINTERS: Plates, R. Haazen, Paris; text, Imprimerie Union, Paris.
CATALOGUE RAISONNÉ: Grohmann XLVI–IL.
COLLECTION: The Museum of Modern Art, New York. Henry Church Fund

The small drawings the German artist executed while hiding in unoccupied France during the years of World War II anticipated in scale and intensity his portraits in this book. In Paris after the war, Wols was befriended by Sartre and illustrated two of his books with drypoints in the informal tachiste manner, which concentrated into visible form the author's Existentialist philosophy.

144

145

J E A N F A U T R I E R
French. 1898–1964

La Femme de ma vie

AUTHOR: André Frénaud (French, born 1907).
PUBLISHER: Paris: Librairie Auguste Blaizot,
1947. First edition.
PAGINATION: 26 unnumbered folios; 1 large
plate folded in twelve.
PAGE SIZE: 11⅜ x 7⁷⁄₁₆" (29 x 18 cm).
IMAGES: 6 etchings and aquatints with photo-
engraved reproduction of Fautrier's handwriting,
including 1 folded and lined with pink lace, in
color on ivory wove Auvergne paper.
IMAGE SHOWN: Large folded plate, 21¼ x
35¹³⁄₁₆" (54 x 91 cm).
HOUSING: Publisher's Auvergne paper wrapper
covered with pink lace.
EDITION: 27: 1 numbered 1 on Japan paper,
including original drawing on which the prints
were based; 5 numbered 2–6 on Japan paper; 15
numbered 7–21 on Auvergne paper (this copy,
no. 21); 6 *hors-commerce*, marked A–F.
PRINTER: Jean Fautrier at Chatenay, France.

TYPOGRAPHY: Author's manuscript and artist's
transcription.
CATALOGUE RAISONNÉ: Mason 188–203.
COLLECTION: Graphische Sammlung
Staatsgalerie Stuttgart

*Working from a combination of his own draw-
ing and the author's manuscript, the artist cre-
ated one large print. Cut into five pages, the
same print constituted the whole text of the
book; this is interspersed with pages on which
only the title appears in different colors. The
large folded print, backed with pink lace, is
placed at the end of the book, presenting the
complete poetic tribute to Frénaud's La Femme
de ma vie (Woman of My Life) .*

MATTA (ROBERTO SEBASTIAN
ANTONIO MATTA ECHAURREN)
Chilean, born 1911

Arcane 17

AUTHOR: André Breton (French. 1896–1966).
PUBLISHER: New York: Brentano's, 1944.
PAGINATION: 178 pages: (2), [1–8], 9–176
(including flyleaves); 4 reproductions *hors-texte*.
PAGE SIZE: 9¹⁄₁₆ x 6⁵⁄₁₆" (23 x 16 cm), irreg.
IMAGES: 1 etching and aquatint (frontispiece),
in color on *chine collé* on white wove Umbria
paper, and 4 photolithographic reproductions,
after tarot card designs, in color on ivory wove
paper mounted on pale orange-yellow wove
paper.
IMAGE SHOWN: Frontispiece, 5 x 2¾" (12.7 x
7 cm).
HOUSING: Publisher's white wove paper
binding.
EDITION: 325: 25 marked A–Y on Umbria
paper, with etching (this copy, marked T,
signed); 300 numbered 1–300 on Oxbow paper.
PRINTER: Albert Martin, Inc., New York.
CATALOGUE RAISONNÉ: Sabatier 8.
COLLECTION: The Museum of Modern Art,
New York. Purchase

*Although he was a young, essentially unknown
painter when he arrived in America from
France, Matta had already entered the Sur-
realist circle. His friendship with Breton, the
leader of the Surrealists, led to his contribution
of an etched frontispiece for Breton's only book
written and published in America. Matta be-
came a prolific printmaker and book artist when
he returned to Europe after World War II.*

146

L'OUEST DERRIÈRE SOI PERDU

L'ouest derrière soi perdu, présumé englou-
ti, touché de rien, hors-mémoire, s'arrache à sa
couche elliptique, monte sans s'essoufler, enfin
se hisse et rejoint. Le point fond. Les sources
versent. Amont éclate. Et en bas le delta verdit.
Le chant des frontières s'étend jusqu'au belvé-
dère d'aval. Content de peu est le pollen des
aulnes.

58

147

ALBERTO GIACOMETTI
Swiss. 1901–1966

Retour amont

AUTHOR: René Char (French. 1907–1988).
PUBLISHER: Paris: GLM [Guy Lévis Mano],
1965. First edition.
PAGINATION: 68 pages: [1–8], 9–59, (9).
PAGE SIZE: 9⅛ x 7¼" (24.5 x 18.4 cm).
IMAGES: 4 aquatints, in black on ivory wove
Rives BFK paper.
IMAGE SHOWN: 8¾ x 6½" (22.2 x 16.6 cm).
HOUSING: Publisher's ivory wove paper wrap-
per; publisher's blue-gray cloth solander box,
lined with light blue-gray suedelike cloth.
EDITION: 188: 148 numbered 1–148 (this copy,
no. 51); 40 numbered I–XL, reserved for printers
and/or authors.
PRINTERS: Plates, Crommelynck, Paris; text,
Guy Lévis Mano, Paris.
TYPOGRAPHY: Garamond.
CATALOGUE RAISONNÉ: Lust 188–191.
COLLECTION: The Museum of Modern Art,
New York. Monroe Wheeler Fund

*Giacometti's typically attenuated figures emerge
from a vast void of densely aquatinted black in
the plates that accompany his friend's poem
written after the deaths of Char's sister and the
painter Nicolas de Staël. The book was com-
pleted only a few weeks before Giacometti died.*

148

De Staël was one of the most admired abstract painters in post–World War II Europe. He derived inspiration from the land, sea, and sky, which he translated into constellations of small gouges in the woodcuts he made for the verses of the hermetic poet Char.

NICOLAS DE STAËL
French, born Russia. 1914–1955

Poèmes

AUTHOR: René Char (French. 1907–1988).
PUBLISHER: Paris: [Nicolas de Staël], 1952.
PAGINATION: 48 unnumbered folios.
PAGE SIZE: 14½ x 11⅛" (36.9 x 28.3 cm).
IMAGES: 14 wood engravings, in black, and 1 lithograph (publisher's folder), in color on cream wove Arches paper (executed 1951).
IMAGE SHOWN: Frontispiece, 13¹⁵/₁₆ x 10⅝" (35.4 x 27 cm).
HOUSING: Publisher's cream wove Arches paper wrapper; publisher's ivory wove paperboard folder with continuous lithograph on front and back, lined with cream paper; in clear plexiglass case, probably made for Louis E. Stern.
EDITION: 120: 15 numbered 1–15, with 2 supplementary suites; 90 numbered 16–105 (this copy, no. 69, signed); 15 *hors-commerce*, numbered I–XV.
PRINTER: Marthe Fequet et Pierre Baudier, Paris.
TYPOGRAPHY: Firmin Didot.
CATALOGUE RAISONNÉ: Woimant and de Staël 2–15, 94.
COLLECTION: The Museum of Modern Art, New York. Louis E. Stern Collection

GÜNTHER UECKER
German, born 1930

Vom Licht

AUTHORS: Various.
PUBLISHER: Heidelberg: Galerie Rothe, 1973.
PAGINATION: 28 unnumbered folios.
PAGE SIZE: 20 1/16 x 20 1/16" (51 x 51 cm).
IMAGES: 12 embossings on ivory wove paper.
IMAGE SHOWN: With excerpts by Ernst Wilhelm Lotz (German. 1890–1914) and Else Lasker-Schüler (German. 1869–1945), 18 5/8 x 37 13/16" (47.3 x 96 cm), irreg.
HOUSING: Unbound, in publisher's black linen folder, lined with ivory paper, made by Hans Bichelmeier, Mannheim; publisher's white cardboard box.
EDITION: 80: 60 numbered 1/60–60/60 (this copy, no. 26/60, signed); 15 numbered I–XV; 5 *hors-commerce*, marked "H.C."
PRINTERS: Plates, Tünn Konerding; text, Siebdruck-Technik Essen.
BOOK DESIGNERS: Tünn Konerding and Günther Uecker.
TYPOGRAPHY: Times Antiqua, set by Letter-Service, Essen.
COLLECTION: The Museum of Modern Art, New York. Mrs. Stanley Resor Fund (by exchange)

One of the Gruppe Zero, which was most active in Düsseldorf during the early 1960s, Uecker used nails to alter his all-white canvases or placed them on their surfaces. The other artists in the group, Heinz Mack and Otto Piene, also made their works from aggressive elements such as metal punctures and fire. The resulting artworks were composed by the play of light created by such elements, and in Uecker's book about light, the uninked, embossed patterns made by nails produce shadows that echo the meaning and structure of each text.

149

150

EDUARDO CHILLIDA
Spanish, born 1924

Die Kunst und der Raum/L'Art et l'espace

AUTHOR: Martin Heidegger (German. 1889–1976).
PUBLISHER: St. Gall: Erker-Verlag/Erker Presse [Franz Larese and Jürg Janett], 1969.
PAGINATION: 2 vols. I: 28 pages: [1–4], 5–26, (2); II: 38 pages: (1), [1], 2–11, [12], 25 pages *hors-texte*, including 7 plates and 18 blank pages. 1 phonograph record.
PAGE SIZE: 8⅜ x 6 1/16" (21.3 x 15.4 cm).
IMAGES: 7 lithographs, in black on cream wove Japan paper pasted onto ivory wove Rives BFK paper; 1 lithograph (folder), in black on cream wove Japan paper.
IMAGE SHOWN: 6 5/16 x 6" (16.1 x 15.3 cm), irreg.
HOUSING: I: publisher's cream Japan paperboard binding, with ivory wove endpapers; II: publisher's ivory wove Rives BFK paper wrapper; cream wove Japan paperboard folder with continuous lithograph on front and back, lined with ivory paper. Both in publisher's cream Japan paperboard slipcase. Record housed separately in glossy ivory paper cover, with photograph of artist on back.
EDITION: 150: 25 numbered 1–25, with supplementary suite; 125 numbered 26–150 (this copy, no. 97, signed).
PRINTERS: Vol. I, Zollikofer & Co., A.G., St. Gall; vol. II, Erker-Presse, St. Gall.
TYPOGRAPHY: Vol. II: Author's manuscript.

CATALOGUE RAISONNÉ: Michelin, pages 83–85.
COLLECTION: The Museum of Modern Art, New York. Given in memory of Louise A. Boyer by Lily Auchincloss and Frances Keech

The Spanish artist's collage lithographs for the two-volume presentation of Heidegger's philosophical lecture on space are composed of motifs that suggest the angled blocks of stone in his sculptures.

PIERRE ALECHINSKY
Belgian, born 1927

Le Rêve de l'ammonite

AUTHOR: Michel Butor (French, born 1926).
PUBLISHER: [Montpellier, France]: Editions
Fata Morgana, [1975]. First edition.
PAGINATION: 2 parts. Book: 42 unnumbered
folios; suites: 21 plates.
PAGE SIZE: 12¹³⁄₁₆ x 9¹³⁄₁₆" (32.5 x 25 cm).
SHEET SIZE: Suites: lithographs, 12⅞ x 19¾"
(32.8 x 50.2 cm); aquatints, 19¾ x 25⅞" (50.2 x
65.8 cm).
IMAGES: 10 lift-ground aquatints, in color; 27
lithographs (including wrapper front), in black;
supplementary suite of 5 aquatints, in black, and
16 lithographs, in color, on ivory wove Arches
paper (executed 1972–74).
IMAGES SHOWN: Left page, 11⅝ x 1¼" (29.5 x
3.1 cm), irreg., right page, 11⅜ x 8¹⁄₁₆" (28.9 x
20.5 cm), irreg.
HOUSING: Book: publisher's ivory wove Arches
paper wrapper with lithograph on front, in pub-
lisher's folder and slipcase; suite: publisher's
cream paperboard folder with reproductions on
front and back, lined with ivory paper; made by
Adine, Paris.

EDITION: 180: 5 numbered 1–5, with supple-
mentary drawing, manuscript fragment, copper
plate, and 2 supplementary suites; 30 numbered
6–35, with 2 supplementary suites; 120 numbered
36–155; 25 *hors-commerce*, numbered I–XXV,
with 2 supplementary suites, reserved for collab-
orators (this copy, nos. XXI/XXV, each supple-
mentary sheet signed).
PRINTERS: Aquatints in book, Moret, Paris;
aquatints in suite, Jean Clerté, Bougival; litho-
graphs, Clot, Bramsen et Georges, Paris; text,
La Charité, Montpellier.
CATALOGUE RAISONNÉ: Butor and Sicard 31.
COLLECTION: The Museum of Modern Art,
New York. Gift of the artist

One of the most prolific book artists of the sec-
ond half of this century, Alechinsky is adept at
filling margins and full pages with his fantastic
visions, from volcanos to ammonites, the fossils
of prehistoric cephalopods. He is partial to
working directly with writers, and did so in this
case completely by mail. After he sent a set of
etchings to Butor, the writer invented a text in
parts, each referring to sections of the prints.
The numbers given to each part of the text are
also printed on glassine sheets overlaying the
related prints, interrupting them as in a dis-
turbed dream—the subject of this book.

151

152

ANTONI TÀPIES
Spanish, born 1923

Anular

AUTHOR: José-Miguel Ullán (Spanish, born 1944). Trans. by Claude Esteban.
PUBLISHER: Paris: R.L.D. [Robert and Lydia Dutrou], [1981]. First edition.
PAGINATION: 50 unnumbered folios.
PAGE SIZE: 12⅞ x 9⁷⁄₁₆" (32.7 x 24 cm), irreg.
IMAGES: 21 lift-ground aquatints (including wrapper), with soft-ground etching, etching, aquatint, and carborundum: 17 in black and 4 in color; 1 soft-ground etching, in black; and 1 aquatint and carborundum, in color with paint additions; most on cream wove Auvergne Richard de Bas paper, 8 folios die-cut and/or torn or burnt.
IMAGE SHOWN: 12¹³⁄₁₆ x 18¹³⁄₁₆" (32.6 x 47.8 cm), irreg.
HOUSING: Bound in accordion fold in publisher's cream wove Arches paper wrapper, with continuous aquatint on front and back under clear-plastic dust jacket; publisher's brown paperboard folder and slipcase, lined with ivory paper.
EDITION: 150: 35 numbered 1–35, with supplementary suite; 90 numbered 36–125 (this copy, no. 112, signed); 15 *hors-commerce*, numbered I–XV, reserved for artist and author; 10 *hors-commerce*, marked A–J.

PRINTERS: Plates, Morsang, Paris; text, Fequet et Baudier, Paris.
TYPOGRAPHY: Reproduced typewritten text.
CATALOGUE RAISONNÉ: Puig, pages 102–103.
COLLECTION: The Museum of Modern Art, New York. Abby Aldrich Rockefeller Fund (by exchange)

One of a set of books by an exiled Spanish poet who collaborated with several artists, Anular *has been designed to emphasize its political motivation through torn pages and negative signs. The poet's text is superimposed over the densely printed lines of one of Spain's discarded constitutions, while heavy black marks are the artist's commentary upon this confrontation. The ring called for in the title seems to refer to the persistent cycle of dictatorship overtaking democracy, which has been the Spanish experience.*

NOT VITAL
Swiss, born 1948

Poesias rumantsches cun disegns da Not Vital

AUTHORS: Pier Paolo Pasolini (Italian. 1922–1975); Luisa Famos (Swiss. 1930–1974); Andri Peer (Swiss. 1921–1985).
PUBLISHER: Poestenkill, N.Y.: Edition Gunnar A. Kaldewey, 1987.
PAGINATION: 20 unnumbered folios.
PAGE SIZE: 19¼ x 12⅜" (48.9 x 31.4 cm), irreg.
IMAGES: 5 wash-and-graphite drawings with collage, abraded, and/or torn, and 1 object pasted in, on dark-brown paper made from cedar tree bark by Shusaku Tomis in Wajma, Japan.
IMAGE SHOWN: With poem, "Di d'inviern," by Famos, 19¼ x 24¾" (48.9 x 62.9 cm).
HOUSING: Tan, rough, wove de Wint paper wrapper, with a printed label on front; sugar-pine wood slipcase made by Shahin, Albany.
EDITION: 60: 25 on light-brown paper; 25 on dark-brown paper (this copy, signed); 10 deluxe copies in elephant folio format.
PRINTER: Text, Kaldewey Press, Poestenkill, N.Y.
CATALOGUE RAISONNÉ: Kaldewey 12.
COLLECTION: The Resource Collections of the Getty Center for the History of Art and the Humanities

The three poems embellished by the artist are printed in his native tongue, Rhaeto-Romansch, a language spoken in the Engadin valley of Switzerland.

HOWARD HODGKIN
British, born 1932

The Way We Live Now

AUTHOR: Susan Sontag (American, born 1933).
PUBLISHER: London: Karsten Schubert, 1991.
PAGINATION: 40 pages: [1–10], 11–34, (6); 15 folios *hors-texte*; 1 unbound plate.
PAGE SIZE: 11¼ x 8⁵⁄₁₆" (28.6 x 21.2 cm).
IMAGES: 7 lift-ground aquatints (including front and back "endpapers" and unbound plate), in color with tempera additions; and 1 tempera (dust jacket); on cream laid Fabriano Ingres Avorio paper (except dust jacket) (executed 1990).
IMAGE SHOWN: *As You'd Been Wont— Wantonly/Wantonly/Eros Past*, 11¼ x 16½" (28.5 x 42 cm).
HOUSING: Publisher's beige paperboard binding, cream laid endpapers, blue wove Fabriano paper dust jacket with continuous tempera on front, back, and flaps, made by Dieter Schulke, England.
EDITIONS: 243: 200 numbered 1–200 (this copy, no. 12, signed); 25 artist's proofs; 7 publisher's proofs; 5 *hors-commerce*; 6 numbered I–VI, reserved for presentation; unbound plate: 50 (numbered 1/50–50/50).
PRINTERS: Aquatints and tempera, 107 Workshop, Box, Wiltshire; text, C. H. Printing, Corsham, Wiltshire.

BOOK DESIGNER: Gordon House.
TYPOGRAPHY: Bembo.
COLLECTION: The Museum of Modern Art, New York. Purchased in part with funds from Mrs. Donald B. Straus

Sontag's text, first published in The New Yorker *magazine in 1986, was one of the first stories about the AIDS epidemic by a major writer. Hodgkin's lushly colored aquatints refer to specific passages in the text, such as the telephone that transmits the latest news of friends who have become ill, or, in this case, thoughts about the victim's precarious way of life. This edition was sold to benefit AIDS-related organizations in England and America.*

154

I stopped making maps when they be-
gan being used to describe the roads that
circled our diaries, the holes we filled
with pages of refusal. One eye open, the
other staring into the mirror that intro-
duces the body to sleep, it's borrowed
pincers. There is no way to either turn
back or mend the rocks. And now
there is no way to follow the stars
that have closed us out of their light

155

JÜRGEN PARTENHEIMER
German, born 1947

Giant Wall

AUTHOR: John Yau (American, born 1950).
PUBLISHER: [San Francisco]: Hine Editions,
1991.
PAGINATION: 24 unnumbered folios (including
flyleaves).
PAGE SIZE: 14¹⁵⁄₁₆ x 11" (38 x 28 cm).
IMAGES: 21 etchings (including box and 1 dupli-
cate), most with soft-ground etching and/or
aquatint, in black, and 1 black wash-and-pencil
drawing (dust jacket); on cream wove Auvergne
Richard de Bas paper.
IMAGE SHOWN: 14¹⁵⁄₁₆ x 21¹⁵⁄₁₆" (37.9 x 55.7 cm),
irreg.
HOUSING: Publisher's cream wove paper bind-
ing; publisher's cream wove paper dust jacket
with continuous drawing on front and back; pub-
lisher's cream wove paper solander box, with
continuous etching on front and back.
EDITION: 20 numbered 1–20 (this copy, no. 9,
signed).

PRINTERS: Plates, Limestone Press, San
Francisco; text, Richard Urban.
TYPOGRAPHY: Van Dijck.
COLLECTION: The Museum of Modern Art,
New York. Miles O. Epstein, Richard A. Epstein,
and Sarah C. Epstein Funds

*The title of this book refers to the bright galax-
ies that surround us, forming a giant astro-
physical wall, the components of which inspired
the compositions of the artist as well as the
thoughts of the poet.*

ICI

EN DEUX

QUENTIN ÉDITEUR

GENEVIÈVE ASSE
French, born 1923

Ici en deux

AUTHOR: André du Bouchet (French, born 1924).
PUBLISHER: Geneva: Quentin Editeur, 1982.
PAGINATION: 48 unnumbered folios.
PAGE SIZE: 13³⁄₁₆ x 10" (33.5 x 25.5 cm), irreg.
IMAGES: 4 aquatint and drypoints, in color (including wrapper front and back); 4 drypoints, in black; 4 unworked and uninked plates; all on ivory laid Angoumois paper (except wrapper).
IMAGE SHOWN: Frontispiece, 12¼ x 8¹⁵⁄₁₆" (31.1 x 22.8 cm).
HOUSING: Publisher's ivory laid paper wrapper with aquatint and drypoints, in pale green, on front and back; publisher's two-part light-green-gray paperboard slipcase.
EDITION: 75: 10 numbered 1–10, with 2 supplementary prints and suite; 50 numbered 11–60 (this copy, no. 45, signed); 15 without prints, reserved for author.
PRINTERS: Plates, Atelier Georges Leblanc, Paris; text, Imprimerie Union, Paris.

COLLECTION: The Museum of Modern Art, New York. A. Conger Goodyear and Mrs. Stanley Resor Funds (by exchange)

With the simplicity of single vertical lines, pale inks, and impressed plates, which transform rough paper into silken panels, Asse has distilled the processes and materials of the intaglio printmaker into a visual poetry as minimal as that of the author du Bouchet. Imitating the title, Ici en deux *(Here in Halves), the artist has bisected the cover, frontispiece, and title with her plates, as well as interrupted lines of verse with a sharp line, splitting the page in two.*

ROBERT RYMAN
American, born 1930

Nohow On

AUTHOR: Samuel Beckett (French, born Ireland.
1906–1990).
PUBLISHER: [New York]: The Limited Editions
Club, 1989.
PAGINATION: 136 pages: (4), [1–4], 5–128, (4);
6 plates *hors-texte*.
PAGE SIZE: 10⅝ x 7 7/16" (27 x 18 cm).
IMAGES: 6 aquatints, in color on ivory wove
Arches paper, 3 *chine collé* with various oriental
papers (including one with pen-and-ink
inscription).
IMAGE SHOWN: 5 15/16 x 3¾" (15.2 x 9.5 cm).
HOUSING: Publisher's full black leather bind-
ing, ivory wove endpapers and quadruplicate fly-
leaves, made by Garthegaat Bindery; publisher's
black linen solander box, lined with gray suede.
EDITION: 550 numbered 1–550 (this copy,
no. 293, signed).
PRINTERS: Plates, Wingate Studio and
Renaissance Press; text, Shagbark Press.
BOOK DESIGNER: Benjamin Shiff.
TYPOGRAPHY: Monotype Bodoni, Bauer
Bodoni, and font designed by Daniel Carr set at
Golgonooza Letter Foundry.

CATALOGUE RAISONNÉ: Sandback RRGP/1.
COLLECTION: The Museum of Modern Art,
New York. Gift of The Limited Editions Club

*The serene, faintly visible white paintings,
drawings, and prints of Ryman's Minimalist
oeuvre have concentrated and focused attention
on incidents within their spaces. His subtle,
but visually intriguing, aquatints are placed
within Beckett's set of three texts, one of which,
"Worstword Ho," is written in a kind of
stuttering street repartee, punctuated through-
out with the phrase "Nohow on."*

157

158

ELLSWORTH KELLY
American, born 1923

Un Coup de dés jamais n'abolira le hasard

AUTHOR: Stéphane Mallarmé (French. 1842–1898).

PUBLISHER: [New York]: The Limited Editions Club, 1992.

PAGINATION: 54 unnumbered folios.

PAGE SIZE: 17 x 12⅜" (43.2 x 31.5 cm).

IMAGES: 11 lithographs, in black on ivory wove Rives BFK paper.

IMAGES SHOWN: Left, text page, 17 x 12⅜" (43.2 x 31.5 cm); below, 15½ x 12⅜" (39.4 x 31.5 cm), irreg.

HOUSING: Publisher's full black leather binding with ivory wove Rives BFK endpapers; publisher's black linen solander box lined with black velour.

EDITION: 300 numbered 1–300 (this copy, no. 175, signed).

PRINTERS: Plates, Trestle Editions, New York; text, Wild Carrot Letterpress, Hadley, Mass.

TYPOGRAPHY: Bodoni, set by Golgonooza Letter Foundry.

COLLECTION: The Museum of Modern Art, New York. Purchased with funds given by Mrs. Melville Wakeman Hall

Well known as a painter of flat, shaped, bright-colored, or black-and-white canvases, Kelly has also consistently made linear drawings of plants and flowers. In his prints the white paper is the equivalent of a surrounding wall for the single form printed on it. For his first book he has entirely isolated his black forms from the famous, typographically innovative text.

159

564. A language-game: bringing building stones, reporting the number of available stones. The number is sometimes estimated, sometimes established by counting. Then the question arises "Do you believe there are as many stones as that?", and the answer "I know there are—I've just counted them". But here the "I know" could be dropped. If, however, there are several ways of finding something out for sure, like counting, weighing, measuring the stack, then the statement "I know" can take the place of mentioning *how* I know.

Counting Alternatives : Double Square Branch

160

MEL BOCHNER
American, born 1940

On Certainty/Über Gewissheit and
Counting Alternatives: The Wittgenstein Illustrations

AUTHOR: Ludwig Wittgenstein (Austrian. 1889–1951). Trans. by Denis Paul and G. E. M. Anscombe.
PUBLISHER: San Francisco: Arion Press, 1991.
PAGINATION: 2 parts. Book: 74 unnumbered folios; suite: 3 unnumbered folios and 12 plates.
PAGE SIZE: 14⅜ x 12¹⁵⁄₁₆" (36.5 x 33 cm).
SHEET SIZE: Suite, 20 x 14¹⁵⁄₁₆" (50.8 x 38 cm).
IMAGES: 17 line-block reproductions after drawings (including identical endpapers and title page duplicated on front and back covers), in color on ivory wove Rives paper; supplementary suite, in color on ivory wove T. H. Saunders paper (drawings executed 1971).
IMAGE SHOWN: 10⅜ x 10⅜" (26.4 x 26.4 cm), irreg.
HOUSING: Book: publisher's gray and blue linen binding, with line-block reproductions on front and back, and ivory wove Rives endpapers, with line-block reproductions; publisher's gray linen slipcase; suite: publisher's gray and blue linen solander box, lined with ivory paper.
EDITIONS: Book: 326: 300 numbered 1–300 (this copy, no. 10, signed); 26 *hors-commerce*, marked A–Z; suite: 40: 30 numbered 1/30–30/30 (this copy, no. 10/30, signed); 5 artist's proofs; 5 publisher's proofs.
PRINTER: Arion Press, San Francisco.
BOOK DESIGNER: Andrew Hoyem.
TYPOGRAPHY: Plantin, set by M & H Type.

COLLECTION: The Museum of Modern Art, New York. John B. Turner Fund

This book and accompanying portfolio, with the addition of Wittgenstein's text, repeat a series of drawings the artist made in 1971. In his graphic responses to the philosopher's proposals, Bochner has made a series of diagrams that might also function as plots for the placement of objects in his floor sculptures.

LEONARD BASKIN
American, born 1922

Voyages: Six Poems from White Buildings

AUTHOR: Hart Crane (American. 1899–1932).
PUBLISHER: New York: The Museum of
Modern Art, 1957.
PAGINATION: 15 unnumbered folios (including
flyleaves), and 2 plates tipped in.
PAGE SIZE: 9½ x 11" (24.1 x 28 cm), irreg.
IMAGES: 6 wood engravings: 2 in black on
cream laid Amalfi paper, 1 in black on cream
wove Japan paper, 1 in black on green laid Japan
Moriki paper, and 2 in color on cream wove
Japan paper; 1 woodcut, in black on green laid
Japan Moriki paper; and 1 wood-engraved pub-
lisher's vignette in black on cream laid Amalfi
paper.
IMAGE SHOWN: 5⅝ x 5⁹⁄₁₆" (14.3 x 14.1 cm),
irreg.
HOUSING: Publisher's blue wove paper cover
bound with string; in publisher's blue paperboard
folder with flaps, lined with ivory paper.
EDITION: 1,000: 975 numbered 1–975 (this
copy, no. 3, signed); 25 *hors-commerce*, marked
with letters, reserved for reviewers.
PRINTER: Leonard Baskin at The Gehenna
Press, Northampton, Mass.
BOOK DESIGNER: Leonard Baskin.

TYPOGRAPHY: Perpetua.
CATALOGUE RAISONNÉ: Fern and O'Sullivan
294–296, 298–300 (woodcut not catalogued).
COLLECTION: The Museum of Modern Art,
New York

*In 1951 Baskin founded The Gehenna Press in
Worcester, Massachusetts (he moved to North-
ampton, its present location, in 1956), in order
to print his favorite texts augmented by his own
wood engravings. Baskin's enterprise also pio-
neered the practicality of producing artists'
books of high quality in America. His prints
received the highest award at the São Paolo
Bienal in 1961, and were exhibited all over the
world. This volume was one of the highlights of
the special publishing program, initiated by
The Museum of Modern Art in the 1950s,
devoted to encouraging artists to make books.*

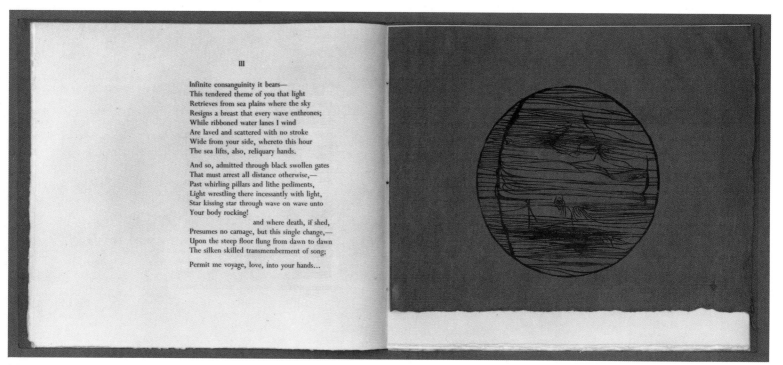

161

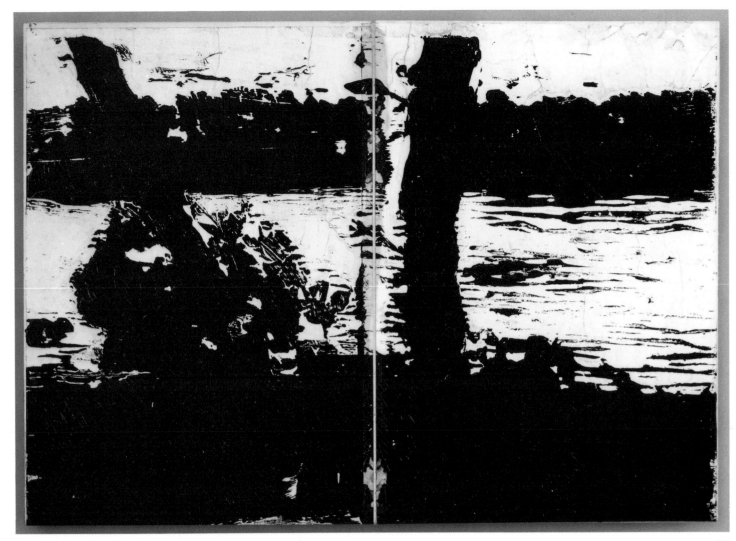

162

ANSELM KIEFER
German, born 1945

Der Rhein

PUBLISHER: [Hornbach: Anselm Kiefer], 1983.
PAGINATION: 20 unnumbered folios (including covers).
PAGE SIZE: 23¼ x 16½" (59 x 42 cm).
IMAGES: 21 woodcuts (including front and back covers), in black on ivory paper mounted on cardboard.
IMAGE SHOWN: 22¹⁵⁄₁₆ x 33⅛" (58.2 x 84.1 cm), irreg.
HOUSING: Artist's cardboard glued to canvas binding, with woodcuts, in black on ivory paper, mounted on front and back covers.
EDITION: 10 unnumbered (this copy, signed).
PRINTER: Anselm Kiefer.
COLLECTION: The Museum of Modern Art, New York. Purchase

A considerable amount of Kiefer's work is in the form of unique books made of diverse materials, such as metal and cardboard covered with clay, nearly obliterated photographs, and watercolors. In addition, Kiefer has made many woodcuts that depict German heroes of old, temples, and the great artery of German folklore, the Rhine River. Books like Der Rhein *have been made from sets of some of these as well as from single prints cut into pages.*

163

PIERRE ALECHINSKY, FRED
BECKER, BEN ZION, LETTERIO
CALAPAI, PETER GRIPPE,
SALVATORE GRIPPE, STANLEY
WILLIAM HAYTER, FRANZ KLINE,
WILLEM DE KOONING, JACQUES
LIPCHITZ, EZIO MARTINELLI,
BEN NICHOLSON, IRENE RICE
PEREIRA, HELEN PHILLIPS,
ANDRÉ RACZ, KURT ROESCH,
ATTILO SALEMME, LOUIS
SCHANKER, KARL SCHRAG,
ESTEBAN VICENTE, ADJA
YUNKERS

21 Etchings and Poems

AUTHORS: Various.
PUBLISHER: New York: Morris Gallery [Morris
Weisenthal], 1960. (Initiated by Peter Grippe.)
PAGINATION: 24 unnumbered folios.
PAGE SIZE: 19⅞ x 16⅞" (50.5 x 42.8 cm).
IMAGES: 10 etchings (most with engraving,
soft-ground etching, aquatint, and/or drypoint),
2 engravings, 2 lift-ground aquatints, 2 dry-
points, 3 soft-ground etchings, and 1 photo-
gravure (all with etched manuscript by author or
artist), in black on cream wove Rives BFK paper
(prints executed 1951–56).
IMAGES SHOWN: Left, Peter Grippe
(American, born 1912), Untitled, etching with
"The Hand that Signed the Paper Felled a City"
by Dylan Thomas (British. 1914–1953), 13¹³⁄₁₆ x
11¾" (35.1 x 29.9 cm); below, Kline (American.
1910–1962), Untitled, photogravure with
"Poem" by Frank O'Hara (American. 1926–
1966), 8⁵⁄₁₆ x 14⁷⁄₁₆" (21.2 x 36.7 cm).
HOUSING: Publisher's blue linen folder with
flaps, lined with gray paper.

EDITION: 62: 50 numbered 1–50 (this copy,
no. 32, signed), 12 artist's proofs.
PRINTER: Plates, Andersen-Lamb, Brooklyn,
N.Y. (except Racz).
TYPOGRAPHY: Etched manuscript.
COLLECTION: The Museum of Modern Art,
New York. Gift of Mrs. Jacquelynn Shlaes

*In 1950 Hayter returned to France, leaving his
New York print workshop, Atelier 17, in the
hands of Peter Grippe. A year later Grippe
initiated this project, setting the style of each
print with his own collaboration with Dylan
Thomas: each artist would create images
around poems handwritten by their authors.
Most of the artists knew how to etch (the ex-
ceptions were late contributors to the project,
American painters de Kooning and Kline).
Among the writers were art critics such as Sir
Herbert Read and Harold Rosenberg, and some
of the most interesting poets and writers of the
time, such as Richard Wilbur, William Carlos
Williams, and Theodore Roethke. The com-
pleted work was finally issued in 1960.*

164

GRACE HARTIGAN
American, born 1922

Salute

JOAN MITCHELL
American. 1926–1992

The Poems

AUTHORS: James Schuyler (American, born 1923); John Ashbery (American, born 1927).
PUBLISHER: New York: Tiber Press, 1960. First edition of some poems.
PAGINATION: 2 of 4-vol. series (others are Michael Goldberg, *Odes* by Frank O'Hara, and Alfred Leslie, *Permanently* by Kenneth Koch); each vol., 20 unnumbered folios.
PAGE SIZE: 17½ x 14¹⁄₁₆" (44.4 x 35.8 cm).
IMAGES: 5 screenprints (including front cover), in color on ivory wove Hahnemühle paper.
IMAGES SHOWN: Above, Mitchell, 17¼ x 13¹⁵⁄₁₆" (43.8 x 35.4 cm); right, Hartigan, 11⅛ x 13⅞" (29.6 x 35.3 cm), irreg.
HOUSING: Publisher's ivory wove Hahnemühle paperboard bindings, each with screenprint on front, ivory wove endpapers, clear-plastic dust jacket; olive linen slipcase (for all 4 vols.), made by Russell-Rutter, New York.
EDITION: 225: 200 numbered 1–200; 25 numbered I–XXV, reserved (this copy inscribed "XV for The Museum of Modern Art").

PRINTERS: Plates, Tiber Press, New York; text, Brüder Hartmann, West Berlin.
TYPOGRAPHY: Walbaum-Antiqua, set by Brüder Hartmann, West Berlin.
COLLECTION: The Museum of Modern Art, New York. Gift of Richard Miller

These are two of four volumes devoted to poems by American poets and screenprints by their painter friends. Serigraph, or screenprint, a method of making a stable stencil, allowed the artist to paint an image with gum on silk, which could be lifted, leaving openings through which paint or ink could pass onto paper. Both Hartigan and Mitchell used it to convey their own versions of Abstract Expressionism.

PIERRE ALECHINSKY, KAREL
APPEL, ENRICO BAJ, ALAN
DAVIE, JIM DINE, OYVIND
FAHLSTRÖM, SAM FRANCIS,
ROBERT INDIANA, ALFRED
JENSEN, ASGER JORN, ALLAN
KAPROW, KIKI KOGELNIK,
ALFRED LESLIE, ROY
LICHTENSTEIN, JOAN MITCHELL,
CLAES OLDENBURG, MEL
RAMOS, ROBERT RAUSCHENBERG,
REINHOUD, JEAN-PAUL
RIOPELLE, JAMES ROSENQUIST,
ANTONIO SAURA, KIMBER
SMITH, K. R. H. SONDERBORG,
WALASSE TING, BRAM VAN
VELDE, ANDY WARHOL, TOM
WESSELMANN

1¢ Life

AUTHOR: Walasse Ting (Chinese, born 1929).
PUBLISHER: Bern: E. W. Kornfeld, 1964. First edition.
PAGINATION: 176 pages: (2), [1–8], 9–168, [169–173], (1).
PAGE SIZE: 16¹/₁₆ x 11⁵/₁₆" (40.8 x 28.8 cm), irreg.
IMAGES: 62 lithographs: 3 in black and 59 in color; reproductions; all on ivory wove Rives BFK paper.
IMAGES SHOWN: Below, Francis (American, born 1923), *Pink Venus Kiki*, 15³/₈ x 22" (39 x 55.9 cm); opposite, Warhol (American. 1928–1987), *Marilyn Monroe I Love Your Kiss Forever Forever*, 11⅛ x 21¼" (29.5 x 54 cm).
HOUSING: Publisher's ivory linen wrapper around ivory wove Rives BFK paper, under publisher's cream wove paper dust jacket with screenprinted reproduction, after design by Machteld Appel, on front; publisher's blue linen solander box, lined with white linen.
EDITION: 2,100: 100 (signed) on ivory wove Rives paper, 20 for New York, 20 for Paris,

20 for rest of world, 40 *hors-commerce*, reserved for collaborators (this copy, signed and inscribed "Exemplaire H.C./Paris"); 2,000 (unsigned), numbered, on white wove paper.
PRINTERS: Plates, Maurice Beaudet, Paris; text, Georges Girard, Paris; screenprinted dust jacket, Atelier Ravel, Paris.
CATALOGUES RAISONNÉS: Warhol: Feldman and Schellmann 5. Francis: Lembark L82.
COLLECTION: The Museum of Modern Art, New York. Gift of the author, Walasse Ting, the editor, Sam Francis, and the publisher, E. W. Kornfeld

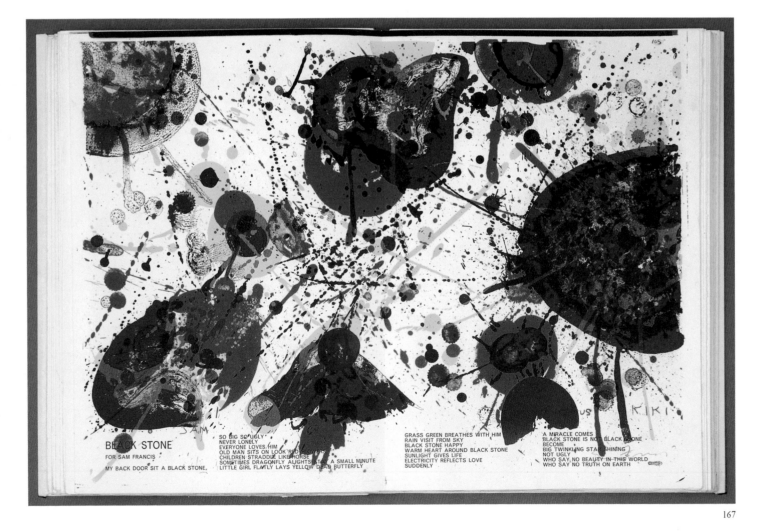

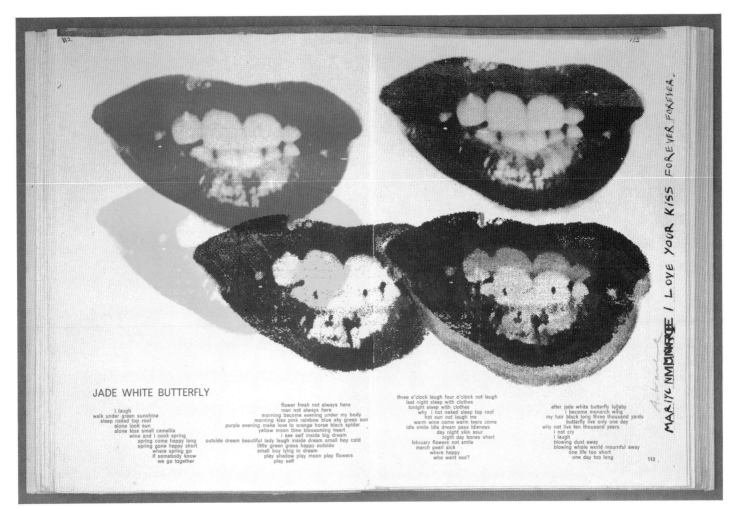

168

In the early 1960s the Chinese artist-poet Ting brought lithographic plates to artist friends of his and Sam Francis to illustrate his book of poems. Pop artists Warhol, Lichtenstein, Oldenburg, Rosenquist, Indiana, Wesselmann, and Dine were among the twenty-eight artists who contributed lithographs. Placed side by side with those of better established European and American, mostly gestural, painters their images seemed brighter and better suited to the jaunty typography of the pages, doubtless due to the commercial graphics that had influenced them.

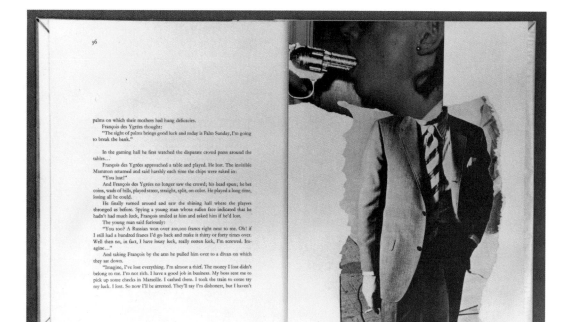

169

JIM DINE
American, born 1935

The Poet Assassinated

AUTHOR: Guillaume Apollinaire (Guillaume
Apollinaire de Kostrowitsky; French, born Italy.
1880–1918). Trans. by Ron Padgett.
PUBLISHER: New York: Tanglewood Press
Inc., 1968. First English edition.
PAGINATION: 130 pages: [1–8], 9–128, [129–
130]; suite of 8 plates.
PAGE SIZE: 9¹⁵⁄₁₆ x 7¹⁵⁄₁₆" (25.3 x 20.2 cm).
SHEET SIZE: 10 x 8" (25.4 x 20.3 cm).
IMAGES: 50 photolithographs (including detail
of frontispiece repeated 16 times), in black on
white wove Euroset paper; 2 screenprints, 1 in
black on ivory wove paper (wrapper), 1 in color
on ivory linen (slipcase); suite of 8 pochoirs, 7 in
color and 1 in black on ivory wove paper.
IMAGE SHOWN: 9¹⁵⁄₁₆ x 7⅜" (25.3 x 18.7 cm),
irreg.
HOUSING: Publisher's ivory wove paper wrap-
per with continuous screenprint, in black on
front and back; publisher's ivory linen slipcase
with continuous screenprint, in pink on front and
back.

EDITION: More than 250: 250 numbered 1–250,
with suite (this copy, no. 188, signed); unknown,
unnumbered edition (without suite).
CATALOGUE RAISONNÉ: Mikro.
COLLECTION: The Museum of Modern Art,
New York. Gift of Dr. and Mrs. Aaron Esman

*After appearing on the New York art scene in
his mid-twenties, first in Happenings and then
with paintings of objects that were, he felt, mis-
represented as Pop art, Dine moved to London
in 1967. While there he associated with poets,
wrote, and made a number of prints, including
several composed of photomontages, such as
those in this book—one of several British com-
memorations of the fiftieth anniversary of
Apollinaire's death.*

ROBERT INDIANA
American, born 1928

Numbers

AUTHOR: Robert Creeley (American, born 1926). Trans. by Klaus Reichert.
PUBLISHERS: Stuttgart: Edition Domberger; Düsseldorf: Galerie Schmela, 1968. First edition.
PAGINATION: 32 unnumbered folios.
PAGE SIZE: 25⁹⁄₁₆ x 19¹¹⁄₁₆" (65 x 50 cm).
IMAGES: 10 screenprints, in color on white wove paper.
IMAGE SHOWN: 23⁷⁄₁₆ x 19⅝" (59.6 x 49.8 cm).
HOUSING: Publisher's beige linen folder with flaps, lined with ivory paper.
EDITION: 160: 125 numbered 1–125 (this copy, no. 26, signed); 35 numbered I–XXXV.
PRINTER: Domberger KG, Bonlanden bei Stuttgart.
TYPOGRAPHY: Set by Dr. Cantz'sche Druckerei, Stuttgart-Bad Cannstatt.

CATALOGUES RAISONNÉS: Domberger G15–24. Sheehan 46–55.
COLLECTION: The Museum of Modern Art, New York. The Celeste and Armand Bartos Foundation Fund

Appropriating the methods and signs of advertising to create a new art in the 1960s, Indiana made paintings and prints of single but powerfully symbolic words like EAT and LOVE. Taking Johns's lead in the use of numeral stencils in his paintings, Indiana devised his own in the bright, unmodulated colors of screenprinting. Their candid but flashy impression is partnered by Creeley's typically Pop verse in short stanzas.

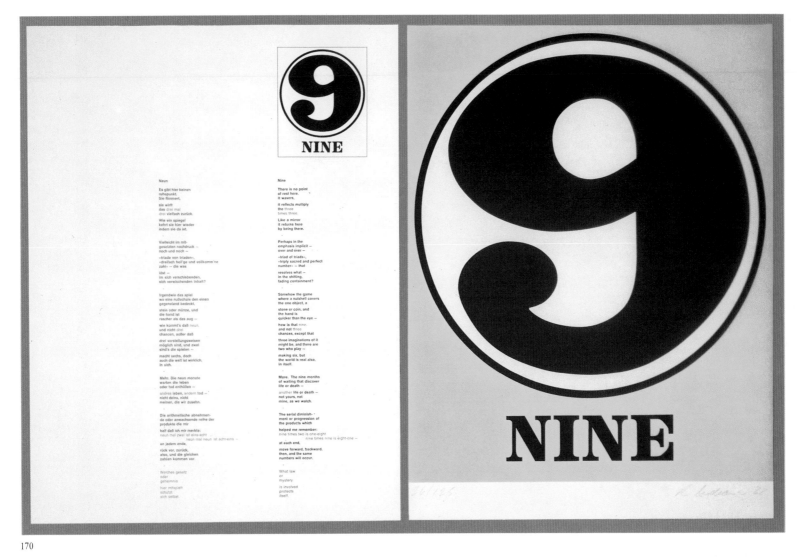

D A V I D H O C K N E Y
British, born 1937

Fourteen Poems

AUTHOR: C. P. Cavafy (Greek. 1863–1933). Trans. by Nikos Stangos and Stephen Spender.
PUBLISHER: London: Editions Alecto Limited, 1967.
PAGINATION: 33 unnumbered folios.
PAGE SIZE: 18⅜₆ x 12¹⁵⁄₁₆" (46.6 x 33 cm).
IMAGES: 12 etchings (8 with aquatint), in black; and supplementary etching and aquatint, in black; all on ivory wove Crisbrook Imperial paper (executed 1966).
IMAGE SHOWN: *Two Boys Aged 23 or 24*, 13⅞ x 8⅞" (35.2 x 22.5 cm).
HOUSING: Publisher's violet silk binding with ivory wove endpapers, made by Tillotsons (Bolton), Limited; in publisher's black silk slipcase, made by Galerie der Spiegel, Cologne.
EDITIONS: Book: 550: edition A: 300: 250 numbered 1–250, 50 artist's proofs, with supplementary etching (this copy, artist's proof, signed); edition B: 250 numbered 251–500; portfolio: 120: edition C: 50 numbered 1/75–50/75; edition D: 40: 25 numbered 51/75–75/75, 15 artist's proofs, with text on folders containing etchings; edition E: 30: 25 numbered I–XXV, 5 artist's proofs on Vellum Royal paper, with supplementary etching.
PRINTERS: Plates, Editions Alecto Limited, London; text, Tillotsons (Bolton), Limited.
BOOK DESIGNER: Gordon House.
TYPOGRAPHY: Monotype Univers.
CATALOGUE RAISONNÉ: Brighton 47–59.
COLLECTION: The Museum of Modern Art, New York. Given anonymously

Hockney's largest painting of 1961 was inspired by the words of the Greek poet Cavafy. In 1966 the artist decided to illustrate a book of Cavafy's poems about homosexual love. He went to Beirut, which he felt was the modern equivalent of the writer's Alexandria, but few of his etchings refer to places or incidents in the poems. The translators and artist together decided which print was to accompany each poem.

Two boys aged 23 or 24

He had been at the café from half past ten
expecting him soon to appear.
Midnight – he was still waiting.
One thirty; now the café was nearly empty.
He bored himself reading newspapers
mechanically. Of his miserable three shillings
only one remained; the rest he spent
on coffee and brandy while waiting for so long.
He had smoked up all his cigarettes.
He felt exhausted now by waiting. Because,
being alone for hours, disturbing thoughts
of having gone astray in his life began to gnaw at him.

But when he saw his friend come in, at once
fatigue, boredom and worries disappeared.

His friend brought unexpected news.
He had won sixty pounds at the casino.

Their handsome faces, superb youth,
the sensual love they felt for one another,
were now refreshed, renewed, invigorated
by the sixty pounds from the casino.

And full of joy and strength, beauty and emotion,
they went – not to the houses of their decent families
(where they were now unwanted anyway)
but to a very special place they knew
of ill repute. They took a bedroom there
ordered expensive drinks and went on drinking.

And when the expensive drinks were finished,
when it was nearly dawn,
content, they gave themselves to love.

stretching away like a moonlit sea to the horizon, whatever that really is. *They* want you to like it. And you honor them in liking it. You cause pleasure before sleep insists, draws over to where you may yet be. And some believe this is merely a detail. And they may be right. And we may be the whole of which all that truly happens is only peelings and shreds of bark. Not that we are too much more than these. Remember they don't have to thank you for it either.

The subtracted sun, all I'm going by here, with the boy, this new maneuver is less than the letter in the wind

JUDITH SHEA
American, born 1948

Haibun

AUTHOR: John Ashbery (American, born 1927).
PUBLISHER: Colombes, France: Collectif Génération, [1990].
PAGINATION: 20 unnumbered folios. Partially uncut to allow for some pages to fold up or out.
PAGE SIZE: 13¹⁄₁₆ x 9¹⁵⁄₁₆" (33.2 x 25.2 cm), irreg.
IMAGES: 7 soft-ground etchings (4 with pochoir), 3 in black and 4 in color, on ivory wove Rives BFK paper.
IMAGE SHOWN: 13¹⁄₁₆ x 9¹⁵⁄₁₆" (33.2 x 25.2 cm), irreg.
HOUSING: Publisher's ivory wove paper wrapper; publisher's gray linen folder and slipcase, lined with marbleized paper.
EDITION: More than 32: 30 numbered 1–30 (this copy, no. 14, signed); 2 dedicated copies; several *hors-commerce*, reserved for collaborators and friends.
PRINTERS: Plates, René Tazé, Neuilly; text, Francis and Jean-Marc Mérat.
COLLECTION: The Museum of Modern Art, New York. John B. Turner Fund

In her lithographs for this book the artist has placed drawings related to her torso and clothing sculptures on pages that are folded in ways that initially conceal them from the reader. The process of turning the pages from right to left in order to read Ashbery's text expands into a separate spatial experience, as flaps must be opened in other directions.

JASPER JOHNS
American, born 1930

Foirades/Fizzles

AUTHOR: Samuel Beckett (French, born Ireland. 1906–1990). English translation by author.
PUBLISHER: [London and New York]: Petersburg Press, 1976. First English edition.
PAGINATION: 62 unnumbered folios (including endpapers and excluding binding support leaves).
PAGE SIZE: 12¹⁵/₁₆ x 9¹³/₁₆" (33 x 25 cm).
IMAGES: 26 lift-ground aquatints (most with etching, soft-ground etching, drypoint, screen-print, and/or photogravure), 5 etchings (some with soft-ground etching and/or drypoint), 1 soft-ground etching, and 1 aquatint: 31 in black, 2 (endpapers) in color; and 1 lithograph (box lining), in color; all on ivory wove Auvergne Richard de Bas paper (executed 1975–76).
IMAGES SHOWN: Below, left page, *Four Panels (ABCD)*, *Four Panels (BCDA)*, and *Four Panels (CDAB)*, 3 plates, each 2⅞ x 7½" (7.3 x 19.1 cm), right page, *Four Panels (DABC)*, 2⅞ x 7½" (7.3 x 19.1 cm); opposite, *Words (Buttock Knee*

Sock . . .), 10⁹/₁₆ x 17⅜" (26.8 x 44.1 cm).
HOUSING: Publisher's ivory wove paper binding with aquatint endpapers, bound in accordion fold around support leaves; publisher's beige linen solander box with purple tassel, lined with lithograph; made by Rudolf Rieser, Cologne.
EDITION: 300: 250 numbered 1/250–250/250 (this copy, no. 14/250, signed); 30 artist's proofs, numbered I–XXX; 20 dedicated copies *hors-commerce*.
PRINTERS: Aquatints and etchings, Atelier Crommelynck, Paris; lithograph, Petersburg Press, New York; text, Fequet et Baudier, Paris.
TYPOGRAPHY: Caslon Old Face, set by Fequet et Baudier, Paris.
CATALOGUES RAISONNÉS: Field 215–248. Universal 173.
COLLECTION: The Museum of Modern Art, New York. Gift of Celeste and Armand Bartos (in perpetuity)

I gave up before birth, it is not possible otherwise, but birth there had to be, it was he, I was inside, that's how I see it, it was he who wailed, he who saw the light, I didn't wail, I didn't see the light, it's impossible I should have a voice, impossible I should have thoughts, and I speak and think, I do the impossible, it is not possible otherwise, it was he who had a life, I didn't have a life, a life not worth having, because of me, he'll do himself to death, because of me, I'll tell the tale, the tale of his death, the end of his life and his death, his death alone would not be enough, not enough for me, if he rattles it's he who will rattle, I won't rattle, he who will die, I won't die, perhaps they will bury him, if they find him, I'll be inside, he'll rot, I won't rot, there will be nothing of him left but bones, I'll be inside, nothing left but dust, I'll be inside, it is not possible otherwise, that's how I see it, the end of his life and his death, how he will go about it, go about coming to an end, it's impossible I should know, I'll know, step by step, impossible I should tell, I'll tell, in the present, there will be no more talk of me, only of him, of the end of his life and his death, of his burial if they find him, that will be the end, I won't go on about worms, about bones and dust, no one cares about them, unless I'm bored in his dust, that would surprise me, as stiff as I was in his flesh, here long silence, perhaps he'll drown, he always wanted to drown, he didn't want them to find him, he can't want now any more, but he used to want to drown, he usen't to want them to find him, deep water and a millstone, urge spent like all the others, but why one day to the left, to the left and not elsewhither, here long silence, there will be no more I, he'll never say I any more, he'll never say anything any more, he won't talk to anyone, no one will talk to him, he won't talk to himself, he won't think any more, he'll go on, I'll be inside, he'll come to a place and drop, why there and not elsewhere, drop and sleep, badly because of me, he'll get up and go on, badly because of me, he can't stay still any more, because of me, he can't go on any more, because of me, there's nothing left in his head, I'll feed it all it needs.

174

The short story Beckett provided for this book is printed in English and French, doubling the amount of pages and opportunities for the addition of the artist's imagery. Johns's contributions are mostly based upon the composition of one of his paintings. Confronting sets of the English and French names of objects in that painting, shown as if in a magic translating mirror, combine the artist's interest in ready-made letters with the ambiguity of how they are used.

BARBARA KRUGER
American, born 1945

My Pretty Pony

AUTHOR: Stephen King (American, born 1946).
PUBLISHER: New York: Library Fellows of
the Whitney Museum of American Art, 1988.
First edition.
PAGINATION: 34 unnumbered folios (including
endpapers).
PAGE SIZE: 20 x 13½" (50.9 x 34.3 cm).
IMAGES: 9 lithographs (1 with screenprint) and
8 screenprints, in color on ivory wove Rives
paper.
IMAGE SHOWN: 20 x 13½" (50.9 x 34.3 cm),
irreg.
HOUSING: Publisher's quarter red leather over
stainless-steel binding, enclosing digital clock
made by Herman Hirsch, Hi-Tech Stainless Steel
Specialties, Dallas, on front, wove endpapers in
red; made by BookLab, Austin.
EDITION: 280: 250 unnumbered (this copy,
signed); 30 *hors-commerce*, numbered I–XXX.
PRINTERS: Lithographs, Derrière L'Etoile
Studios, New York; screenprints, Pinwheel,
New York; text, A. Colish, Mt. Vernon, N.Y.
BOOK DESIGNER: Barbara Kruger.
TYPOGRAPHY: Century Schoolbook and
Helvetica.
COLLECTION: The Museum of Modern Art,
New York. The Associates Fund in honor of
Riva Castleman

The artist used three elements in her illustrations: her signature band of words mimicking commercial claims in advertisements, enlarged reproductions of photographs, and a hand holding a digital clock. As the theme of King's story is the perception of the passage of time, the third element recalls that fact and is superimposed upon what seem to be slowed representations of horse accidents. Bands containing two or three words taken from the text placed on top of the indefinite pictures make direct connections to the story.

175

FRANCESCO CLEMENTE
Italian, born 1952

The Departure of the Argonaut

AUTHOR: Alberto Savinio (Andrea de Chirico;
Italian. 1891–1952). Trans. by George Scrivani.
PUBLISHER: [New York and London]:
Petersburg Press, 1986.
PAGINATION: 102 unnumbered folios (includ-
ing flyleaves); 4 unbound folios.
PAGE SIZE: 25⁹⁄₁₆ x 19¹¹⁄₁₆" (65 x 50 cm).
IMAGES: 49 photolithographs (including
vignettes), 43 in color and 6 in black on cream
wove Japan Okawara paper (executed 1983–86).
IMAGE SHOWN: 25⁹⁄₁₆ x 39³⁄₈" (65 x 100 cm),
irreg.
HOUSING: Publisher's cream wove Japan
Okawara paper binding (sheets assembled in an
accordion fold) and beige linen solander box,
designed by Rudolph Rieser and made by
Helmut Kloss, Cologne.

EDITIONS: Bound: 232: 200 numbered 1–200;
32 numbered I–XXXII, of which 12 are dedi-
cated (this copy, unnumbered, signed, and
inscribed "for the Museum of Modern Art");
unbound: 56: 50 numbered 1–50, 6 numbered
I–VI.
PRINTERS: Plates, Rolf Neumann, Stuttgart;
text, Staib and Mayer, Stuttgart.
TYPOGRAPHY: Bembo.
COLLECTION: The Museum of Modern Art,
New York. Gift of Petersburg Press

*Clemente's interest in books as a medium in
which to experiment creatively has been accom-
panied by a desire to publish the works of others
as well. In association with the writer and edi-
tor Raymond Foye he founded Hanuman
Books, which has issued dozens of small book-
lets printed in Madras, India, devoted to the
writings of authors they admire. Like Clemente's
many images in Savinio's tale, their appear-
ance is based on local Indian practice and taste,
which Clemente, who has worked for years in
the area, finds inspiring.*

MIMMO (DOMINICO)
PALADINO
Italian, born 1948

Piccolo circolo chiuso

AUTHOR: Salvatore Licitra (Italian, born 1953).
PUBLISHER: [Milan]: G. Upiglio and Grafica
Uno, 1991. First edition.
PAGINATION: 32 unnumbered folios.
PAGE SIZE: 12 x 7¹¹⁄₁₆" (30.5 x 19.5 cm).
IMAGES: 17 lift-ground aquatints (14 with etch-
ing, 6 relief-printed) and 1 etching, in black on
ivory laid Zerkall paper (except frontispiece).
IMAGES SHOWN: Left page, 7⅞ x 3⅞" (20 x
9.8 cm), right page, 8⅞ x 3⅝" (22.6 x 9.2 cm).
HOUSING: Publisher's quarter black linen over
ivory paperboard binding, with design in red on
front and back, ivory wove endpapers printed in
red; in publisher's red paperboard slipcase.
Bound with closed-bolt pages by Giovanni de
Stefanis.
EDITION: 125: 99 numbered 1–99 (this copy,
no. 15, signed); 26 numbered I–XXVI.
PRINTERS: Plates, Giorgio Upiglio, Milan; text,
Ruggero Olivieri.
TYPOGRAPHY: Times.
COLLECTION: The Museum of Modern Art,
New York. Gift of Giorgio Upiglio

*In the late 1970s a group of Italian painters
arrived on the international art scene. Three of
them, Francesco Clemente, Sandro Chia, and
Enzo Cucchi, were associated by the initials of
their last names, but others, like Paladino,
successfully pursued similar figurative issues.
The prominence of a type of gaunt human head
in his, Clemente's, and Cucchi's imagery
relates their work to elements of tribal ritual
and magic.*

LOUISE BOURGEOIS
American, born France, 1911

Homely Girl, a Life

AUTHOR: Arthur Miller (American, born 1915).
PUBLISHER: New York: Peter Blum Edition, 1992. First edition.
PAGINATION: 2 vols. I: 44 pages: (6), 1–30, [31–32], (6); 10 plates *hors-texte*; II: 44 pages: (6), 1–30, [31], (7); 8 double-page plates *hors-texte*.
PAGE SIZE: 11½ x 8¹¹⁄₁₆" (29.3 x 22 cm).
IMAGES: I: 10 drypoints, in black on cream wove paper; II: 8 photolithographic reproductions of medical photographs, in color on ivory wove paper.
IMAGES SHOWN: Right, 7⁵⁄₁₆ x 5³⁄₈" (18.6 x 13.7 cm); below, 5¾ x 17" (14.6 x 43.2 cm).
HOUSING: Publisher's quarter tan leather over light-olive linen (vol. I) or gray linen (vol. II) binding, cream wove endpapers; in publisher's gray linen slipcase, made by Judi Conant.
EDITION: 1,301: 100 numbered 1/100–100/100 with drypoints; 1 *hors-commerce*, numbered I/I, with drypoints (this copy, signed); 1,200 unnumbered.
PRINTERS: Plates, Harlan & Weaver Intaglio, New York; text, The Stinehour Press, Lunenburg, Vt.
TYPOGRAPHY: Monotype Emerson.
BOOK DESIGNER: Klaus Baumgärtner.
CATALOGUE RAISONNÉ: Wye and Smith 126–143.

COLLECTION: The Museum of Modern Art, New York. Gift of the artist

There are two versions of this book, which contains a text written for the artist. In the trade edition, Bourgeois's tentative drawings of flowers, printed in red-brown on cream-colored backgrounds, have a light, optimistic effect on the text. In the limited edition black drypoint sketches of flowers and two cataclysmic abstractions lead to a more profound reading of the text. A second volume, in both editions, repeating the same text, contains color photographs from ophthalmological studies of pairs of eyes that overwhelm and disrupt the pages of type, as they magnify disturbing nuances in the story.

178

179

PABLO PICASSO
Spanish. 1881–1973

Pismo/Escrito

AUTHOR: Iliazd (Ilia Zdanevitch; Russian.
1894–1975).
PUBLISHER: [Paris]: Latitud Cuarenta y Uno
[Iliazd], 1948. First edition.
PAGINATION: 36 unnumbered folios (irregular
folding).
PAGE SIZE: Variable, with flaps, 14¼ x 3⅝"
(36.2 x 9.2 cm) to 14¼ x 9⅝" (36.2 x 24.5 cm).
IMAGES: 5 engravings, 2 with etching (title page
and duplicate on wrapper front), and 2 etchings,
in black on cream wove Antique Japan paper
(except wrapper) (executed 1947–48).
IMAGES SHOWN: Left side, *Nu de profil: Garde
gauche*, 12⅞ x 2⅝" (32.7 x 6.7 cm); right side,
Pismo, section of title page, 13¹⁄₁₆ x 8⅛" (33.2 x
20.7 cm).
HOUSING: Publisher's cream, rough, laid paper
wrapper, over cream wove paper wrapper, over
vellum-wrapped boards with engraving (dupli-
cate of title page) on front, over interior cream
wove paper wrapper; quarter vellum over gray
paperboard solander box, lined with cream
paper, made by Gerhard Gerlach for Louis E.
Stern.

EDITION: 66: 50 numbered 1–50 on Antique
Japan paper (this copy, no. 42, signed); 8 *hors-
commerce*, numbered HC1–HC8 on eighteenth-
century Holland paper; 5 *hors-commerce*,
numbered HC9–HC13 on Marais paper; 3
unnumbered *hors-commerce* on vellum, reserved
for artist, poet, and "muse."
PRINTERS: Plates, Roger Lacourière, Paris;
text, Imprimerie Union, Paris.
BOOK DESIGNER: Iliazd.
TYPOGRAPHY: Gill.
CATALOGUES RAISONNÉS: Cramer 48. Baer
784–788.
COLLECTION: The Museum of Modern Art,
New York. Louis E. Stern Collection

Among the books that were published by Iliazd,
most of which are distinguished by his unique
sense of typography and page design, Pismo/
Escrito *is outstanding for its unorthodox format.
Picasso's prints appear on the folded-back parts
of pages; information about the production of
the book as well as several sections of the love
letter of the title appear on equally narrow
pages tucked between normal ones. Through the
variety of page sizes and placements the artist
and the poet, designer, and publisher have
created a halting and clumsy object that com-
plements the subject of the text.*

180

De la part de fora fins al fons,
cinc mil pams; i de dalt a baix,
tres mil pams. L'edifici tindrà
setanta metres d'alçària per
quaranta de llargària, als seus
quatre costats; amb vuit esglaons
a l'entrada.

Pierrot s'ha comprat un cotxe
i el voldria canviar lletra per
lletra perquè les coses li van
malament.

Què li doneu per la A?
Què li doneu per la U?
Què li doneu per la T?
Etcètera.

181

ANTONI TÀPIES
Spanish, born 1923

El pà a la barca

AUTHOR: Joan Brossa (Spanish, born 1919).
PUBLISHER: Barcelona: Sala Gaspar, 1963.
PAGINATION: 50 unnumbered folios.
PAGE SIZE: 15¼ x 10¹⁵⁄₁₆" (38.7 x 27.8 cm), irreg.
IMAGES: 22 lithographs (including wrapper),
some with collage, in color; 4 collages, 2 with
line block in color; on various papers.
IMAGE SHOWN: 15⅛ x 3¹¹⁄₁₆" (38.5 x 9.4 cm),
irreg.
HOUSING: Publisher's torn brown wove
wrapping-paper wrapper with continuous litho-
graph on front and back, around ivory card-
board; publisher's olive-brown vellum exterior
wrapper with rope trim on spine.
EDITION: 135: 40 numbered 1–40, with supple-
mentary suite; 70 numbered 41–110 (this copy,
no. 75, signed); 15 dedicated copies numbered I–
XV, with supplementary suite and drawing; 10
hors-commerce, marked A–J, reserved for collab-
orators.

PRINTERS: Plates, Damià Caus, Barcelona;
text, Foto-Repro, Barcelona.
CATALOGUES RAISONNÉS: Galfetti 48–72.
Puig, pages 35–37.
COLLECTION: The Museum of Modern Art,
New York. Monroe Wheeler Fund

This book of collages, typewritten text, torn
sheets, and other unconventional methods and
materials is covered with vellum in simulation
of the kind of bindings found on old manu-
scripts and early printed books in monastic
libraries.

182

PABLO PICASSO
Spanish. 1881–1973

La Rose et le chien

AUTHOR: Tristan Tzara (Samuel Rosenstock; French. 1896–1963).
PUBLISHER: Alès: PAB [Pierre André Benoit, 1958]. First edition.
PAGINATION: 8 unnumbered folios.
PAGE SIZE: 11⅛ x 7⅝" (28.3 x 19.3 cm).
IMAGES: 4 drypoint and engravings on celluloid, in black, on ivory laid Montval paper.
IMAGE SHOWN: *Lignes de la main*, 1¹⁵⁄₁₆" (5 cm) diameter, mounted on top of three printed disks, mounted on *Main*, 10⅞ x 7⁵⁄₁₆" (27.6 x 18.9 cm).
HOUSING: Publisher's vellum wrapper with lettering in black on the front.
EDITION: More than 22: 22 numbered 1–22 (this copy, no. 18, signed); 2 additional exhibition copies; and 4 or 5 *hors-commerce* in gray Montval paper wrappers.
PRINTER: Pierre André Benoit.

CATALOGUES RAISONNÉS: Cramer 91. Baer 999–1002.
COLLECTION: The New York Public Library, Astor, Lenox, and Tilden Foundations. Spencer Collection

Another oddity of bookmaking, this work includes a set of printed volvelles, *or rotating disks, that reveal different texts as they are moved. Picasso contributed two prints of hands that might turn the disks of Tzara's poem, one on top of them and one underneath.*

TULLIO D'ALBISOLA
(TULLIO SPARTACO MAZZOTTI)
Italian. 1899–1971

Parole in libertà futuriste, tattili-termiche olfattive

AUTHOR: Filippo Tommaso Marinetti (Italian. 1876–1944).

PUBLISHER: Rome: Edizioni Futuriste di Poesia, [1934].

PAGINATION: 15 unnumbered folios (including covers).

PAGE SIZE: 9³⁄₁₆ x 8¹¹⁄₁₆" (23.3 x 22 cm).

IMAGES: 26 lithographs (including dedication, 9 text pages with layout by Marinetti, table of contents, and covers), 1 with photolithograph, in color on tin-plated metal sheets (executed 1932).

IMAGE SHOWN: Cover, 9³⁄₁₆ x 8¹¹⁄₁₆" (23.3 x 22 cm).

HOUSING: Publisher's tin-plated metal binding with lithographs on front and back; tubular metal spine.

EDITION: Unknown, probably less than 25 (this copy, no. I/XI, signed).

PRINTER: Lito Latta, Savona.

BOOK DESIGNERS: Tullio d'Albisola and Filippo Tommaso Marinetti.

COLLECTION: The Museum of Modern Art, New York. Gift of the Associates of the Department of Prints and Illustrated Books and of Elaine Lustig Cohen in memory of Arthur A. Cohen

This book of lithographs on tin is an innovation of the ceramist d'Albisola working with the Italian Futurist writer Marinetti, whose famous texts, some published before World War I, were here put into the context of late Futurist design. A portrait of Marinetti declaiming his areopoesia *(airplane poetry)* and selections of his text face d'Albisola's renderings of his words, isolated and given tempo and rhythm, that is, given "liberty."

183

BRUNO MUNARI
Italian, born 1907

Libro Illeggibile N.Y. 1

PUBLISHER: New York: The Museum of
Modern Art, 1967.
PAGINATION: 20 unnumbered folios.
PAGE SIZE: 8½ x 8½" (21.6 x 21.6 cm).
IMAGES: 13 screenprint reproductions, after
drawings and collages (including dust jacket), in
black and white on various papers; 8 folios with
die-cut circular holes; red string threaded
through folios 6–20.
IMAGE SHOWN: 8½ x 17" (21 x 43.2 cm).
HOUSING: Publisher's heavy black wove paper
cover, bound with two staples; in publisher's
laminated red paper dust jacket, with screenprint
reproduction on front.
EDITION: c. 2,000 (this copy, no. 1,363).
PRINTER: Lucini, Milan.
BOOK DESIGNER: Bruno Munari.
COLLECTION: The Museum of Modern Art,
New York

*After abstraction was accepted as an art form,
it was possible to make sequences of abstrac-
tions that would produce curiosity, understand-
ing, and pleasure. The idea of abstract forms
being accessible to all cultures (the idealist
message of the Russian revolutionary artists)
found its true home in books, and particularly
those for children. Munari's geometric collages
and cutouts in books, while meant to be serious
studies of form, were also models for later
books that taught through play.*

184

185

ENRICO BAJ
Italian, born 1924

Meccano, ou l'analyse matricielle du langage

AUTHOR: Raymond Queneau (French. 1903–1976).

PUBLISHER: Milan: Sergio Tosi e Paolo Bellasich, 1966.

PAGINATION: 21 unnumbered folios.

PAGE SIZE: 7¹¹⁄₁₆ x 20⅞" (19.5 x 53 cm).

IMAGES: 17 collagraphs and 1 supplementary unbound screenprint, in color on ivory wove Rosapina Fabriano paper (except supplementary print).

IMAGE SHOWN: 7⅛ x 14¾" (18.1 x 37.5 cm), irreg.

HOUSING: Publisher's half red leather over ivory laid Fabriano paperboard binding; in publisher's black cardboard folder with flap and black cloth ties.

EDITION: 194: 1 numbered 1, with supplementary Queneau manuscript, original work by Baj, suite, and screenprint; 5 numbered 2–6, with supplementary original work by Baj, suite, and screenprint; 19 numbered 7–25, with supplementary suite and screenprint; 49 numbered 26–74 with supplementary screenprint (this copy,

no. 27, signed); 100 numbered 75–174; 20 *hors-commerce*, reserved for collaborators.

PRINTER: Sergio Tosi, Milan

CATALOGUE RAISONNÉ: Petit B. 10 and P. 146–150.

COLLECTION: The Museum of Modern Art, New York. Monroe Wheeler Fund

Baj's art has always included a strong element of farce, so the use of sprockets, bolts, and other fabricated metal objects to enhance Queneau's analysis of language parodies the author's own mechanic's approach. Various, often humorous, shapes scatter across the extremely oblong and clumsy pages, accentuating another aspect of the subject of the book.

186

ROBERT RAUSCHENBERG
American, born 1925

Shades

AUTHOR: Robert Rauschenberg.
PUBLISHER: West Islip, N.Y.: Universal
Limited Art Editions, 1964.
IMAGES: 6 lithographs, in black on plexiglass
plates: 1 mounted permanently (title page), and
5 inserted interchangeably in a slotted aluminum
frame.
IMAGE SHOWN: Frame containing plates, 15⅛ x
14½ x 11¾" (38.4 x 36.8 x 29.9 cm).
PLATE SIZE: 14 x 14" (35.5 x 35.5 cm).
HOUSING: Slotted aluminum frame containing
1 permanently mounted lithograph on plexiglass
(title page) and light bulb.
EDITION: 27: 24 numbered 1/24–24/24 (this
copy, no. 1/24, signed); 3 artist's proofs, marked
0/24, 00/24, and 000/24.
PRINTER: Universal Limited Art Editions, West
Islip, N.Y.

CATALOGUES RAISONNÉS: Foster 22. Sparks
Rauschenberg 18.
COLLECTION: The Museum of Modern Art,
New York. Gift of the Celeste and Armand
Bartos Foundation

*Rauschenberg had long worked with printed
matter when he made this, his first "book."
But he redefined the basic book—an object
filled with a sequence of elements—by taking
new materials and using old ones differently.
From an aluminum framework, plexiglass
sheets, and transferred preprinted images, he
made an object in which the individual plexi-
glass "pages" could be moved directionally
and sequentially by the viewer.*

STEPHEN BASTIAN, JOHN CAGE,
MERCE CUNNINGHAM, JASPER
JOHNS, SOL LEWITT, ROBERT
RAUSCHENBERG, ROBERT RYMAN,
MICHAEL SILVER

The First Meeting of the Satie Society

AUTHOR: John Cage (American. 1912–1992).
PUBLISHER: New York: Osiris, 1992 [1993].
PAGINATION: 8 books: *Cinekus²*, 12 unnumbered folios; *Mesdamkus²*, 38 unnumbered folios; *Musikus²*, 18 unnumbered folios; *Relakus²*, 16 unnumbered folios; *Sonnekus²*, 15 unnumbered folios; *Variations with Interludes and Variations*, 120 unnumbered folios; *Writings through the Essay on the Duty of Civil Disobedience*, 20 unnumbered folios; *Words for the Satie Society*, one folded panel of 3 folios.
PAGE SIZE: Various.
IMAGES: 11 etchings and 8 photogravures, in black; 36 burn monotypes, c. 63 drawings and mixed mediums, some *chine collé*, on Sekishu Torinoko Gampi, Gasenshi Echizen, and other handmade papers.
IMAGES SHOWN: Above, Cage, *Variations with Interludes and Variations*, 10½ x 13" (26.7 x

187

33 cm); below, *Valise*, 26¼ x 21½ x 5" (66.7 x 54.6 x 12.7 cm).
HOUSING: Nickel-silver and laminated glass (broken by chance) valise designed by Cage, with twenty quotations by Satie (positioned by chance), hand-punched onto the inside and outside of the metal frame; 7 books with covers of various papers bound with string; 1 three-panel

folder; bound and/or assembled by Kim O'Donnell, Garthegaat Bindery, Easthampton, Mass.
EDITION: 24: 16 numbered I–XVI, bound (this copy); 8 numbered XVII–XXIV, unbound, unfolded sheets.
PRINTERS: Plates, Clary Nelson, Chestnut Street Press; Sue Ann Evans, Evans Editions; Peter Petengill, Wingate Studio. Texts, Daniel Keleher, Wild Carrot Letterpress; Arthur Larson, Horton Tank Graphics.
BOOK DESIGNER: Benjamin Shiff.
TYPOGRAPHY: Futura Light; Folio; Venus; Bauer Bodoni.
COLLECTION: Osiris, New York

In 1985 when Cage read his "mesostics" at what he called The First Meeting of the Satie Society he was presenting to the radical composer Satie the tribute of a disciple. There are references to Marcel Duchamp, James Joyce, Marshall McLuhan, Henry David Thoreau, and others within the eight texts, each containing a vertical phrase or name (string), which limits its length and the structure of each line. As a composer of music, "mesostic" poems, and art, Cage was unpredictable, confrontational in the most selfless way, and remarkable in every way. The publication of the eight parts of this gift to Satie, enclosed in a cracked-glass valise, incorporates prints, pastels, and drawings made over a period of nearly eight years by Cage's friends. The completion of the last drawings in this work after Cage's death in 1992 was accomplished by the dancer-choreographer Cunningham.

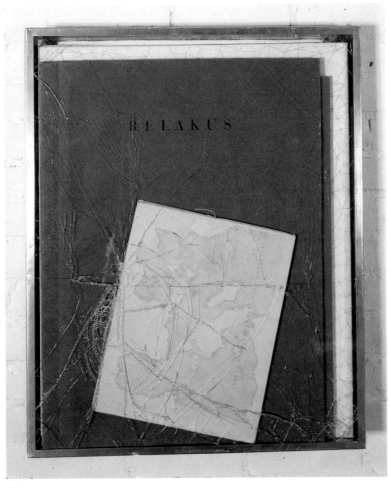

188

189

ROBERT DELAUNAY
French. 1885–1941

Tour Eiffel

AUTHOR: Vicente Huidobro (Chilean. 1893–1948).
PUBLISHER: Madrid, 1918.
PAGINATION: 7 unnumbered folios.
IMAGE: 1 pochoir (front cover), in color on cream wove paper.
PAGE SIZE: 12¹⁵⁄₁₆ x 9⅝" (32.9 x 24.4 cm), irreg.
COVER SIZE: 13¾ x 10¼" (35 x 26 cm).
IMAGE SHOWN: Cover, 8 x 7³⁄₁₆" (20.4 x 18.2 cm), irreg.
HOUSING: Publisher's cream wove paper cover with pochoir on front; bound with string.
EDITION: Unknown.
COLLECTION: The Museum of Modern Art, New York. Mrs. Stanley Resor Fund

After his several well-known representations in paintings and lithographs of Paris's Eiffel Tower, Delaunay reinvented his vision of this famous icon for book illustrations. The pochoir cover he made for the Chilean writer Huidobro's poem about the tower transformed it into a sign incorporating the four directions of the compass.

ERNST LUDWIG KIRCHNER
German. 1880–1938

Umbra vitae

AUTHOR: Georg Heym (German. 1887–1912).
PUBLISHER: Munich: Kurt Wolff Verlag, 1924.
PAGINATION: 74 pages: (8), 1–62, [63], (3).
PAGE SIZE: 9⁹⁄₁₆ x 6⅛" (23.1 x 15.6 cm).
IMAGES: 50 woodcuts (including cover, end-
papers, title page, and table of contents tailpiece),
1 in black and 49 in color on cream laid paper
(except cover and endpapers) (executed 1905–23).
IMAGE SHOWN: Cover, 9¼ x 13⅜" (23.5 x
34 cm), irreg.
HOUSING: Publisher's yellow linen binding
with continuous woodcut, in green and black, on
front and back; cream laid endpapers, with wood-
cuts in pink, front and back.

EDITION: 510: 10 numbered 1–10 on Japan
paper; 500 numbered 11–510 (this copy, no. 109).
PRINTER: Spamerschen, Leipzig.
CATALOGUES RAISONNÉS: Dube 758–807 and
61/II. Not in Schiefler.
COLLECTION: The Museum of Modern Art,
New York. Louis E. Stern Collection

*The Expressionist poet Heym was twenty-
four in 1912 when he drowned while skating.
Many years later his work was collected in this
volume designed and illustrated by Germany's
leading Expressionist artist. Kirchner made
several series of prints on literary subjects, but
only three were in the form of books, of which
Umbra vitae was the artist's major effort. Its
woodcut illustrations were influenced by the
peasant woodcarvings in the area of Switzer-
land where he lived after World War I.*

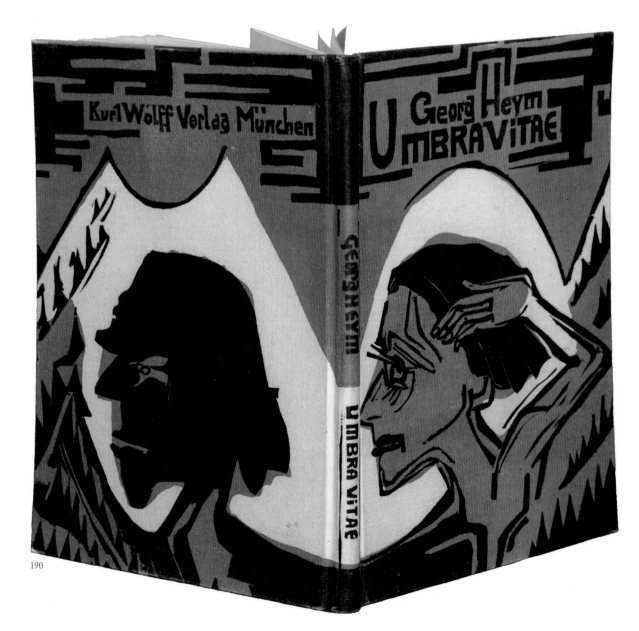

190

191

WIFREDO LAM
Cuban. 1902–1982

Le Rempart de brindilles

AUTHOR: René Char (French. 1907–1988).
PUBLISHER: Paris: Louis Broder, [1953]. First edition.
PAGINATION: 56 pages: (4), [1–14], 15–44, (8).
PAGE SIZE: 8¼ x 6⅛" (21 x 15.5 cm).
IMAGES: 5 etching and aquatints, 1 with watercolor and gouache additions (wrapper), in color on ivory wove Rives BFK paper.
IMAGE SHOWN: Wrapper, 8³⁄₁₆ x 12⁹⁄₁₆" (20.8 x 32 cm), irreg.
HOUSING: Publisher's ivory wove Rives paper wrapper, with continuous etching and aquatint, in color on front and back, in yellow-white laid paperboard folder, lined with ivory paper; publisher's yellow-white paperboard slipcase, with reproductions on front and back.
EDITION: 120: 15 numbered 1–15, with hand additions; 85 numbered 16–100 (this copy, no. 74, signed); 20 *hors-commerce*, numbered I–XX. Additional run of 30 numbered RC1–

RC30, without plates, reserved for printers and/or author.
PRINTERS: Plates, Georges Visat, Paris; text, Imprimerie Union, Paris.
COLLECTION: The Museum of Modern Art, New York. Louis E. Stern Collection

Between 1942 and 1952 Lam spent most of his time in the Caribbean, particularly in his Cuban homeland, literally finding his roots. For the jacket of his first book in 1953, Lam created an important color etching, enhancing it with watercolor and gouache. His images of native masks and spiked forms created an emphatic introduction to Char's Le Rempart de brindilles *(The Rampart of Twigs).*

HENRY MOORE
British. 1898–1986

Elephant Skull

AUTHOR: Henry Moore. Preface by Henry J. Seldis.
PUBLISHER: Geneva: Gérald Cramer, 1970.
PAGINATION: 94 unnumbered folios.
PAGE SIZE: 19¾ x 14¾" (50.2 x 37.5 cm), irreg.
IMAGES: 33 etchings (including wrapper), 5 with drypoint, in black on ivory wove Rives paper (except wrapper) (executed 1969–70).
IMAGE SHOWN: Wrapper, 20⅛ x 32⅜" (51.2 x 82.2 cm), irreg.
HOUSING: Publisher's vellum wrapper, with continuous etching on front and back, around ivory cardboard; publisher's beige linen solander box, lined with cream paper.
EDITION: More than 115: 15 numbered 1–15, with supplementary suite; 85 numbered 16–100; 5 *hors-commerce*, numbered I–V, with supplementary suite; 10 *hors-commerce*, numbered VI–XV; several other *hors-commerce* (this copy, signed,

and inscribed "The Museum of Modern Art, New York").
PRINTERS: Plates, Lacourière et Frélaut, Paris; text, Fequet et Baudier, Paris.
TYPOGRAPHY: Caslon.
CATALOGUE RAISONNÉ: Cramer 109–146.
COLLECTION: The Museum of Modern Art, New York. Gift of the artist and the publisher

The English sculptor Moore created his first book illustrations for Prométhée *by Johann Wolfgang von Goethe in 1950. After completing many lithographs and etchings, some of which were in books and portfolios, he embarked upon a series of etchings of an old elephant skull given to him by Julian and Juliette Huxley. The mystery that he found in the empty eye sockets and the patterns of surface cracks motivated him to also write about his work in this book. The etching on vellum that forms the book's jacket magnifies the motif of cracked bone that runs throughout the series.*

192

JEAN (HANS) ARP, HANS
BELLMER, VICTOR BRAUNER,
SERGE BRIGNONI, ALEXANDER
CALDER, BRUNO CAPACCI,
ELISABETH VAN DAMME, JULIO
DE DIEGO, ENRICO DONATI,
MARCEL DUCHAMP, MAX ERNST,
DAVID HARE, JACQUES HÉROLD,
MARCEL JEAN, WIFREDO LAM,
JACQUELINE LAMBA, MAN RAY,
MARIA, MATTA, JOAN MIRÓ, KAY
SAGE, YVES TANGUY, DOROTHEA
TANNING, TOYEN

*Le Surréalisme en 1947, exposition interna-
tionale du surréalisme*

AUTHORS: Various; edited by André Breton
(French. 1896–1966).
PUBLISHER: [Paris]: Pierre à Feu [Maeght
Editeur], 1947. First edition.
PAGINATION: 144 pages: [1–7], 8–139, [140], (4)
(including endpapers); 48 plates and reproduc-
tions *hors-texte*.
PAGE SIZE: 9⁷⁄₁₆ x 7¹⁵⁄₁₆" (24 x 20.3 cm).
IMAGES: 18 lithographs: 6 in color, 12 in black;
4 etchings (2 with aquatint), in black; 1 photo-
gravure, in color; 2 woodcuts, in black; 1 Ready-
made object (folder front); reproductions; on
ivory wove paper (except folder front).
IMAGE SHOWN: Duchamp (American, born
France. 1887–1968), Readymade, 7¹⁵⁄₁₆ x
16¹⁵⁄₁₆ x ⅜" (20.3 x 17.6 x 1 cm).
HOUSING: Publisher's cream wove paper bind-
ing under pink paperboard folder with Ready-
made object (foam rubber on black velvet)
mounted on front and labeled "Prière de
Toucher" on back, lined with ivory paper; red-
brown linen exterior folder and slipcase, lined
with cream paper.
EDITION: 999: 950 numbered 1–950 (this copy,
no. 691, signed); 49 numbered I–XLIX.
PRINTERS: Etchings, Lacourière, Paris; wood-
cuts and lithographs, Mourlot Frères, Paris; text,
Imprimerie Union, Paris.
CATALOGUE RAISONNÉ: Duchamp: Schwarz
328.
COLLECTION: The Museum of Modern Art,
New York. Henry Church Fund

*This volume is somewhat more than the cata-
logue for the postwar international exhibition
that was meant to show the survival of the
Surrealist movement. The work of eighty-seven
artists representing twenty-four countries was
exhibited, but the book contains prints by only
two dozen. Breton organized the exhibition with
Duchamp, and the latter's Dadaist predilection
for shock is perfectly accomplished in his
Readymade foam-rubber cover accompanied by
a label stating, "please touch."*

193

194

A N D Y W A R H O L
American. 1928–1987

Flash–November 22, 1963

AUTHOR: Phillip Greer (American. 1930–1985).
PUBLISHER: Briarcliff Manor, N.Y.: Racolin
Press, [1968].
PAGINATION: 26 pages: (*4*), [1], 2–18, (*4*); 11
plates; 9 pages *hors-texte*.
PAGE SIZE: 21½ x 21¼" (54.6 x 54 cm).
SHEET SIZE: 20⅞ x 20⅞" (53.1 x 53.1 cm).
IMAGES: 12 screenprints (including folder): 1 in
black, 11 in color, on ivory wove paper (except
folder).
IMAGE SHOWN: Folder, 20¾ x 42¹¹⁄₁₆" (52.7 x
108.5 cm), irreg.
HOUSING: Publisher's white linen folder, with
continuous screenprint on front and back; pub-
lisher's clear plexiglass box with removable slid-
ing side.
EDITION: 236: 200 numbered 1–200 (this copy,
no. 77, signed, and inscribed with dedication to
David Whitney by Warhol); 10 marked A–J,
with 3 supplementary screenprints; 26 *hors-
commerce*, numbered I–XXVI.

PRINTER: Aetna Silkscreen Products, Inc.,
New York.
BOOK DESIGNER: Andy Warhol.
TYPOGRAPHY: Screenprinted.
CATALOGUE RAISONNÉ: Feldman and
Schellmann 32–42, page 44.
COLLECTION: The Museum of Modern Art,
New York. Gift of Philip Johnson

*The assassination of John F. Kennedy was a
tragedy of belief for Americans and the entire
Western world. It was the first event of such
major importance to have been televised from
the moment of occurrence through nearly every
ensuing incident. From these disturbing videos
Warhol, the reaper of the preexisting photo-
graphic image, compiled this book, its text a
pseudo-teletyped moment-by-moment account
written by Greer. The silver-printed cover
reproduces a front page of a newspaper camou-
flaged by standardized floral patterns from
graphic transfer sheets.*

195

DIETER ROTH (DITER ROT)
Swiss, born Germany, 1930

Daily Mirror (Gesammelte Werke Band 10)

AUTHOR: Dieter Roth.
PUBLISHER: Cologne, London, Reykjavík:
Edition Hansjörg Mayer, 1970. (Variant of *Daily
Mirror Book*. Reykjavík: Forlag Ed., 1961.)
PAGINATION: 470 pages: (6´), 1–462, (2).
PAGE SIZE: 9¹/₁₆ x 6¹¹/₁₆" (23 x 17 cm).
IMAGES: Offset lithographs (enlargements of
sheets cut from *Daily Mirror* newspaper), in
black, on ivory wove paper.
IMAGE SHOWN: Cover, 9¼ x 17 x 1" (23.5 x 43.2
x 2.5 cm).
HOUSING: Publisher's light-gray wove paper
binding, with offset lithography, enclosed in
yellow painted corrugated cardboard cover with
square cutouts on front and back containing 2
signed miniature books cut from *Daily Mirror*
newspaper; loose gray string ties.

EDITION: 1,000: 100 numbered 1–100, with
cover multiple designed by Roth (this copy,
no. 72, signed "Dieter Roth"); 900 unnumbered.
PRINTER: Staib + Mayer, Stuttgart.
BOOK DESIGNER: Dieter Roth.
CATALOGUE RAISONNÉ: Roth 43.
COLLECTION: The Museum of Modern Art
Library, New York

When Mayer published reprints or reproduc-
tions of Roth's early books, a limited edition of
each was also issued with newly created covers
by the artist. On the reproduction of his book of
enlarged pages from a newspaper, Roth added
a yellow corrugated cover with miniature news-
paper books inserted in cut-out spaces in the
front and back.

Lenders to the Exhibition

Carlton Lake Collection, Harry Ransom
Humanities Research Center,
The University of Texas at Austin

Department of Printing & Graphic Arts,
Houghton Library, Harvard
University, Cambridge

Bibliothèque Nationale de France,
Département des Livres Imprimés

Cabinet des Estampes du Musée d'Art et
d'Histoire, Geneva

Städtische Galerie im Lenbachhaus, Munich

The Metropolitan Museum of Art,
New York

The Pierpont Morgan Library, New York

The New York Public Library, Astor,
Lenox, and Tilden Foundations.
Henry W. and Albert A. Berg Collection;
Spencer Collection; Rare Books and
Manuscripts Division

Library of the Whitney Museum of
American Art, New York

Musée Picasso, Paris

Department of Rare Books and Special
Collections, University of Rochester
Library

The Resource Collections of the Getty
Center for the History of Art and the
Humanities, Santa Monica

Graphische Sammlung Staatsgalerie
Stuttgart

The Toledo Museum of Art

National Gallery of Art, Washington, D.C.

Pierre Alechinsky

Georges Bauquier

Nelson Blitz, Jr., and Catherine Woodard

John Gibson

Arne and Milly Glimcher

Edouard Jaguer

Jasper Johns

E. W. Kornfeld, Bern

Thomas P. Whitney

Two private collections

Carus Gallery, New York

Ex Libris, New York

Marina Picasso Collection, Jan Krugier
Gallery, New York

Osiris, New York

CATALOGUE OF THE EXHIBITION

*Books, prints, and drawings in the exhibition
are listed alphabetically by the name of the
artist and in some cases by the name of the book;
works by "various artists" are listed at the end
of the catalogue. In the entries, brackets enclose
information that does not appear on the works.
Unless otherwise noted, the following measure-
ments are given: page size for books, sheet size
for drawings, composition size for lithographs
and woodcuts, and plate size for etchings and
other intaglio prints; height precedes width.
Translations of foreign-language titles are
provided only for prints and drawings. Works
illustrated in this publication are indicated by
a plate or text-figure number at the end of the
entry.*

Josef Albers. *Formulation: Articulation* by
Josef Albers. New York: Harry N. Abrams,
Inc.; New Haven: Ives-Sillman, Inc., 1972.
Screenprints. 15 x 20⅛" (38.1 x 51 cm). The
Museum of Modern Art, New York. Gift of
The Josef Albers Foundation. *Plate 75*

Tullio d'Albisola (Tullio Spartaco
Mazzotti). *Parole in libertà futuriste, tattili-
termiche olfattive* by Filippo Tommaso
Marinetti. Rome: Edizioni Futuriste di
Poesia, [1934]. Lithographs on tin-plated
metal sheets. 9⅟16 x 8ⁱⁱ⁄16" (23.3 x 22 cm).
The Museum of Modern Art, New York.
Gift of the Associates of the Department of
Prints and Illustrated Books and of Elaine
Lustig Cohen in memory of Arthur A.
Cohen. *Plate 183*

Pierre Alechinsky. *Le Rêve de l'ammonite*
by Michel Butor. [Montpellier, France]:
Editions Fata Morgana, [1975]. Lift-ground
aquatints and lithographs. 12¹³⁄16 x 9¹³⁄16"
(32.5 x 25 cm); supplementary suite, litho-
graphs, 12⅞ x 19¾" (32.8 x 50.2 cm), aqua-
tints, 19¾ x 25⅞" (50.2 x 65.8 cm). The

Museum of Modern Art, New York. Gift of
the artist. *Plate 151*

Apocalypsis Sancti Johannes. [Germany,
c. 1470]. Woodcuts. 10¾ x 8¼" (27.2 x
21 cm). The Pierpont Morgan Library, New
York. PML 21786, f. 35v. *Figure 16*

Jean (Hans) Arp. *Vingt-cinq poèmes* by
Tristan Tzara (Samuel Rosenstock). Zurich:
Collection Dada, 1918. Woodcuts. 7¾ x
5⁵⁄16" (19.7 x 13.5 cm), irreg. The Museum
of Modern Art, New York. Purchase.
Plates 129–130

Second copy: Ex Libris, New York

Geneviève Asse. *Ici en deux* by André du
Bouchet. Geneva: Quentin Editeur, 1982.
Aquatints, drypoints, and unworked and
uninked plates. 13³⁄16 x 10" (33.5 x 25.5 cm),
irreg. The Museum of Modern Art,
New York. A. Conger Goodyear and
Mrs. Stanley Resor Funds (by exchange).
Plate 156

Enrico Baj. *Meccano, ou l'analyse matricielle
du langage* by Raymond Queneau. Milan:
Sergio Tosi e Paolo Bellasich, 1966. Colla-
graphs and supplementary screenprint.
7¹¹⁄16 x 20⅞" (19.5 x 53 cm). The Museum of
Modern Art, New York. Monroe Wheeler
Fund. *Plate 185*

Georg Baselitz. *Malelade* by Georg Baselitz.
Cologne and New York: Michael Werner,
[1990]. Drypoints and etchings. 20⅛ x 28¾"
(51.2 x 73 cm). The Museum of Modern Art,
New York. Gift of The Cosmopolitan Arts
Foundation. *Plate 103*

Leonard Baskin. *Voyages: Six Poems from
White Buildings* by Hart Crane. New York:
The Museum of Modern Art, 1957. Wood
engravings and woodcut. 9½ x 11" (24.1 x
28 cm), irreg. The Museum of Modern Art,
New York. *Plate 161*

Aubrey Beardsley. *Salome, a Tragedy in
One Act* by Oscar Wilde. London: Elkin
Mathews & John Lane; Boston: Copeland &
Day, 1894. Line-block reproductions, after
drawings. 8½ x 6⅝" (21.6 x 16.8 cm). The
New York Public Library, Astor, Lenox,
and Tilden Foundations. Henry W. and
Albert A. Berg Collection. *Plate 32*

Max Beckmann. *Die Fürstin* by Kasimir
Edschmid. Weimar: Gustav Kiepenheuer,
1918. Drypoints. 12⅜ x 9⁵⁄16" (31.5 x 23 cm),
irreg. The Museum of Modern Art, New
York. Louis E. Stern Collection. *Plate 126*

Max Beckmann. *Apokalypse* from the Bible.
Frankfurt am Main: Bauersche Giesserei,
1943. Lithographs, some with watercolor
additions. 15⅜ x 11¾" (39 x 30 cm). National
Gallery of Art, Washington, D.C. Gift of
Mrs. Max Beckmann. *Plate 66*

Hans Bellmer. *La Poupée* by Hans Bellmer.
Paris: GLM [Guy Lévis Mano], 1936. Pho-
tographs and line-block reproductions, after
drawings. 6⅛ x 4½" (15.5 x 11.5 cm). The
Museum of Modern Art, New York.
Purchase. *Plates 141–142*

Joseph Beuys. *Die Leute sind ganz prima in
Foggia* by Joseph Beuys. [Heidelberg]:
Edition Staeck; [Naples]: Modern Art
Agency; and [Milan]: Studio Marconi, 1973
[1974]. Screenprints. 12⅜ x 8¾" (31.5 x
22.2 cm). Collection John Gibson. *Plate 79*

Mel Bochner. *On Certainty/Uber Gewissheit*
and *Counting Alternatives: The Wittgenstein
Illustrations* by Ludwig Wittgenstein. San
Francisco: Arion Press, 1991. Line-block
reproductions, after drawings. 14⅜ x 12¹⁵⁄16"
(36.5 x 33 cm); supplementary suite, 20 x
14¹⁵⁄16" (50.8 x 38 cm). The Museum of
Modern Art, New York. John B. Turner
Fund. *Plate 160*

David Bomberg. *Russian Ballet* by David Bomberg. London: Henderson's, 1919. Lithographs. 8⁷⁄₁₆ x 5⁵⁄₁₆" (21.4 x 13.5 cm), irreg. The Museum of Modern Art, New York. Gift of Peter Selz. *Plate 82*

Pierre Bonnard. *Parallèlement* by Paul Verlaine. Paris: Ambroise Vollard Editeur, 1900. Lithographs, ornamental woodcuts (cut by Tony Beltrand), and line-block reproductions. 11⅛ x 9⅜" (29.5 x 23.9 cm), irreg. The Museum of Modern Art, New York. Louis E. Stern Collection. *Plates 8–9*

Second copy: The New York Public Library, Astor, Lenox, and Tilden Foundations. Spencer Collection

Pierre Bonnard. Proof for image on page 81 of *Parallèlement*. [c. 1897–1900]. Lithograph. 5 x 8¹¹⁄₁₆" (12.8 x 22 cm). Bequest of Philip Hofer, Department of Printing & Graphic Arts, Houghton Library, Harvard University

Pierre Bonnard. Proof, with text, for image on page 81 of *Parallèlement*. [c. 1897–1900]. Lithograph. 5 x 8¹¹⁄₁₆" (12.8 x 22 cm). Bequest of Philip Hofer, Department of Printing & Graphic Arts, Houghton Library, Harvard University

Louise Bourgeois. *He Disappeared into Complete Silence* by Louise Bourgeois. New York: Gemor Press, [1947]. Engravings. 10 x 7" (25.5 x 17.8 cm), irreg. The Museum of Modern Art, New York. Abby Aldrich Rockefeller Fund. *Plate 95*

Louise Bourgeois. *Homely Girl, a Life* by Arthur Miller. New York: Peter Blum Edition, 1992. Drypoints and photolithographic reproductions, after medical photographs. 11½ x 8¹¹⁄₁₆" (29.3 x 22 cm). The Museum of Modern Art, New York. Gift of the artist. *Plates 178–179*

Constantin Brancusi. *Tales Told of Shem and Shaun, Three Fragments from Work in Progress* by James Joyce. Paris: The Black Sun Press, 1929. Photogravure reproduction, after pen-and-ink drawing. 8³⁄₁₆ x 6½" (20.8 x 16.5 cm). The Museum of Modern Art, New York. Mary Ellen Meehan Fund. *Plate 138*

Georges Braque. *Le Piège de Méduse* by Erik Satie. Paris: Editions de La Galerie Simon [Kahnweiler], 1921. Woodcuts. 12¹³⁄₁₆ x 8¹⁵⁄₁₆"

(32.5 x 22.7 cm). The Museum of Modern Art, New York. Louis E. Stern Collection. *Plate 122*

Georges Braque. *Théogonie* by Hesiod. 1932. (Commissioned by Vollard.) Suite of etchings with remarques, some with drypoint. Each sheet, 21 x 14¹³⁄₁₆" (53.4 x 37.7 cm), irreg. The Museum of Modern Art, New York. Louis E. Stern Collection. *Figure 22; plate 41*

Georges Braque. *Théogonie* by Hesiod. Paris: Maeght Editeur, 1955. (Commissioned by Vollard.) Etchings, photogravures, and aquatint. 17½ x 13¼" (44.4 x 33.7 cm), irreg. The Museum of Modern Art, New York. Louis E. Stern Collection. *Plate 40*

Georges Braque. *Milarepa* by Milarepa. Paris: Maeght Editeur, 1950. Aquatints, soft-ground etching, and etched initials. 9⅛ x 13¹⁄₁₆" (23.2 x 33.2 cm), irreg. The Museum of Modern Art, New York. Louis E. Stern Collection. *Plate 46*

Marcel Broodthaers. *Un Coup de dés jamais n'abolira le hasard* by Stéphane Mallarmé. Antwerp: Galerie Wide White Space; Cologne: Galerie Michael Werner, 1969. Photolithographs. 12¹³⁄₁₆ x 9¹³⁄₁₆" (32.5 x 25 cm). The Museum of Modern Art, New York. Purchased with funds given by Howard B. Johnson in honor of Riva Castleman. *Plate 114*

Edward Burne-Jones and William Morris. *The Works of Geoffrey Chaucer, Now Newly Imprinted* by Geoffrey Chaucer. Hammersmith [London]: Kelmscott Press, [1896]. Wood engravings, after drawings by Burne-Jones (cut by W. H. Hooper) and after designs by Morris. 16⅝ x 11⅛" (42.2 x 28.2 cm), irreg. The Museum of Modern Art, New York. Louis E. Stern Collection. *Plate 33*

Alexander Calder. *Fables* by Aesop. Paris: Harrison; New York: Minton, Balch and Company, [1931]. Line-block reproductions, after pen-and-ink drawings, and supplementary pen-and-ink drawing. 9¹³⁄₁₆ x 7¹¹⁄₁₆" (25 x 19.5 cm), irreg. The Museum of Modern Art, New York. Gift of Monroe Wheeler. *Plate 52*

Second copy: The Museum of Modern Art Library, New York

Marc Chagall. *Mein Leben* by Marc Chagall. Berlin: Paul Cassirer, 1923. Etchings. Each sheet, 10¹³⁄₁₆ x 8¹¹⁄₁₆" (27.5 x 22 cm) to 17⅛ x 13⅛" (43.5 x 33.4 cm). The Museum of Modern Art, New York. Louis E. Stern Collection. *Plates 88–89*

Marc Chagall. *My Life* by Marc Chagall. New York: The Orion Press, 1960. Reproductions. 8³⁄₁₆ x 6³⁄₁₆" (20.8 x 15.7 cm). The Museum of Modern Art Library, New York

Marc Chagall. *Four Tales from the Arabian Nights*, excerpts from ancient Persian, Indian, and Arabian tales. New York: Pantheon Books, Inc., [1948]. Lithographs and photolithographic reproductions, after drawings. 16¹⁵⁄₁₆ x 12¹⁵⁄₁₆" (43.1 x 33 cm). The Museum of Modern Art, New York. Louis E. Stern Collection. *Plates 47–48*

Eduardo Chillida. *Die Kunst und der Raum/ L'Art et l'espace* by Martin Heidegger. St. Gall: Erker-Verlag/Erker Presse [Franz Larese and Jürg Janett], 1969. Lithographs pasted onto paper. 8⅜ x 6¹⁄₁₆" (21.3 x 15.4 cm). The Museum of Modern Art, New York. Given in memory of Louise A. Boyer by Lily Auchincloss and Frances Keech. *Plate 150*

Giorgio de Chirico. *Calligrammes* by Guillaume Apollinaire (Guillaume Apollinaire de Kostrowitsky). [Paris]: Librairie Gallimard, 1930. Lithographs. 12¹³⁄₁₆ x 10" (32.5 x 25.5 cm), irreg. The Museum of Modern Art, New York. Louis E. Stern Collection. *Plate 133*

Francesco Clemente. *The Departure of the Argonaut* by Alberto Savinio (Andrea de Chirico). [New York and London]: Petersburg Press, 1986. Photolithographs. 25⁹⁄₁₆ x 19¹¹⁄₁₆" (65 x 50 cm). The Museum of Modern Art, New York. Gift of Petersburg Press. *Plate 176*

Salvador Dali. *Les Chants de maldoror* by Comte de Lautréamont (Isidore Ducasse). Paris: Albert Skira Editeur, 1934. Etchings. 12¹³⁄₁₆ x 10" (32.5 x 25.5 cm). The Museum of Modern Art, New York. Louis E. Stern Collection. *Plate 18*

Salvador Dali. Drawing for plate 29 of *Les Chants de maldoror* by Comte de Lautréamont (Isidore Ducasse). [1932–33]. Pencil. 8½ x 6¼" (21.5 x 15.8 cm).

Graphische Sammlung Staatsgalerie Stuttgart. *Plate 19*

Salvador Dali. States I, II, and III of Plate 29 for *Les Chants de maldoror* by Comte de Lautréamont (Isidore Ducasse). [Paris: Albert Skira Editeur, 1934]. Three etchings with remarques. Each, 11¾ x 7¼" (29.8 x 18.4 cm). Graphische Sammlung Staatsgalerie Stuttgart

Robert Delaunay. *Tour Eiffel* by Vicente Huidobro. Madrid, 1918. Pochoir. 12¹⁵⁄₁₆ x 9⅝" (32.9 x 24.4 cm), irreg. The Museum of Modern Art, New York. Mrs. Stanley Resor Fund. *Plate 189*

Sonia Delaunay-Terk. *La Prose du Transsibérien et de la petite Jehanne de France* by Blaise Cendrars (Frédéric-Louis Sauser). Paris: Editions des Hommes Nouveaux [Blaise Cendrars], 1913. Pochoir. 81⅛ x 14¼" (207.4 x 36.2 cm), irreg. The Museum of Modern Art, New York. Purchase. *Plate 118*

Sonia Delaunay-Terk. *La Prose du Transsibérien et de la petite Jehanne de France* by Blaise Cendrars (Frédéric-Louis Sauser). 1913. Annotated proof for pochoir, with watercolor. 78¹³⁄₁₆ x 14⁷⁄₁₆" (199.5 x 36.7 cm) overall. Cabinet des Estampes du Musée d'Art et d'Histoire, Geneva. *Plate 119*

Sonia Delaunay-Terk. Wrapper for *La Prose du Transsibérien et de la petite Jehanne de France* by Blaise Cendrars (Frédéric-Louis Sauser). [1913]. Oil on parchment. 7¾ x 8" (19.7 x 20.3 cm) (unfolded). Cabinet des Estampes du Musée d'Art et d'Histoire, Geneva

André Derain. *L'Enchanteur pourrissant* by Guillaume Apollinaire (Guillaume Apollinaire de Kostrowitsky). Paris: Henry Kahnweiler Editeur, 1909. Woodcuts. 10⁷⁄₁₆ x 7⅞" (26.5 x 20 cm). The Museum of Modern Art, New York. Louis E. Stern Collection. *Plates 12–13*

André Derain. Drawing for the Kahnweiler vignette for *L'Enchanteur pourrissant* by Guillaume Apollinaire (Guillaume Apollinaire de Kostrowitsky). [1909]. Brush and ink. 6⅜ x 8⅞" (16.2 x 22.6 cm). Carlton Lake Collection, Harry Ransom Humanities Research Center, The University of Texas at Austin. *Figure 9*

André Derain. Proof of a plate for *L'Enchanteur pourrissant* by Guillaume Apollinaire (Guillaume Apollinaire de Kostrowitsky). [1909]. Woodcut. 8³⁄₁₆ x 6¾" (20.8 x 17.1 cm), irreg. Carlton Lake Collection, Harry Ransom Humanities Research Center, The University of Texas at Austin

André Derain. Proof of a plate for *L'Enchanteur pourrissant* by Guillaume Apollinaire (Guillaume Apollinaire de Kostrowitsky). [1909]. Woodcut. 8³⁄₁₆ x 6½" (20.8 x 16.5 cm), irreg. Carlton Lake Collection, Harry Ransom Humanities Research Center, The University of Texas at Austin

Jim Dine. *The Poet Assassinated* by Guillaume Apollinaire (Guillaume Apollinaire de Kostrowitsky). New York: Tanglewood Press Inc., 1968. Photolithographs, screenprints, and pochoirs. 9¹⁵⁄₁₆ x 7¹⁵⁄₁₆" (25.3 x 20.2 cm). The Museum of Modern Art, New York. Gift of Dr. and Mrs. Aaron Esman. *Plate 169*

Second copy (trade edition): Private collection

Jim Dine. *The Apocalypse, The Revelation of Saint John the Divine* from the Bible. San Francisco: The Arion Press, 1982. Woodcuts. 15 x 11¼" (38.2 x 28.5 cm), irreg. The Museum of Modern Art, New York. Purchase. *Plate 67*

Jean Dubuffet. *Labonfam abeber par inbo nom* by Jean Dubuffet. [Paris: Jean Dubuffet], 1950. Photolithographic reproductions, after ink drawings. 11⅛ x 8¹¹⁄₁₆" (28.2 x 22 cm), irreg. The Museum of Modern Art, New York. The Associates Fund. *Plate 143*

Jean Dubuffet. *La Lunette farcie* by Jean Dubuffet. Alès and Paris: PAB [Pierre André Benoit], 1962 [1963]. Lithographs. 17⁷⁄₁₆ x 14¹⁵⁄₁₆" (43.4 x 38 cm), irreg. The Museum of Modern Art, New York. Gift of Mr. and Mrs. Ralph F. Colin. *Plate 99*

Jean Dubuffet. Manuscript for *La Lunette farcie* by Jean Dubuffet. [January, 1962]. Pen and black ink, with oil paint. 9⅛ x 8⅛" (23.2 x 20.7 cm). Bibliothèque Nationale de France, Département des Livres Imprimés. *Plate 98*

Marcel Duchamp. *La Mariée mise à nu par ses célibataires, même* (the *Green Box*) by

Marcel Duchamp. Paris: Edition Rrose Sélavy [Duchamp], [1934]. Collotype reproductions, after photographs, drawings, and manuscript notes. Variable, 2¹¹⁄₁₆ x 3¹³⁄₁₆ (7.4 x 9.7 cm) to 12⅜ x 9½" (31.4 x 24.2 cm). The Museum of Modern Art, New York. Purchase. *Plate 78*

Raoul Dufy. *Le Bestiaire, ou cortège d'Orphée* by Guillaume Apollinaire (Guillaume Apollinaire de Kostrowitsky). Paris: Deplanche, Editeur d'Art, 1911. Woodcuts. 12¹³⁄₁₆ x 10" (32.5 x 25.5 cm), irreg. The Museum of Modern Art, New York. Louis E. Stern Collection. *Plates 50–51*

Albrecht Dürer. *Della simmetria de i corpi humani, libri quattro*. Venice: Domenico Nicolini, 1591. Woodcuts. 13¹⁄₁₆ x 8⅝" (32.2 x 22 cm). Collection Arne and Milly Glimcher. *Figure 13*

Max Ernst. *Une Semaine de bonté, ou les sept éléments capitaux* by Max Ernst. Paris: Editions Jeanne Bucher, 1934. Line-block reproductions, after collages. 10¾ x 8¹⁄₁₆" (27.3 x 20.5 cm). The Museum of Modern Art, New York. Louis E. Stern Collection. *Plate 109*

Max Ernst. *Le Lion de Belfort*, Vol. I of *Une Semaine de bonté, ou les sept éléments capitaux* by Max Ernst. Paris: Editions Jeanne Bucher, 1934. Line-block reproductions, after collages, and soft-ground etching. 10¾ x 8¹⁄₁₆" (27.3 x 20.5 cm). The New York Public Library, Astor, Lenox, and Tilden Foundations. Spencer Collection. *Plate 110*

Max Ernst. *65 Maximiliana, ou l'exercice illégal de l'astronomie* by Max Ernst. Paris: Le Degré Quarante et Un [Iliazd], 1964. Etchings, some with aquatint, aquatints, and line-block reproductions of the artist's "secret writing," drawings, and collages. 16¹⁄₁₆ x 12" (40.8 x 30.5 cm). The New York Public Library, Astor, Lenox, and Tilden Foundations. Spencer Collection. Gift of Dorothea Tanning. *Plate 26*

Walker Evans. *American Photographs* by Lincoln Kirstein. New York: The Museum of Modern Art, 1938. Relief halftone reproductions, after photographs. 8¾ x 7¾" (22.2 x 19.7 cm). The Museum of Modern Art, New York. *Plate 116*

Second copy: The Museum of Modern Art, New York

Jean Fautrier. *La Femme de ma vie* by André Frénaud. Paris: Librairie Auguste Blaizot, 1947. Etching and aquatints. 11⅜ x 7¹/₁₆" (29 x 18 cm). Graphische Sammlung Staatsgalerie Stuttgart. *Plate 145*

Antonio Frasconi. *12 Fables of Aesop*, retold by Glenway Wescott. New York: The Museum of Modern Art, 1954. Linoleum cuts. 10½ x 7½" (26.6 x 19 cm). The Museum of Modern Art, New York. *Plate 53*

Paul Gauguin. *Noa Noa.* [1894]. Autograph manuscript. 15¾ x 10¼" (40 x 26.1 cm), irreg. The Resource Collections of the Getty Center for the History of Art and the Humanities. *Figure 6; plate 2*

Paul Gauguin. *Noa Noa (Fragrant Scent).* [1893–94; printed by Louis Roy, Paris]. Woodcut with stencil. 14¹/₁₆ x 8⅛" (35.7 x 20.7 cm). The Museum of Modern Art, New York. Lillie P. Bliss Collection. *Plate 1*

Paul Gauguin. Wood block for *Noa Noa.* [c. 1893–94]. 13⅞ x 8" (35.3 x 20.3 cm). The Metropolitan Museum of Art, New York. Harris Brisbane Dick Fund, 1937

Paul Gauguin. *Nave Nave Fenua (Fragrant Isle).* [1893–94; printed by Louis Roy, Paris]. Woodcut with stencil. 13¹⁵/₁₆ x 8¹¹/₁₆" (35.5 x 20.5 cm). The Museum of Modern Art, New York. Gift of Abby Aldrich Rockefeller

Paul Gauguin. *Te Faruru (Here We Make Love).* [1893–94; printed by Louis Roy, Paris]. Woodcut with stencil. 14¹/₁₆ x 8¹/₁₆" (35.7 x 20.5 cm). The Museum of Modern Art, New York. Gift of Abby Aldrich Rockefeller

Paul Gauguin. *Te Atua (The Gods).* [1893–94; printed by Gauguin]. Woodcut. 8¹/₁₆ x 14" (20.5 x 35.5 cm). The Museum of Modern Art, New York. Gift of Abby Aldrich Rockefeller. *Plate 3*

Paul Gauguin. *Noa Noa* by Paul Gauguin [and Charles Morice]. Munich: R. Piper & Co. Verlag, 1926. Facsimile of autograph manuscript with collotype reproductions of the artist's watercolors, pen-and-ink drawings, woodcuts, and photographs. 12⅛ x 9⅛" (30.8 x 23.2 cm). The Museum of Modern Art Library, New York. *Plate 4*

Second copy: The New York Public Library, Astor, Lenox, and Tilden Foundations. Spencer Collection. Gift of Henry Mottek

Alberto Giacometti. *L'Air de l'eau* by André Breton. Paris: Editions Cahiers d'Art, 1934. Engravings. 11⅞ x 7¹/₁₆" (30.2 x 18 cm), irreg. The Museum of Modern Art, New York. Louis E. Stern Collection. *Plate 136*

Alberto Giacometti. *Retour amont* by René Char. Paris: GLM [Guy Lévis Mano], 1965. Aquatints. 9⅝ x 7¼" (24.5 x 18.4 cm). The Museum of Modern Art, New York. Monroe Wheeler Fund. *Plate 147*

Gilbert & George (Gilbert Proesch and George Passmore). *Side by Side* by Gilbert & George. Cologne and New York: König Brothers, 1972. Photolithographic reproductions, after photographs. 7½ x 4¹⁵/₁₆" (19 x 12.5 cm). The Museum of Modern Art, New York. Purchase. *Plate 101*

Francisco de Goya. *Los caprichos* by Francisco de Goya. [Madrid: Francisco de Goya, 1799]. Aquatints, most with etching. 11⅞ x 7⅞" (30.1 x 20 cm). The Museum of Modern Art, New York. Louis E. Stern Collection. *Figure 2*

Francisco de Goya. *Los desastres de la guerra* by Francisco de Goya. Madrid: Real Academia de Nobles Artes de San Fernando, 1863. Etchings, most with aquatint (prints executed 1810–20). 9¹³/₁₆ x 13¾" (25 x 35 cm), irreg. The Museum of Modern Art, New York. Louis E. Stern Collection. *Figure 19*

Juan Gris (José Victoriano González). *Ne Coupez pas mademoiselle, ou les erreurs des P.T.T.* by Max Jacob. Paris: Editions de La Galerie Simon [Kahnweiler], 1921. Lithographs. 12⁹/₁₆ x 8¹⁵/₁₆" (32 x 22.8 cm). The Museum of Modern Art, New York. Louis E. Stern Collection. *Plate 123*

George Grosz. *Ecce Homo* by George Grosz. Berlin: Der Malik-Verlag, 1923. Photolithographic reproductions, after watercolors and drawings. 13¾ x 9¾" (34.9 x 24.8 cm). The Museum of Modern Art, New York. Louis E. Stern Collection. *Plates 107–108*

Grace Hartigan. *Salute* by James Schuyler. New York: Tiber Press, 1960. Screenprints. 17½ x 14¹/₁₆" (44.4 x 35.8 cm). The Museum of Modern Art, New York. Gift of Richard Miller. *Plate 166*

David Hockney. *A Rake's Progress* by David Hockney. London: Editions Alecto, in association with The Royal College of Art, 1963. Etching and aquatints. 19¹¹/₁₆ x 24⅛" (50 x 62.5 cm), irreg. The Museum of Modern Art, New York. Mr. and Mrs. Ralph F. Colin, Leon A. Mnuchin, and Joanne M. Stern Funds. *Plate 102*

David Hockney. *A Rake's Progress*, with poems by David Posner. London and New York: Lion and Unicorn Press, 1967. Reproductions. 14⁹/₁₆ x 15⅜" (37 x 39 cm). Department of Rare Books and Special Collections, University of Rochester Library

David Hockney. *Fourteen Poems* by C. P. Cavafy. London: Editions Alecto Limited, 1967. Etchings, some with aquatint. 18⁵/₁₆ x 12¹⁵/₁₆" (46.6 x 33 cm). The Museum of Modern Art, New York. Given anonymously. *Plate 171*

David Hockney. *Fourteen Poems from C. P. Cavafy.* [London: Editions Alecto Limited, 1967]. Suite of etchings, some with aquatint. Each sheet, 22³/₁₆ x 15½" (56.3 x 39.4 cm) to 22⁹/₁₆ x 16" (57.3 x 40.6 cm). The Museum of Modern Art, New York. Gift of the Celeste and Armand Bartos Foundation

Howard Hodgkin. *The Way We Live Now* by Susan Sontag. London: Karsten Schubert, 1991. Lift-ground aquatints with tempera additions, and 1 tempera. 11¼ x 8⁵/₁₆" (28.6 x 21.2 cm). The Museum of Modern Art, New York. Purchased in part with funds from Mrs. Donald B. Straus. *Plate 154*

Hypnerotomachia Polifili. Venice: Aldus Manutius, 1499. Woodcuts. 11¼ x 8" (29.8 x 20.3 cm). The New York Public Library, Astor, Lenox, and Tilden Foundations. Rare Books and Manuscripts Division. *Figure 12*

Robert Indiana. *Numbers* by Robert Creeley. Stuttgart: Edition Domberger; Düsseldorf: Galerie Schmela, 1968. Screenprints. 25⁹/₁₆ x 19¹¹/₁₆" (65 x 50 cm). The Museum of Modern Art, New York. The Celeste and Armand Bartos Foundation Fund. *Plate 170*

Marcel Janco. *La Première Aventure céléste de Mr. Antipyrine* by Tristan Tzara (Samuel Rosenstock). [Zurich]: Collection Dada, 1916. Woodcuts. 8¹³/₁₆ x 5¹³/₁₆" (22.4 x

14.8 cm). The Museum of Modern Art, New York. Purchase. *Plates 127–128*

Alfred Jarry. *Les Minutes de sable mémorial* by Alfred Jarry. [Paris]: Mercure de France, [1894]. Woodcuts and line-block reproduction, after pen-and-ink drawing. 5¼ x 4⁵⁄₁₆" (13.4 x 10.9 cm), irreg. The Museum of Modern Art, New York. *Figure 5; plates 80–81*

Jasper Johns. *Foirades/Fizzles* by Samuel Beckett. [London and New York]: Petersburg Press, 1976. Lift-ground aquatints, etchings, and lithograph. 12¹⁵⁄₁₆ x 9¹³⁄₁₆" (33 x 25 cm), irreg. The Museum of Modern Art, New York. Gift of Celeste and Armand Bartos (in perpetuity). *Plates 173–174*

Second copy: Collection Nelson Blitz, Jr., and Catherine Woodard

Jasper Johns. Sketches for *Foirades/Fizzles*. [c. 1975]. Pencil with pen and brush and ink. 14¾ x 23" (37.5 x 58.4 cm), irreg. Collection the artist. *Figure 25*

Jasper Johns. Sketch for *Words (Buttock Knee Sock . . .)* from *Foirades/Fizzles*. [c. 1975]. Pencil with pen and brush and ink. 14⅜ x 17¾" (36.5 x 45.1 cm), irreg. Collection the artist

Asger Jorn. *Held og hasard/Dolk og guitar* by Asger Jorn. Silkeborg: [Asger Jorn], 1952. Linoleum cuts and monotype. 10¼ x 7⁹⁄₁₆" (26 x 19.2 cm). Collection Pierre Alechinsky. *Plate 97*

Second copy: Private collection, Paris

Vasily Kandinsky. *Klänge* by Vasily Kandinsky. Munich: R. Piper & Co. Verlag, [1913]. Woodcuts. 11¹⁄₁₆ x 10⅞" (28.1 x 27.7 cm). The Museum of Modern Art, New York. Louis E. Stern Collection. *Plate 83*

Second copy: Carus Gallery, New York

Vasily Kandinsky. *Sound of Trumpets (Large Resurrection)* [*Klänge der Posaunen (Grosse Auferstehung)*]. [1910–11]. Watercolor, India ink, and pencil on thin cardboard. 12¼ x 12¼" (32.5 x 32.5 cm). Städtische Galerie im Lenbachhaus, Munich. *Plate 85*

Vasily Kandinsky. *Large Resurrection (Grosse Auferstehung)*, proof of the black block for *Klänge*. [1911]. Woodcut. 8⅝ x 8¹¹⁄₁₆" (21.9 x 22 cm). The Museum of Modern Art, New

York. Johanna and Leslie J. Garfield Fund. *Plate 84*

Ellsworth Kelly. *Un Coup de dés jamais n'abolira le hasard* by Stéphane Mallarmé. [New York]: The Limited Editions Club, 1992. Lithographs. 17 x 12⅜" (43.2 x 31.5 cm). The Museum of Modern Art, New York. Purchased with funds given by Mrs. Melville Wakeman Hall. *Plates 158–159*

Anselm Kiefer. *Der Rhein*. [Hornbach: Anselm Kiefer], 1983. Woodcuts. 23¼ x 16½" (59 x 42 cm). The Museum of Modern Art, New York. Purchase. *Plate 162*

Ernst Ludwig Kirchner. *Umbra vitae* by Georg Heym. Munich: Kurt Wolff Verlag, 1924. Woodcuts. 9¹⁄₁₆ x 6⅛" (23.1 x 15.6 cm). The Museum of Modern Art, New York. Louis E. Stern Collection. *Plate 190*

Second copy: The Toledo Museum of Art. Gift of Molly and Walter Bareiss

Oskar Kokoschka. *Die träumenden Knaben* by Oskar Kokoschka. Leipzig: Kurt Wolff Verlag, 1917. (First edition, Vienna: Wiener Werkstätte, 1908; unsold copies reissued 1917.) Transfer lithographs and line-block reproductions, after drawings. 9⁷⁄₁₆ x 10¹³⁄₁₆" (24 x 27.5 cm). The Museum of Modern Art, New York. Louis E. Stern Collection. *Plate 35*

Oskar Kokoschka. *Mörder Hoffnung der Frauen* by Oskar Kokoschka. Berlin: Verlag Der Sturm, [1916]. Line-block reproductions, after pen-and-ink drawings, with gouache additions. 13⁷⁄₁₆ x 9¾" (34.1 x 24.8 cm). The Museum of Modern Art, New York. Louis E. Stern Collection. *Plate 87*

Second copy: The Museum of Modern Art, New York. Purchase. *Plate 86*

Oskar Kokoschka. Poster for *Mörder Hoffnung der Frauen*. [Vienna: Internationale Kunstschau, 1909]. Lithograph. 48 x 31⁵⁄₁₆" (122 x 79.5 cm). The Museum of Modern Art, New York. Purchase fund. *Figure 14*

Barbara Kruger. *My Pretty Pony* by Stephen King. New York: Library Fellows of the Whitney Museum of American Art, 1988. Lithographs and screenprints. 20 x 13⁷⁄₁₆" (50.9 x 34.2 cm). The Museum of Modern Art, New York. The Associates Fund

in honor of Riva Castleman. *Figure 28; plate 175*

Second copy: Library of the Whitney Museum of American Art, New York

František (or Frank) Kupka. *Quatre histoires de blanc et noir* by František Kupka. Paris: [František Kupka], 1926. Woodcuts. 12¹⁵⁄₁₆ x 9¹⁵⁄₁₆" (33 x 25.3 cm). The Museum of Modern Art, New York. Gift of Mr. and Mrs. Alfred H. Barr, Jr. *Plates 68–70*

Wifredo Lam. *Le Rempart de brindilles* by René Char. Paris: Louis Broder, [1953]. Etching and aquatints, 1 with watercolor and gouache additions. 8¼ x 6⅛" (21 x 15.5 cm). The Museum of Modern Art, New York. Louis E. Stern Collection. *Plate 191*

Henri Laurens. *Les Pélican* by Raymond Radiguet. Paris: Editions de La Galerie Simon [Kahnweiler], 1921. Etchings, some with drypoint. 12⁹⁄₁₆ x 8⅞" (32 x 22.5 cm). The Museum of Modern Art, New York. Louis E. Stern Collection. *Plates 124–125*

Fernand Léger. *La Fin du monde, filmée par l'ange N.D.* by Blaise Cendrars (Frédéric-Louis Sauser). Paris: Editions de la Sirène, 1919. Pochoirs, some with line-block reproductions, after pen-and-ink drawings. 12⅜ x 9¹³⁄₁₆" (31.5 x 25 cm). The Museum of Modern Art, New York. Louis E. Stern Collection. *Plates 120–121*

Second copy: The Museum of Modern Art Library, New York

Fernand Léger. Corrected proofs for *La Fin du monde, filmée par l'ange N.D.* by Blaise Cendrars (Frédéric-Louis Sauser). 1919. Line-block reproductions, after ink drawings, with handwritten notes by Cendrars. 12⅜ x 9¹³⁄₁₆" (31.5 x 25 cm). Bibliothèque Nationale de France, Département des Livres Imprimés

Fernand Léger. *Cirque* by Fernand Léger. Paris: Tériade Editeur, 1950. Lithographs. 16½ x 12⁹⁄₁₆" (42 x 32 cm), irreg. The Museum of Modern Art, New York. Louis E. Stern Collection. *Plates 20–21*

Fernand Léger. Study for *Les Trapézistes*, from *Cirque* by Fernand Léger. [c. 1950]. Gouache. 19⁹⁄₁₆ x 25⅜" (49 x 64.5 cm). Collection Georges Bauquier. *Figure 10*

Sol LeWitt. *Six Geometric Figures and All Their Combinations* by Sol LeWitt. New

York: Parasol Press, Ltd., 1980. Etchings. 9¹⁄₁₆ x 9¹⁄₁₆" (23 x 23 cm). The Museum of Modern Art, New York. Gift of Allen Skolnick. *Plates 76–77*

Sol LeWitt. 10 of 127 canceled copper plates for *Six Geometric Figures and All Their Combinations*. [1980]. Various dimensions. The Museum of Modern Art, New York. Gift of Allen Skolnick

El Lissitzky (Lazar Markovich Lissitzky). *Pro dva kvadrata* by El Lissitzky. Berlin: Skythen, 1922. Line blocks, some with relief halftone, and 1 relief halftone. 10¹⁵⁄₁₆ x 8¾" (27.9 x 22.2 cm). The Museum of Modern Art, New York. Gift of Philip Johnson, Jan Tschichold Collection. *Plate 71*

Second copy: Carus Gallery, New York

Aristide Maillol. *Les Eclogues* by Virgil. Weimar: Cranach Presse, 1926. Wood engravings. 13³⁄₁₆ x 9¹³⁄₁₆" (33.5 x 25 cm), irreg. The Museum of Modern Art, New York. Louis E. Stern Collection

Aristide Maillol. *The Eclogues* by Virgil. London: Emery Walker Limited [for Cranach Presse], 1927. Wood engravings. 12¹⁵⁄₁₆ x 9¹¹⁄₁₆" (33 x 24.6 cm), irreg. The Museum of Modern Art, New York. Henry Church Fund. *Plate 38*

Aristide Maillol. Sketches, including Cranach Presse vignette, for *The Eclogues* by Virgil. [c. 1912–25]. Pencil. 10⅝ x 8³⁄₁₆" (27 x 20.7 cm). Bequest of Philip Hofer, Department of Printing & Graphic Arts, Houghton Library, Harvard University. *Figure 26*

Kasimir Malevich. *Suprematism: 34 Risunka* by Kasimir Malevich. Vitebsk: Unovis, 1920. Lithographs and woodcut. 8⁹⁄₁₆ x 7¹⁄₁₆" (21.7 x 17.9 cm). Cabinet des Estampes du Musée d'Art et d'Histoire, Geneva. *Plates 73–74*

Man Ray (Emmanuel Rudnitsky). *Facile* by Paul Eluard (Eugène Grindel). Paris: Editions GLM [Guy Lévis Mano], 1935. Photogravure reproductions, after photographs. 9⁹⁄₁₆ x 7⁷⁄₁₆" (24.2 x 18 cm). The Museum of Modern Art, New York. *Plate 137*

Second copy: The Museum of Modern Art, New York

Frans Masereel. *La Ville*. Paris: Editions Albert Morancé, [1925]. Woodcuts. 11¹⁄₁₆ x 8¹¹⁄₁₆" (28.1 x 22 cm), irreg. The Museum of Modern Art, New York. Purchase. *Plate 106*

André Masson. *Soleils bas* by Georges Limbour. Paris: Editions de La Galerie Simon [Kahnweiler], 1924. Drypoints. 9½ x 7½" (24.2 x 19 cm), irreg. The Museum of Modern Art, New York. Gift of Walter P. Chrysler, Jr. *Plate 131*

André Masson. *Les Conquérants* by André Malraux. Paris: Albert Skira, [1949]. Lift-ground aquatints. 14¹³⁄₁₆ x 11¹⁄₁₆" (37.7 x 28.1 cm). The Museum of Modern Art, New York. Gift of Mr. and Mrs. Ralph F. Colin. *Plate 64*

Henri Matisse. *Poésies* by Stéphane Mallarmé. Lausanne: Albert Skira & Cie, Editeurs, 1932. Etchings. 12¹⁵⁄₁₆ x 9¹³⁄₁₆" (33 x 25 cm). The Museum of Modern Art, New York. Louis E. Stern Collection. *Plates 15–17*

Henri Matisse. *Pasiphaé, chant de Minos (Les Crétois)* by Henry de Montherlant. [Paris]: Martin Fabiani Editeur, 1944. Linoleum cuts. 12¹³⁄₁₆ x 9¾" (32.5 x 24.8 cm). The Museum of Modern Art, New York. Louis E. Stern Collection. *Plate 42*

Henri Matisse. Maquette for *Pasiphaé, chant de Minos (Les Crétois)* by Henry de Montherlant. [1944]. Letters and designs in pencil and red pencil on the 1938 edition of text published by Grasset, Paris. 8⅝ x 6¹¹⁄₁₆" (22 x 17 cm). Bibliothèque Nationale de France, Département des Livres Imprimés. *Figure 23*

Henri Matisse. Placement maquette for *Pasiphaé, chant de Minos (Les Crétois)* by Henry de Montherlant. [1944]. Pen-and-ink, pencil, and red pencil. 5⁵⁄₁₆ x 4³⁄₁₆" (13.5 x 10.6 cm). Bibliothèque Nationale de France, Département des Livres Imprimés

Henri Matisse. *Pasiphaé, chant de Minos (Les Crétois)* by Henry de Montherlant. Paris: Les Héritiers de l'Artiste, 1981. Linoleum cuts (plates, executed 1943–44, rejected from 1944 edition). 12¹³⁄₁₆ x 9¹³⁄₁₆" (32.5 x 25 cm). The Museum of Modern Art, New York. Gift of the Heirs of Henri Matisse

Henri Matisse. *Jazz* by Henri Matisse. [Paris]: Tériade Editeur, 1947. Pochoirs after cut-

paper collages (executed by Edmond Vairel) and reproductions after drawings (executed by Draeger Frères). 16½ x 12¹¹⁄₁₆" (42 x 32.2 cm), irreg. The Museum of Modern Art, New York. Louis E. Stern Collection. *Plates 22–23*

Henri Matisse. *The Codomas (Les Codomas)*, proof of the plate for *Jazz*. [c. 1944]. Zinc relief cut, after cut-paper collage. 16¾ x 25¹¹⁄₁₆" (42.5 x 65.3 cm), irreg. The Museum of Modern Art, New York. Gift of Joanne M. Stern

Matta (Roberto Sebastian Antonio Matta Echaurren). *Arcane 17* by André Breton. New York: Brentano's, 1944. Etching and aquatint, and photolithographic reproductions, after tarot card designs. 9¹⁄₁₆ x 6⁵⁄₁₆" (23 x 16 cm), irreg. The Museum of Modern Art, New York. Purchase. *Plate 146*

Matta (Roberto Sebastian Antonio Matta Echaurren). *Un Soleil, un Viet-Nam* by Jean-Paul Sartre. Paris: Comité Viet-Nam National, 1967. Lithographs. 11¾ x 8¹³⁄₁₆" (29.9 x 22.4 cm). The Museum of Modern Art, New York. Purchase. *Plate 65*

Henri Michaux. *Meidosems* by Henri Michaux. [Paris]: Les Editions du Point du Jour, 1948. Lithographs. 9¹⁵⁄₁₆ x 7½" (25.2 x 19 cm), irreg. The Museum of Modern Art, New York. Abby Aldrich Rockefeller Fund. *Plate 96*

Joan Miró. *Enfances* by Georges Hugnet. Paris: Editions Cahiers d'Art, [1933]. Etchings. 11 x 8¾" (28 x 22.2 cm), irreg. The Museum of Modern Art, New York. Louis E. Stern Collection. *Plate 134*

Joan Miró. *A toute épreuve* by Paul Eluard (Eugène Grindel). Geneva: Gérald Cramer, [1958]. Woodcuts, most with collagraph and/or collage. 12⁹⁄₁₆ x 9¹³⁄₁₆" (32 x 25 cm). The Museum of Modern Art, New York. Louis E. Stern Collection. *Plates 28–29*

Joan Miró. Woodblock for plate from *A toute épreuve*. [c. 1947–58]. 13 x 9¹³⁄₁₆" (33 x 24.9 cm). The Museum of Modern Art, New York. Gift of Gérald Cramer in honor of Riva Castleman. *Plate 27*

Joan Miró. Maquette for *Amoureuses*, from *A toute épreuve* [c. 1947–58]. Gouache, colored pencil, pencil, and collage. 12¹³⁄₁₆ x 19¹¹⁄₁₆" (32.5 x 50 cm). Cabinet des Estampes

du Musée d'Art et d'Histoire (Fondation Gérald Cramer), Geneva

Joan Mitchell. *The Poems* by John Ashbery. New York: Tiber Press, 1960. Screenprints. 17½ x 14¹/₁₆" (44.4 x 35.8 cm). The Museum of Modern Art, New York. Gift of Richard Miller. *Plate 165*

László Moholy-Nagy. *Malerei, Photographie, Film* by László Moholy-Nagy. Munich: Albert Langen Verlag, 1925. (Bauhausbücher 8.) Relief halftone reproductions, after photographs by various artists. 9¹/₁₆ x 7¹/₁₆" (23 x 17.9 cm). The Museum of Modern Art Library, New York. *Figure 24; plate 72*

Second copy: Ex Libris, New York

Henry Moore. *Elephant Skull* by Henry Moore. Geneva: Gérald Cramer, 1970. Etchings. 19¼ x 14¾" (50.2 x 37.5 cm), irreg. The Museum of Modern Art, New York. Gift of the artist and the publisher. *Plate 192*

William Morris, see Burne-Jones

Robert Motherwell. *A la pintura/To Painting* by Rafael Alberti. West Islip, N. Y.: Universal Limited Art Editions, 1972. Aquatints and/or lift-ground aquatints and etchings. 25⁹/₁₆ x 37¹⁵/₁₆" (65 x 96.5 cm). The Museum of Modern Art, New York. Gift of Celeste Bartos. *Plate 31*

Bruno Munari. *Libro Illeggibile N.Y. 1*. New York: The Museum of Modern Art, 1967. Screenprint reproductions, after drawings and collages, some folios with die-cut circular holes and red string threaded through them. 8½ x 8½" (21.6 x 21.6 cm). The Museum of Modern Art, New York. *Plate 184*

Paul Nash. *Genesis* from the Bible. Soho [London]: The Nonesuch Press, 1924. Wood engravings. 10⁷/₁₆ x 7½" (26.5 x 19 cm), irreg. The Museum of Modern Art, New York. A. Conger Goodyear Fund. *Plate 36*

Mimmo (Dominico) Paladino. *Piccolo circolo chiuso* by Salvatore Licitra. [Milan]: G. Upiglio and Grafica Uno, 1991. Lift-ground aquatints and etching. 12 x 7¹¹/₁₆" (30.5 x 19.5 cm). The Museum of Modern Art, New York. Gift of Giorgio Upiglio. *Plate 177*

Eduardo Paolozzi. *Metafisikal Translations* by E[duardo] Paolozzi. [London]: Eduardo Paolozzi, 1962. Screenprints. 11¾ x 8³/₁₆" (29.8 x 20.8 cm). The Museum of Modern Art, New York. Given anonymously. *Plate 100*

Jürgen Partenheimer. *Giant Wall* by John Yau. [San Francisco]: Hine Editions, 1991. Etchings and wash-and-pencil drawing. 14¹⁵/₁₆ x 11" (38 x 28 cm). The Museum of Modern Art, New York. Miles O. Epstein, Richard A. Epstein, and Sarah C. Epstein Funds. *Plate 155*

A. R. Penck (Ralf Winkler). *Standarts*. Cologne: Galerie Michael Werner; Munich: Verlag Jahn und Klüser, 1970. Photolithographic reproductions, after drawings. 11⅝ x 7¹¹/₁₆" (29.6 x 19.5 cm). The Museum of Modern Art, New York. Purchase. *Plate 115*

Second copy: The Museum of Modern Art Library, New York

Pablo Picasso. *The Eagle (L'Aigle)*. [1907]. Woodcut. 3¼ x 3¹/₁₆" (8.3 x 7.8 cm). Musée Picasso, Paris. *Figure 18*

Pablo Picasso. *Saint Matorel* by Max Jacob. Paris: Henry Kahnweiler Editeur, 1911. Etchings. 10⁷/₁₆ x 8¹¹/₁₆" (26.5 x 22 cm), irreg. The Museum of Modern Art, New York. Louis E. Stern Collection. *Plate 14*

Second copy: The Museum of Modern Art, New York. Abby Aldrich Rockefeller Fund

Pablo Picasso. *Les Métamorphoses* by Ovid. Lausanne: Albert Skira Editeur, 1931. Etchings. 12¹³/₁₆ x 10¼" (32.5 x 26 cm), irreg. The Museum of Modern Art, New York. Louis E. Stern Collection. *Plate 39*

Pablo Picasso. *Fragment de corps de femme*, drawing for *Les Métamorphoses* by Ovid. 1931. Pencil. 10⅛ x 13" (25.7 x 33 cm). Private collection

Pablo Picasso. *Fragment de corps de femme*, supplementary plate for *Les Métamorphoses* by Ovid. [Lausanne: Albert Skira Editeur, 1931]. Etching with remarques. Sheet, 12¹¹/₁₆ x 9¹³/₁₆" (32.2 x 24.9 cm). The Museum of Modern Art, New York. Gift of Anatole Pohorilenko in memory of Monroe Wheeler

Pablo Picasso. *La Barre d'appui* by Paul Eluard (Eugène Grindel). Paris: Editions Cahiers d'Art, 1936. Etching and lift-

ground aquatints. 8¼ x 6¼" (21 x 15.9 cm). The Toledo Museum of Art. Purchased with funds given by Molly and Walter Bareiss in honor of Barbara K. Sutherland and with funds from the Mrs. George W. Stevens Fund. *Plate 140*

Pablo Picasso. Four subjects for *La Barre d'appui*. [1936]. Etching and lift-ground aquatint. 16½ x 12½" (42 x 31.7 cm). The Museum of Modern Art, New York. Purchase. *Plate 139*

Pablo Picasso. *Sueño y mentira de Franco* by Pablo Picasso. [Paris]: Pablo Picasso, [1937]. Etching and lift-ground aquatints. 22⅛ x 15⅛" (57.5 x 38.5 cm), irreg. The Museum of Modern Art, New York. Louis E. Stern Collection. *Plates 60–61*

Pablo Picasso. Autograph manuscript, dated April 28, 1938. Black crayon on the back of a blue invitation card. 6⅞ x 4¾" (17.5 x 12 cm). Musée Picasso, Paris

Pablo Picasso. Autograph manuscript, dated April 28–May 1, 1938. India ink on Arches paper. 10¹/₁₆ x 6⅞" (25.5 x 17.5 cm). Musée Picasso, Paris. *Plate 92*

Pablo Picasso. *Head of a Woman No. 1: Portrait of Dora Maar (Tête de femme no. 1: Portrait de Dora Maar)*. [January–June, 1939]. Aquatint and drypoint. 11¹¹/₁₆ x 9⁵/₁₆" (29.8 x 23.7 cm). Collection E. W. Kornfeld, Bern. *Plate 91*

Pablo Picasso. *Head of a Woman No. 3: Portrait of Dora Maar (Tête de femme no. 3: Portrait de Dora Maar)*. [January–June, 1939]. Aquatint. 11¾ x 9⁵/₁₆" (29.9 x 23.7 cm). Musée Picasso, Paris

Pablo Picasso. *Head of a Woman No. 4: Portrait of Dora Maar (Tête de femme no. 4: Portrait de Dora Maar)*. [April–May, 1939]. Aquatint. 11⅞ x 9⁵/₁₆" (30.1 x 24 cm). The Museum of Modern Art, New York. Gift of Mrs. Melville Wakeman Hall. *Plate 90*

Pablo Picasso. *Head of a Woman No. 5: Portrait of Dora Maar (Tête de femme no. 5: Portrait de Dora Maar)*. [January–June, 1939]. Aquatint and drypoint. 11¾ x 9⁵/₁₆" (29.9 x 23.7 cm). Musée Picasso, Paris

Pablo Picasso. *Standing Nude I (Nu debout I)*, state I. [April 25, 1939]. Engraving. 11⅛ x 3¾" (29.5 x 9.6 cm). Marina Picasso Col-

lection, Jan Krugier Gallery, New York. *Figure 15*

Pablo Picasso. *Standing Nude I* (*Nu debout I*), state IV. [April 27, 1939]. Engraving and aquatint. 11⅝ x 3¾" (29.5 x 9.6 cm). Marina Picasso Collection, Jan Krugier Gallery, New York. *Plate 93*

Pablo Picasso. *Little Standing Nude* (*Petit nu debout*) and *Standing Nude I* (*Nu debout I*), state III. April 27, 1939. *Little Standing Nude*: engraving, 11⅝ x 2" (29.6 x 5.1 cm); *Standing Nude I*: engraving and aquatint, 11⅛ x 3¾" (29.5 x 9.6 cm), both printed on the same sheet of paper. Marina Picasso Collection, Jan Krugier Gallery, New York. *Plate 94*

Pablo Picasso. *Le Chant des morts* by Pierre Reverdy. Paris: Tériade Editeur, 1948. Lithographs. 16½ x 12⁹⁄₁₆" (42 x 32 cm). The Museum of Modern Art, New York. Louis E. Stern Collection. *Plate 63*

Pablo Picasso. *Pismo/Escrito* by Iliazd (Ilia Zdanevitch). [Paris]: Latitud Cuarenta y Uno [Iliazd], 1948. Engravings and etchings. Variable, 14¼ x 3⅝" (36.2 x 9.2 cm) to 14¼ x 9⅝" (36.2 x 24.5 cm). The Museum of Modern Art, New York. Louis E. Stern Collection. *Plate 180*

Pablo Picasso. *La Rose et le chien* by Tristan Tzara (Samuel Rosenstock). Alès: PAB [Pierre André Benoit], [1958]. Drypoint and engravings on celluloid. 11⅛ x 7⅝" (28.3 x 19.3 cm). The New York Public Library, Astor, Lenox, and Tilden Foundations. Spencer Collection. *Plate 182*

Robert Rauschenberg. *Shades* by Robert Rauschenberg. West Islip, N. Y.: Universal Limited Art Editions, 1964. Lithographs on plexiglass plates, 1 mounted permanently and 5 inserted interchangeably in a slotted aluminum frame. 15⅛ x 14½ x 11¾" (38.4 x 36.8 x 29.9 cm). The Museum of Modern Art, New York. Gift of the Celeste and Armand Bartos Foundation. *Plate 186*

Odilon Redon. *La Tentation de Saint Antoine* by Gustave Flaubert. [Paris]: Editions Ambroise Vollard, [1938]. Lithographs, and wood engravings by Georges Aubert after Redon's drawings. 17½ x 12¹⁵⁄₁₆" (44.5 x 33 cm), irreg. The Museum of Modern Art, New York. Louis E. Stern Collection. *Figure 7; plate 11*

Johannes Regiomontanus. *Calendarium.* Venice: Maler, Ratdolt & Löslein, 1476. Woodcuts. 11⅜ x 8⅛" (28.9 x 20.6 cm). The Pierpont Morgan Library, New York. PML 314, f. 20v. *Figure 1*

Larry Rivers. *Stones* by Frank O'Hara. [West Islip, N. Y.]: Universal Limited Art Editions, [1960]. Lithographs and oil drawing. 18¹¹⁄₁₆ x 23⅝" (47.5 x 60 cm), irreg. The Museum of Modern Art, New York. Gift of Mr. and Mrs. E. Powis Jones. *Plate 30*

Dieter Roth (Diter Rot). *Bok 3c.* Reykjavík: Forlag Ed. [Dieter Roth and Einar Bragi], 1961. Offset lithographs. 7¹⁵⁄₁₆ x 7⅞" (20.2 x 20 cm). The Museum of Modern Art Library, New York. *Plate 111*

Dieter Roth (Diter Rot). *Daily Mirror (Gesammelte Werke Band 10)* by Dieter Roth. Cologne, London, Reykjavík: Edition Hansjörg Mayer, 1970. Offset lithographs, in painted corrugated cardboard cover with square cutouts on front and back containing 2 miniature books. 9⅟₁₆ x 6¹¹⁄₁₆" (23 x 17 cm). The Museum of Modern Art Library, New York. *Plate 195*

Georges Rouault. *Cirque de l'étoile filante* by Georges Rouault. Paris: Ambroise Vollard Editeur, 1938. Aquatint and lift-ground aquatint and etchings, and wood engravings by Georges Aubert after Rouault's drawings. 17⁵⁄₁₆ x 13³⁄₁₆" (44 x 33.5 cm), irreg. The Museum of Modern Art, New York. Louis E. Stern Collection. *Figure 8; plate 10*

Georges Rouault. *Miserere* by Georges Rouault. Paris: Edition de L'Etoile Filante, 1948. (Commissioned by Vollard.) Aquatints and lift-ground aquatints over photogravure. 25¹⁵⁄₁₆ x 19¾" (66 x 50.2 cm), irreg. The Museum of Modern Art, New York. Louis E. Stern Collection. *Figures 20–21; plates 56–57*

Olga Rozanova. *Vojna* by Alexei Kruchenykh. [St. Petersburg: Olga Rozanova and Alexei Kruchenykh, 1916]. Woodcuts, 1 with collage. 15⅛ x 11⅞" (38.5 x 30.2 cm). The Museum of Modern Art, New York. Prints and Illustrated Books Endowment Fund, Abby Aldrich Rockefeller Fund (by exchange), Mary Ellen Meehan Fund, Riva Castleman Fund, Purchase, and Purchase (by exchange). *Plates 54–55*

Olga Rozanova. Cover for *Vojna* by Alexei Kruchenykh. [St. Petersburg: Olga Rozanova and Alexei Kruchenykh, 1916]. Woodcut and collage. 16⅛ x 12¹³⁄₁₆" (42.2 x 32.5 cm). Collection Thomas P. Whitney

Edward Ruscha. *Twentysix Gasoline Stations* by Edward Ruscha. [Hollywood]: National Excelsior Publication, 1962 [1963]. Offset halftone reproductions, after photographs. 7 x 5½" (17.8 x 14 cm). The Museum of Modern Art, New York. *Plate 117*

Second copy (third edition, 1969): The Museum of Modern Art, New York

Robert Ryman. *Nohow On* by Samuel Beckett. [New York]: The Limited Editions Club, 1989. Aquatints (including one with pen-and-ink inscription). 10⅝ x 7⁷⁄₁₆" (27 x 18 cm). The Museum of Modern Art, New York. Gift of The Limited Editions Club. *Plate 157*

Kurt Schwitters. *Die Kathedrale* by Kurt Schwitters. Hannover: Paul Steegemann, [1920]. (*Die Silbergäule*, vol. 41/42.) Transfer lithographs, 1 with collage. 8¹³⁄₁₆ x 5⅝" (22.4 x 14.3 cm). The Museum of Modern Art, New York. Gift of Edgar Kaufmann, Jr. *Plates 104–105*

André Dunoyer de Segonzac. *Les Croix de bois* by Roland Dorgelès (Roland Lécavelé). Paris: Editions de la Banderole, [1921]. Drypoints and line-block reproductions, after drawings. 9¾ x 7¼" (24.7 x 18.4 cm). Gift of Philip Hofer, Department of Printing & Graphic Arts, Houghton Library, Harvard University. *Plate 58*

André Dunoyer de Segonzac. *Les Géorgiques* by Virgil. [Paris: André Dunoyer de Segonzac, 1947] (title page imprinted 1944). (Commissioned by Vollard.) Etchings, some with drypoint, and drypoint. 17¹⁵⁄₁₆ x 13⅜" (45.5 x 34 cm). The Museum of Modern Art, New York. Louis E. Stern Collection. *Plates 43–44*

Kurt Seligmann. *The Myth of Oedipus*, retold by Meyer Schapiro. New York: Durlacher Bros.–R. Kirk Askew, Jr., 1944. Etchings and line-block reproduction. 22¹³⁄₁₆ x 15⁹⁄₁₆" (58 x 39.5 cm), irreg. The Museum of Modern Art, New York. Gift of Henry Church. *Plate 45*

Ben Shahn. *The Alphabet of Creation* by Moses de Léon (Moses ben Shem Tov de Léon). New York: Pantheon, 1954. Line-block reproductions after brush- or pen-and-ink drawings, and supplementary brush- and pen-and-ink drawing. 10¹³⁄₁₆ x 6¹¹⁄₁₆" (27.5 x 17 cm). The Museum of Modern Art, New York. Louis E. Stern Collection. *Plate 37*

Judith Shea. *Haibun* by John Ashbery. Colombes, France: Collectif Génération, [1990]. Soft-ground etchings, some with pochoir. 13¹⁄₁₆ x 9¹⁵⁄₁₆" (33.2 x 25.2 cm), irreg. The Museum of Modern Art, New York. John B. Turner Fund. *Plate 172*

Nicolas de Staël. *Poèmes* by René Char. Paris: [Nicolas de Staël], 1952. Wood engravings and lithograph. 14½ x 11⅛" (36.9 x 28.3 cm). The Museum of Modern Art, New York. Louis E. Stern Collection. *Plate 148*

Yves Tanguy. *Dormir dormir dans les pierres* by Benjamin Péret. Paris: Editions Surréalistes, 1927. Line-block reproductions, after pen-and-ink drawings, some with gouache additions. 8¾ x 6¹³⁄₁₆" (22.3 x 17.3 cm). The Museum of Modern Art, New York. Louis E. Stern Collection. *Plate 132*

Antoni Tàpies. *El pà a la barca* by Joan Brossa. Barcelona: Sala Gaspar, 1963. Lithographs, some with collage, and collages. 15¼ x 10¹⁵⁄₁₆" (38.7 x 27.8 cm), irreg. The Museum of Modern Art, New York. Monroe Wheeler Fund. *Plate 181*

Antoni Tàpies. *Anular* by José-Miguel Ullán. Paris: R.L.D. [Robert and Lydia Dutrou], [1981]. Lift-ground aquatints, 1 soft-ground etching, aquatint, and carborundum with paint additions; some folios die-cut and/or torn or burnt. 12⅞ x 9⁷⁄₁₆" (32.7 x 24 cm), irreg. The Museum of Modern Art, New York. Abby Aldrich Rockefeller Fund (by exchange). *Plate 152*

Henri de Toulouse-Lautrec. *Yvette Guilbert* by Gustave Geffroy. Paris: L'Estampe Originale [André Marty], 1894. Lithographs. 14¾ x 15⅛" (37.5 x 38.5 cm), irreg. The Museum of Modern Art, New York. Louis E. Stern Collection. *Plates 5, 7*

Henri de Toulouse-Lautrec. *Yvette Guilbert* by Gustave Geffroy. Proofs without text [1894]. Lithographs. 15¹⁄₁₆ x 15⅛" (38.3 x 38.5 cm), irreg. The Museum of Modern

Art, New York. Vincent D'Aquila and Harry Soviak Bequest. *Plate 6*

Henri de Toulouse-Lautrec. *Histoires naturelles* by Jules Renard. Paris: H. Floury Editeur, 1899. Transfer lithographs. 12½ x 8⅞" (31.7 x 22.5 cm). The Museum of Modern Art, New York. Louis E. Stern Collection. *Plate 49*

Günther Uecker. *Vom Licht* by various authors. Heidelberg: Galerie Rothe, 1973. Embossings. 20¹⁄₁₆ x 20¹⁄₁₆" (51 x 51 cm). The Museum of Modern Art, New York. Mrs. Stanley Resor Fund (by exchange). *Plate 149*

Henry van de Velde. *Also sprach Zarathustra, ein Buch für Alle und Keinen* by Friedrich Nietzsche. Leipzig: Insel Verlag, 1908. Line-block reproductions, after designs by van de Velde. 14⅝ x 10⅛" (37 x 25.4 cm). The New York Public Library, Astor, Lenox, and Tilden Foundations. Spencer Collection. *Plate 34*

Second copy: Purchased with income from the fund established in memory of Caroline Miller Parker by Augustin H. Parker, Department of Printing & Graphic Arts, Houghton Library, Harvard University

Jacques Villon. *Poèmes de Brandebourg* by André Frénaud. [Paris]: NRF [Nouvelle Revue Française], 1947. Soft-ground etchings. 11 x 8¹¹⁄₁₆" (28 x 22 cm), irreg. The Museum of Modern Art, New York. Louis E. Stern Collection. *Plate 62*

Not Vital. *Poesias rumantsches cun disegns da Not Vital* by Pier Paolo Pasolini, Luisa Famos, and Andri Peer. Poestenkill, N.Y.: Edition Gunnar A. Kaldewey, 1987. Wash-and-graphite drawings with collage, abrasions, and/or torn, and 1 object pasted in. 19¼ x 12⅜" (48.9 x 31.4 cm), irreg. The Resource Collections of the Getty Center for the History of Art and the Humanities. *Plate 153*

Andy Warhol. *Flash—November 22, 1963* by Phillip Greer. Briarcliff Manor, N.Y.: Racolin Press, [1968]. Screenprints. 21½ x 21¼" (54.6 x 54 cm). The Museum of Modern Art, New York. Gift of Philip Johnson. *Plate 194*

Wols (Otto Alfred Wolfgang Schulze). *Visages, précédé de portraits officiels* by

Jean-Paul Sartre. Paris: [Pierre] Seghers, 1948. Drypoints. 7½ x 4¹³⁄₁₆" (19 x 12.2 cm). The Museum of Modern Art, New York. Henry Church Fund. *Plate 144*

VARIOUS ARTISTS

John Buckland-Wright, Stanley William Hayter, Josef Hecht, Dalla Husband, Vasily Kandinsky, Roderick Mead, Joan Miró, Dolf Rieser, Luis Vargas. *Fraternity* by Stephen Spender. [Paris: Stanley William Hayter], 1939. Engravings, drypoint, and etching. 8⅞ x 6⅜" (22.5 x 16.2 cm), irreg. The Museum of Modern Art, New York. Abby Aldrich Rockefeller Fund. *Plate 59*

Jean (Hans) Arp, Hans Bellmer, Victor Brauner, Serge Brignoni, Alexander Calder, Bruno Capacci, Elisabeth van Damme, Julio de Diego, Enrico Donati, Marcel Duchamp, Max Ernst, David Hare, Jacques Hérold, Marcel Jean, Wifredo Lam, Jacqueline Lamba, Man Ray, Maria, Matta, Joan Miró, Kay Sage, Yves Tanguy, Dorothea Tanning, Toyen. *Le Surréalisme en 1947, exposition internationale du surréalisme* by various authors; edited by André Breton. [Paris]: Pierre à Feu [Maeght Editeur], 1947. Lithographs, etchings, woodcuts, photogravure, Readymade object, and reproductions. 9⁷⁄₁₆ x 7⁵⁄₁₆" (24 x 20.3 cm). The Museum of Modern Art, New York. Henry Church Fund. *Plate 193*

Jean (Hans) Arp, Georges Braque, Camille Bryen, Marc Chagall, Oscar Dominguez, Serge Férat, Alberto Giacometti, Albert Gleizes, Raoul Hausmann, Henri Laurens, Fernand Léger, Alberto Magnelli, André Masson, Henri Matisse, Jean Metzinger, Joan Miró, Pablo Picasso, Léopold Survage, Sophie Taeuber-Arp, Edgard Tytgat, Jacques Villon, Wols. *Poésie de mots inconnus* by various authors. Paris: Le Degré 41 [Iliazd], 1949. Woodcuts, lithographs, etchings, drypoints, engravings, aquatints, and linoleum cut. 12¹³⁄₁₆ x 9¹³⁄₁₆" (32.5 x 25 cm), irreg. The Museum of Modern Art, New York. Louis E. Stern Collection. *Figure 11; plates 24–25*

Second copy: 6⁵⁄₁₆ x 5⅛" (16 x 13.2 cm) (folded). The Toledo Museum of Art. Gift of Molly and Walter Bareiss

Fernand Léger. Maquette for page from *Poésie de mots inconnus*. April 4, 1949. Watercolor, India ink, and pencil, with text, "Berceuses pour Chalva," by Iliazd (Ilia Zdanevitch), written in pencil by Iliazd. 12⅛ x 9¾" (32 x 24.8 cm). Bibliothèque Nationale de France, Département des Livres Imprimés

Joan Miró. Maquette for page from *Poésie de mots inconnus*. October 19–28, 1948. Watercolor, with text, "Toto-vaca," by Tristan Tzara (Samuel Rosenstock), written in pencil by Iliazd (Ilia Zdanevitch). 12¹¹⁄₁₆ x 9¾" (32.3 x 24.8 cm). Bibliothèque Nationale, Paris, Département des Livres Imprimés

Pierre Alechinsky, Fred Becker, Ben Zion, Letterio Calapai, Peter Grippe, Salvatore Grippe, Stanley William Hayter, Franz Kline, Willem de Kooning, Jacques Lipchitz, Ezio Martinelli, Ben Nicholson, Irene Rice Pereira, Helen Phillips, André Racz, Kurt Roesch, Attilo Salemme, Louis Schanker, Karl Schrag, Esteban Vicente, Adja Yunkers. *21 Etchings and Poems* by various authors. New York: Morris Gallery [Morris Weisenthal], 1960. Etchings, engravings, lift-ground aquatints, drypoints, and photogravure (all with etched manuscripts by author or artist). 19⅞ x 16⅞" (50.5 x 42.8 cm). The Museum of Modern Art, New York. Gift of Mrs. Jacquelynn Shlaes. *Plates 163–164*

Pierre Alechinsky, Karel Appel, Enrico Baj, Alan Davie, Jim Dine, Oyvind Fahlström, Sam Francis, Robert Indiana, Alfred Jensen, Asger Jorn, Allan Kaprow, Kiki Kogelnik, Alfred Leslie, Roy Lichtenstein, Joan Mitchell, Claes Oldenburg, Mel Ramos, Robert Rauschenberg, Reinhoud, Jean-Paul Riopelle, James Rosenquist, Antonio Saura, Kimber Smith, K. R. H. Sonderborg, Walasse Ting, Bram van Velde, Andy Warhol, Tom Wesselmann. *1¢ Life* by Walasse Ting. Bern: E. W. Kornfeld, 1964. Lithographs and reproductions. 16¹⁄₁₆ x 11⁵⁄₁₆" (40.8 x 28.8 cm), irreg. The Museum of Modern Art, New York. Gift of the author, Walasse Ting, the editor, Sam Francis, and the publisher, E. W. Kornfeld. *Plates 167–168*

Walasse Ting. Letter to E. W. Kornfeld, regarding *1¢ Life*. April 19, 1963. Autograph manuscript. Sheet, 11 x 8½" (28 x 21.7 cm). Collection E. W. Kornfeld, Bern

Alfred Jensen. Letter to Walasse Ting, regarding *1¢ Life*. May 14, 1963. Autograph manuscript with watercolor additions. Sheet, 11 x 8½" (28 x 21.7 cm). Collection E. W. Kornfeld, Bern

Alan Davie. Letter to Walasse Ting, regarding *1¢ Life*. July 25, 1963. Autograph manuscript. Sheet, 8 x 6⅞" (20.2 x 17.5 cm). Collection E. W. Kornfeld, Bern

Carl Andre, Robert Barry, Douglas Huebler, Joseph Kosuth, Sol LeWitt, Robert Morris, Lawrence Weiner. *Untitled* (*Xerox Book*). New York: Siegelaub/Wendler, 1968. Photocopies. 10¹⁵⁄₁₆ x 8⁵⁄₁₆" (27.9 x 21.2 cm). The Museum of Modern Art, New York. Gift of Mrs. Ruth Vollmer. *Plates 112–113*

Second copy: The Museum of Modern Art Library, New York

Stephen Bastian, John Cage, Merce Cunningham, Jasper Johns, Sol LeWitt, Robert Rauschenberg, Robert Ryman, Michael Silver. *The First Meeting of the Satie Society* by John Cage. New York: Osiris, 1992 [1993]. Etchings, pastel, pencil, and pen-and-ink drawings, photogravures, platinum photograph over pasted watercolor, and burned monotypes, in nickel-silver and laminated glass case (valise). Various dimensions; John Cage, *Valise*, 26¼ x 21½ x 5" (66.7 x 54.6 x 12.7 cm). Osiris, New York. *Plates 187–188*

BIBLIOGRAPHY

Compiled by Daniel Starr

The following listing has been grouped into four categories: General References, Publishers, Artists and Authors, and Reproductions. The first group gives a selection of books and articles on the modern art of the book. The second lists readings by or about the principal publishers included in this survey; the third focuses on artists and authors, listing catalogues raisonnés and other relevant sources under their individual names. The fourth category, Reproductions, gives reissued versions of a number of this survey's publications.

GENERAL REFERENCES

Adler, Jeremy, and Ulrich Ernst. *Text als Figur: Visuelle Poesie von der Antike bis zur Moderne.* 2d ed. Weinheim: VCH, 1987.

Andel, Jaroslav. *The Avant-Garde Book, 1900–1945.* New York: Franklin Furnace, 1989.

Armstrong, Elizabeth, and Joan Rothfuss. *In the Spirit of Fluxus.* Minneapolis: Walker Art Center, 1993.

Barthel, Gustav, ed. *Französische Maler illustrieren Bücher: Die illustrierten Bücher des 19. und 20. Jahrhunderts in der Graphischen Sammlung der Staatsgalerie Stuttgart.* Stuttgart: Höhere Fachschule für das Graphische Gewerbe, 1965.

Benedikt, Michael, comp. *The Poetry of Surrealism: An Anthology.* Boston: Little, Brown, 1974.

Bentivoglio, Mirella. *Il librismo, 1896–1990: Dalla cornice alla copertina dal piedestallo allo scaffale.* Sardinia: Arte Duchamp, 1990.

————. "The Reinvention of the Book in Italy." *The Print Collector's Newsletter* 24, no. 3 (July–August 1993): 93–96.

Bertrand, Gérard. *L'Illustration de la poésie a l'époque du cubisme, 1909–1914: Derain, Dufy, Picasso.* Paris: Editions Klincksieck, 1971.

Bloch, Susi R. Introduction to *The Book Stripped Bare: A Survey of Books by 20th Century Artists and Writers.* Hempstead, N.Y.: Emily Lowe Gallery, Hofstra University, 1973.

Bussche, Willy van den, and Freddy de Vree. *Cobra Post Cobra.* Ostende: Provinciaal Museum voor Moderne Kunst, 1991.

Cain, Julien. *French Art of the Book.* San Francisco: California Palace of the Legion of Honor, 1949.

Castleman, Riva. *Modern Artists as Illustrators/Artistas Modernos como Ilustradores.* New York: The Museum of Modern Art, 1981.

Chapon, François. *Le Peintre et le livre: L'Age d'or du livre illustré en France, 1870–1970.* Paris: Flammarion, 1987.

Compton, Susan P. *Russian Avant-Garde Books, 1917–34.* London: The British Library, 1992.

————. *The World Backwards: Russian Futurist Books, 1912–16.* London: British Museum Publications, 1978.

Coron, Antoine. *Le Livre et l'artiste: Tendance du livre illustré français, 1967–1976.* Paris: Bibliothèque Nationale, 1977.

————, ed. *50 livres illustrés depuis 1947.* Paris: Bibliothèque Nationale and Centre National des Lettres, 1988.

Davis, Bruce. *German Expressionist Prints and Drawings: The Robert Gore Rifkind Center for German Expressionist Studies.* Vol. 2, *Catalogue of the Collection.* Los Angeles: The Los Angeles County Museum of Art; Munich: Prestel-Verlag, 1989.

Dixon, Christine, and Cathy Leahy. *Manet to Matisse: French Illustrated Books.* Canberra: Australian National Gallery, 1991.

Eaton, Timothy A., ed. *Books as Art.* 2d ed., rev. Boca Raton: Boca Raton Museum, 1991.

Farmer, Jane M. "Prints and the Art of the Book in America." In *American Prints and Printmaking, 1956–1981,* 69–81. (*Print Review* 13. New York: Pratt Graphics Center, 1981.)

Field, Richard S. *The Fable of the Sick Lion: A Fifteenth-Century Blockbook.* Middletown, Conn.: Davison Art Center, Wesleyan University, 1974.

Focus on Minotaure: The Animal-Headed Review. Geneva: Musée d'Art et d'Histoire, 1987.

Garvey, Eleanor M. "Cubist and Fauve Illustrated Books." *Gazette des beaux-arts* 63 (January 1964): 37–50.

Garvey, Eleanor M., and Philip Hofer. *The Artist & the Book, 1860–1960, in Western Europe and the United States.* Boston: Museum of Fine Arts; Cambridge, Mass.: Harvard College Library, Department of Printing & Graphic Arts, 1961.

Garvey, Eleanor M., Anne B. Smith, and Peter A. Wick. *The Turn of a Century, 1885–1910: Art-Nouveau—Jugendstil Books.* Cambridge, Mass.: Department of Printing & Graphic Arts, Harvard University, 1970.

Garvey, Eleanor M., and Peter A. Wick. *The Arts of the French Book, 1900–1965: Illustrated Books of the School of Paris.* Dallas: Southern Methodist University Press, 1967.

Glaister, Geoffrey Ashall. *Glaister's Glossary of the Book: Terms Used in Papermaking, Printing, Bookbinding and Publishing. . . .* 2d ed. Berkeley and Los Angeles: University of California Press, 1979.

Graf, Dieter, and Friedrich W. Heckmanns. *Buch & Bild: Buchgrafik des XX. Jahrhunderts.* Düsseldorf: Kunstmuseum, 1970.

Guest, Tim, and Germano Celant. *Books by Artists.* Toronto: Art Metropole, 1981.

Harthan, John. *The History of the Illustrated Book: The Western Tradition.* London: Thames and Hudson, 1981.

Hendricks, Jon, comp. *Fluxus Codex.* Detroit: The Gilbert and Lila Silverman Fluxus Collection; New York: Harry N. Abrams, 1988.

Hernad, Béatrice, and Karin von Maur. *Papiergesänge: Buchkunst im zwanzigsten Jahrhundert: Künstlerbücher, Malerbücher und Pressendrucke aus den Sammlungen der Bayerischen Staatsbibliothek, München.* Munich: Prestel-Verlag, 1992.

Hirschberger, Elisabeth. *Dichtung und Malerei im Dialog: Von Baudelaire bis Eluard, von Delacroix bis Max Ernst.* Tübingen: G. Narr, 1993.

Hogben, Carol, and Rowan Watson, eds. *From Manet to Hockney: Modern Artists' Illustrated Books*. London: The Victoria and Albert Museum, 1985.

Hubert, Renée Riese. *Surrealism and the Book*. Berkeley and Los Angeles: University of California Press, 1988.

———. "The Artist's Book: The Text and Its Rivals." *Visible Language* 25, no. 2/3 (Spring 1991): 117–333.

Hultén, Pontus, ed. *Futurism & Futurisms*. New York: Abbeville Press, 1986. (Translation of *Futurismo & futurismi*. Milan: Bompiani, 1986.)

James, Philip. *An Exhibition of French Book Illustration, 1895–1945*. London: Council for the Encouragement of Music and the Arts, [1945].

Janecek, Gerald. *The Look of Russian Literature: Avant-Garde Visual Experiments, 1900–1930*. Princeton: Princeton University Press, 1984.

Jentsch, Ralph. *The Artist and the Book in Twentieth-Century Italy*. Turin: Umberto Allemandi, 1992.

———. *Illustrierte Bücher des Deutschen Expressionismus*. Stuttgart: Edition Cantz, 1989.

Lake, Carlton. *Baudelaire to Beckett: A Century of French Art & Literature: A Catalogue of Books, Manuscripts, and Related Material from the Collections of the Humanities Research Center*. Austin: Humanities Research Center, University of Texas, 1976.

Lambert, Jean-Clarence. *Cobra*. New York: Abbeville Press, 1984.

Lang, Lothar. *Expressionist Book Illustration in Germany, 1907–1927*. Boston: New York Graphic Society, 1976. (Translation of *Expressionistische Buchillustration in Deutschland, 1907–1927*. Lucerne: Verlag C. J. Bucher, 1975.)

———. *Konstruktivismus und Buchkunst*. Leipzig: Edition Leipzig, 1990.

———. *Surrealismus und Buchkunst*. Leipzig: Edition Leipzig, 1992.

Leperlier, François. *Paris in the 1930's: Surrealism and the Book*. Paris and New York: Zabriskie, 1991.

Lista, Giovanni. *Le Livre futuriste de la libération du mot au poème tactile*. Modena: Editions Panini, 1984.

Long, Paulette, ed. *Paper: Art & Technology*. San Francisco: World Print Council, 1979. (Proceedings of the International Paper Conference, March 1978, San Francisco.)

Marziano, Luciano, and Luciano Caruso. *Far libro: Libri e pagine d'artista in Italia*. Florence: Centro Di, 1989.

Mason, Rainer Michael. *Moderne–postmoderne: Deux cas d'école: L'avant-garde russe et hongroise, 1916–1925: Giorgio de Chirico, 1924–1934*. Geneva: Cabinet des Estampes and Editions du Tricorne, 1988.

Mayor, A. Hyatt. *Prints & People: A Social History of Printed Pictures*. New York: The Metropolitan Museum of Art, 1971.

Melot, Michel. *The Art of Illustration*. New York: Skira/Rizzoli, 1984.

Mercier, Vivian. *The New Novel from Queneau to Pinget*. New York: Farrar, Straus and Giroux, 1971.

Moeglin-Delcroix, Anne. "Livre d'artistes." *Nouvelles d'estampes*, no. 122 (April–June 1992): 75–84.

———. *Livres d'artistes*. Paris: Bibliothèque Publique d'Information, Centre Georges Pompidou, 1985.

Mourlot, Fernand. *Gravés dans ma mémoire: Cinquante ans de lithographie avec Picasso, Matisse, Chagall, Braque, Miró*. Paris: Editions Robert Lafont, 1979.

Nannucci, Maurizio, and Pier Luigi Tazzi, eds. *Art in Bookform*. Florence: Zona Archives, 1987.

Peppin, Brigid, and Lucy Micklethwait. *Book Illustrators of the Twentieth Century*. New York: Arco Publishing, 1984.

Phillips, Elizabeth, and Tony Zwicker. *The American Livre de Peintre*. New York: The Grolier Club, 1993.

Phillpot, Clive. "Twentysix Gasoline Stations That Shook the World: The Rise and Fall of Cheap Booklets as Art." *Art Libraries Journal* 18, no. 1 (1993): 4–13.

Popitz, Klaus, ed. *Von Odysseus bis Felix Krull: Gestalten der Weltliteratur in der Buchillustration des 19. und 20. Jahrhunderts*. Berlin: D. Reimer, 1982.

Raabe, Paul. *Die Autoren und Bücher des literarischen Expressionismus: Ein bibliographisches Handbuch*. 2d ed. Stuttgart: J. B. Metzlersche Verlagsbuchhandlung, 1992.

Ray, Gordon N. *The Art of the French Illustrated Book, 1700 to 1914*. New York: The Pierpont Morgan Library, 1982.

Richman, Gary. *Offset: A Survey of Artist's Books*. Cambridge, Mass.: New England Foundation for the Arts, 1984.

Skira, Albert. *Anthologie du livre illustré par les peintres et sculpteurs de l'école de Paris*. Introduction by Claude Roger-Marx. Geneva: Editions Albert Skira, 1946.

Solf, Sabine, and Harriett Watts. *Ut Pictura Poesis: Weltliteratur im Malerbüchern der Herzog August Bibliothek*. Wolfenbüttel: Herzog August Bibliothek, 1991.

Stein, Donna. *Contemporary Illustrated Books: Word and Image, 1967–1988*. New York: Independent Curators Incorporated, 1989.

———, ed. *Cubist Prints, Cubist Books*. New York: Franklin Furnace, 1983.

Strachan, W. J. *The Artist and the Book in France: The 20th Century Livre d'Artiste*. New York: George Wittenborn, 1969.

Symmes, Marilyn. *The Bareiss Collection of Modern Illustrated Books from Toulouse-Lautrec to Kiefer*. Toledo: The Toledo Museum of Art, 1985.

Tiessen, Wolfgang, ed. *Die Buchillustration in Deutschland, Osterreich und Schweiz seit 1945: Ein Handbuch*. 6 vols. Neu-Isenburg: Verlag der Buchhandlung Wolfgang Tiessen, 1968–89.

Tselos, Dimitri. *Modern Illustrated Books from the Collection of Louis E. Stern*. Catalogue by Samuel Sachs, II. Minneapolis: The Minneapolis Institute of Arts, 1959.

Watts, Harriett. *Das Buch des Künstlers: Die schönsten Malerbücher aus der Sammlung der Herzog August Bibliothek, Wolfenbüttel*. Edited by Carl Haenlein. Hannover: Kestner-Gesellschaft, 1989.

Wheeler, Monroe. *Modern Painters and Sculptors as Illustrators*. New York: The Museum of Modern Art, 1936. (2d ed.: 1938; 3d ed.: 1946.)

Wilson, Martha. "La pagina como espacio artistico: Desde 1909 hasta la presente." In *Libros de artistas*. Madrid: Dirección General de Bellas Artes, Archivos y Bibliotecas, 1982.

PUBLISHERS

Alecto

Spencer, Charles, ed. *A Decade of Printmaking*. London: Academy Editions; New York: St. Martin's Press, 1973.

Arion Press

Hoyem, Andrew. "Collaboration in the Book Arts." *Visible Language* 25, no. 2/3 (Spring 1991): 197–215.

Benoit

Coron, Antoine. *La Fruit donné: Ephémérides de Pierre André Benoit*. Paris: Bibliothèque Nationale, 1989.

———, ed. *Miró au Musée P.A.B., 1953–1985*. Alès: Musée Bibliothèque Pierre André Benoit, 1990.

———, ed. *Picasso & P.A. Benoit, 1956–1967: Livres en jeu*. Introduction by Brigitte Baer. Alès: Musée Bibliothèque Pierre André Benoit, 1991.

Black Sun Press

Wolff, Geoffrey. *Black Sun: The Brief Transit and Violent Eclipse of Harry Crosby*. New York: Random House, 1976.

Cahiers d'Art

Hommage à Christian et Yvonne Zervos. Paris: Centre National d'Art Contemporain, 1970.

Cassirer

Brühl, Georg. *Die Cassirers: Streiter für den Impressionismus*. Leipzig: Edition Leipzig, 1991.

Collectif Génération

Livres d'artistes de "Collectif Génération." Paris: Association Française d'Action Artistique and Editions Générations, 1991.

Yau, John, and Jacques Lepage. *Collectif Génération: Livres d'artistes*. London: The Victoria and Albert Museum, [1990].

Cramer

Ehrenström, Annick. *Un Editeur genevois, Gérald Cramer: Au fil de ses archives de 1942 à 1986*. Geneva: Bibliothèque Publique et Universitaire de Genève, 1988.

Cranach Presse

Müller-Krumbach, Renate. *Harry Graf Kessler und die Cranach Presse in Weimar*. Hamburg: Maximilian-Gesellschaft, 1969.

Erker-Presse

Kaeser, Hans-Peter. *Partnerschaft, Literatur, Kunst: Bibliophile Bücher der Erker-Presse*. St. Gallen: Kunstverein St. Gallen, 1979.

Fabiani

Fabiani, Martin. *Quand j'étais marchand de tableaux*. Paris: Julliard, 1976.

Gallimard

Assouline, Pierre. *Gaston Gallimard: A Half-Century of French Publishing*. San Diego: Harcourt, Brace, Jovanovich, 1988.

Gehenna Press

Baskin, Lisa Unger. *The Gehenna Press: The Work of Fifty Years, 1942–1992*. Dallas: Bridewell Library; [Leeds, Mass.]: The Gehenna Press, 1992.

GLM

Coron, Antoine, ed. *Les Editions GLM, 1923–1974: Bibliographie*. Paris: Bibliothèque Nationale, 1981.

Gunther, Horst, and Antoine Coron. *Guy Lévis Mano: Verleger, Typograph, Dichter*. Wolfenbüttel: Herzog August Bibliothek, 1989.

Grafica Uno

Upiglio, Giorgio. *Libricartelle 1962/1989*. Milan: Limited Editions Grafica Uno, [1988].

Iliazd

Abrami, Artemisia Calcagni, and Lucia Chimirri, eds. *I Libri di Iliazd*. Florence: Centro Di, 1991.

Isselbacher, Audrey. *Iliazd and the Illustrated Book*. New York: The Museum of Modern Art, 1987.

Le-Gris Bergmann, Françoise. *Iliazd: Maître d'oeuvre du livre moderne*. Montreal: Galerie d'Art de l'Université du Québec à Montréal, 1984.

Leymarie, Jean. *Le Rencontre Iliazd-Picasso: Hommage à Iliazd*. Catalogue by François Chapon. Paris: Musée d'Art Moderne de la Ville de Paris, 1976.

Lionel-Marie, Annick, and Germain Viatte, eds. *Iliazd*. Paris: Centre Georges Pompidou, Musée National d'Art Moderne, 1978.

Kahnweiler

Chapon, François. "Livres de Kahnweiler." In *Daniel-Henry Kahnweiler: Marchand, éditeur, écrivain*. Edited by Isabelle Monod-Fontaine and Claude Laugier, 45–76. Paris: Centre Georges Pompidou, 1984.

Hugues, Jean, ed. *50 ans d'édition de D.-H. Kahnweiler*. Paris: Galerie Louise Leiris, 1959.

Kahnweiler, Daniel-Henry. *My Galleries and Painters*. New York: Vintage Press, 1971. (Translation of *Mes Galeries et mes peintres: Entretiens avec Francis Crémieux*. Paris: Gallimard, 1961.)

Kahnweiler, Daniel-Henry, and Wilhelm Weber. *Hommage à Kahnweiler*. Kaiserslautern: Pfalzgalerie, 1970.

Kaldewey Press

The First Five Years: An Exhibition of the Kaldewey Press at Harvard University. Poestenkill, N.Y.: Kaldewey Press, 1990.

Livres de peintre: Artist Books: Kaldewey Press, New York, à la Galerie Yvon Lambert, Paris. Poestenkill, N.Y.: Kaldewey Press, 1993.

Kelmscott Press

Peterson, William S. *A Bibliography of the Kelmscott Press*. Oxford: Clarendon Press, 1985.

———. *The Kelmscott Press: A History of William Morris's Typographical Adventure*. Berkeley: University of California Press, 1991.

Limited Editions Club

Newman, Ralph Geoffrey, and Glen Norman Wiche. *Great and Good Books: A Bibliographical Catalogue of the Limited Editions Club, 1929–1985*. Chicago: Ralph Geoffrey Newman, 1989.

Maeght

A proximité des poètes et des peintres: Quarante ans d'Edition Maeght. Tours: Centre de Création Contemporaine, 1986.

Prat, Jean-Louis. *Peintres-illustrateurs du XXe siècle: Aimé Maeght bibliophile: 200 éditions originales*. Saint-Paul, France: Fondation Maeght, 1986.

Mathews

Nelson, James G. *Elkin Mathews: Publisher to Yeats, Joyce, Pound*. Madison: University of Wisconsin Press, 1989.

Nonesuch Press

Bradfield, Judith. *An Introduction to the Nonesuch Press: Illustrated from Material in the National Art Library*. London: The Victoria and Albert Museum, 1986.

Dreyfus, John. *A History of the Nonesuch Press*. Introduction by Geoffrey Keynes; descriptive catalogue by David McKitterick, Simon Rendall, and John Dreyfus. London: Nonesuch Press, 1981.

Petersburg Press

Petersburg Press, London: 1968–1976. Paris: Galerie de France, 1978.

Edition Rothe

Rothe, Wolfgang, ed. and comp. *Rothe: Gesamtverzeichnis der Originaldruckgraphik, 1958–1989*. Frankfurt am Main: Graphisches Kabinett im Westend, 1989.

Seghers

Seghers, Colette. *Pierre Seghers: Un Homme couvert de noms*. Paris: R. Laffont, 1981.

Skira

Skira, Albert. *Vingt ans d'activité*. Geneva and Paris: Editions Albert Skira, 1948.

Steegemann Verlag

Meyer, Jochen. *Der Paul Steegemann Verlag: 1919–1935 und 1949–1960: Geschichte, Programm, Bibliographie*. Stuttgart: Fritz Eggert, 1975.

Der Sturm

Brühl, Georg. *Herwarth Walden und "Der Sturm."* Leipzig: Edition Leipzig, 1983.

Tériade

Anthonioz, Michel, ed. *Hommage à Tériade*. Paris: Centre National d'Art Contemporain, 1973.

Bolliger, Hans. *Tériade éditeur: Revue Verve*. Bern: Klipstein & Kornfeld, 1960.

Universal Limited Art Editions

Sparks, Esther. *Universal Limited Art Editions: A History and Catalogue: The First Twenty-Five Years*. Chicago: The Art Institute of Chicago; New York: Harry N. Abrams, 1989.

Vollard

Drake, Christopher. *Ambroise Vollard, Editeur: Les peintres-graveurs, 1895–1913*. London: Agnew's, 1991.

Johnson, Una E. *Ambroise Vollard, Editeur: Prints, Books, Bronzes*. New York: The Museum of Modern Art, 1977.

Sorlier, Charles. *Marc Chagall et Ambroise Vollard*. Paris: Editions Galerie Matignon, 1981.

Vollard, Ambroise. *Recollections of a Picture Dealer*. Boston: Little, Brown, 1936.

Wheeler

"Profile: Monroe Wheeler." *Apollo* 79, no. 28 (June 1964): 503–05.

Kurt Wolff and Pantheon

Ermarth, Michael, ed. *Kurt Wolff: A Portrait in Essays and Letters*. Chicago and London: The University of Chicago Press, 1991.

ARTISTS AND AUTHORS

Albers

Miller, Jo. *Josef Albers: Prints, 1915–1970*. New York: The Brooklyn Museum, 1973.

D'Albisola

Presotto, Danilo, ed. *Quaderni di Tullio D'Albisola*. 3 vols. Savona: Liguria, 1981–87.

Alechinsky

Butor, Michel, and Michel Sicard. *Alechinsky: Travaux d'impression*. Paris: Galilée, 1992.

Rivière, Yves. *Pierre Alechinsky: Les Estampes de 1946 à 1972*. [Paris]: Yves Rivière Editeur, 1973.

Apollinaire

Adhémar, Jean, Lise Dubief, and Gérard Willemetz. *Apollinaire, Paris, 1969*. Paris: Bibliothèque Nationale, 1969.

Greet, Anne Hyde. *Apollinaire et le livre de peintre*. Paris: Lettres Modernes Minard, 1977.

Hubert, Renée Riese. "Apollinaire and Dine: A Re-Enactment of the Poet's Assassination." *Symposium* 34, no. 4 (Winter 1980/81): 333–51.

Arp

[Arntz, Wilhelm F.]. "Hans Arp, Graphik: Verzeichnis der graphischen Arbeiten von Hans Arp, 1912–1966." *Arntz-Bulletin* 1, no. 3–10 (1968): 98–283, 307–36.

Bolliger, Hans. *Hans Arp: Graphik, 1912–1959*. Bern: Klipstein & Kornfeld, 1959.

Mann, Philip. "Symmetry, Chance, Biomorphism: A Comparison of the Visual Art and Poetry of Hans Arp's Dada Period (1916–1924)." *Word & Image* 6, no. 1 (January–March 1990): 82–99.

Watts, Harriett. *Hans Arp und Sophie Taeuber-Arp: Die Elemente der Bilder und Bücher*. Wolfenbüttel: Herzog August Bibliothek, 1988.

Asse

Mason, Rainer Michael. *Geneviève Asse, l'oeuvre gravé: Catalogue raisonné*. Geneva: Cabinet des Estampes, 1977.

Baj

Petit, Jean, ed. *Baj: Catalogue de l'oeuvre graphique et des multiples*. 2 vols. Geneva: Rousseau Editeur, n.d.

Baselitz

Jahn, Fred. *Baselitz: Peintre-graveur: Werkverzeichnis der Druckgrafik*. 2 vols. Bern: Verlag Gachnang & Springer, 1983–87.

Baskin

Fern, Alan, and Judith O'Sullivan. *The Complete Prints of Leonard Baskin: A Catalogue Raisonné, 1948–1983*. Boston: Little, Brown, 1984.

Beardsley

Kuryluk, Ewa. *Salome and Judas in the Cave of Sex: The Grotesque: Origins, Iconography, Techniques*. Evanston: Northwestern University Press, 1987.

Reade, Brian. *Aubrey Beardsley*. New York: Bonanza Books, 1967.

Wallen, Jeffrey. "Illustrating *Salome*: Perverting the Text?" *Word and Image* 8, no. 2 (April–June 1992): 124–32.

Beckmann

Gallwitz, Klaus, comp. and ed. *Max Beckmann: Die Druckgraphik: Radierungen, Lithographien, Holzschnitte*. 2d ed. Karlsruhe: Badischer Kunstverein, 1962.

Glaser, Curt, Julius Meier-Graefe, Wilhelm Fraenger, and Wilhelm Hausenstein. *Max Beckmann*. Munich: R. Piper & Co. Verlag, 1924.

Hofmaier, James. *Max Beckmann: Catalogue Raisonné of His Prints*. 2 vols. Bern: Gallery Kornfeld, 1990.

Jannasch, Adolf. *Max Beckmann als Illustrator*, Neu-Isenburg: Verlag Wolfgang Tiessen, 1969.

Schulz-Hoffmann, Carla, and Judith C. Weiss, eds. *Max Beckmann Retrospective*. St. Louis: The Saint Louis Art Museum; Munich: Prestel-Verlag; New York: W. W. Norton & Co., 1984.

Smitmans, Adolph. "Max Beckmanns Bilder zur Johannesapokalypse." In *Max Beckmann, Apokalypse*. Albstadt: Städtische Galerie, 1988.

Bellmer

Pieyre de Mandiargues, André. Introduction to *Hans Bellmer: Oeuvre gravé*. Paris: Denoël, 1969.

Beuys

Schellmann, Jörg, ed. *Joseph Beuys, die Multiples: Werkverzeichnis der Auflagenobjekte und Druckgraphik*. 7th ed. Munich and New York: Edition Schellmann, 1992.

Stüttgen, Johannes. "Die Stempel von Joseph Beuys: Eine noch nicht abgeschlossene Untersuchung der Rolle der Stempel im Werk von Joseph Beuys mit vorangestellter Erklärung zur Frage der Schönheit." In *Joseph Beuys: Zeichnungen, Skulpturen, Objekte*. Edited by Wilfried Dickhoff and Charlotte Werhahn, 155–208. [Düsseldorf]: Edition Achenbach, 1988.

Bomberg

Cork, Richard. *David Bomberg*. New Haven and London: Yale University Press, 1987.

Bonnard

Bouvet, Francis. *Bonnard: The Complete Graphic Work*. New York: Rizzoli, 1981.

Jarry, Alfred. "Parallèlement." *La Revue blanche* 24, no. 185 (February 15, 1901): 317.

Roger-Marx, Claude. *Bonnard lithographe*. Monte-Carlo: André Sauret Editions du Livre, 1952.

Terrasse, Antoine. *Pierre Bonnard, Illustrator: A Catalogue Raisonné*. New York: Harry N. Abrams, 1989. (Translation of *Bonnard illustrateur: Catalogue raisonné*. Paris: Editions Adam Biro, 1988.)

Terrasse, Charles. *Bonnard*. Paris: Henri Floury, 1927. (Catalogue of graphic works by Jean Floury.)

Bourgeois

Wye, Deborah, and Carol Smith. *Louise Bourgeois, the Complete Prints*. New York: The Museum of Modern Art, 1994.

Braque

Mundy, Jennifer. *Georges Braque, Printmaker*. London: The Tate Gallery, 1993.

Vallier, Dora. *Braque, l'oeuvre gravé: Catalogue raisonné*. [Paris]: Flammarion, 1982.

Breton

Angliviel de la Beaumelle, Agnès, Isabelle Monod-Fontaine, and Claude Schweisguth. *André Breton: La Beauté convulsive*. Paris: Musée Nationale d'Art Moderne, Centre Georges Pompidou, 1991.

Matthews, J. H. *André Breton*. New York: Columbia University Press, 1967.

Broodthaers

Galerie Jos Jamar. *Marcel Broodthaers: Het Volledig Grafisch Werk en de Boeken/Complete Graphic Work and Books*. Knokke-Duinbergen: Galerie Jos Jamar, 1989.

Galerie Michael Werner. *Marcel Broodthaers: Catalogue des livres/Catalogue of Books/Katalog der Bücher, 1957–1975*. Cologne: Galerie Michael Werner; New York: Marian Goodman Gallery, 1982.

Marcel Broodthaers. London: The Tate Gallery, 1980.

Burne-Jones

Robinson, Duncan. *William Morris, Edward Burne-Jones, and the Kelmscott Chaucer*. London: Gordon Fraser, 1982.

Cage

Cage, John. *Rolywholyover: A Circus*. Los Angeles: Museum of Contemporary Art, 1993. (Includes Cage's autobiography.)

Sontag, Susan, Richard Francis, Mark Rosenthal, Anne Seymour, David Sylvester, and David Vaughan. *Dancers on a Plane: Cage, Cunningham, Johns*. London: Anthony d'Offay Gallery, 1989.

Calder

Carandente, Giovanni. *Calder*. Milan: Electa Editrice, 1983.

Cendrars

Parrot, Louis, and J. H. Levesque. *Blaise Cendrars*. [Paris]: Editions Pierre Seghers, 1948.

Sidoti, Antoine. *La Prose du Transsibérien et de la petite Jehanne de France: Blaise Cendrars–Sonia Delaunay, novembre–décembre 1912–juin 1914: Genèse et dossier d'une polémique*. Paris: Lettres Modernes, 1987.

Chagall

Chagall, Marc. *My Life*. Translated by Elisabeth Abbott. New York: Orion Press, 1960.

Kornfeld, Eberhard W. *Verzeichnis der Kupferstiche, Radierungen und Holzschnitte von Marc Chagall*. Vol. 1, *Werke 1911–1966*. Bern: Verlag Kornfeld und Klipstein, 1970.

Mourlot, Fernand. *The Lithographs of Chagall*. 4 vols. Monte Carlo: André Sauret, Editions du Livre, 1960–74.

Sorlier, Charles. *Chagall Lithographs*, vols. 5–6. New York: Crown Publishers, 1984–86. (Continues Fernand Mourlot's *The Lithographs of Chagall*.)

———. *Marc Chagall: Le Livre des livres/The Illustrated Books*. [Paris]: Editions André Sauret and Editions Michèle Trinckvel, 1990.

Char

Char, René. *Selected Poems of René Char*. Edited by Mary Ann Caws, and Tina Jolas. New York: New Directions, 1992.

Chillida

Michelin, Gisèle. *Chillida: L'Oeuvre graphique/Graphic Work*. Paris: Maeght Editeur, 1978.

De Chirico

Ciranna, Alfonso. *Giorgio de Chirico: Catalogo delle opere grafiche (incisioni e litografie), 1921–1969*. Introduction by Cesare Vivaldi.

Milan: Alfonso Ciranna; Rome: Edizione La Medusa, 1969.

Dali

Descharnes, Robert. *Salvador Dali: The Work, the Man*. New York: Harry N. Abrams, 1984. (Translation of *Dali: L'oeuvre et l'homme*. Lausanne: Edita, 1984.)

Mason, Rainer Michael. *Vrai Dali/Fausse gravure: L'Oeuvre imprimé 1930–1934*. Geneva: Cabinet des Estampes du Musée d'Art et d'Histoire, 1992.

Maur, Karin von. *Salvador Dali, 1904–1989*. Stuttgart: Verlag Gerd Hatje, 1989.

Delaunay

Delaunay, Robert. *Du cubisme à l'art abstrait: Documents inédits publiés par Pierre Francastel et suivis d'un catalogue de l'oeuvre de R. Delaunay par Guy Habasque*. Paris: S.E.V.P.E.N., 1957.

Delaunay-Terk

Cohen, Arthur A. *Sonia Delaunay*. New York: Harry N. Abrams, 1975.

Madsen, Axel. *Sonia Delaunay, Artist of the Lost Generation*. New York: McGraw-Hill, 1989.

Sidoti, Antoine. *La Prose du Transsibérien et de la petite Jehanne de France: Blaise Cendrars–Sonia Delaunay, novembre–décembre 1912–juin 1914: Genèse et dossier d'une polémique*. Paris: Lettres Modernes, 1987.

Sonia Delaunay: Gouaches, pochoirs, eaux fortes, lithographies, livres illustrés, éditions. Montreal: Galerie Treize, 1981.

Derain

Adhémar, Jean. *Derain*. Paris: Bibliothèque Nationale, 1955.

Hilaire, Georges. *Derain*. Geneva: Pierre Cailler Editeur, 1959.

Hoog, Michel, ed. *Un certain Derain*. Paris: Réunion des Musées Nationaux, 1991.

Dine

D'Oench, Ellen G., and Jean E. Feinberg. *Jim Dine Prints, 1977–1985*. New York: Harper & Row, 1986.

Galerie Mikro. *Jim Dine, Complete Graphics*. Edited by Wibke Von Bonin and Michael S. Cullen. Berlin: Galerie Mikro, 1970.

Hubert, Renée Riese. "Apollinaire and Dine: A Re-Enactment of the Poet's Assassination." *Symposium* 34, no. 4 (Winter 1980/81): 333–51.

Krens, Thomas, and Riva Castleman. *Jim Dine: Prints, 1970–1977*. New York: Harper & Row; Williamstown, Mass.: The Williams College Artist-In-Residence Program, 1977.

Dorgelès

Bertrand-Py, Françoise, Nicole Villa, and Marie Hélène Millot. *Roland Dorgelès, de Montmartre à*

l'Académie Goncourt. Paris: Bibliothèque Nationale, 1978.

Dupray, Micheline. *Roland Dorgelès: Un siècle de vie littéraire française*. Paris: Presses de la Renaissance, 1986.

Dubuffet

Arnaud, Noel. *Jean Dubuffet, gravures et lithographies: Catalogue général*. Silkeborg: Silkeborg Kunstmuseum, 1961.

Schmitt, Ursula. *Supplément au catalogue des gravures et lithographies de Jean Dubuffet*. Silkeborg: Silkeborg Kunstmuseum, 1966.

Webel, Sophie. *L'Oeuvre gravé et les livres illustrés par Jean Dubuffet: Catalogue raisonné*. 2 vols. Paris: B. Lebon, 1991.

Duchamp

D'Harnoncourt, Anne, and Kynaston McShine. *Marcel Duchamp: A Retrospective*. Philadelphia: Philadelphia Museum of Art; New York: The Museum of Modern Art, 1973.

Schwarz, Arturo. *The Complete Works of Marcel Duchamp*. 2d ed., rev. New York: Harry N. Abrams, 1970.

Dufy

Courthion, Pierre. *Raoul Dufy*. Geneva: Pierre Cailler Editeur, 1951.

Edschmid

Zimmermann, Erich, comp. *Kasimir Edschmid, 1890–1966*. Darmstadt: Hessische Landes- und Hochschulbibliothek, 1970.

Eluard

Gateau, Jean-Charles. *Eluard, Picasso et la peinture (1936–1952)*. Geneva: Librairie Droz, 1983.

———. *Paul Eluard et la peinture surréaliste (1910–1939)*. Geneva: Librairie Droz, 1982.

Lionel-Marie, Annick, ed. *Paul Eluard et ses amis peintres, 1895–1952*. Paris: Centre Georges Pompidou, 1982.

Ernst

Linke, Claudia, ed. and comp. *Max Ernst: Graphik und Bücher: Sammlung Lufthansa*. Stuttgart: Verlag Gerd Hatje, 1991.

Rainwater, Robert, ed. *Max Ernst Beyond Surrealism: A Retrospective of the Artist's Books and Prints*. New York: The New York Public Library, 1986.

Schamoni, Peter, ed. *Max Ernst, Maximiliana: The Illegal Practice of Astronomy: Hommage à Dorothea Tanning*. Boston: New York Graphic Society, 1974.

Schmidt, Katharina, Hans Bolliger, Mario-Andreas v. Lüttichau, and Klaus Schrenk, eds. *Max Ernst: Illustrierte Bücher und druckgraphische Werke*. Cologne: Wienand Verlag, 1989.

Spies, Werner, ed., and Helmut R. Leppien, comp. *Max Ernst, Oeuvre-Katalog: Das graphische Werk*. Houston: Menil Foundation; Cologne: Verlag M. DuMont Schauberg, 1975.

Evans

Keller, Ulrich. "Walker Evans *American Photographs*: Eine transatlantische Kulturkritik." In *Walker Evans, Amerika: Bilder aus den Jahren der Depression*, 59–77. Edited by Michael Brix and Birgit Mayer. Munich: Schirmer/Mosel, 1990.

Fautrier

Mason, Rainer Michael. *Jean Fautrier: Les Estampes: Nouvel essai de catalogue raisonné*. Geneva: Cabinet des Estampes, 1986.

Francis

Lembark, Connie W. *The Prints of Sam Francis: A Catalogue Raisonné, 1960–1990*. 2 vols. New York: Hudson Hills Press, 1992.

Frasconi

Baltimore Museum of Art. *The Work of Antonio Frasconi, 1952–1963: Woodcuts, Lithographs and Books*. Baltimore: Baltimore Museum of Art, 1963.

Hentoff, Nat. Introduction to *Frasconi Against the Grain: The Woodcuts of Antonio Frasconi*. Appreciation by Charles Parkhurst. New York: Macmillan, 1974.

Symmes, Marilyn. "*. . . Other Languages, Other Signs . . .*": The Books of Antonio Frasconi*. Purchase: Neuberger Museum of Art, State University of New York at Purchase, 1992.

Gauguin

Brettell, Richard. "1893–1894 Suite of Woodcut Illustrations for *Noa Noa*." In *The Art of Paul Gauguin*, by Richard Brettell, Françoise Cachin, Claire Frèches-Thory, and Charles F. Stuckey, 317–22. Washington, D.C.: National Gallery of Art, 1988.

Gauguin, Paul, and Charles Morice. "Noa Noa." *La Revue blanche* 14 (October–December 1897): 81–103.

Loize, Jean. Preface and notes to *Noa Noa*, by Paul Gauguin; poems by Charles Morice. Paris: André Balland, [1966].

Mongan, Elizabeth, Eberhard W. Kornfeld, and Harold Joachim. *Paul Gauguin: Catalogue Raisonné of His Prints*. Bern: Galerie Kornfeld, 1988.

Morice, Charles. *Paul Gauguin*. Paris: H. Floury, 1917. (New ed. pub. 1920.)

Giacometti

Lust, Herbert C. *Giacometti: The Complete Graphics and 15 Drawings*. New York: Tudor Publishing, 1970.

Gilbert & George

Ratcliff, Carter. Introduction to *Gilbert & George: The Complete Pictures, 1971–1985*. New York: Rizzoli, 1986.

Gris

Gris, Juan. *Letters of Juan Gris*. Collected by Daniel-Henry Kahnweiler, translated and edited by Douglas Cooper. London, 1956.

Kahnweiler, Daniel-Henry. *Juan Gris, His Life and Work*. Translated by Douglas Cooper. Rev. ed. New York: Harry N. Abrams, 1969.

Rosenthal, Mark. *Juan Gris*. New York: Abbeville Press, 1983.

Grosz

Dückers, Alexander. *George Grosz: Das druckgraphische Werk*. Frankfurt am Main: Propyläen-Verlag, 1979.

George Grosz: Obra gráfica: Los años de Berlín. Valencia: IVAM Centre Julio Gonzalez, 1992.

Hartigan

Diggory, Terence. *Grace Hartigan and the Poets: Paintings and Prints*. Saratoga Springs, N.Y.: Skidmore College, 1993.

Hayter

Black, Peter, and Désirée Moorhead. *The Prints of Stanley William Hayter: A Complete Catalogue*. Mount Kisco, N.Y.: Moyer Bell Ltd., 1992.

Hockney

Brighton, David. Introduction to *David Hockney Prints, 1954–77*. [London]: Petersburg Press, 1979.

Curtis, Penelope, comp. and ed. *David Hockney: Paintings and Prints from 1960*. Liverpool: Tate Gallery Liverpool, 1993.

Livingstone, Marco. *David Hockney*. Rev. ed. New York: Thames and Hudson, 1987.

Hodgkin

Knowles, Elizabeth, comp. *Howard Hodgkin: Prints 1977 to 1983*. London: The Tate Gallery, 1985.

Serota, Nicholas, ed. *Howard Hodgkin: Forty Paintings, 1973–84*. Essay by John McEwen, interview by David Sylvester. New York: George Braziller; London: The Whitechapel Art Gallery, 1984.

Huidobro

Raynal, Maurice. *Une Exposition de poèmes de Vincent Huidobro*. [Paris]: La Galerie G. L. Manuel Frères, 1922.

Indiana

Katz, William. Introduction to *Robert Indiana: Druckgraphik und Plakate, 1961–1971/The Prints and Posters, 1961–1971*. Commentary by Robert Indiana. Stuttgart and New York: Edition Domberger, 1971.

Sheehan, Susan. *Robert Indiana Prints: A Catalogue Raisonné, 1951–1991*. New York: Susan Sheehan Gallery, 1991.

Jacob

Jacob, Max. *Max Jacob: Correspondance*. Edited by François Garnier. 2 vols. Paris: Editions de Paris, 1953–55.

Kamber, Gerald. *Max Jacob and the Poetics of Cubism*. Baltimore: The Johns Hopkins Press, 1971.

Janco

Seuphor, Michel. *Marcel Janco*. Amriswil, Switzerland: Fischbacher, 1963.

Jarry

Arrivé, Michel. *Peintures, gravures et dessins d'Alfred Jarry*. Paris: Collège de Pataphysique & Cercle Français du Livre, 1968.

Giedion-Welcker, C. *Alfred Jarry: Eine Monographie mit Photos, Zeichnungen und Holzschnitten*. Zurich: Verlag Die Arche, 1960.

Gourmont, Remy de. "Les Livres: Les Minutes de sable mémorial par Alfred Jarry." *Mercure de France* 12 (October 1894): 177–78.

Johns

Castleman, Riva. *Jasper Johns: A Print Retrospective*. New York: The Museum of Modern Art, 1986.

Field, Richard S. *Jasper Johns: Prints, 1970–1977*. Middletown, Conn.: Wesleyan University, 1978.

Field, Richard S., Andrew Bush, Richard Shiff, Fred Orton, and James Cuno. *Foirades/Fizzles: Echo and Allusion in the Art of Jasper Johns*. Los Angeles: Grunwald Center for the Graphic Arts, 1987.

Geelhaar, Christian. *Jasper Johns: Working Proofs*. [London]: Petersburg Press, 1980.

The Prints of Jasper Johns, 1960–1992: A Catalogue Raisonné. Text by Richard S. Field. West Islip, N.Y.: Universal Limited Art Editions, 1994.

Jorn

Asger Jorn: Werkverzeichnis, Druckgrafik. Edited by Jurgen Weihrauch. Munich: Galerie van de Loo, 1976.

Hansen, Per Hofman. *Bibliografi over Asger Jorns Skrifter/A Bibliography of Asger Jorn's Writings*. Silkeborg: Silkeborg Kunstmuseum, 1988.

Kandinsky

Kandinsky, Wassily. *Kandinsky: Complete Writings on Art*. Edited by Kenneth C. Lindsay and Peter Vergo. 2 vols. Boston: G. K. Hall, 1982.

———. "Mes Gravures sur bois." *XXe siècle* 1, no. 3 (1938): 31.

Long, Rose-Carol Washton. *Kandinsky, The Development of an Abstract Style*. Oxford: Clarendon Press; New York: Oxford University Press, 1980.

McGrady, Patrick John. "An Interpretation of Wassily Kandinsky's *Klänge*." Ph.D. diss., State University of New York at Binghamton, 1989.

Roethel, Hans Konrad. *Kandinsky, das graphische Werk*. Cologne: Verlag M. DuMont Schauberg, 1970.

Kelly

Axson, Richard H. *The Prints of Ellsworth Kelly: A Catalogue Raisonné, 1949–1985*. New York: Hudson Hills Press, 1987.

Kiefer

Adriani, Götz, ed. *The Books of Anselm Kiefer, 1969–1990*. New York: George Braziller, 1991.

Kirchner

Dube, Annemarie, and Wolf-Dieter Dube. *E. L. Kirchner, das graphische Werk*. 2d, rev. ed. 2 vols. Munich: Prestel Verlag, 1980.

Kokoschka

Arntz, Wilhelm F. et al. *Oskar Kokoschka: Aus seinem Schaffen, 1907–1950*. Munich: Prestel-Verlag, 1950.

Dolinschek, Ilse. "Oskar Kokoschkas Entwicklung als Illustrator, 1906 bis 1909: Eine Untersuchung anhand der Illustrationen *Die träumenden Knaben* und *Mörder Hoffnung der Frauen*." Ph.D. diss., Katholische Universität, Eichstätt, 1983.

Kokoschka, Oskar. *Schriften, 1907–1955*. Compiled and annotated by Hans Maria Wingler. Munich: Albert Langen, George Müller, 1956.

Schvey, Henry I. *Oskar Kokoschka: The Painter as Playwright*. Detroit: Wayne University Press, 1982.

Wingler, Hans Maria, and Friedrich Welz, eds. *O. Kokoschka, das druckgraphische Werk*. 2 vols. Salzburg: Verlag Galerie Welz, 1975–81.

Kruger

Linker, Kate. *Love for Sale: The Words and Pictures of Barbara Kruger*. New York: Harry N. Abrams, 1990.

Tallman, Susan. "Counting Pretty Ponies: Barbara Kruger and Stephen King Make Book." *Arts Magazine* 63, no. 7 (March 1989): 19–20.

Kupka

František Kupka, 1871–1957, ou l'invention d'une abstraction. Paris: Musée d'Art Moderne de la Ville de Paris, 1989.

Lam

Fouchet, Max-Pol. *Wifredo Lam*. Barcelona: Ediciones Polígrafa, 1976.

Laurens

Völker, Brigitte. *Henri Laurens: Werkverzeichnis der Druckgraphik*. Hannover: Edition Brusberg, 1985.

Léger

Saphire, Lawrence. *Fernand Léger: The Complete Graphic Work*. New York: Blue Moon Press, 1978.

LeWitt

Singer, Susanna. *Sol LeWitt, Prints 1970–86*. London: The Tate Gallery, 1986.

Lissitzky

Bowlt, John E. "El Lissitzky." In *El Lissitzky*. Edited by Krystyna Rubinger, 47–56. Cologne: Galerie Gmurzynska, 1976.

Debbaut, Jan, and Mariëlle Soons, eds. *El Lissitzky, 1890–1941: Architect, Painter, Photographer, Typographer*. Eindhoven: Municipal Van Abbemuseum; New York: Thames and Hudson, 1990.

Hemken, Kai-Uwe. *El Lissitzky, Revolution und Avantgarde*. Cologne: DuMont Buchverlag, 1990.

Railing, Patricia. *More About Two Squares*. Cambridge, Mass.: MIT Press, 1991.

Maillol

Greet, Anne Hyde. "Conversations in Arcady: Vergil, Maillol and Kessler, *Eclogues* I, II, V and VI." *Word & Image* 3, no. 4 (October–December 1987): 225–47.

Guérin, Marcel. *Catalogue raisonné de l'oeuvre gravé et lithographié de Aristide Maillol*. 2 vols. Geneva: Editions Pierre Cailler, 1965–67.

Rewald, John, ed. *The Woodcuts of Aristide Maillol: A Complete Catalogue*. New York: Pantheon, 1943.

Malevich

Karshan, Donald. *Malevich: The Graphic Work: 1913–1930: A Print Catalogue Raisonné*. Jerusalem: The Israel Museum, 1975.

Nakov, Andrei B. "Malevich as Printmaker." *The Print Collector's Newsletter* 7, no. 1 (March–April 1976): 4–10.

Mallarmé

Florence, Penny. *Mallarmé, Manet and Redon*. Cambridge: Cambridge University Press, 1986.

Mallarmé, Stéphane. *Selected Poetry and Prose*. Edited by Mary Ann Caws. New York: New Directions, 1982.

Malraux

Cazenave, Michel. *Malraux*. [Paris]: Editions Balland, 1985.

Madsen, Axel. *Malraux: A Biography*. New York: William Morrow, 1976.

Prat, Jean-Louis, and Nicole Worms de Romilly, eds. *André Malraux*. Saint Paul, France: Fondation Maeght, 1973.

Masereel

Avermaete, Roger, Pierre Vorms, and Hanns-Conon von der Gabelentz. *Frans Masereel*. [Antwerp]: Fonds Mercator; New York: Rizzoli, 1977.

Masson

Galerie Flak. *André Masson et l'univers de ses livres*. Paris: Galerie Flak, 1992.

Saphire, Lawrence. *André Masson: The Complete Graphic Work*. Vol. 1, *Surrealism 1924–49*. Yorktown Heights, N.Y.: Blue Moon Press, 1990.

Saphire, Lawrence, and Patrick Cramer. *André Masson, the Illustrated Books: Catalogue Raisonné*. Geneva: Patrick Cramer, forthcoming.

Matisse

Duthuit, Claude, and Françoise Garnaud. *Henri Matisse: Catalogue raisonné des ouvrages illustrés*. Paris, 1988.

Hahnloser-Ingold, Margrit, and Roger Marcel Mayou. *Henri Matisse, 1869–1954: Gravures et lithographies*. Bern: Galerie Kornfeld, 1982.

Roussakov, Youri. Introduction to *Henri Matisse: L'Art du livre*. Nice: Musée Matisse, 1986.

Szymusiak, Dominique. *Matisse et Baudelaire*. Le Cateau-Cambrésis: Musée Matisse, 1992.

Matta

Sabatier, Roland. *Matta: Catalogue raisonné de l'oeuvre gravé, 1943–1974*. Stockholm: Sonet; Paris: Editions Visat, 1975.

Michaux

Bertelé, René. *Henri Michaux: Une étude, un choix de poèmes, et une bibliographie*. Paris: Editions Pierre Seghers, 1957.

Miró

Cooper, Douglas. Preface to *Joan Miró: Bois gravés pour un poème de Paul Eluard*. Paris: Berggruen, 1958.

Cramer, Patrick. *Joan Miró, the Illustrated Books: Catalogue Raisonné*. Geneva: Patrick Cramer, 1989.

Dupin, Jacques. *Miró Engraver*. 3 vols. New York: Rizzoli, 1989–92.

Greet, Anne Hyde. Introduction to *A Toute Epreuve*, by Paul Eluard, illustrations by Joan Miró. 2 vols. New York: George Braziller, 1984.

Mourlot, Fernand, Michel Leiris, Raymond Queneau, Joan Teixidor, Nicolas Calas, Elena Calas, and Patrick Cramer. *Joan Miró,*

Lithographs. 6 vols. New York: Tudor Publishing, 1972–92.

Solf, Sabine, and Harriett Watts. *Paul Eluard und Joan Miró: A Toute Epreuve: Leuchtend klare Metamorphosen*. Wolfenbüttel: Herzog August Bibliothek, 1990.

Mitchell

Sheehan, Susan. *Joan Mitchell: Prints and Illustrated Books: A Retrospective*. New York: Susan Sheehan Gallery, 1993.

Moholy-Nagy

Kostelanetz, Richard, comp. *Moholy-Nagy*. New York: Praeger Publishers, 1970.

Moore

Cramer, Gérald, Alistair Grant, David Mitchinson, and Patrick Cramer. *Henry Moore: Catalogue of Graphic Work*. 4 vols. Geneva: Gérald Cramer and Patrick Cramer, 1973–86.

Morris

Lochnan, Katharine A., Douglas E. Schoenherr, and Carole Silver, eds. *The Earthly Paradise: Arts and Crafts by William Morris and His Circle from Canadian Collections*. Toronto: The Art Gallery of Ontario and Key Porter Books, 1993.

Motherwell

McKendry, John J. *Robert Motherwell's "A La Pintura": The Genesis of a Book*. New York: The Metropolitan Museum of Art, 1972.

Terenzio, Stephanie. *The Prints of Robert Motherwell*. Catalogue raisonné by Dorothy C. Belknap. New York: Hudson Hills Press and The American Federation of Arts, 1991.

Munari

Tanchis, Aldo. *Bruno Munari: Design as Art*. Cambridge: MIT Press, 1987.

Nash

Fletcher, John Gould. "The Wood Engravings of Paul Nash." *Print Collector's Quarterly* 15 (1928): 209–33.

Postan, Alexander. *The Complete Graphic Works of Paul Nash*. London: Secker and Warburg, 1973.

Paladino

Paparoni, Demetrio. Introduction to *Mimmo Paladino: Prints, 1987–1991*, London: Waddington Graphics, 1991.

Paolozzi

Miles, Rosemary. *The Complete Prints of Eduardo Paolozzi: Prints, Drawings, Collages, 1944–77*. London: The Victoria and Albert Museum, 1977.

Partenheimer

Kern, Hermann, Annie Bardon, Bruno Glatt, Maria Kreutzer, Jürgen Partenheimer, and Ludwig Hohl. *Jürgen Partenheimer: Linolschnitte*

und Bücher. Reutlingen: Schul-, Kultur- und Sportamt Rathaus Reutlingen, 1988.

Meyer, Werner, ed. *Jürgen Partenheimer: Varia: Bilder einer Sammlung*. Stuttgart: Edition Cantz, 1992.

Penck

Penck, A. R., and Erik Mosel. *A. R. Penck: Graphik Ost/West*. Brunswick: Kunstverein Braunschweig, 1986.

Picasso

Baer, Brigitte, see Geiser.

Bloch, Georges. *Pablo Picasso*. 4 vols. Bern: Kornfeld et Klipstein, 1968–1979. (Vols. 1, 2, and 4 comprise the *Catalogue de l'oeuvre gravé et lithographié*.)

Brassaï. *Conversations avec Picasso*. Paris: Gallimard, 1964. (Translated as *Picasso and Company*. Garden City, N.Y.: Doubleday, 1966.)

Geiser, Bernhard, and Brigitte Baer. *Picasso, peintre-graveur: Catalogue raisonné de l'oeuvre gravé*. 5 vols. Bern: Editions Kornfeld, 1986–92. (Vols. 1–2 by Geiser, revised by Baer; vols. 3–5 by Baer.)

Goeppert, Sebastian, Herma Goeppert-Frank, and Patrick Cramer. *Pablo Picasso, The Illustrated Books: Catalogue Raisonné*. Geneva: Patrick Cramer, 1983.

Matarasso, Henri. *Bibliographie des livres illustrés par Pablo Picasso: Oeuvres graphiques, 1905–1956*. Nice: Galerie H. Matarasso, 1956.

Mourlot, Fernand. *Picasso lithographe*. 4 vols. Monte-Carlo: André Sauret, Editions du Livre, 1949–64.

———. *Picasso lithographe*. Paris: Editions André Sauret, 1970.

Picasso, Pablo. *Picasso: Collected Writings*. Edited by Marie-Laure Bernadac and Christine Piot. New York: Abbeville Press, 1989.

Sabartés, Jaime. *Picasso, An Intimate Portrait*. New York: Prentice-Hall, 1948.

Radiguet

Crosland, Margaret. *Raymond Radiguet: A Biographical Study with Selections from His Work*. London: Peter Owen, 1976.

Rauschenberg

Foster, Edward A. Introduction to *Robert Rauschenberg: Prints 1948/1970*. Minneapolis: The Minneapolis Institute of Arts, 1970.

Kotz, Mary Lynn. *Rauschenberg: Art and Life*. New York: Harry N. Abrams, 1990.

Redon

Florence, Penny. *Mallarmé, Manet and Redon*. Cambridge: Cambridge University Press, 1986.

Mellerio, André. *Odilon Redon*. Paris: Société pour l'Etude de la Gravure Française, 1913. (Reprint: New York: Da Capo Press, 1968.)

———. *Odilon Redon, peintre, dessinateur et graveur*. Paris: H. Floury, 1923. (Reprint: New York: Da Capo Press, 1968.)

Roth

Roth, Dieter. *Books and Graphics (Part 1): From 1947 until 1971*. Stuttgart, London, and Reykjavík: Edition Hansjörg Mayer, 1971. (Collected Works, vol. 20.)

———. *Books and Graphics (Part 2) and Other Stuff: From 1971 until 1979 (Including Supplement to Part 1)*. Stuttgart and London: Edition Hansjörg Mayer, 1979. (Collected Works, vol. 40.)

Schwarz, Dieter. *Auf der Bogen Bahn: Studien zum literarischen Werk von Dieter Roth*. Zurich: Seedorn, 1981.

Rouault

Blunt, Anthony. Introduction to *Miserere*, by Georges Rouault, preface by Rouault. Boston: Boston Book & Art Shop and The Trianon Press, 1963.

Chapon, François. *Le Livre des livres de Rouault/The Illustrated Books by Rouault*. Paris: Editions André Sauret and Editions Michèle Trinckvel, [1992].

Chapon, François, and Isabelle Rouault. *Rouault, Oeuvre gravé*. 2 vols. Monte-Carlo: Editions André Sauret, 1978.

Dorival, Bernard. *Le Miserere de Georges Rouault*. La Rochelle: Musée des Beaux-Arts, 1977.

Wheeler, Monroe. Introduction to *Miserere*, by Georges Rouault, preface by Rouault. New York: The Museum of Modern Art, 1952.

Rozanova

Olga Rozanova, 1886–1918. Helsinki: Helsingin kaupungin taidemuseo, 1992.

Ruscha

Edward Ruscha (Ed-werd Rew-shay) Young Artist: A Book Accompanying the Exhibition of Prints, Drawings and Books of Edward Ruscha. Minneapolis: The Minneapolis Institute of Arts, 1972.

Ryman

Sandback, Amy Baker. *Robert Ryman Prints, 1969–1993*. New York: Parasol Press, 1994.

Sartre

Sicard, Michel, ed. *Sartre e l'arte: Omaggio à Jean-Paul Sartre*. Rome: Edizione Carte Segrete, 1987.

Satie

Satie, Erik. *The Writings of Erik Satie*. Edited and translated by Nigel Wilkins. London: Eulenburg Books, 1980.

Schwitters

Büchner, Joachim, and Norbert Nobis. *Kurt Schwitters, 1887–1948: Ausstellung zum 99. Geburtstag*. [Berlin]: Propyläen-Verlag, 1986.

Elderfield, John. *Kurt Schwitters*. New York: Thames and Hudson, 1985. (Catalogue of an exhibition held at The Museum of Modern Art.)

Segonzac

Lioré, Aimée, and Pierre Cailler. *Catalogue de l'oeuvre gravé de Dunoyer de Segonzac*. 8 vols. Geneva: Pierre Cailler Editeur, 1958–70.

Seligmann

Mason, Rainer Michael. *Kurt Seligmann: Oeuvre gravé*. Geneva: Cabinet des Estampes and Editions du Tricorne, 1982.

Shahn

McNulty, Kneeland. *The Collected Prints of Ben Shahn*. Philadelphia: Philadelphia Museum of Art, 1967.

Prescott, Kenneth W. *The Complete Graphic Works of Ben Shahn*. New York: Quadrangle Books / The New York Times Book Co., 1973.

Staël

Woimant, Françoise, and Françoise de Staël. *Nicolas de Staël: L'Oeuvre gravé*. Paris: Bibliothèque Nationale, 1979.

Tanguy

Wittrock, Wolfgang. *Yves Tanguy: Das druckgraphische Werk / The Graphic Work*. Düsseldorf: Wolfgang Wittrock Kunsthandel, 1976.

Tàpies

Galfetti, Mariuccia. *Tàpies: Obra Gráfica*. 2 vols. Barcelona: Editorial Gustavo Gili, 1973–80.

Garcia, Josep-Miquel, Daniel Giralt-Miracle, and Arnau Puig. *Tàpies und die Bücher / Els Llibres de Tàpies*. Frankfurt am Main: Schirn Kunsthalle, 1991.

Watts, Harriett. *Antoní Tàpies: Die Bildzeichen und das Buch*. Wolfenbüttel: Herzog August Bibliothek, 1988.

Wye, Deborah. *Antoni Tàpies in Print*. New York: The Museum of Modern Art, 1991.

Toulouse-Lautrec

Adriani, Götz. *Toulouse-Lautrec, the Complete Graphic Works: A Catalogue Raisonné: The Gerstenberg Collection*. New York: Thames and Hudson, 1988.

Delteil, Loys. *H. de Toulouse-Lautrec*. 2 vols. Le Peintre-graveur illustré: XIXe et XXe siècles, 10–11. Paris: Chez l'Auteur, 1920.

Toulouse-Lautrec, Henri de. *The Letters of Henri de Toulouse-Lautrec*. Edited by Herbert D. Schimmel. Oxford and New York: Oxford University Press, 1991.

Wick, Peter. Introduction to *Yvette Guilbert*, by Gustave Geffroy, illustrated by Henri de Toulouse-Lautrec. Facsimile ed. New York: Walker and Company; Cambridge, Mass.: Department of Printing & Graphic Arts, Harvard College Library, 1968.

Wittrock, Wolfgang. *Toulouse-Lautrec, The Complete Prints*. Edited and translated by Catherine E. Kuehn. 2 vols. London: Sotheby's Publications, 1985.

Tzara

Schwarz, Arturo. "Tristan Tzara: Théoricien dada." *Europe* 53, no. 555–56 (July–August 1975): 165–72.

Tzara, Tristan. *Tzara: Oeuvres complètes*. Edited by Henri Béhar. 6 vols. Paris: Flammarion, 1975–91.

Van de Velde

Sembach, Klaus-Jürgen, and Birgit Schulte, eds. *Henry van de Velde: Ein europäischer Künstler seiner Zeit*. Cologne: Wienand Verlag, 1992.

Villon

Auberty, Jacqueline, and Charles Pérussaux. *Jacques Villon: Catalogue de son oeuvre gravé*. Paris: P. Prouté et ses Fils, 1950.

Ginestet, Colette de, and Catherine Pouillon. *Jacques Villon, les estampes et les illustrations: Catalogue raisonné*. Paris: Arts et Métiers Graphiques, 1979.

Vital

Rainwater, Robert. "Signs of Life: Not Vital's Prints & Books." *The Print Collector's Newsletter* 23 (July–August 1992): 81–87.

Stutzer, Beat. *Not Vital: Druckgraphik & Multiples*. Chur: Bündner Kunstmuseum, 1991.

Warhol

Feldman, Frayda, and Jörg Schellmann. *Andy Warhol Prints: A Catalogue Raisonné*. Rev. ed. New York: Ronald Feldman Fine Arts, 1989.

Wols

Grohmann, Will. "Das Graphische Werk von Wols." *Quadrum*, no. 6 (1959): 95–118.

Karabelnik-Matta, Marianne, ed. *Wols: Bilder, Aquarelle, Zeichnungen, Photographien, Druckgraphik*. Zurich: Kunsthaus Zürich, 1989.

REPRODUCTIONS

Baselitz, Georg. *Malelade*. Eindhoven: Lecturis, [1991].

Beardsley, Aubrey. *Salome: A Tragedy in One Act* by Oscar Wilde. Boston: Branden Publishing Company, 1989.

Beckmann, Max. *Apokalypse*. Frankfurt am Main: Propyläen-Verlag, 1974.

———. *Die Fürstin* by Kasimir Edschmid. Frankfurt am Main: Propyläen Verlag, 1973.

Bonnard, Pierre. *Parallèlement* by Paul Verlaine. Paris: Editions L.C.L., [1965].

———. *Parallèlement* by Paul Verlaine. Paris: Adagp, 1977.

Calder, Alexander. *Fables of Aesop, According to Sir Roger L'Estrange*. New York: Dover Publications, 1967.

Chagall, Marc. *Arabian Nights: Four Tales from a Thousand and One Nights*. Introduction by Norbert Nobis. Munich: Prestel-Verlag, 1988.

Clemente, Francesco. *The Departure of the Argonaut*, by Alberto Savinio; translated by George Scrivani. Reduced format ed. New York: Petersburg Press, 1986.

Dufy, Raoul. *Le Bestiaire, ou cortège d'Orphée* by Guillaume Apollinaire; translated by Lauren Shakely. New York: The Metropolitan Museum of Art, 1977.

Ernst, Max. *Une Semaine de bonté, ou les sept éléments capitaux: Roman*. Paris: Pauvert, 1968.

Evans, Walker. *American Photographs*. Essay by Lincoln Kirstein. Fiftieth-anniversary ed. New York: The Museum of Modern Art, 1988.

Frasconi, Antonio. *12 Fables of Aesop*. Retold by Glenway Wescott. New York: The Museum of Modern Art, 1967.

Gauguin, Paul. *Noa Noa*. Edited by Gilles Artur, Jean-Pierre Fourcade, and Jean-Pierre Zingg. Tahiti: L'Association des Amis du Musée Gauguin; New York: The Gauguin and Oceania Foundation, 1987.

Grosz, George. *Ecce Homo*. Introduction by Henry Miller. New York: Grove Press, 1966.

———. *Ecce Homo*. Frankfurt am Main: Makol Verlag, 1975.

———. *Ecce Homo*. New York: Dover Publications, 1976.

Hodgkin, Howard. *The Way We Live Now* by Susan Sontag. New York: Noonday Press, 1991.

Jarry, Alfred. *Les Minutes de sable mémorial / César-Antéchrist*. Edited and annotated by Philippe Audoin. Paris: Gallimard, 1977.

Jorn, Asger. *Held & Hasard*, *Dolk & Guitar*. Borgen, Denmark: Skandinavisk Institut for Sammenlignende Vandalisme, 1963.

Kirchner, Ernst Ludwig. *Umbra Vitae*: *Nachgelassene Gedichte* by Georg Heym, postscript and annotations by Elmar Jansen. Munich: Ellermann, 1969.

Kokoschka, Oskar. *Die träumenden Knaben und andere Dichtungen*. Introduction by Hans Maria Wingler. Salzburg: Verlag Galerie Welz, 1959.

―――. *Die träumenden Knaben*. Vienna: Verlag Jugend und Volk, 1968.

Kruger, Barbara, and Stephen King. *My Pretty Pony*. New York: Alfred A. Knopf and Whitney Museum of American Art, 1989.

Lissitzky, El. *About Two Squares*: *In 6 Constructions*: *A Suprematist Tale*. Cambridge, Mass.: MIT Press, 1991.

Maillol, Aristide. *The Eclogues*: *The Georgics*, by Virgil. Franklin Center, Pa.: Franklin Library, 1981.

Matisse, Henri. *Jazz*. Introduction by Riva Castleman. New York: George Braziller, 1992.

―――. *Poésies* by Stéphane Mallarmé. Paris: Editions L.C.L., 1966.

―――. *Poésies de Stéphane Mallarmé*. Geneva: Production Edito-Service, [1984].

Michaux, Henri. *Meidosems*: *Poems and Lithographs*. Santa Cruz, Calif.: Moving Parts Press, 1992.

Miró, Joan. *A Toute Epreuve* by Paul Eluard, introduction by Anne Hyde Greet. 2 vols. New York: George Braziller, 1984.

Moholy-Nagy, László. *Malerei, Fotografie, Film*. Postscript by Otto Stelzer. Mainz: Kupferberg, 1967.

―――. *Painting, Photography, Film*. Note by Hans Maria Wingler, postscript by Otto Stelzer. Cambridge, Mass.: MIT Press, 1987.

Redon, Odilon. *La Tentation de Saint Antoine* by Gustave Flaubert. Paris: Editions L.C.L., 1969.

Roth, Dieter. *Bok 3c*: *Wiederkonstruktion des Buches aus dem Verlag Forlag Ed. 1961*. Reykjavík and Düsseldorf: Edition Hansjörg Mayer, 1971. (Collected Works, vol. 1.)

Ruscha, Edward. *Twentysix Gasoline Stations*, 3d ed. [Los Angeles], 1969.

Schwitters, Kurt. *Kathedrale*. Bern: H. Lang, 1975.

Shahn, Ben. *The Alphabet of Creation*: *An Ancient Legend from the Zohar*. New York: Schocken Books, 1982.

Toulouse-Lautrec, Henri de. *A Bestiary by Toulouse-Lautrec*. Cambridge, Mass.: Fogg Art Museum, 1970.

―――. *Yvette Guilbert* by Gustave Geffroy; introduction by Peter Wick. New York: Walker and Company; Cambridge, Mass.: Department of Printing & Graphic Arts, Harvard College Library, 1968.

PHOTOGRAPH CREDITS

Photographs of works of art reproduced in this publication have been provided in most cases by the owners or custodians of the works, identified in the captions and Catalogue of the Exhibition. Individual works of art appearing herein may be protected by copyright in the United States of America or elsewhere and may thus not be reproduced in any form without the permission of the copyright owners. The following copyright notices appear at the request of the artist's heirs and representatives and/or the owners of individual works. Photographers and sources are listed alphabetically below, keyed to figure and plate numbers.

Courtesy Pierre Alechinsky: Plate 97

Courtesy Brigitte Baer, Paris; © S.P.A.D.E.M./A.R.S.: Figure 15; plates 91, 92

Dean Beasom, National Gallery of Art, Washington, D.C.: Plate 66

© Cliché Bibliothèque Nationale de France, Paris: Figure 23; plate 98

Galerie Kornfeld, Bern: Plate 90

The Resource Collections of the Getty Center for the History of Art and the Humanities: Figure 6; plates 2, 153

By permission The Houghton Library, Harvard University: Figure 26; plate 58

All works of Jasper Johns: © Jasper Johns/ VAGA, New York, 1994

Kate Keller, The Museum of Modern Art, New York: Figure 7; plates 1, 3, 16, 22, 23, 28, 29, 48, 68, 69, 76, 77, 118, 130, 136, 155, 160, 162, 164, 173, 178, 179, 186, 190

James Mathews, The Museum of Modern Art, New York: Figure 27

All works of Henri Matisse: © Succession H. Matisse/Artists Rights Society (A.R.S.), New York

All works of Joan Miró: © Estate of Joan Miró/Artists Rights Society (A.R.S.), New York

© Musée d'Art et d'Histoire, Geneva: Plates 73, 74

Courtesy Musée Fernand Léger, Biot, France (© Georges Banquier - S.P.A.D.E.M., Paris): Figure 10

Mali Olatunji, The Museum of Modern Art, New York: Figures 2, 3, 4, 5, 8, 11, 20, 21, 22, 24, 25; plates 4, 5, 6, 7, 8, 9, 10, 11, 12, 13, 14, 15, 18, 20, 21, 24, 25, 27, 30, 31, 33, 35, 36, 37, 38, 39, 40, 41, 42, 43, 44, 45, 46, 47, 49, 50, 51, 52, 53, 54, 55, 56, 57, 59, 60, 61, 62, 63, 64, 65, 67, 70, 71, 72, 75, 78, 79, 80, 81, 82, 83, 84, 87, 88, 89, 94, 95, 96, 99, 100, 101, 102, 103, 104, 105, 106, 107, 108, 109, 111, 112, 113, 114, 115, 116, 117, 120, 121, 122, 123, 124, 125, 126, 127, 128, 129, 131, 132, 133, 134, 137, 138, 139, 141, 142, 143, 144, 146, 147, 148, 149, 150, 151, 152, 154, 156, 157, 158, 159, 161, 163, 165, 166, 167, 168, 169, 170, 171, 172, 174, 175, 176, 177, 180, 181, 183, 184, 185, 189, 191, 192, 193, 194, 195.

Osiris, New York: Plates 187, 188

Rolf Petersen, The Museum of Modern Art, New York: Figures 14, 17

© Succession Picasso, for each work appearing with the following credit: Musée Picasso, Paris, and Marina Picasso Collection, Jan Krugier Gallery, New York

The Pierpont Morgan Library, New York: Figures 1, 16

Carlton Lake Collection, Harry Ransom Humanities Research Center, The University of Texas at Austin: Figure 9; plate 135

© Photo R.M.N. - S.P.A.D.E.M., Cliché des Musées Nationaux, Paris: Figure 18; plate 93

Robert D. Rubic, New York City: Figure 12; plates 26, 32, 34, 110, 182

Yves Siza, © Musée d'Art et d'Histoire, Geneva: Plate 119

S.P.A.D.E.M., Paris, is the exclusive French agent for reproduction rights for Picasso; A.R.S., New York is the exclusive United States agent for S.P.A.D.E.M.

Graphische Sammlung Staatsgalerie Stuttgart: Plates 19, 145

Städtische Galerie im Lenbachhaus, Munich: Plate 85

Soichi Sunami, The Museum of Modern Art, New York: Plate 17

The Toledo Museum of Art: Plate 140

All works of Andy Warhol: © The Estate and Foundation of Andy Warhol

© Wenk/Guest 1984, The Museum of Modern Art, New York: Plate 86

© Whitney Museum of American Art, New York: Figure 28

Ellen Page Wilson, The Pace Gallery, New York: Figure 13

INDEX

Le
Cygne

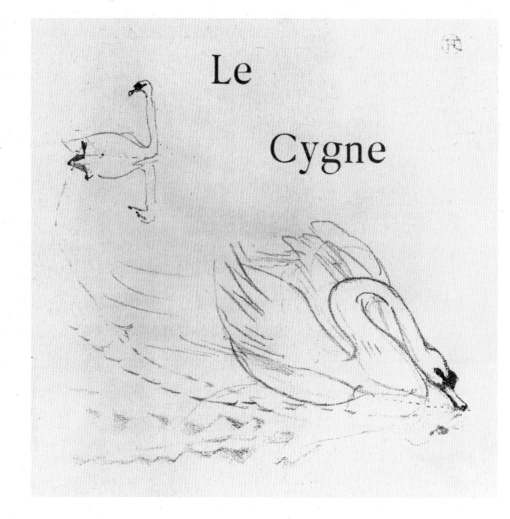